MR BRIDGES' ENLIGHTENMENT MACHINE

FORTY YEARS ON TOUR IN GEORGIAN BRITAIN

Barb Drummond

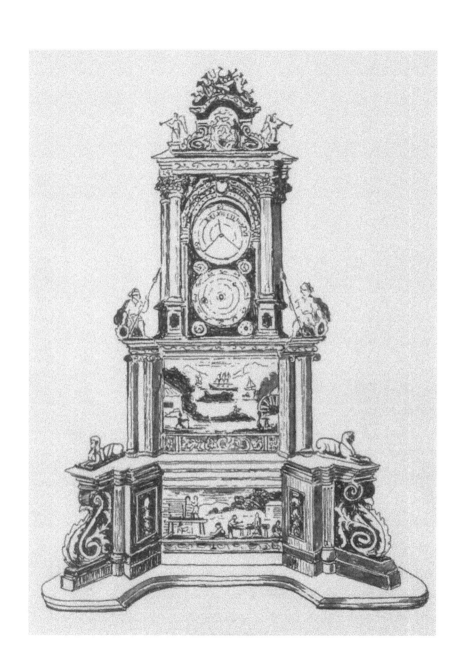

Copyright © 2018 by Barb Drummond

Published 2018

Barb Drummond has asserted her right to be identified as the author of this work in accordance with the Copyright, Designs and Patents Act 1988.

barbdrummond.com

ISBN 978-1-912829-00-2 ebook

ISBN 978-1-912829-01-9 paperback

ISBN 978-1-912829-02-6 hardback

All images copyright the author unless stated otherwise.

Microcosm print on p. xi reproduced with permission British Library.

Print of handbill c.1750 on p. xiii reprinted with permission of Westminster Archives.

By the same author:

The Midas of Manumission: The Orphan Samuel Gist and his Virginian Slaves

Frolicksome Women & Troublesome Wives: Wife Selling in England

How these curiosities would be quite forgot, did not idle fellows such as I am put them down.
 John Aubrey

INTRODUCTION

In a quiet corner of the British Museum, not far from its bustling entrance, are the remains of one of the most important machines ever made. Though recognised by the Horology Department as a fine example of English clockwork, it was not listed in their 1981 catalogue of scientific instruments. This is because the surviving astronomical component was part of a much larger, more intriguing machine. For many years it was not on display, as its importance lies not in its 'clockness', but in the role the complete structure played in preparing the ground for both the Enlightenment and the Industrial Revolution.

The machine was called *The Microcosm or Little World* and was built by carpenter Henry Bridges of Waltham Abbey. It was huge — ten feet high and six feet wide at the base — and was first put on display at Henry's house in September 1733. Based on the design of a Roman temple, it comprised four tiers carrying moving displays of classical scenes, the astronomical clock that still survives, a land and seascape, and a carpenter's yard. The performance was accompanied by music.

Henry claimed it was "fit to adorn the palace of a prince", but it became a show which toured Britain, Ireland and the Americas for over forty years. It entertained with moving scenes, it educated with

the latest astronomical discoveries and claims were made that it stimulated the senses, encouraged learning and much of its publicity in the press was addressed "to the curious". The machine was indeed a very curious one.

The author's attention was drawn to the story of Henry and his machine after I had written about his son James whose troubled career in rebuilding Bristol's eponymous bridge had long intrigued me. James was a highly talented, personable engineer and architect who claimed to have had no prior experience before arriving in this busy port in 1756. After years of struggling for acceptance he suddenly left, like Clint Eastwood's character in the film *Pale Rider*. So Henry's life began as a back story to that of James but, as I continued my research, the father's story soon eclipsed that of his son.

Henry and later owners produced a wide range of advertisements in the press, handbills and an explanatory booklet, so they were adept at self-promotion. James claimed that Henry had taught him all he knew, so we can list him as an early civil engineer.

The story of Henry Bridges, like that of his invention, is a strange one. It is made up of scores of facts and ideas apparently heading off in different directions and for years it seemed impossible to shape it into a book, like trying to turn a hydra into a snake. It was clear that there was an incredible story to be told, but the gaps in the historical record made it like an unfinished jigsaw puzzle: intriguing to look at, but not making a lot of sense.

Henry himself seems equally confusing. A modern clockmaker described the qualities required for success in this profession, which have not changed with time: "patience, an ability to overview, and an obsession with precision".[1] To which should be added an ability to spend long periods alone, focused on a single task. But to show the clock at fairs, to promote it and give lectures he must have enjoyed — or craved — the company of others, from aristocrats to servants and children, so Henry must also have been an extrovert. To have taught himself so many skills, he must have had a passion for learning. But to survive on the road and to transport the giant machine from place to place for so long he must also have had immense phys-

ical strength and endurance. He could thus be called a Renaissance man.

But Britain in the eighteenth century was going through immense economic and social upheavals, so he also had to be light on his feet, quick to adapt, doing whatever was needed to survive, so he was more an early example of Darwin's *survival of the fittest*. But as the following will show, he was more a creature of his age, a Georgian Man.

Henry's machine was incredibly complex, both in its internal workings and its external appearance. There is a wonderfully childlike sensibility in his collection of moving scenes, like a child drawing its home and family and then holding it up for the world to see. But the show he provided and the philosophy behind it were far more radical, more wide ranging and extraordinary than it seems.

The term *microcosm* is also infuriatingly difficult to pin down. The modern usage of it being a little world representing the larger one works, but the concept dates back to antiquity, so has evolved over time. *Brewer's Dictionary of Phrase and Fable* provides a definition based on Paracelsus. Our ancestors believed the world to be alive: its eyes were the sun and moon, its body the earth, its intellect the ether and its wings the sky. Man was seen as a miniature version of the larger system. By understanding one, they believed they could comprehend the other; hence astrology was seen as a means of understanding and predicting the future of men.[2]

Thomas Turner, shopkeeper and former schoolmaster of East Hoathley in Sussex, recorded his visit to The Microcosm in 1758. The editor of his diary, Dr G.H. Jennings, praises Turner's book for providing "this picturesque presentation of his own very picturesque microcosm".[3] This shows the modern practice of using a miniature world to represent the wider world in compact form to enable complex ideas to be discussed and understood.

Henry was born at the end of the seventeenth century, when early science was struggling to emerge from the swamp of guesswork, superstition and religious disputes. Natural philosophers laid the groundwork for modern science by emphasising the importance of close observation and repeated experimentation. They collected

curiosities for investigation and discussion and looked for patterns and similarities in these little worlds. The practice of curiosity and improvements helped rebuild England after the drawn-out chaos of The Reformation and Civil War.

The term *microcosm* is little used in daily speech. But it appears in a surprisingly wide range of categories from sociology to performance art and environmental studies. By investigating something small, parallels can be drawn with the wider world. So it is with Henry Bridges and his machine. Once you start looking for it, the records are there. And by investigating the story of Henry's little world, a door is opened to a curiously little known world of eighteenth century history that continues to influence our world today.

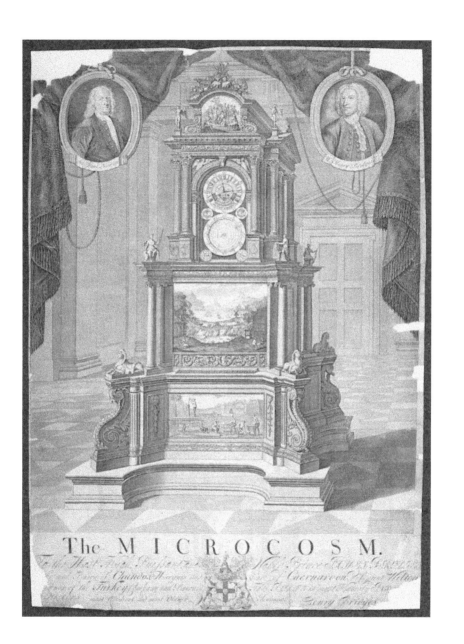

To be seen by Four, Five, or more, at One Shilling each; in a large Room, at the King's

The MICROCOSM:
Or, The WORLD in MINIATURE,
Lately made by
Mr HENRY BRIDGES;

AFTER Ten Years close Study and Application, when exhibited to public View, was honoured with the Presence of the ROYAL FAMILY, as well as the Nobility and Gentry, and received the Approbation and Applause of the most ingenious Professors of the several Arts and Sciences that compose it.

The Author having thus succeeded beyond his Expectation, in his first Attempt, has since, with the utmost Assiduity, made considerable Additions and Improvements; so that the Piece is now compleatly finished, and humbly offered to the Curious for their further Approbation.

This Machine, for the Magnificence of its Structure, the Beauty of its Painting and Sculpture, the Excellency of its Music, the vast Variety and Justness of its moving Figures, is esteemed one of the most curious Pieces of Mechanism, that ever appeared in Europe.

Its Height is Ten Feet, and Breadth in the Basis Six; and consists properly of four Parts. In the Top are Three beautiful Scenes, which change alternately.

I. The First represents the Nine Muses, playing on divers musical Instruments, as the Harp, Hautboy, Bass Viol, &c.

The Second introduces *Orpheus* in the Forest, playing on his Lyre, and beating exact Time to each Tune; who by his exquisite Harmony charms even the wild Beasts.

The Third shews a delightful Grove, wherein are Birds flying, and in various other Motions, warbling out their melodious Notes.

II. In the Second Part, under a grand Arch of the Corinthian Order, stands a large Clock (and is as the Primum Mobile of this stately Work) which shews all the Celestial Phænomena: First according to the ancient Ptolomaick System, tho' now exploded; Secondly, according to that of Copernicus (or the true Solar System) where the Planets move in Elyptical Orbs round the Sun, in their Periodical Times, always shewing the immediate State of the Heavens.

To illustrate which System, and to make the Motions of the Heavenly Bodies more obvious and discernable by the Eye.

III. In the Third Part are added Two Planetariums (never before exhibited.) The First represents the Solar System with the Orbits and their proper Excentricities, in Proportion to each other: In which the Planets, in their like Proportions, perform their respective annual and diurnal Motions, by Clock-work, with a Velocity of Ten Months Motion in Ten Minutes.

The Second is a System of Jupiter and his Four Satellites, in like Proportion, performing their proper Revolutions with the Solar System; exhibiting their Immersions into, and Emersions out of Jupiter's Shadow; with their Occultations by, and Transits over the Body of that Planet; as also their mutual Transits amongst each other, with many more Astronomical Phænomena than can be here expressed.

Likewise in this Part is a fine Landscape, with a Prospect of the Sea, where Ships are sailing with a proportionable Motion, according to their seeming Distance. On the Land are Coaches, Carts and Chaises passing along, with their Wheels turning as if on the Road, altering their Posture as they ascend or descend a steep Hill: At a great Distance is a Wind-Mill going, and nearer, on a River, is a Powder-Mill at work. On the same River Swans are swimming, fishing and bending their Necks backwards to feather themselves, as if actually alive; also the Sporting of the Dog and Duck, and many other Curiosities, too tedious here to particularize.

IV. In the lowest, or Pedestal Part, is shewn a Carpenter's Yard, wherein the various Branches of that Trade are most naturally represented. At the same Time it performs several fine Pieces of Musick, either single, or in Consort, in a very elegant Manner, most of which are entirely new, or composed on Purpose for this Machine.

This Work is judged by all who have seen it, worthy to adorn the Palace of a Prince, as it exceeds whatever has been done of this Kind. And as it will bear seeing more than once, 'tis hoped no Person will take it amiss, if not admitted to see it a second Time gratis.

N.B. *Mr Bridges being engaged in much Business at Home, would gladly dispose of this Machine, either wholly, or in Partnership.*

1
SUCCINCTLY DESCRIBING THE MICROCOSM

An accurate description of The Microcosm is akin to a group of blind people describing an elephant, with each person laying their hands on a different part to construct their own version of the beast.

How people described The Microcosm during its career seemed to depend on their level of education, area of expertise, and whether they were the owner or observer of it. As most accounts were "puff", for promotional use, allowances must be made for bias and exaggeration. We are fortunate the astronomical clock component survives; it is part of the Courtney A. Ilbert collection of clocks in the British Museum, so most articles on it have been written by horologists.

An article by R.W. Symonds in *Country Life* in 1944[1] described it as an eighteenth century picture machine of complex and original design which used epicyclic (a circle rolling on the outside of another) gears to accurately demonstrate planetary movements. But it was also a travelling show, a music machine, a display of the latest astronomical discoveries, a pedagogic tool, and an example of fine technology and skilled workmanship that provided an inspiration to learning. It performed as a piece of public entertainment but also as a serious demonstration of astronomy, a field essential to Britain's

extensive maritime industries as she forged ahead of her European rivals. The story also provides insights into the early advertising industry, travel, communication, social history and the fine and applied arts.

Shows of clockwork and automata at fairs tended to be housed in simple boxes like nineteenth century grandfather clocks. They presented a single — if highly complex — show, such as a famous battle. The Microcosm was found in a similar oak case which provided space for its pendulum, which served as a framing device and protected it from damage. But the original case was part of the show, displaying images of the arts, and helped to present the different shows in their best light.

The most detailed picture of The Microcosm comes from the large copperplate print Henry Bridges produced in 1734, drawn by R. West and engraved by the sculptor R. Sheppard, shown on page xi. It was sold at the show for the ensuing decades and provided the model for all subsequent images. It shows the enormous four- storied structure in the marbled hall of a mansion. The print was dedicated to "The most high, Puissant, noble prince, James Brydges, Duke and Baron of Chandos, Marquis and Earl of Carnarvon, Viscount Wilton, Governor of the Turkey Company and Baronet". Brydges was the wealthiest aristocrat of his age and a major patron of the arts and sciences. This dedication seems to have led some writers to claim it represented his palace of Canons at Edgware, or even that The Microcosm was built there, but they provide no evidence of either. Such dedications were often made to the rich and powerful in the hope of acquiring patronage or to equate the work with such exalted society. The machine was shown flanked by framed medallions of Henry Bridges and of Isaac Newton who allegedly approved of the machine, despite the fact he died in 1727, two years after the clock was begun and five before its completion.

This 1734 engraving is a masterpiece which provides a wealth of fine details, on which the following word picture is largely based.

The apex is a forest of baroque musical instruments including drums, trumpets and fiddles in the baroque style of Grinling Gibbons

(1648–1720) who became master carver to William III. Beneath this in descending order were:

Tier 1

From about 1750 a handbill was produced to promote the show, as shown on page xii which extended the initial construction time of eight years' study to ten, and provides some clarity as to this level, made up of three alternating scenes:

"Nine muses dancing and playing music on the harp, hautboy, bass viol etc.

Orpheus playing his lyre and beating time in the forest charming the wild beasts.

A forest grove with birds flying and singing."[2]

John Farmer's *The History of Waltham Abbey* of 1735 praised "the present ingenious Mr Henry Bridges" and includes a descriptive poem by "Philotechnos"'. After introductory praise he described the Muses, Pegasus "with hovering wings". The copperplate print shows this image, with Pegasus hovering above the muses. The grove of birds is described by Farmer as singing, with:

> "Amongst these little, sweet, harmonious crew,
> As if 'twas Summer, we hear a Voice: Cuckoo."[3]

This has led some writers to suggest it was one of the earliest cuckoo clocks, which seem to have arrived in England from Italy about 1735. William Winters, a later historian of Waltham Abbey, appears to be the source of this; in 1886 he claimed the clock "chimed the hour with the notes of a cuckoo."[4]

But the handbill stated the birds were "warbling out their melodious notes", as part of the coming of spring. The cuckoo was part of this performance, rather than playing a role in timekeeping which became the defining feature of Black Forest clocks from the nineteenth century.

No instruments were named as playing the music, merely that the pieces were performed either solo or in concert, and that many of the tunes were new, with some specifically composed for The Microcosm.

An assumption seems to have been widespread that these alternating scenes were automata, but the engraving is in partial profile, so we can see the structure was quite deep. But there is no way these scenes could have alternated to fit the frame of the case if they were separate pieces of machinery. We have to assume the scenes were painted on cloth, like stage or garden scenery of the time and so rotated within the structure as a continuous strip, probably appearing with suitable music.

Tier 2

The main, clockwork component was framed by Corinthian columns and arches resembling an unnamed Roman temple. Its shape can be seen crowning a number of public buildings such as London's Coliseum. Corinthian capitals are the most ornate, so impart prestige to the show. But they are also feminine, so provide a counterbalance to the masculine technology.

This tier was described as the *primum nobile*, referring to the first floor in Palladian mansions which were popular in the early eighteenth century. They were inspired by Roman villas which were in the centre of farms which had rusticated basements for storage at ground level. The *primum nobile* was the main reception and entertainment area, reached by a grand external staircase. It was also the level on which such works of art would be displayed.

The Microcosm was ten feet high, so this tier was mostly above eye level for many viewers, but its elevation served to show its high status. This was further emphasised by being encircled by imagery on the case, examples of the ancient gods Mercury and Minerva and of Britannia, thus further reinforcing its high status and worth.

It displayed two main dials, each flanked below by lesser ones.

The uppermost dial's lower arc is interrupted by a triangular plate. The print shows an ornate edging enclosing a floral crown above the words "Henry Bridges/Waltham Abbey". It was a legal requirement for clockmakers to include their names on the dial to ensure high standards and accountability and to trace them if lost or stolen. The Microcosm's face is so crowded the British Museum's staff claim this is the only place Henry could have included his name. Most clocks

also include the word "fecit" confirming the name was that of the maker, but this is omitted. Is this due to lack of space or an admission that Henry was not the clock's maker?

This clock face is incredibly complex, with a series of concentric rings beginning at the outer edge which records the minutes which surrounds a ring showing the hours, suggesting it was built primarily as a timekeeper. The third ring has a pair of horizons which show the rising and the setting of the sun; the components move behind the name plate, further justifying the latter's position. Within this circle is shown the zodiac, then at the centre, the earth is marked with major lines of longitude and latitude.

The whole was said to represent the discredited Ptolemaic, earth-centred universe, but the earth is so small and the whole so dominated by the timekeeping components that this seems doubtful. Also, earth-centred is not the same as Ptolemaic, which challenges the repeated claims that this dial was designed to compare the two theories of the universe. What it does show is a snapshot of the universe in motion at the present moment.

Some authors suggest Henry didn't know which system was correct, so included both to hedge his bets. But the sun-centred system was well established by then and Henry claimed to be comparing the old system — based on what appeared to be true — with the new Copernican system, based on observation and research. He was telling a story, not demonstrating a single fact. The pamphlet produced decades later made this clear by describing the Ptolemaic system as "an erroneous system and is now exploded".[5] This seems to echo the many images in Post-Reformation churches which contrasted the Old and New Testaments of the Bible. The latter focused on the life of Jesus who was often depicted as *The Light of the World;* so, like The Microcosm, it demonstrated how the new world was an improvement on the old.

This display of two very different philosophies of how the universe worked is generally described in accounts of The Microcosm as being unique, but this is only true for Britain. In the Habsburg collection at the Kunsthistorisches Museum in Vienna is an item described as a

Planetary Clock of c.1605. It is claimed to be the first astronomical clock to show the earth-centred model of the solar system. The clockwork component was by Jost Buergi (1552–1632) who collaborated with the astronomer Johannes Kepler in Prague at the court of Emperor Rudolph II. An ornate silver, gilt bronze and rock crystal case almost hides the horological masterpiece. It shows the sun-centred universe in motion, which takes about nineteen years to complete a circuit. It is flanked below by small dials indicating the eclipses of the moon and sun. Below this is a smaller dial showing the old, earth-centred system.[6]

It is unlikely Henry ever saw this extraordinary piece, but it must have been famous, so could have been featured in print to inspire his design. Henry lived over a century later, so there was plenty of time for images and perhaps even copies of the clock to have been circulating. It is interesting that he reversed the order, placing the old system above the new and adding the extra features. Both clocks demonstrated the solar system moving in real time.

Another description of The Microcosm comes from an incredible book, *Curiosities of Clocks and Watches* written by E. J. Wood, a prominent Mormon and an officer in the American Civil War, so was written long after The Microcosm vanished from other records. After the usual details of the figures on the top of the machine, he records the uppermost of the two dials:

> "It showed the rising, southing, and setting of the sun, which always pointed out the hour of the day, and rose and set at the same time as it really did. There were two blue circular plates, called horizons one on the left hand, and the other on the right, which rose and fell according to the lengthening or shortening of the days, in order to regulate the sun's rising and setting; so that as the sun went round in twenty-four hours, being within the hour circle, it passed by every hour on the plate, and pointed out the time of the day. In order to tell the time in the night after the sun was set, there was an hour hand placed directly opposite to the sun, also a minute and second hand, all on one centre, so that the time of the day or night might be as easily known by this as

by any other clock. There were two other hands on this centre, one called the moon's nodes, which showed the time of the eclipses; and the other the equation of time. Or the difference between the sun and the clocks."[7]

Below and flanking each central dial is a pair of smaller dials. The upper, earth-centred one is flanked on the left (as we see it) and displays the day, date and month; the other shows the phases of the moon. These were common elements in clocks of the time.

The main lower dial represents the Copernican system, with a smiling sun in the centre, and the earth highlighted amidst the revolving planets. It shows Jupiter and Saturn with their moons but of course omits Uranus as Herschel was yet to discover it. The outer ring shows the zodiac signs, as these continued to be part of astronomical research. As on the above main dial, hours and minutes are displayed, so again, the planets can be seen moving in real time.

Below and flanking this is a pair of small dials. A staff member at the British Museum provided the following description of them in response to my enquiry:

"Bottom left dial (as viewed): the inner scale indicates 0–28 years; the outer scale indicates the dominical letters (for the Julian calendar). Each year is given a dominical [i.e. relating to the Lord] letter A–G with the 1st January always being A, the dominical letter for the year is the letter for the first Sunday of the year (e.g. if the first Sunday is the 3rd January, then the dominical letter for that year is C). The double letters are leap years (i.e. with a dominical letter for the period 1st January to 28th February, and the next letter for the rest of the year). This cycle repeats every twenty-eight years, hence the 0–28 seen on the dial. Dominical letters allow days of the week to be worked out for the rest of the year, e.g. so that calendars can be calculated. They are seen on most perpetual calendar tokens.

"Bottom right dial: the inner scale indicates 0–19 years; the outer scale indicates the epacts. The solar (tropical) year is about three hundred and sixty-five and a quarter days, while the lunar (synodic)

month is just over twenty-nine and a half days on average. Thus the solar year is eleven days longer than the lunar year (i.e. twelve lunar months). After one year the solar starts eleven days after the lunar year, after two years, it starts twenty-two days after. These excess days are epacts. Whenever the epact reaches or exceeds thirty the epact number is reduced by thirty, hence the numbering seen (an embolismic/intercalary month is inserted into the lunar calendar). Nineteen years is the metatonic cycle, which approximates a common multiple of the solar year and the synodic (lunar) month, hence 0–19 seen on the dial. Epacts and dominical letters are used in calculating Easter."

All these dials seem unlikely components of a travelling show. They provide details a gentleman or cleric could use for calculating astronomical events, especially for Easter. This confirms The Microcosm was never designed as a travelling show, but probably for a client who specified the design. Henry's achievement was thus to include the clockwork into a larger, more complex machine.

The clock was found in Paris in 1928 with Henry's name plate replaced, which has led some writers to assume this was to conceal the clock's English origins during the French wars. But staff at the British Museum question this, as the new plate completes the numbering for the hours and minutes in the outermost rings. The alteration may have been simply to complete the timekeeping component, probably after Henry died when there was no longer any reason for it to be recorded for legal reasons.

Tier 3

Astronomy was originally restricted to the above tier, but the two main dials showed the solar system moving in conjunction with the clock, i.e. in real time, so were too slow to be entertaining.

The Microcosm appeared in London at the end of 1741 when it was "enhanced" with a new solar system and display of Jupiter and her moons, which seems to mean the addition of two displays.[8] In 1750 Henry's machine was renamed in newspaper advertisements *The Modern Microcosm* when he announced the inclusion of two planetari-

ums, i.e. the accelerated solar system, and Jupiter, with its four satellites showing them passing in front and behind the planet, in addition to Neptune and eclipses that only happen at a New or Full Moon, and the annual motion of each with many other astronomical phenomena. Later additions demonstrated the solar eclipse (predicted for 1761), the Transit of Venus (expected in 1764) and a cometarium (Halley's Comet was expected to return in 1758).[9] These many and at times confusing additions converted a gentleman's timekeeper into a public display, suggesting Henry had abandoned any attempt to sell the machine to a wealthy collector.

A booklet by Edward Davies titled *A succinct description of that elaborate and matchless pile of art, called the microcosm with a short account of the solar system: interspersed with poetical sentiments on the planets...* was published from 1760. It clarifies the several additions, i.e. the two planetariums showing the planets which accelerated their movements to show ten months in ten minutes, the other demonstrating Jupiter and its satellites in motion, also faster than real time. Dr J.T. Desaguliers had invented what became known as the cometarium in 1732, but Henry was presenting a far more complex display.

Milburne[10] guessed these were separate machines, but if so, why did they share the name? And how could all these additions fit into what seems to have been a limited space on Tier 2?

Henry was tinkering with his beast, expanding and adding to it in response to new discoveries, hoping to attract new audiences and to encourage repeat visits. With the building of canals and turnpikes from the 1730s, travel became easier and faster for him, but this also increased the amount and variety of the competition; The Microcosm could no longer rely on its novelty value to attract custom.

After describing the second tier, Wood described the further additions:

"Underneath were folding doors, which on being opened discovered four other systems in which the motions of the planets were more clearly described. The first was the solar system; the second, the system of Jupiter and his moons; the third, the eclipses of the sun and

moon; and the fourth, the earth's annual motion. Another piece of mechanism represented the course of the comet of 1759."[11]

It seems the additions eclipsed the original display. The opening doors were also mentioned in the above pamphlet but it was unclear how they were arranged. In 1755 a musical machine by Richard Breckell was on display in New York which told the story of a jilted fiancé, *The Tragedy of Bateman*. The performance began with a pair of folding doors flying open and a curtain rising so automata were mimicking live theatre.[12] It seems Henry's show, like many scientific demonstrations, was drifting from its scientific origins to become more an entertainment for the masses.

Two large systems, i.e. the accelerated solar system and Jupiter and its moons, including their eclipses, were on the right and on the left respectively. But did this mean they shared the same face or were on the right and left sides of the structure? The two lesser systems showed the moon's eclipse and below this, the planets' retrograde motions.

But it confirms Wood's description by claiming another mechanism was placed on the right which showed the elliptical movement and changing speeds of the comet [i.e. Halley's] with the changing length of its tail as it approached the sun.[13]

Why was this specifically on the right? Does this mean the other additions were on the left of the main structure? It seems all these sources were addressed to people who visited the show, providing an *aide memoire* rather than *a priori* information for educational purposes.

Wood's account is also notable as the language and details are very different to others, suggesting they are from a different source, i.e. not Henry's publicity or the British press. But Wood failed to mention the lower tiers with the land/seascape or the carpenter's yard, so they must have held little interest for him or the information was absent from his source. The opening doors make the machine sound more like a cupboard or cabinet which suggests he had not seen any images of it. But the astronomical details suggest this account is from the same period as the 1750 handbill.

Whilst Wood's account confirms the site of the numerous additions, it raises further problems as to how space was found for them. The structure widened from the top down, allowing room for the pendulum which controlled the astronomical part. The additions were sited too low to have such power sources, though a train may have led from the main clock mechanism to drive all the other elements. But this would make dismantling and reassembling and adjusting the machine difficult and time-consuming, suggesting the clock travelled in its complete form. But space was still needed for the barrel organ and keyboards, so it seems Henry was something of a magician, or a precursor of Dr Who, defying the basic laws of physics with a structure much larger inside than out. Wood's lucid and informative book was written in 1866, long after The Microcosm vanished from the records, so is a fresh source, but, infuriatingly, no references are provided.

Henry further confuses the story as the additions were mentioned in his ads from late 1737. But the handbill from c.1750 only described two planetariums, claiming they were "never before exhibited", so were they yet more improvements? They were described in great detail in the booklet, which was published in several editions from 1760 onwards.

It is possible that their construction coincided with a surge in popularity for astronomy with the flurry of strange events such as Halley's Comet and the Transit of Venus which Cook sailed to Tahiti to observe. *A succinct Description...* notes how fearful people were of such strange events, so these additions may have been to calm fears and to educate the public. If they were separate structures they may have been sold off to help pay for the machine's travelling costs. Cross-checking dates throws up a real curiosity here: Almost all the above ominous astronomical events occurred during the Seven Years' War (1756–1763). The Transit of Venus was due the year after it ended. At the height of the war, were people drawn to astronomy to find astrological omens? Such a reversion to superstition continued into modern times, as talking to the dead helped families deal with the grief of losing soldiers after World War I. Astrology became

popular in World War II Britain and daily horoscopes in papers were used to send coded messages. People may have visited Henry's show to seek solace for their superstitions and fears. If so, The Microcosm again served to bridge the old world of superstition and guesswork with the modern concepts of science and experimental philosophy.

On the engraving of The Microcosm, the third tier is described as a land and seascape. This is an incredibly detailed picture, with several planes progressing into the distance from the viewer. Farmer described the front of the third tier in detail with:

> *"The Ships all under Sail to Windward play;*
> *Coaches, Carts, Horses, move on the Highway,*
> *And Horsemen riding without Stop or Stay,*
> *Farther from Sight, a Windmill's seen, whose Sails*
> *Are turning round, as blown by prosp'rous Gales.*
> *The silent Swans, majestically all move,*
> *There's Dog and Duck for Sport; if that you love."*[14]

All of these were common elements in words and images of the time, and in many clockwork displays. But this tier also included scenes that were specific to Henry's home town. Foregrounding and flanking all this activity is a pair of buildings:

> *"A Mill for making of Gun-powder's there,*
> *And water flows amazing and more rare.*
> *Which from a Model on River's took*
> *Worthy Walton's Works..."*[15]

To the right was depicted a watermill, on the left possibly the same, though the wheel is not shown, so it was perhaps horse-driven. Closest to the viewer on the left were elements which were omitted from other accounts:

> *"A Pattern of Industry, in Corner sets,*
> *It's a woman old that Spins, her Fingers wets.*

> In th' other Corner, if you look you'll find,
> My Pretty Maids, a Workman, Knives to grind".[16]

This showed female, domestic industry, and on the right was a knife grinder watched by a young servant woman, so the machine attempted to show the world in its broadest sense. The imagery is detailed and the different scenes reminiscent of the multiple frames of mediaeval manuscripts.

The landscape was incredibly crowded and technically complex, but as with the muses etc., it is unclear which — if any — elements were physically moving. The ships, swan and dog and duck may have been rocking as if animated. The carriages may have moved across the scene like a fairground shooting gallery, and the mills, knife grinding and spinning wheel may have been rotating, perhaps hand cranked by the showman.

Tier 4

The lowest tier on the engraving is that of a carpenter's yard showing various stages of men at work, from left a vertical saw in a pit, then planing, hammering etc. Farmer writes:

> "There's a Yard amazing, with what Art
> The Carpenter's perform'd in ev'ry Part.
> Some use the Saw; others with Skill the Plain;
> With Mallet, Chissel other some again
> Hew with the Ax, grind Tools..."[17]

In the background a pile of wood was being seasoned to stop it shrinking in use, and what seems to be a ship being built, and several wooden buildings, thus displaying the whole world of Henry's trade. The Latin poem in the booklet *A succinct description...* claimed this level also included a shipbuilder's yard where carpenters were "pressing on with the joyful task, envisaging chains for the French or Spanish." But this was published from 1760 onwards, so seems to have misinterpreted a peaceful, productive scene to a more militarised period. In the wake of the Great Fire, stone was replacing wood for buildings and

gents returning from their Grand Tours were building new, Palladian stone villas. This tier thus serves to praise Henry's trade, but also represents a moment frozen in time, with perhaps a sense that it was about to be superseded by masonry, though shipbuilding in wood continued for much longer. Or perhaps this had become a standard element of show clocks, as Richard Breckell's clock also showed a working carpenter's yard, which had nothing to do with the main display of a young man who suffered in love.[18]

Behind the carpenter's yard is yet another charming domestic element:

> "The two Boys with Innocence do play
> Boards a-cross, now up, now down they sway;
> So merrily they live, because from School away!"[19]

The boys are shown on what we now call a see-saw which seems to be balanced on a wooden fence, so provides us with a rare example of children at play, possibly included as it was yet another up and down movement which could be demonstrated on the machine. It may also suggest the children at play were the carpenter's children, symbolising the continuity of Henry's trade.

The vertical arrangement of elements in The Microcosm must have had a purpose, especially as Bridges on several occasions described himself as its author, suggesting its design included elements of storytelling. Art historian Martin Kemp mentions a traditional hierarchy of genres in early art history, with history paintings being seen as the most prestigious, echoing images of heroism and sacrifice in national folklore and of Christ and his saints. Below these were portraits, then scenes of common life, landscapes and animals, below which, still lifes were the least esteemed.[20] Henry's placing of ancient gods at the apex seems to reflect this hierarchy, but he reversed the order of common life (i.e. the carpenter's yard) with the landscape.

Some authors have suggested he placed his home at the base, with imagery rising up in respect to its distance from his humble origins as a carpenter. But carpentry was a far from humble trade. It was highly

regarded and many carpenters became master builders, local dignitaries and mayors. It seems more likely that its representation on the base echoes its role as the foundation of English society, the heart of oak, the wooden walls of England, the rich folklore and its role in housing and furnishing the nation. It was also the trade of Jesus and his father.

Another reading may be that his base shows hand working skills, then technology in carriages and mills, the supreme form of technology in the clockwork, all of which were crowned with images of the arts, which provide inspiration for the lower levels.

The machine seems to have been overcrowded but somehow space suggests the audience was not sitting in rows as for a modern performance, but encouraged to move around it, to promenade and view it from all angles, so it was a very Georgian show. Set against this was Charles Clay's huge, ornate musical clock, *The Temple of the Four Great Monarchies of the World* which had a base which turned around.[21] No mention was made of this in any of The Microcosm's contemporary accounts, but it did have a large, solid base which resembled that of Clay's work, so this is a possible inspiration.

Even the grandest venues were much smaller than their modern equivalents, and it was not until 1761 that Garrick controversially banned seating on the stage, which had allowed the audience to interact with players, so The Microcosm's audiences must have been small enough to allow all its elements to be easily seen and discussed. Private views were advertised for groups of four or more which explains why in some towns, so many performances were held: up to six per day.

R.L. Edgeworth's account of his visit to the show in 1765 states he returned repeatedly and was allowed to see the workings.[22] But another, recent American source[23] states the show ended with a *reveal*, when the audience saw all the wheels in motion, suggesting a more extensive viewing of the machinery, which in turn suggests the show formed a bridge between the religious ritual of the Mass and modern magic. But in this instance, it had musical accompaniment, so had elements of fairground or nineteenth century magic shows.

Perhaps because so many details vary or are unclear in surviving images, The Microcosm's ornate case has attracted little attention. It was described as being in the form of a Roman temple, but which one? Was it based on a specific building, or was it a vague hybrid to demonstrate the main principles of Roman architecture? It showed a hierarchy of images with gods at the apex which echoes that of objects known variously as curiosity cabinets, Kunst Kabinets or Kunstkammer. Mauriès describes a cabinet presented to Phillip II, Duke of Pomerania in 1612 which was crowned by a silver Mount Parnassus, the nine muses and seven liberal arts with displays of astronomy and human achievements on lower levels,[24] an arrangement similar to Henry's machine. This cabinet was a diplomatic gift, demonstrating power and affluence, but it also created a neutral space for strangers to meet and discuss its contents. Such gifts showed the giver welcomed the recipient as an equal, offering them the chance to pursue further discoveries and collecting. The objects in the collections could be interpreted and understood in different ways, so were useful icebreakers for parties to get to know and trust each other prior to important diplomatic or trade negotiations. They also show how curiosity had moved from the private realm of the alchemists and wizards into the public realm. The mass of knowledge had expanded to no longer be contained within the communities of natural philosophers; it was adopted by their patrons and set fashions for the lower levels of society.

2

THE WORLD BEFORE THE LITTLE WORLD

The idea that the past is another country is so overused to have become a cliché, but the huge gulf which separates modern Britain from its rich history cannot be over-emphasised. We have inherited images of knights and castles, peasants dancing at the end of harvests, and monasteries protected in a dreamlike world of faith and art.

But there were also horrific pirate raids, invasions, wars and famines. Peasants rebelled and Magna Carta was written, and reluctantly signed. Henry VIII's closure of the monasteries triggered social, economic and political upheavals that continue to reverberate.

The end of the monastic system was not a single act, nor was it deliberate. Like so much in British history, it was designed to deal with a single problem. In this case it was triggered by the lack of a male heir for the English throne which threatened a relapse into the carnage of the Wars of the Roses. But the lack of planning unleashed a Pandora's Box of arguments over religious practice and social behaviour which are yet to be resolved. The zeal with which church properties were plundered suggests that the Church of Rome was already unpopular. Or perhaps claims that St Augustine had grafted Christianity onto pagan roots meant that Rome's control was never

fully accepted in these distant, debatable islands. Eamon Duffy describes the popular festival of Candlemas, in which blessed candles were taken home to fend off evil. Clerics complained that this protective use dominated the official practices and common people used and adapted Christian rituals without official approval.[1]

Some sources express surprise at the ease with which the Reformation happened in England, especially considering the strength of the Marian cult. But counterbalancing this was an undercurrent of native mysticism and the sturdy independence of island peoples, which were always at odds with the Roman Church.

The oldest objects in Tate Britain's art collection date from 1545 because Henry's break with Rome and the iconoclasm carried out by his children Edward VI and Elizabeth I was so extensive that almost all art in the country was destroyed. As the museum's director Penelope Curtis wrote in *Art Under Attack*,[2] the collection is made up of religious art that was overlooked by, or hidden from, the iconoclasts. Thus each item has a dual history: its original use and its survival.

The Reformed Church of England had no need for art; its very existence was based on its rejection of decoration and rituals. The new, national church's practices focused firmly on the written word. The few fine arts and crafts objects which survived were relegated to the smaller, secular world. Instead of praising the Christian God, art became entertainment or an indulgence for the wealthy, a means of promoting their own worth and power. Huge religious complexes were adapted to practical use or the stone used to make country houses for the newly rich, thus secularising and privatising what had been communal public spaces. The purpose of such sites shifted from saving souls and helping the poor to making money and self-interest. Fortunately, many new landlords were good Christians, so they upheld their role in supporting local communities.

Henry Bridges was born in 1697 when much of England's population was scattered in tiny rural settlements unworthy of the term 'hamlet'. All but the elite travelled by foot, and goods were mostly carried by packhorse. People made or repaired their own buildings and implements. Women grew most of their family's food, and sold

surplus eggs, cheese and 'green stuff' at local markets, where they caught up on news and gossip.

The parish church was their oldest and biggest building, which they helped to construct and maintain. In mediaeval times the building was divided by a rood screen, through which parishioners viewed priests performing masses. Above the screen was the rood loft where the sculptured image of Christ on his cross (rood) was displayed. It was flanked by statues of the Virgin Mary, John the Evangelist and local saints. These and side altars for private worship were paid for by parishioners, as acts of charity and for prayers to reduce their own time in purgatory. Churches were places of sanctuary and respite from their harsh lives. In modern terms, they were 'immersive environments', with light filtering through stained glass, candles flickering on altars, the scents of incense and of rushes underfoot, of music and drama when the parish enacted Christmas and Easter stories. Saints' festivals brought communities together and charity was distributed to the poor. Mother's Day originated as the date when servants returned to their mother church to celebrate its Saint's Day. Flowers were often gathered on the journey home to decorate the church.

Church buildings dominated the landscape, as landmarks to guide sailors and lost travellers, both literally and metaphorically. The church was a major landowner and so also played an important secular role. The porch formed the boundary between the sacred realm and the secular, where rents were paid, marriages contracted and charitable donations collected. Its bells warned of impending deaths, celebrated royal births and victories in battle and urged the community to rush into the fields to help with the harvest when storms threatened. Annual fairs were held in church grounds which allowed the purchase of items that locals could not produce and the hiring of servants and farm workers as well as providing opportunities to catch up with distant friends and relatives, to see travelling shows, and for drinking and dancing on holy days. The Reformation thus destroyed a system of community practice and survival techniques for many people.

When Henry VIII dissolved the monasteries, he destroyed the

church's role in local government, law enforcement, and provision of clean water supplies, schools, hospitals, care for the aged and infirm, land management and patronage of the arts. Religious houses employed a wide range of tradesmen and artists, some of whom were clerics. Henry VIII's reforms forced them to change careers or to seek work in towns, sending formerly bustling rural areas such as Bridges' home town of Waltham Abbey into decline. Large-scale works such as canals for transportation and irrigation were no longer maintained, so farmland declined in fertility as the population increased. Closure of the masonry yards meant that the Tudor Age became the age of wooden buildings, which led to a rise in fires, including the famous one in London.

The monasteries were largely celibate communities which helped limit population growth, especially among the poor. Youngest sons of the elite joined the clergy as they were excluded from inheritance, but were in reserve if their families failed to produce male heirs. Henry VIII executed the heads of so many aristocratic families that it virtually became a point of honour to have suffered such a loss. Voltaire claimed in 1731 that the youngest sons of rich families went into trade, and so apparently commerce filled this role of the monastic system. Pevsner cites *Whitaker's Almanack* on the resulting destruction of aristocratic dynasties, with only twenty dukes, marquises, earls and viscounts out of three hundred and ninety who could trace their titles before 1600, but around two hundred and ten are from the nineteenth century. A similar pattern is shown in baronies, with only thirty before 1600 and four hundred after 1800.[3]

Most people married when accommodation became available. They had to work to save up enough to set up their new home, usually when they were in their late twenties, which provided a further brake on the population. But when the religious houses closed, these brakes were weakened or lost. Priests were given pensions and allowed to marry; some became teachers or chaplains. Young people moved to the cities where men earned adult wages at the end of their apprenticeships (usually at the age of twenty-one). This allowed them to marry earlier, when their wives were stronger and more fertile, and so

added at least one extra surviving child to each union which further expanded urban centres.

Counterbalancing this was the failure by many of the increasingly crowded towns to maintain former monastic reservoirs and conduits, causing a lack of clean water. There was more organic human and animal waste in the streets, which provided a fertile environment for the spread of disease. Infants were particularly vulnerable, and some families failed to produce a single adult offspring. In the countryside, with clean air and fresh food, families fared better, and so provided a steady flow of young people to towns and cities. Before clean water and sewage systems were built by Sir Joseph Bazalgette (1819–91) in the nineteenth century, the *Great Wen* of London maintained its population by inward migration. Urban centres were especially unhealthy in summer, when the rich fled to their country estates, making them unavailable to deal with problems such as epidemics. One of the reasons used to justify fox hunting in England was to connect such migratory landlords with their rural tenants, to encourage them to provide charity and support local businesses. Some country houses employed the elderly and infirm on projects such as knot gardens, which were labour-intensive but not physically demanding. Monastic houses paid workers mostly in food and lodgings, which allowed them to keep down wages. But with their closure, low wages became the norm in the countryside, further fuelling emigration to towns.

The Civil War furthered the chaos of the Reformation. The cold wind of Presbyterianism made seventeenth century England a bleak place: churches were whitewashed, stained glass smashed and statues defaced. Religious festivals, theatres and alcohol were banned, although many wills recorded brewing equipment. Ale provided energy and nutrition for hard-working labourers, so its production was, like baking, considered women's work. Ale houses were often run by poor women as one of the few options to maintain themselves. But ale was perishable, so could only be produced in small quantities.

The introduction of hops from Europe gave beer a longer shelf life, allowing batches to become larger and the process more mechanised to become the realm of men.

A king and several bishops had been executed, so what little authority survived was often ignored or held in contempt. Even the rules of warfare were broken. Traditionally, battles paused to allow soldiers to return home and bring in the harvest. The aim of conflicts was not to cause starvation on either side. But under Cromwell, the country starved and soldiers went unpaid, fuelling a widespread sense of the world turning upside down. Friends and relatives were pitched against each other, and so the most basic social exchanges became difficult or unworkable.

Parishioners paid tithes to support the poor but, Post-Reformation, these funds supported the new clergy and their families. Poor Rates were introduced under Elizabeth to deal with the growing poverty and the risks of the poor turning to crime. But this new taxation was widely resented and often hard or impossible to collect, especially from the many Nonconformists who built their own meeting houses. Their clerics held regular jobs, and so Anglican priests were seen as lazy or as parasites. Many people — especially the young and able — despaired of better times, so they sought new lives in the colonies, which caused further social disruption, and in some regions left behind an ageing, less productive, population. Those who remained needed to learn how to forgive and forget, to relearn how to make society and government work, to mend social and familial bonds; to rediscover and reinvent what they had lost.

The Restoration of the Monarchy in 1660 should have brought peace, but decades of plundering and disorder had taken their toll. A major role of royalty is to unite people in a shared culture, in order to forge a shared history. But a succession of foreign monarchs and their courts had failed to do so. For decades, celebrations of royal births and marriages were shunned, and royal deaths were celebrated instead of mourned by people with differing religious practices and/or politics.

Pre-Reformation parish churches had served united communities, with everyone praying under a single roof and participating in the

same celebrations and rituals, such as the annual rogation, which mapped out the parish boundaries and provided a chance to settle disputes. But the rise of so many Nonconformist groups disrupted such unity. Different houses of worship led to separate social, familial, business and charitable connections. Non-Anglicans were excluded from holding office, but many found alternative outlets for their energies, turning to social reform and pioneering the industrial revolution.

In the early eighteenth century, the poet Alexander Pope (1688–1744) became the first English author to make a living from his pen, independent of wealthy patrons, so was also independent in his choice of output. His translation of *The Iliad* was paid for by subscription, with friends and supporters paying half the costs in advance and the rest on delivery. He was feted for his work, and his friends included many rich and powerful people but, as a Catholic, he was not allowed to live near Westminster or the royal court.[4] He helped plan the literary monument which became Poets' Corner in Westminster Abbey, but he could not be buried there. His bust sits beside those of Shakespeare and Milton.

Chaucer provides an excellent account of public socialising in his *Canterbury Tales*, Strangers travelled together on pilgrimage, exchanging stories to build up a shared history, from which social bonds were forged. The Reformation abolished pilgrimages and most religious festivals. Social intercourse shifted from vandalised sacred spaces to public, civic spaces, especially urban centres during fairs and markets. Many European towns and cities still feature spaces for promenading, where people can exercise, meet and converse with neighbours. In Ivo Andric's Nobel Prize winning novel *The Bridge Over the Drina*, he describes how, in former Yugoslavia, the Christians, Jews and Moslems co-existed, using the bridge on their various sacred days as the major open space in the town. People walked, danced, flirted, sang, chatted or just sat. This allowed each community their day of relaxation and freedom, a chance to reconnect with friends and neighbours, and to recharge their batteries. The English are unique in never having developed this practice, except during the late seventeenth and eighteenth centuries.

The late seventeenth century also saw the establishment of coffee houses and gentlemen's clubs: neutral spaces where religious and political affiliations were put aside, allowing men to relax and discuss news and matters of importance. Upon entering such an establishment, a man would take the nearest available seat, and so strangers met and fell into conversation. Letters and newspapers were read aloud, so the illiterate and visually impaired were not excluded. A man could spend many hours there, making and extending friendships and contacts, for the price of a cup of coffee. Some coffee houses became known as 'penny universities' where specialist subjects could be learnt and discussed. The Royal Society — the oldest and most famous scientific society in the world — was founded for the elite to discuss science. It held public demonstrations to encourage understanding and support for the subject.

Stone crosses marked the centres of towns and villages, where public announcements were made, news and gossip shared and celebrations held. Women congregated at the nearby parish pumps. But some public crosses were seen as idolatrous and so were destroyed by Puritans, the most spectacular being London's Cheapside Cross. By the mid-seventeenth century it had been extended to reach a massive eleven metres in height, adorned with statues of saints and royalty. It was destroyed by Parliamentary forces over the course of six days in 1643.[5]

From the late seventeenth century onwards, the affluent could also visit spas, of which there were over a hundred at various times, including seventeen in the capital, such as Sadler's Wells and St George's Spa. Some were short-lived, but the most famous and infamous was at Bath, as Edward Hutton described in his *Highways & Byways of Somerset*:

"The people of the countryside, of the provinces generally... found in Bath the means of social intercourse with the new aristocracy... the bureaucracy and the governing class, just as previously the British landowner and provincial had found there the means for the same intercourse with the Roman officialdom; in fact the existence of the governing class in both periods depended upon the establishment of

such an intercourse... in both periods the same means were found and in the same place."⁶

Richard ('Beau') Nash (1674-1761) was master of ceremonies in Bath from 1705. He arranged subscription assemblies and balls where people were forced to interact with those of different social status and religious beliefs. He established the rituals of drinking the waters and bathing which brought people into contact with strangers, and helped build up shared histories, forging new social bonds. Wearing swords and late night drinking were banned, so drunken fights and duelling declined. Most famously and importantly, Nash enforced polite standards of social behaviour. The clean, wide streets encouraged promenading and public interactions. These improvements were crucial in forging the famous English characteristics of good manners and politeness — now much mocked as old-fashioned and irrelevant — but they were vital in rebuilding society and laying the foundations of the future British Empire.

Under the Tudors, English towns and cities became dirty, crowded and dark as a result of overhanging buildings. Many large houses were built with galleries on the top floor for walking and playing indoor sports in bad weather. Freemasonry was revived and attracted members outside the building trade. The Spalding Gentlemen's Society was founded in 1712 and still exists. By the early eighteenth century, science lecturing became established as a popular form of entertainment. The editor of *The Spectator* and *The Tatler* Richard Steele included lectures in the performances at his Great Room, the *Censorium*, which presented the best of music and drama.⁷

We also need to bear in mind how harsh life was for our ancestors, even for the rich. Fanny Burney's horrific account of surgery for breast cancer and Bach's cataract surgery highlight the suffering of people before the advent of modern healthcare, especially pain relief. Behaviour which seems to us bizarre or extraordinary needs to be set

against the pervasive dangers of their lives, and the fact that many people endured excruciating physical and mental pain.

People went to churches for respite, as a refuge from daily life. Before the Reformation, people could commune with saints who were always there, always listening with sympathy and who could intercede with God on their behalf. Images of saints often show extreme or bizarre forms of torture. About half the saints were for women in childbirth; St Margaret of Antioch was invoked as she had burst out of the belly of a dragon. The saints' sufferings reflected the suffering of Christ, and evoked empathy from people suffering similar agonies.

The use — or alleged worship — of saints' images was one of the first practices to be outlawed by Henry VIII but Duffy describes how effective faith and prayer could be. He records a sailor who received horrific abdominal injuries in a sea battle. He smelled so bad that his messmates abandoned him in a boat. But he appealed to the sailor's patron saint St Erasmus (Elmo) who had been disembowelled and so empathised with his agonies. The sailor lay in the boat with the saint, companions in suffering, and survived.[8]

Peter Quennell writes of the wide range of chronic diseases endured by people in the eighteenth century:

> "The hand holding a calf-bound volume had been twisted and knobbed by gout; the face under the candlelight was scarred by small pox. Child after child died before it had left its cradle; women struggled resignedly from one childbirth to the next. The young and hopeful dropped off overnight, a prey to mysterious disorders that the contemporary physician could neither diagnose nor remedy. But these tragedies brought their compensation. Since the accidents of birth and maladies of childhood then accounted for a large proportion of human offspring, few men and women reached maturity who did not possess deep reserves of physical and nervous strength. In the debility of such a man as Horace Walpole there was, he himself admitted, something Herculean."[9]

This is of huge importance in reading about our ancestors, espe-

cially in Georgian times. Living with constant pain impairs a person's concentration; it disturbs sleep and can make people intolerant, unreasonable, and lose their faith. It drains the colour from their lives, so causes them to behave irrationally. Viewing them from the lofty heights of our modern world, many show signs of severe mental illness. By the mid-eighteenth century, suicide was widespread in England, and coroners went to great lengths to list it as lunacy to allow them a Christian burial.

Hogarth's famous engraving of *Gin Lane* is often cited as an example of the depths of depravity that London's poor had reached by this time. Their excessive alcohol consumption has drawn parallels with the modern underclass, allegedly hooked on junk food, drink and drugs.

But this is a modern misreading of the image. Gin production was encouraged in the late seventeenth century to profit from surplus grain, when the population was still low following the Civil War. But by the 1750s the population had more than recovered and food shortages were becoming common. Hogarth's print was in support of the Gin Act designed to limit the waste of grain in gin production. Also neglected by modern critics is the image's pairing with *Beer Street* which shows happy, well-fed people drinking locally brewed, English beer, which provided energy and nutrients for hard-working people as opposed to the empty (nutrient-free), destructive calories of gin. The problem was not with alcohol per se, but with a particular form of it. Wine consumption also attracted criticism as it was the chosen tipple of Europeans and its consumption was included in Catholic communion.

Many authors — especially evangelists — bemoaned the large intake of alcohol and claimed drunkenness was almost universal among the lower classes. But by the early nineteenth century, the journalist William Cobbett condemned the replacement of beer and cider with tea as many workers, especially at harvest time, were doing heavy physical labour all day. Like modern athletes, they struggled to maintain their intake of calories and nutrients, so high energy alcoholic drinks were essential. When consumed by people involved in intense

activity, alcohol is completely broken down to provide energy; drunkenness occurs when the balance between consumption and activity is lost. Replacing them with tea provided no calories unless sugar was added. Tannin in tea impaired their uptake of food, so reduced the amount of work they could complete. It also cost money, which would have been better spent on food.

The loss of physician priests and their reference books during the Reformation caused a general decline in healthcare, so people shared medical folklore and grew and collected herbs. Wise women were consulted, and in the early twentieth century folklorist-cleric Sabine Baring-Gould praised a local woman as being superior to his local doctor.[10] In the eighteenth century, travelling quacks became popular. They put on shows of juggling, tumbling and fiddling to attract crowds and 'soften them up' before the banter led to sales.[11] In the face of what we now understand to be infectious diseases such as tuberculosis, typhoid, diphtheria, malaria and fevers, but especially smallpox, physicians and surgeons offered herbs of dubious benefit, and bloodletting and heavy metals which could in themselves prove fatal. The high numbers of infants helped spread disease and were often its main victims. The promiscuity of men like Boswell resulted in frequent attacks of venereal diseases which often seemed to be cured only to return, so they continued to spread disease whilst experimenting with cures. When Lady Mary Wortley Montague introduced inoculation against smallpox from Turkey in 1718, the procedure saved many lives. But it involved the subcutaneous introduction of infected cells from victims, so carried the risks of contracting the disease or of blood poisoning.

Even walking the streets of towns held dangers unimaginable to modern urbanites: there were no pavements, so pedestrians had to compete with lumbering carriages, farm carts and chair men. Horses and cattle bolted on the way to market, trampling and/or goring victims. Butchers' boys and messengers galloped through crowds; factories and building sites overflowed onto roadways. Shopkeepers and market traders encroached on the streets, and cellar doors were left open for the unwary to fall into. Chamber pots were emptied from

open windows, flowerpots and loose tiles from ruinous buildings crashed onto unwary heads. The chaos was heightened by the cries of street vendors and frightened animals, the clatter of hooves on cobblestones, the hammering on construction sites and of local industries, and occasional explosions, all of which could prevent warning cries being heard. Most streets were still lined by overhanging Tudor buildings, so were dark by day and had few — if any — lamps at night, which provided an ideal environment for accidents and crime.

Poor quality drinking water led to a high consumption of alcohol, which could add to the confusion, and to fights which could be fatal. The corrupt politics of the age triggered riots over matters ranging from food shortages to the introduction of turnpike tolls. Celebrations descended into drunken brawls. Towns and cities were often built beside rivers, so there was a risk of falling in and drowning, especially after a late night pint or ten. Cooking was still mostly on open fires, so people — especially children — sometimes set themselves alight. A cure for hiccups was to set the victim's nightshirt on fire. Children's games could prove fatal, as when a child hid in an oven during a game of hide-and-seek and her siblings lit a fire beneath it to force her out. Almost every commodity of trade such as wool, wine, grain, rope and sails, was flammable, and many early factories such as potteries, glassmaking, brewers, distillers, limekilns, bakers of bread and sugar, and even gunpowder makers, were in the centre of mouldering old wooden towns, so were prone to catch fire. The lack of manpower for the navy caused the pressgangs to be overactive at times, leading to fights involving swords and guns.

Attendance at church on Sunday was made compulsory by Queen Elizabeth I, and absenteeism was punished with fines, which suggests that many people preferred to use their day of rest for rest. Some Anglican clerics were more interested in money than their pastoral duties, so were absent or neglectful, providing yet more reasons to avoid Divine Service.

The Reformation opened up discussions on faith and religious practices. English translations of the Bible allowed wide access to the sacred text, which became the textbook for teaching literacy, further reducing clerical power and authority. Groups such as the Quakers claimed that they could speak directly to God, making clerics unnecessary to intercede on their behalf or to interpret His words. The Civil War unleashed a flood of ideas on how to think and behave, as soldiers were brought together from different regions to discuss politics, faith and philosophy; they sang songs about better worlds, just as the American Civil War helped forge their modern United States and, according to a recent BBC radio documentary narrated by Kris Kristofferson, to found the modern music industry.

But the existence of the Christian God was not publicly challenged. When early scientists, or 'natural philosophers', discovered the wonders of the world around them, when astronomers raised doubts as to where God lived in heaven, this should have shattered people's faith. But the alternative to a well ordered Christian universe was a world born out of chaos. Newton could not conceive that such complexity could arise by chance, so his discoveries provided further proof to him of God being the genesis and engine of the universe. The long-held belief of an earth-centred universe had been disproved, as had the notion that the earth was made of different matter to the rest of the cosmos, but research in science was hampered by lack of proper tools. New planets could not be seen without improved telescopes, microbes could not be viewed without microscopes, and time could not be measured without accurate clocks, so from the late seventeenth century, natural philosophers began to work with — or become themselves — scientific instrument makers.

The closure of the monasteries caused the loss or decline of skills such as painting, sculpture, glassmaking and masonry. Many of these skills were re-introduced from Europe by Protestant Huguenots fleeing persecution in France. Other tradesmen and artists followed the courts when the Houses of Stuart, Orange and then Hanover become rulers. By the start of the eighteenth century, English clockmaking was claimed to be of the highest standard; as the rich

continued to crave such elite objects, the demand for them continued through the upheavals of the Reformation. Craftsmen such as royal clockmakers Thomas Tompion (1638–1713) and his collaborator, nephew and heir George Graham (1673–1751) invented improvements in clock design that were still in use in the late twentieth century. Their extraordinary achievements were recognised by their being buried in Westminster Abbey.

The Netherlands in the late seventeenth century produced the Golden Age of painting as artists were able to transfer their skills from sacred to secular images. They popularised the art of landscape, or 'landskip'. This was not a huge leap as much religious art included background details that allowed the identification of each saint. In England, a few artists survived by painting portraits for aristocrats or for the court, but most either emigrated or changed careers. With only two universities in England, some young men studied at Scottish or European universities. Others were privately educated and went on the Grand Tour to complete their education. They saw and studied classical art and architecture, returning with a passion for it, and often a collection of art to adorn new estates.

The Grand Tour is often described as an extended vacation and spending spree, but some tourists also visited Vienna, the German Courts and the Low Countries. Rarely recorded were the young men who visited Switzerland, especially Geneva. Whig families encouraged their sons to study in the Protestant republic, to study at the Academy and to "learn the French tongue uncontaminated by Popery",[12] to prepare them in expectation of becoming Britain's future leaders

At the start of the eighteenth century, England was a backward agricultural country at the farthest edge of European civilisation. The expansion of settlements in the Americas thrust her into the forefront of exploration and colonisation. By mid-century she had fought her way to dominance in the Americas and was encroaching on Asia and Africa. But there was never any grand design, as Roger Fry describes:

> "It is a record of cabal and intrigue working through a system of organised corruption and privileged robbery under the leadership of or

in opposition to a king of irreproachable domestic virtue... We watch her [England] blundering into huge disasters and no less blundering into scarcely sought-for successes. She acquired empires to East and West without clearly knowing what she was about, lost America by sheer bulldoggish inflexibility and tenacity and finally plunged into the vortex of European politics and the long misery of the Napoleonic wars."[13]

Following the 'locust years' of the Tudors, when the huge monastic estates were sold off, Stuart monarchs survived in part by selling trade monopolies. Queen Anne hoped to encourage literacy, so when the monopoly on printing held by London Stationers' Company expired in 1698, she refused to renew it, which triggered an expansion in publishing in London and the provinces. She passed the world's first copyright act in 1710. The Statute of Anne was "for the encouragement of Learned Men to Compose and Write useful books". This led to the establishment of Legal Deposit Libraries to preserve literature in perpetuity. Though the Stationers were already depositing at Oxford University a copy of every book printed.

The term that keeps recurring across the eighteenth century was 'improvement', whether referring to country estates, the building of new wide, clean streets, public behaviour or religious observation. As the economy recovered, especially after the end of the Seven Years' War in 1763, people had money to spend on leisure. Entertainments abounded at the great fairs, in coaching inns, pubs and coffee houses, and in new assembly rooms and theatres. In open streets and market places, travelling players, jugglers, mountebanks, magicians and freak shows were willing to relieve people of their pennies. But as the century advanced, so did civilised pastimes. Actors became respectable, magic was stripped from science, and the Age of Enlightenment paved the way for the Industrial Revolution.

In Scotland, the period also saw massive change, as Henry Grey Graham writes:

"Probably no period was so quietly eventful in shaping the fortunes

and character of the country as the eighteenth century. Others are more distinguished by striking incidents, others are more full of the din and tumult and strife which arrest attention and are treated as crises, although they may neither stir the depths nor affect the course of a people's life; but in that century there was a continuous revolution going on — a gradual transformation in manners, customs, opinions, among every class; the rise and progress of agricultural, commercial and intellectual energy that turned waste and barren tracts to fertile fields — stagnant towns to centres of busy trade — a lethargic, slovenly populace to an active, enterprising race — an utterly impoverished country to a prosperous land."[14]

As the race to win the Longitude Prize showed, navigation and astronomy were of immense national importance. The islands of Britain were defended by the navy's *wooden walls* and in the eighteenth century alone, some eleven thousand ships foundered on its coast. On 22 October 1707 Sir Cloudsley Shovel (b.1650) was drowned with two thousand sailors off the coast of Cornwall, a disaster which long haunted the nation, so the public was aware of the dangers and wished to support and promote improvements. Horological research attracted the greatest minds of the age and in the 1680s and '90s publications appeared which attempted to extract science — especially astronomy — from superstition. These were often written by school teachers to supplement their meagre incomes — in English rather than Latin — to maximise sales and readership. England had only two universities: Cambridge was mostly for training clerics, Oxford for lawyers. Members of the various Nonconformist groups could attend lectures there without gaining degrees, or they could study abroad. Non-Anglicans were also excluded from the networking and financial benefits of serving in public offices, so many turned to education, science and technology for advancement.

New publications allowed and/or encouraged the emergence of many great artists and scientists who were self-educated, including the painter Thomas Gainsborough. He was famously fond of scientific aids such as picture boxes and indoor fireworks to improve his art.

These interests probably reflected the work of his two engineer brothers, but also echoed the classical notion of the arts to include technology. Thomas Wright, astronomer and gardener, the *Wizard of Durham*, was a friend of the poet, scholar and bluestocking Elizabeth Carter; together they attended lectures at the home of Royal Society science demonstrator Dr J.T. Desaguliers.[15] Wright submitted two papers on astronomy to the Royal Society but was turned down for membership, possibly due to his humble origins.[16] His theory that the Milky Way was disc-shaped predated the discovery of it being a spiral galaxy so, like many of his age he was ahead of his time.[17] The pool of knowledge was still small enough to allow people to become skilled in several subjects, as the barriers between them were still fluid, still part of the world of curiosity and wonder that marked the dawn of our modern age.

The lack of economic and social stability in the late seventeenth/early eighteenth century seems to echo our modern situation, with lack of job security forcing people to hold down multiple jobs. But in the careers of men such as the brilliant explorer William Dampier, whose maps were used by James Cook on his circumnavigations of the globe, and in Daniel Defoe we see a constant search for income. They hoped to strike gold, to retire to a life of sufficiency, if not of luxury. They were entrepreneurs who seemed to pick up new skills as required. Sir Richard Steele had an incredibly varied career, suggesting a man of huge energy, curiosity and inventiveness, who provided copies of the first edition of *The Tatler* for free. He was a soldier, royal aide, writer, editor, commissioner of stamps and an M.P.. He was involved with Drury Lane Theatre, tried to find the philosopher's stone and promoted a scheme to supply London with fresh fish.[18]

Parallels were drawn between Steele, Sheridan, Fielding, Defoe and many others of the early eighteenth century. All had the skills to have become rich, but often struggled with debt. These are the men who stand out from the early eighteenth century, the Augustan Age. They were the endlessly inventive, creative, heroic, humorous, larger-than-life characters who helped define the English character. There are also

famous examples of men who had risen from poverty to the heights of fame, such as the Royal Surveyor Isaac Ware, a former chimney sweep's assistant, and Royal Clockmaker James Graham had been an impoverished young shepherd.

It is this world that Henry and his machine emerged from, a world devastated by centuries of religious and political disputes and battles. The collapse of population from war, disease and emigration created space for social climbers, for clever, hard-working people to achieve fame and success from humble origins. It was a world that seems to have more in common with Hollywood musicals than modern Britain.

3
OTHER WORLDS

The word 'bible' has evolved through time from the Greek term for a book, or for paper itself. It reflects the importance of writing, and the high status and power of the literate minority. In modern use, it means a large book, one with authority, but with the added force of capitals, it means the Scriptures of the Old and New Testaments. For many centuries Christians have cited the 'Biblical Truth' as the definition of reliability and veracity. The Bible provided information on the origins of the earth and our race; morality tales helped form the framework for civic society and government. Its importance was recognised by the publication in 1611 of the *King James*, or *Authorised*, version which provided a high standard of translation and also conformed with the teachings of the Anglican Church. Its high literary standards reflected the importance of the text; it is rich in metaphors that are still — often unknowingly — in use today. This achievement is even more impressive given how recently English had become a recognised language, in the mid-fourteenth century. In the absence of any other source, it was accepted as the literal truth, and until well into the nineteenth century was still the only reference for what became the sciences of archaeology and geology. It was also the primer to teach

children how to read. In most houses the Bible was not *a* book, but *the* book.

A widespread objection to young women reading novels in the eighteenth century was that fiction overstimulated their emotions, providing romantic ideas that were far removed from the realities of marriage and child rearing. But in 1801 Eugenia de Acton wrote a defence in the introduction to her novel *The Microcosm*. She claimed the classics, but especially some parts of the Bible, such as the *Song of Solomon* and *The Book of Job,* used fables to convey morally uplifting and inspiring examples for readers. The Song of Solomon is an interesting choice as it was often considered to be rather 'naughty'. Miss de Acton defended fiction on the basis that modern authors such as Fielding, Johnson, Moliere and Cervantes were continuing this noble tradition.[1] To this group we could add Hogarth, a fine painter, but whose primary aim was to tell moral fables. His *Tom Nero* was shown as a child torturing animals. He grew up to become a murderer and after being hanged for the crime was dissected and his entrails were eaten by dogs. This suggests that many people were no longer learning morality from the Bible, so he felt a need to educate the public via imagery, echoing the role of the *Bible of the Poor* windows in mediaeval churches.

But the Bible's veracity and Christian faith had previously been stretched to breaking point. Kirkpatrick Sale in his *Conquest of Paradise* described how Europe in the Middle Ages was subject to storms, famines, floods, droughts and plagues of insects on an unprecedented scale which overwhelmed civil authority, especially when leaders also succumbed. Unemployment soared and destitute soldiers, students and vagabonds took to the roads, preying on travellers and furthering the breakdown in law and order.[2] England had endured wars with the French, and the War of the Roses, with its unprecedented ferocity, had been settled with the coronation of Henry VII, Henry VIII's father, so the fear of returning to such anarchy fuelled the need for a male heir.

Christianity failed to explain or provide relief via prayers, pilgrimages or fasting, so donations to the church fell drastically, and clerics became inept and corrupt. People looked for their own explanations

via superstition and folklore, or scapegoats in witches and Jews. The real culprit seems to have been a prolonged period of cold weather, which caused repeated crop failure and triggered soaring levels of hunger-driven crime. With no effective policing, punishments became so gruesome the term *mediaeval* has now become a byword for senseless brutality. In search of safety, people retreated to walled towns which became overcrowded and unhealthy, producing perfect environments for epidemics and the catastrophe of the Black Death.

Britain seems to have fared better than mainland Europe, as it had abundant fertile farmland and the encircling sea moderated its climate, so famines were less common. But Britons joined mainland Europeans in sailing further afield in search of food and sometimes reached North America, providing incentives and information for later explorers and settlers.

Christianity taught the only way to reach heaven was to live a moral life, and then to die, often slowly and painfully. But when Columbus announced his discovery of the New World, it seemed heaven could be reached merely by sailing there in a ship. The ports of Spain were flooded with people desperate to escape the harsh realities of Europe for the promise of paradise on earth.

Martin Luther (1483–1546) fired the opening shot of the Reformation, but the veracity of the Bible had already been undermined by travellers and merchants spreading tales of other lands, cultures and peoples. If there was only one — Christian — God, how could these other civilisations exist? Why did non-Christians seem so unconcerned by being consigned to hell when they died?

The story of Noah's Flood was challenged when animals were discovered that were not named as entering the Ark. How could penguins, birds of paradise and armadillos exist if the whole earth had been drowned? This questioning helped create an audience for travelling menageries which often retreated to London for the winter, especially to the Exeter Exchange where Henry's Microcosm appeared several times. Newspapers record advertisements for displays of exotic animals at fairs and on individual tours. Poet Laureate Robert Southey (1774–1843) recalled from his childhood a shaven monkey shown as a

fairy, and a shaven bear in trousers and coat was presented as an Ethiopian Savage at Bristol Fair.³

Taxidermy provided lifelike exhibits, which in turn led to a market for oddities. A rare survivor from the Tradescant collection is labelled a *Barometz*, or *Vegetable Lamb*, which was believed to live in southern Russia. The creature allegedly lived on a plant where it ate surrounding plants before dying. The object is shaped from the roots of a fern and is now in the Garden Museum at Lambeth. A market developed for other hybrid creatures such as mer-people. P.T. Barnum owned a *Feejee* mermaid and a Japanese *monkey fish* which is on display in London's Horniman Museum. As recently as 1967, in the film *Quatermass and the Pit*, the strange creatures unearthed were compared with fairground mermaids, 'made of old skin and bone', so they survived into the modern age. This market was so successful that it was not until the twentieth century that the Australian platypus was accepted as a genuine creature rather than a taxidermist's hybrid. Even if these creatures were found to be fakes, they served to stimulate discussions on the differences between animals and plants, and between and within various species.

The Bible claimed that man was made in God's image, which was comprehensible in small, genetically similar communities, but when people from exotic lands were brought to Britain, the range of skin colours, physique and facial features must have made the notion of God's appearance a very confusing one.

Before the discovery of the New World, boats were small, navigated by experience and via legally protected landmarks such as church towers and cliffs. When beyond sight of land they followed a line of latitude, using astrolabes or the sun. When trade and conquest expanded to Africa and the Americas, sailors needed improved navigation. The importance of accurate timekeeping at sea was recognised by the launch of the Longitude Prize in 1712. But research was limited by lack of technology, which led sailors to improve their instruments or

commission specialist technicians. This caused an expansion of the market for a wide range of precision instruments such as clocks and telescopes. The astronomer William Herschel famously stayed up all night holding a mirror for his telescope to stop it distorting, which eventually led to his discovery of the *English planet*, Uranus, named after the Goddess and Muse of Astronomers, Urania.

Research advanced in the opposite direction, to the discovery of tiny worlds with the invention of the microscope by Galileo in 1609, which Anton van Leeuwenhoek improved, allowing him to see microscopic animals. As with astronomy, worlds invisible to the naked eye became visible by looking into a metal tube. The invention of the solar microscope turned such investigations into a public spectacle. Sunlight was shone through a slide full of water and projected onto a wall, allowing the audience to see tiny animals moving about and even eating each other. As late as 1858 the poet Walter Savage Landor wrote in praise of this invention and drew parallels between humans and tiny creatures, or *animacules* in their watery world, or microcosm.

Such advances were seen by some as magical at a time when the scientific community was struggling to shed its association with superstition. Only three years after the repeal of the witchcraft act in 1735, the poet and scholar Elizabeth Carter attended lectures by Dr J.T. Desaguliers. She described his house as that of a wizard and claimed (presumably in jest) she feared being turned into a witch.[4] There were even complaints that the Royal Society, founded to advance scientific research, was a cabal of rich men dabbling in magic. The parallels between science and magic continue, as science fiction author Arthur C. Clarke famously claimed it is often difficult to distinguish between advanced technology and magic. Such confusion also applies in the opposite direction, as archaeologists often claim curious objects for which they cannot find a purpose were used for rituals. This default terminology may exaggerate the amount of religion and ritual in ancient societies.

By the early eighteenth century the public had become fascinated by images and tales of different worlds, but they also brought new uncertainties and confusion. Though now read as fiction, Swift's

Gulliver's Travels emerged from, and added to, this debate; discussions about strange animals segued into pondering the very nature of humanity. Swift's book causes problems for modern readers as our relationship and understanding of animals has changed so much. Until the mid-nineteenth century most people still lived on the land; shepherds and cow herds spent more time with their beasts than with humans. They saw animals as friends and partners. The Bible, classics and folklore are rich in animal metaphors; people understood them in a way those who have grown up in our Disneyfied world cannot. The Latin poem included in the pamphlet, "A succinct description..." described the Microcosm as being like "the Pigmies' palace, or the far-famed hall which was Lilliput's boast".

The first — and probably most famous — book of the Old Testament is Genesis, in which God gave humans dominion over animals. But when Swift's Gulliver encountered the Houyhnhnm horses, he grew to respect them and even considered them his betters, so reversing the natural order. The story was especially challenging as its author was a cleric.

But his satire did not emerge from a vacuum. Though educated in Dublin, he completed his M.A. at Oxford's Hart College, where the teaching was less directed to training clerics, which allowed some freedom in the curriculum. Many students were non-establishment figures such as John Donne who was of Catholic heritage, and several were Jesuits. It staged early science demonstrations by Newton and his followers such as John Kiell and J. T. Desaguliers.

By the early eighteenth century, Britain was in a new state of turmoil. She had long been isolated at the farthest edge of European civilisation, invaded by Normans and Romans who plundered her for raw materials. But when Britain founded colonies in the New World, she moved to the forefront of European expansion. As a maritime nation she adapted to long distance trade and exploration, but this came at a high price: conflict with European rivals, and a boom and bust economy that added to the miseries of the poor who were no longer cared for by the monasteries that Henry VIII had closed.

So how did Henry Bridges' display of his *Little World* fit into all this? *Gulliver's Travels* was published in 1726, about a year after Henry began building his machine, so the timing is interesting. The design of The Microcosm was not a random selection of images like other clockwork shows, but displayed a clear hierarchy of elements to tell a story. At the top were seen the arts: the muses, Orpheus with his music, and the changing of the seasons, so all linked with ancient gods. Then the main focus: a piece of precision technology displaying past and present notions of the universe, representing advances in science and technology. Below this was the wider world of road and sea travel, of people at work, of animals, of mills in operation. At the base was the working world of Henry with the carpenter's yard. His little world was not just portraying images of the big world; it demonstrated how it fitted together; thus providing a sense of order. It suggested that all parts were necessary, and that they needed to work together in harmony, a thoroughly Augustan notion.

Henry was called The Microcosm's constructor, maker and owner, but most importantly, its author. He was displaying classical ideals of the arts and architecture, and the clockwork universe designed and maintained by God. The world based on a fixed hierarchy with the monarch and church at the apex and the poor at the base had been disrupted by the Reformation and broken by the Civil War. Henry seems to have been offering a counterbalance to the confusion in people's minds about the rapidly changing world. It also emphasised the importance of education, early science and technology.

The Microcosm was made by an educated, enlightened English man. Not by a foreigner, a magician, a Houyhnhnm, or any other beast. It was a statement of English achievements, a proclamation of the nation's potential. The English nation had survived the execution of bishops, the rule of a usurper and execution of a king, of battles and debates on how to worship and to read the Bible. Henry built a machine that signalled pride in honest English achievements, and faith in the future. The name suggests it was based on classical

notions of the micro/macrocosm, with man's little world being a representation and reflection of God's macrocosm, or big world. In Henry's eyes, his home, and his country were growing from a small world, on the brink of embracing the whole. He is announcing the dawn of enlightenment and empire, a rejection of superstition and idolatry of the old world.

The Microcosm was called a masterpiece — not in the modern sense of a great piece of art — but as a piece of work made by an apprentice to show his skills, evidence to convince his guild to award him the status of a master craftsman. In the Rosslyn Chapel near Edinburgh is an impressively carved apprentice pillar which is claimed to be such a masterpiece. In London's Victoria & Albert (V&A) Museum there is a table clock which bears similarities to Henry's work, though far more ornate and in a case of silver. It is called the *Masterpiece Clock*, produced c.1665–70 by an apprentice and put on display in the master craftsman's workshop in The Hague.[5] It was so successful that several similar clocks were commissioned.

But if The Microcosm was a masterpiece, what trade was Bridges demonstrating? It seems he was demonstrating not a trade, but a new world view, and during its decades on the road, its changing displays reflecting a world in flux, the advance of technology and philosophy, of a new world emerging that would be better than the old one.

When Henry VIII closed the monasteries, their huge libraries were dispersed and many books destroyed. Music survived in England as Elizabeth I loved dancing. Carpentry survived as it was a local trade, and the country was still well covered with forests. But Cathedral masonry yards were closed, ushering in the Tudor age of wood, which in turn led to many fires — especially the great one of London — which finally led to a revival of fire resistant stone and brick buildings. Glassmaking, silk weaving, brick making and clockmaking had to be re-introduced from the continent.

England was isolated from Catholic Europe under the Tudors, church services were in English so the study of the classics suffered. When German physician Thomas Platter visited England in 1599 he knew no English, but Latin was still the lingua franca for Europe's

literate community, so he expected to survive with it and some limited French. He visited Eton where he met a learned don who managed "to converse with the aid of a Priscian, a Latin grammar, but owns that for sixteen years he had not spoken so much Latin in a day".[6]

Historical research is heavily reliant on old documents, images and maps. But they tell us more than details of people and events. The dates when they were produced can also be significant, as they were often made when circumstances were about to change. New-found lands were mapped, properties were surveyed when they were about to be sold. Maps of towns and cities were commissioned prior to the layout of new streets or the demolition and/or construction of major buildings. Drawings of old buildings were made when they were about to be destroyed, which in turn helped drive the interest in 'gothick' architecture and romantic ruins.

So The Microcosm can be seen as a snapshot of England at the time it was made. It indicates a high level of education and knowledge in the small town of Waltham Abbey, as well as of civic pride. But it also raises the question, why then?

When Shropshire gentleman and former barrister Richard Gough wrote *Antiquityes and Memoyres of the Parish of Myddle*, and its sequel *Observations concerning the Seates in Myddle and the familyes to which they belong*[7] between 1700 and 1703, he had no idea it would become the seminal work of English local history. These two books provide fascinating insights into the life in his small parish, and Gough's extensive knowledge provides detailed historical and at times scurrilous information on local people. But even in this isolated parish, as the turbulent seventeenth century drew to a more peaceable close, there were signs of change. Moors were being drained for farming, common land was being enclosed and local families were on the move. It seems Gough sensed the small world he knew was on the cusp of dramatic change, and felt a need to record it before it was swept away by modernity. It is also curious as it seems he had no intention of publishing the work and it was not compiled for any descendants as he had none. So, as with Henry, why did he do it?

The Microcosm, with the arts and sciences it demonstrated, can

thus be seen as a sign that Britain had moved from its place at the furthest edge of civilisation, and was well on its way to becoming a world power. Gough's account was written at the end of his life, so is mostly gazing backwards. By contrast, Henry and subsequent proprietors were looking determinedly to the future. They were observing the changes and improvements, helping to spread the principles of education and improvement that were about to sweep away traditional ways of life.

4

WHAT WAS HENRY THINKING?

The clock was first put on show at Henry's home in 1733. The rear living room with the Carrara marble fireplace may have been specifically built and decorated for the purpose. The following year Henry went to the great expense of producing a large copperplate print, two feet by eighteen inches that showed the beast in the paved hall of a large mansion; over succeeding decades its sales supplemented the income from the show. The machine involved a huge investment of time and money, so must have had a specific goal when he began the project in 1725. In 1736 it was claimed: "This work is judg'd worthy to adorn the Palace of a Prince, as it excels whatever had been done of this kind."[1]

This suggests it was built for an aristocrat: either as a commission or on speculation. Either way, payment was unlikely before the work was completed, so Henry must have had a major source of funding from the outset. The print was dedicated to James Brydges, the Duke of Chandos, whose palace of Canons was at Edgware, then a rural retreat but now engulfed by suburban London. He was the wealthiest magnate of his age, the only one to have his own choir. One author even claimed The Microcosm was built at Canons, but if so, why didn't Chandos keep it?

The dedication may suggest he was the expected owner, or perhaps Henry made it as a showpiece, hoping Chandos would support him to produce more such pieces, as with the V&A's Masterpiece Clock. Such dedications were common in printed books in gratitude to the patron for funding the work. But the dedication refers to the engraving, not to the clock. In later decades when the great magnates such as Chandos and Burlington had died, funding switched to public subscriptions whereby people paid half in advance and the rest on completion/delivery.

Horologist Arthur W.J.G. Ord-Hume praised Henry's clock as being of the highest standard, and was unusual in his combination of timekeeping with both systems of astronomy.[2] But Ord-Hume, like many other authors, claimed Henry made other clocks, though failed to name them. Henry made no such claim, so it is a mystery where this idea originated.

Henry claimed The Microcosm was his first essay, and that he was its author, suggestive of a written composition, but also a term applied to architects and to Cyrus the Great who built the Hanging Gardens of Babylon, suggesting the term meant the instigator of the work. Assumptions were probably made of The Microcosm that a work of such sophistication and skill could not have been made by a novice, and that once these skills were acquired, Henry would continue to practice them.

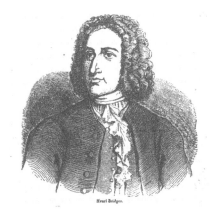

Henry Bridges, History of Horology, Paris, 1840.

Henry and his clock feature in a respected French publication, by Pierre Du Bois of 1849, but only in the Appendix, before Ctesibius, the Alexandrian inventor of the first water clock. It includes an engraving, probably a copy from the original engraving, but which looks more realistic. The brief article claims Henry was from London and had a great reputation as a constructor of clocks and automata. It states he made work for Charles I (several decades too early), and the Duke of Buckingham,[3] a title the Dukes of Chandos acquired a century later. It seems facts were often lost in translation.

Another intriguing item in Paris's Bibliothèque nationale de France is a pamphlet published in Lille by the respected and well established science publisher P.S. Lalou which describes the clock. It is a translation of the many produced in England, which suggests the clock travelled in France, but there are no illustrations or poetry and it is attributed to translator "L. Bridoux".[4] It is also, infuriatingly, undated though on its cover is the number "1762" which has been assumed to be its date of publication. Close inspection reveals it to be written in pencil, so may be a library reference code.

The *Horological Journal* of 1804 mentions a portrait of Henry Bridges also in the Bibliothèque nationale, though it is unclear if they are referring to the Library in Paris or a publication of that name. It claims he had been clockmaker to Charles I and that The Microcosm had been made for the Earl of Rochester. They rightly claim the dress and style were incorrect for this earlier period, and it is intriguing how this could have originated. Perhaps the very existence of these records suggested Henry was more famous in Europe than at home.[5]

From about 1760 the new proprietor of The Microcosm produced a pamphlet which in typically verbose Georgian style was called *A succinct description of that elaborate and matchless pile of art, called the microcosm with a short account of the solar system: interspersed with poetical sentiments on the planets*. It claimed that Henry had funded his project, and it was reasonable to expect financial return for a project which was of such benefit to society.

This confirms Henry paid for the machine himself, but we are still in the dark as to how much it cost him, and where a tradesman could

find such funds. The huge investment of time meant he was not working at his trade, so he must have had other sources of income to tide him over and to pay for his workers. In his will of 1754 he described himself as a gent, i.e. he had no need to work, and so must have been a man of significant, independent income, which means he owned property. We also have no idea how much the subsequent owner Edward Davies paid for it. And when *A succinct description...* claimed Henry had built it with the expectation of public encouragement, what did this mean? To be given money or a pension? To continue touring with the show? To make another machine? Or something else entirely?

In August 1736, Bridges claimed The Microcosm had been praised when shown to the royal family and the court.[6] Records from the royal archives at Windsor are scarce at this time, so this claim cannot be confirmed, but it cannot be disproved either. The Microcosm was the sort of ornate entertainment that appealed to royalty. He also claimed to have impressed "the faculty" and professors, which seems to refer to Oxford rather than Cambridge, but fails to name any of them.

Earlier the same year, an advertisement claimed that Mr Clay, a designer and maker of ornate watches, showed a musical clock to the royal family. They were not interested in buying it but to encourage this great artist, the queen generously spent fifty guineas on the raffle arranged to dispose of it.[7] Clay was clockmaker to His Majesty's Board of Works. As with the granting of royal patents, this was an honorary title which did not provide a livelihood. If the royal family showed little interest in Clay's clocks, there was little chance an outsider like Henry would gain their support.

Many authors suggest a range of precursors to Henry's 'little world' of clockwork-driven moving scenery. The most obvious one — especially from its name — was the *Theatrum Mundi,* brought to London by a German, William Pinkethman in 1709. The term refers to the Renaissance practice of collecting objects to represent the world and was also called a microcosm or theatre of the universe. In the copperplate print, The Microcosm is framed by a velvet curtain, suggesting a theatrical element to the performance. It also had religious connotations, in the

notion that life was transient, a preparation for eternal life at the Resurrection. This encouraged good behaviour and charity by the living. The term survived the Reformation, when Shakespeare claimed in *As You Like It*: "All the world is a stage, all the men and women merely players" in 1599. In the Latin poem included in the pamphlet 'A succinct description...' the seascape was described as a "lifelike tableaux". It continues the metaphor with "To round off the play (for what else but a theatre can this ring of land and water be called?)"

Pinkethman's device showed a landscape with coaches, people and animals, and windmills in the distance, all of which were in motion. A handbill claimed it had taken five years to build and was intended for the Elector of Bavaria's curiosity cabinet. But when his patron died, Pinkethman was forced to recoup his costs by taking it on tour.[8] The image is framed by fringed velvet curtains, suggesting a theatrical element to the show. Many years later the American artist Charles Wilson Peale painted himself drawing back the curtains to reveal his museum of curiosities, so The Microcosm also fitted into the realm of gentlemanly collections.

The timing and details of this machine are close enough to have inspired the construction of The Microcosm, and Henry may have gone on the road for the same reason. He may have intended the machine for the Duke of Chandos who was alleged to have gone spectacularly bankrupt following the bursting of the South Sea Bubble in 1720. But Brydges continued his opulent lifestyle till his death in 1744 when his entry in the *Oxford Dictionary of National Biography* claimed he was "wealthy". Had he been interested, he could have bought several Microcosms.

The New York Gazette of 2 February 1756 claimed Henry had been offered five thousand pounds for it by the Prince of Wales, i.e. Frederick, who died in 1751. If this was true — and this is a very big if — why did he not accept it? This claim is feasible as the prince was fascinated by science and technology. In 1737 his estranged mother Princess Caroline died, and with his servants he passed the mourning period in lectures by Dr J.T. Desaguliers of the Royal Society whose

life is described in a later chapter.[9] The English often looked enviously at the French for their luxury and fashions, but the Protestant aversion to such frivolity and waste was widespread. The recently installed Hanoverians were either too sensible to be collectors of luxury goods or nervous about the response of the mob if they spent public money on trifles. Roger Fry writes of them:

> "Three English kings have shown an appreciation of art. Two, Richard II and Charles I, were put to death, and George IV, living in less brutal times, only had the windows of his state coach broken by an infuriated mob."[10]

British monarchs were also short of cash, so aristocrats like Chandos who plundered the public purse and grew rich by speculations, fraud and enclosing public lands had more money for luxuries and were free from public scrutiny. The monarchs themselves showed little interest in the arts, as the following suggests:

> "King William thinks all
> Queen Mary talks all
> Prince George drinks all
> Princess Anne eats all.
> "It is recorded of Queen Anne that she took no interest in the art or the drama or the literature of her day, but she possessed homely virtues."[11]

Anne spent much of her life pregnant, futilely trying to produce an heir to the throne, and also suffered from dropsy, so this last comment is not surprising.

Colonial wealth made life easier for the later Hanoverians. George III is famous for his madness and for losing the North American colonies, but he was the first monarch for several generations to be born and educated in England. He was interested in horology and Queen Charlotte loved bijoux objectsand novelties. The Royal Collec-

tion contains many items from this period, but they were later collected by Queen Mary.¹²

European economies were static for centuries before Spain established silver mines in Potosi, Bolivia. This was the closest that Europeans ever came to finding El Dorado. But this massive influx of wealth introduced inflation. In Britain from the late seventeenth century, many speculative colonial settlement schemes attracted new money, which contributed to a boom and bust economy with disasters such as the infamous *South Sea Bubble*, the *Mississippi Scheme* and a host of mining ventures which promised to create — but mostly lost — fortunes. It also fuelled a culture of gambling; bankruptcy was probably a large factor in the soaring rates of suicide which became known as the *English Disease* by the mid-eighteenth century. The Microcosm on its extensive travels became part of the swirling morass of colonial expansion and trade as increasing numbers of people took to the road to make a living. It also coincided with a shift of wealth from a handful of rich aristocrats to the expanding middle classes, the merchants and mechanics with time and money to indulge in leisure pursuits and entertainments.

If Henry didn't build The Microcosm for a British monarch or aristocrat, he may have hoped it would be used as a diplomatic gift. Waltham Abbey was on the River Lea, which meets the Thames in London's East End. He was often claimed to be from the capital, so it is possible he had connections with the export trade.

From 1545 Spain supplied silver to China, opening up trade between Europe and the Far East. Members of The Society of Jesus, or the Jesuit Order, were famous for their linguistic abilities and promoting western science and technology. They converted South American natives to Christianity by playing music to them, as Orpheus had charmed beasts. In Roland Joffe's 1986 film *The Mission*, an observer claimed they could have conquered the continent if they'd had an orchestra.

Edward O'Malley describes the appeal of clocks to the Jesuits, as they demonstrated elements of their faith. Clocks created order from chaos, echoing the role of God in creating the earth. He was seen as ruling over a clockwork universe of His own construction. Hence introducing the Chinese to clocks was a form of evangelicalism.[13] From the late sixteenth century, missionaries to the Far East were closely followed by diplomats "with their elaborate gift rituals. Especially favoured were clocks and watches: not for telling time, but as status symbols."[14]

There were also parallels between the concentration and focus on detail required for clockmaking and the sense of awe such pieces inspired, which reflected the mediaeval production of illuminated manuscripts that became redundant with the invention of the printing press.

The many small principalities in what is now Germany created a market for such diplomatic gifts, as Edward J. Wood claimed:

> "At Augsburg were constructed most of the clocks and watches with moving figures, such as a Moor, a monkey blowing a trumpet and similar toys moved by clockwork concealed within them. These toys were chiefly made and used for presents from the ambassadors of Christian countries to Oriental princes and barbarians. At Nuremberg is stated to have been made a miniature silver army of cavalry and infantry, which moved their limbs, went through their exercises and fired by clockwork within them."[15]

But using clockwork for diplomacy entailed risks, as Wood described a piece presented to Louis XIV of France by Bordeau in 1696. It was a mechanical tableau of the king surrounded by diplomats from German and Italian states. On each hour they bowed before the monarch and struck quarter hours with their canes. The stubborn William III of England was designed to bow extremely low. Instead, the Grand Monarch was thrown from his throne to fall prostrate before William. Bordeau was sent to the Bastille for the night.[16]

When the Tudors broke with Rome, they lost access to a large

European market, but also to Africa and the Americas, which the Pope had divided between Spain and Portugal. Protestant nations were thus forced to go further afield for trade, to the Middle and Far East. The Ottoman Empire was at war with the Catholic nations, so England sought common purpose with its leaders. In the locust years of the Tudors, there was a passion for luxury goods such as silk, damask, jewels and gold which Elizabeth was keen to import.

In 1599 Thomas Dallam, blacksmith and musician who built the organ at King's College in Cambridge sailed to the Ottoman Court. He was to deliver and demonstrate his clockwork automata/organ in the hope of encouraging the renewal of trade agreements for Elizabeth's Levant Company merchants. When presented to the sultan, the clock struck, bells chimed, music played, and birds shook their wings at the end of the performance. The sultan was so impressed he asked Dallam to play the keyboard for him. For the duration of his stay, he became the most important Englishman in Istanbul.[17]

The parallel with Dallam was noted by horologists including W. J. G. Ord-Hume who suggested Bridges built his machine as a similar diplomatic gift, as The Microcosm's barrel organ also included a keyboard which visitors to the show were invited to play.[18] In both cases, this added a socialising element to the performance, an important component of diplomatic visits.

When Britain expanded its colonies in the Americas, such ornate diplomatic gifts were not required. Trade goods with Native Americans were of a practical nature, manufactured items such as metal tools, gunpowder and weapons. But as Britons developed a taste for tea and the china to drink it from, diplomacy found a new outlet. In 1766 James Cox, a London jeweller and toymaker produced a pair of gold chariot clocks for the East India Company to present to the Emperor of China.[19] This coincided with the expiry of the company's monopoly of trade with the country.[20] Clive's victory at Plassey in 1759 opened up India to trade with the British, especially for the East India Company. Cox had been involved in this trade for some years, and sometimes employed a Col. Magniac of Clerkenwell who also traded with the region. So it seems Henry's clock was made either too

late or too soon to have oiled the wheels of England's international trade.

There is yet another explanation which reflects the changes wrought by the Tudors. The iconoclasm they unleashed destroyed not just the visual arts but also training and knowledge to produce such works. Famous artists of the early eighteenth century included Germans Frederik Handel and Johan Pepusch, Dutchman Grinling Gibbons and large numbers of Italian marble carvers and plasterers. A rare example of a local artist was Sir James Thornhill (1675–1734), claimed to be the only successful home-grown fine artist in the late seventeenth/early eighteenth centuries.[21] He had a number of important public and royal commissions such as St Paul's, Hampton Court and Blenheim Palace.

As trade recovered from England's disastrous seventeenth century and money poured into England from the American colonies, the newly rich went on the Grand Tour and returned with fine art to decorate the walls of their new country mansions. By the 1730s images of dead Christs and Madonnas were being imported for those who stayed at home,[22] showing Protestant England had overcome its aversion to idolatrous images of saints by shifting them from churches to private residences.

In the BBC Reith Lectures of 1955 Nicholas Pevsner discussed the idea of a national character and how it varied through time while the climate was a constant. He cited Hippocrates who believed climate affected character and history. In 1719 the Abbé du bois applied the concept to art.[23] Europeans mocked the English for their lack of artistic talent, even suggesting England's weather was unsuited for such genius, to the great frustration of Thornhill's son-in-law Hogarth. He trained as a coach painter and with his peers struggled for commercial success against the flood of imported art. Hogarth famously and loudly objected to imported European art and discouraged artists from being corrupted by doing the Grand Tour, especially

to Rome. This echoed much of Henry's puff, encouraging honest English workmanship with:

> "Dare to invent yourselves, to fame aspire
> Be justly warm'd with your own native Fire."[24]

This reflects the age in which The Microcosm was built, a prolonged period of peace. The contrast with the middle of the century is marked, as when the descriptive pamphlet *A succinct description...* described the shipwrights joyfully "envisaging chains for the French or Spanish". Hogarth was a brilliant painter, but he saw his art as a means of telling stories, to educate and improve the viewers. Much of his work echoed late mediaeval art which urged parishioners to live well, repent their sins or they would pay dearly in the afterlife. Garrick claimed Hogarth's intention was "to charm the mind and through the eye correct the heart".[25] These sentiments are again similar to several expressed by Henry's publicity.

Hogarth's work is often derided for being observational rather than the grand history pictures promoted — though seldom produced — by Sir Joshua Reynolds when president of the Royal Academy. The architectural historian Nikolaus Pevsner claims such observational art had a long history in these islands, as seen round the edges of illuminated manuscripts, called *babooneries* as they were often light-hearted. Surprisingly, he claims the art form originated in Britain as records survive from as early as 1260, and can be taken back as far as the Bayeux Tapestry which includes preparation of food and other domestic elements alongside the battle scenes. This work was of course produced by women, making the so-called weaker sex pioneers in British art. Pevsner praised the richness of this heritage as surpassing European collections.[26] From Hogarth this heritage can be taken forward in time to include Joseph Wright, James Gilray, Charles Dickens and the Pre-Raphaelites and into the modern age when it seems to have become ubiquitous in cartoons and graffiti.

The English response to European art and its claim to supremacy was to cite Shakespeare and Milton; London gallery owner John

Boydell claimed English poets were more sublime, so superior to even Michelangelo and Raphael.[27]

Shakespeare is famous for having coined the most number of words in English, but his contemporary the physician Sir Thomas Browne (1605–82) of Norwich ran him a close second. Browne studied at Oxford, Montpellier, Padua and Leiden, so was multilingual and multicultural, so contributed to the rising tide of philosophical investigations. Just as Shakespeare and other playwrights invented new words for entertainment, Brown coined new terms for medicine, philosophy and the many other subjects which fascinated this restless, talented polymath. English words helped fill the void created by the decline of Latin, the destruction of images and the debate over their interpretation and use which continued into the eighteenth century. Because the debate over visual art was so closely linked with English Protestantism, language became a potent tool of nationhood and national pride, so claims that English poets were the match of European painters and sculptors are less far-fetched than they seem.

Much of the debate on religious practice during the Reformation concerned the use — or alleged misuse — of imagery. Art was a huge proselytising tool in the churches, and was crucial to celebrations and rituals which helped bind communities together. Whilst Henry VIII was not against imagery in churches, his bishops were, as they believed that depictions of saints would encourage people to worship the images. The Bishop's Book of 1537 claimed that the use of images in church "was a concession to the dullness of men's wits" and the survival of traces of "gentility" or paganism".[28] The book recommended no images of God the Father. The Archbishop of York urged that people should be taught that "images be suffered only as books... even as saints' lives be written... for the same purpose".[29] Their role was to tell stories as in the windows known as the *Bible of the Poor*. These stories of heroism and benevolence were useful to inspire people to lead Christian lives.

An interest in classical art was free of politics and religion, so fed into the Augustans' passion for polite society and good manners. From this literature, the first of the arts to recover was garden design. This is claimed to be England's true art form, or at least the first in which she excelled and set standards and fashions for the rest of Europe. Early eighteenth century landscaped gardens often featured poetry on signs placed strategically to encourage contemplation, so echoed earlier religious practices when priests processed round cloisters reading prayers. Literature was often a shared experience when read aloud, or it could be a form of meditation and religious contemplation by the pious.

From debates over images and their use, a new type of gallery appeared in London in the 1770s, with sets of paintings designed to tell stories, which were read in a set order rather than crammed onto walls at the Royal Academy and salesrooms. In 1786 the print seller John Boydell launched his *Shakespeare Gallery* followed by Thomas Macklin's *Gallery of Poets* in 1788, Henry Fuseli's *Milton Gallery* of 1799 based on *Paradise Lost,* and Robert Bower's *History Gallery* based on David Hume's *History of England* in 1792.[30] These galleries followed the success in popularising the works of Shakespeare when Garrick became the Bard's greatest interpreter. He often paused at dramatic points in the plays, allowing the audience to savour the moment and to fix his image to become associated with the spoken words.[31]

Images in Boydell's gallery told stories as did the great classical works. In the debates over religious practices, an isolated image was seen as idolatrous, whereas if it told a story, this was considered safe. Pictures in the galleries followed the sequence of the story or poem, which appealed to audiences accustomed to promenading and socialising. Instead of glancing at a single image, viewers were encouraged to read the works on which the images were based, so combining the practices of reading and viewing, a new experience for the English. They moved from being passive observers to actively constructing the narratives as their ancestors had done in churches, especially with stained glass windows known as the *Bible of the Poor* used to instruct the illiterate.

But as with so much of this story, this practice had precedents. Though Hogarth was one of this country's finest painters, Pevsner claimed the story was more important than the imagery, often with a strong moral message underlying it.[32] Reynolds accused Gainsborough of seeing "with the eye of a painter", rather than of a poet,[33] which seems bizarre but again emphasises the Protestant practice of using words as a source of inspiration for images. And yet Fuseli complained there was no market for poetical painting and that the public were only interested in portraiture,[34] the lifeblood of the Royal Academy. So there was a gap between what great artists wished to produce and the art market.

This conflict lay at the heart of the struggle for artists trying to make a living. When Reynolds was President of the Royal Academy he praised heroic imagery, yet he mostly produced portraits (at which he excelled) and which the public wanted. Gainsborough complained of how he was forced to make a living from portraits whilst his heart craved landscapes. With the demise of the great aristocratic families the newly rich were intent on displaying their wealth, to stake their claims on posterity. They understood the need for public display but were often less aware of the role of other art forms such as antique statuary and history paintings.

Following the Napoleonic Wars, Sir Thomas Lawrence toured the continent painting portraits of the victors, often battle-scarred generals in their finery to demonstrate their heroism in defeating Bonaparte. Under Victoria, many parish churches featured windows and memorials to men who made the ultimate sacrifice for their country, and military saints such as George featured in many, so linking the lives of saints with the fallen. Instead of praying to saints, parishioners were encouraged to be grateful for the sacrifice of these men and women, and to be prepared to emulate them, again echoing the *Bible of the Poor* windows.

Some years ago an exhibition was held in Edinburgh featuring Constable's clouds, showing how deeply he had researched weather, a subject commonly regarded as an obsession with the English. At the end of his life he claimed that painting was a science, to be investi-

gated and that "pictures are but the experiments".[35] This draws us back to the early scientists who built tools for their investigations their investigations, and links the fine arts yet again with practical science. It also echoes the role of The Microcosm and curiosity cabinets as foci for the discussion of science.

Fuseli's paintings were so successful at condensing Milton's poem *Paradise Lost* into a comprehensible sequence that over a century later they inspired Soviet filmmaker Sergei Eisenstein's use of montage. He claimed to regret not having read the poem before he made *Alexander Nevsky*.[36] Eisenstein thus spoke not of inventing montage in film, but of recovering the practice from the past. Milton's success was attributed by some to the fact that he was blind when he wrote it, but like Shakespeare he was writing in an age when so much visual art had been destroyed, so text became visual, as word pictures were written to fill the void.

The success of such galleries shows how completely the English had recovered their interest in — and ability to produce — fine art in the absence of European-style aristocratic patronage. Henry's giant machine was built when most houses were still lined with carved wooden panels made necessary by the loss of paintings and tapestry skills. But Palladian architecture created large areas of bare walls, so it is ironic that this minimalist form of architecture welcomed the addition of paintings and decoration, fuelling the market for fine art.

There was also some confusion as to the roles of public galleries at the time. The Royal Academy was founded to promote humanism, yet most of the subjects at its annual exhibition were portraits and landscapes, as this was the main interest of their patrons, some of whose images were hanging on the walls. The growth of literacy led to a rise in book purchasing, some of which included etchings, which in turn created a market for prints and engravings. It was even possible to have books made with prints interleaved with the text, to make them personalised, making them treasured possessions and conversation pieces. Thus such books formed a bridge between text and images, and again echoed mediaeval art in which figures were often accompanied with text, often as speech scrolls.

Hogarth trained as a gold and silversmith before turning to engraving to make a living from his paintings which were not covered by copyright so were widely pirated. The careers of his father-in-law James Thornhill, American Benjamin West who succeeded Reynolds as President of the Royal Academy and Angelika Kaufman were heavily subsidised by the print market, which in turn created an interest in the above public galleries.[37] Prints and engravings were often seen as providing immortality for the works, and more secure careers as the Anglo-Flemish artist James Ensor (1860–1949) turned to print when he realised a single work of art could be destroyed.[38]

Thus the British recovery of fine art was fuelled by commerce, education and entrepreneurship which were at the heart of Henry's philosophy, his touring and performance. The establishment of such galleries shows how large the audience for art had become, but by the 1770s Henry's machine, requiring a small, intimate audience could not compete with such shows. The Microcosm seems to have been a bridge between two social worlds. Jane Austen complained of the dull social scene in Bath at the end of the eighteenth century, but this showed how successful had been the role of Beau Nash in the glory days of the Assembly Rooms decades before. By the time Austen arrived, public socialising at assembly rooms and promenades had established social groups which built the Royal Literary and Philosophical Society and several churches for themselves and for visitors to the spa. It seems the role proclaimed by Henry to encourage the arts and sciences had been largely achieved by the 1780s, shortly after it vanished from the historic record.

5

THE BRIDGES OF WALTHAM ABBEY

Waltham Abbey is on the edge of Essex, one of the largest counties in England. It was described by Pevsner in 1954 as resembling Holland but "less peaceful",[1] due to the post-World War II new housing to resettle Londoners. Despite this, the county remained largely rural, with no major industrial or urban centres. Pevsner described Waltham's abbey as the finest monastic survivor from the twelfth century, devoting almost six pages to its remains, with a mere paragraph on the town living in its shadow. Like Glastonbury, the abbey site has not been built upon; its tombs and apple trees still form a quiet green space in the centre, providing a reminder of what has been lost. It should have become a sleepy backwater at the Reformation. But many nearby estates were purchased by the new Tudor magnates as country retreats so there were many famous visitors.

Norwich and Bristol were the largest cities outside London in the Middle Ages; their wealth was built on the wool trade. But when Henry Bridges was born the eastern counties were declining as trade expanded in western ports trading with the Americas. Waltham Abbey's fresh air and proximity to the capital led to the establishment of schools, such as the one founded for Quakers in the 1680s by

controversial Anglican cleric and schismatic George Keith (c.1638–1716).[2] Another cleric, the popular moderate preacher Thomas Fuller (1607/8–1661) lived there from 1648 where he wrote *The Church History of Britain with additions on Waltham Abbey and Cambridge University*. His *History of Worthies of England* was the first biographical dictionary in England.[3]

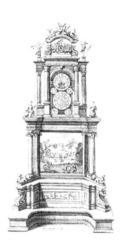

Woodblock image from John Farmer's History of Waltham Abbey, 1735

In the early eighteenth century, Waltham Abbey continued to have some impressive residents: in 1735 Rev. John Farmer, antiquarian, published *The History of Waltham Abbey*[4] which featured Henry's clock. There were at least three clockmakers, so there was a community who owned such expensive items. Dick Turpin's wife was a resident, and their son was baptised at the parish church in August 1737.[5] It even attracted European travel writers, as Sébastien-Isaac Loys' account of the town was recommended by fellow Lausannois the prolific traveller and writer César-François de Saussure in 1727.[6] But when John Loveday of Caversham visited in 1735 he was disappointed as the

church was in need of extensive repair and the Abbey House was "partly vamped up".[7]

In late 1772 the future Irish playwright/politician Richard Brinsley Sheriden was sent to Waltham Abbey to stay with family friends Edward Parker and his wife. The young man had recently recovered from the injuries received in his second duel, and his father had sent him to the rural retreat hoping to keep him out of trouble. Richard had promised his father that his wild days were behind him and that he was determined to settle down and study law. But cheating death twice convinced him he was destined for greatness, and studied as widely as possible in maths, geography, history and Latin whilst there. An intriguing part of his self-education there is the account of him spending his evenings with "'a very ingenious Man', a penniless local autodidact who was teaching him 'Mechanics, Mensuration, Astronomy etc'. He was already dreaming of becoming a modern version of an Elizabethan gentleman, a traveller, polymath 'able to interpret the heavens and understand the movements of the earth beneath them'".[8] This echoes elements of the Microcosm's publicity, but Sheriden took it a step further, using such information not just to improve the world, but to control it, suggesting that access to such knowledge was more important than social or political status.

The town of Waltham Abbey is now part of the vast commuter belt of London, but in Henry's day it was accessible by daily coach and the slower route via the River Lea or Lee which reaches the Thames in the East End. It was one of the few legal sites for the poorly understood and secretive industry of gunpowder production. British History online[9] claims this became the primary industry of the town, after years of competition with corn mills for water to drive the mills. The former abbey was quarried for buildings which limited damage from accidental explosions. Documentary evidence for the mills dates from the Civil War, when they were blown up five times in seven years, suggesting poor knowledge of the trade, or that the surge in demand drove workers to cut corners. There was also widespread fraud as powder ruined by damp on long sea voyages during wartime was often sold later as viable.

Henry's surname is apt for the father of a future bridge builder, and suggests he may have descended from engineers who came from the Low Countries to drain the Fens and build bridges. The print of The Microcosm was dedicated to James Brydges of Canons, and the similarity of their names has been noted, with some sources suggesting they were related. Henry Bridges' son was James and James Brydges' was Henry, leading to suppositions they named their sons after each other, but they were common Christian names, and the Duke's family came from Herefordshire.

The Bridges family name — spelt with or without the 's' — appears frequently in the Waltham Abbey church registers as far back as the mid-sixteenth century. William Bridge was buried in 1597; he was a servant and clerk to Rt. Hon Sir Edward Denny (1547–1600), so was both literate and held a position of trust. Denny was a cousin of Sir Walter Raleigh, a soldier, privateer and adventurer. His father was Sir Anthony, Privy Councillor to Henry VIII and an executor of the king's will, so one of the most powerful men of his age.[10] The word *clerk* is derived from the Old English word *clerc*, or priest, reflecting their role in keeping records for royalty and aristocrats who were sometimes illiterate. Under the laws of primogeniture, the eldest son inherited the family name and most of the property, so younger sons entered the church as a secure livelihood and in reserve if the eldest son failed to produce a male heir.

Few other professions are named, but George Bridges (buried 1631) was a butcher. Peter Bridges (buried 1654) was an elder of Holiefield who served as churchwarden. At the bottom of the social scale, the 1626 burial of Edward Bridge described him as a poor man, meaning his funeral was paid for by the church. The name is scattered through records from nearby parishes, some of whom were tanners, so unlikely close relatives, but these records are incomplete and sometimes contradictory.

Before the Reformation, religious houses provided care and shelter for the aged and infirm, largely paid for by bequests in wills. The beneficiaries would pray for the souls of the departed to reduce the time spent by the soul being purged of its sins in purgatory, so hastening

its journey to heaven. This practice helped bind communities together, as everyone contributed according to their ability. When a wealthy person was dying, church bells rang out details of their age and gender, so those within range would know who they were for and could pray for their souls. The poor hoped to benefit from bequests for food or clothing which were often included in wills, so their prayers were in part driven by self-interest.

Religious communities were labour-intensive, but their members were celibate, so with no families to support and their vows of poverty, they were extremely cost-efficient. The closure of these communities led to a population explosion and rise in beggars, vagrants and thieves under the Tudors, which led to the first vagrancy and poor law Acts from 1597. Religious estates were purchased by Tudor merchants and aristocrats who became new lords of the manors and converted or rebuilt the former church buildings for domestic use. Pevsner complained these were often placed amidst the ruins they helped create due to the high cost of transporting materials. They landscaped gardens with ornate features such as knot gardens, the maintenance of which was undemanding but labour–intensive. Such work was considered an act of charity, employing the least able of the parish to prevent their becoming vagrants or beggars. Such noble job creation schemes were cited to excuse the very rich from paying taxes.

Henry's great-grandfather Thomas was a gardener at Copt Hall, a few miles from Waltham Abbey, an estate in Essex owned by the abbots who gave it to Henry VIII in a futile attempt to save it from dissolution. It was obtained by Sir Thomas Heneage, a favourite of Queen Elizabeth I who often visited him. *A Midsummer Night's Dream* was written for his marriage and was first performed there.[11]

Thomas's position suggests he was from a respected local family, so worthy of employment but of low status, perhaps infirm or disabled. He married Anne Margaret Scarne in 1641. In 1665 a Joseph Cowles was buried in Waltham Abbey; the register notes he was nursed at Thomas Bridges'. It is unclear what this meant. It may be Anne was a local wise woman or nurse, but most people were cared for in their own homes. This suggests Cowles was an infant put out to

nurse, so is another suggestion of their low income and that she was still healthy and fertile. High infant mortality from poor hygiene in towns meant the young were safer in the countryside. Breastfeeding was also a form of family control, which may explain why the couple apparently only had three children.

Eldest sons were usually named after the father, but their first was Nowell, the future grandfather of Henry, baptised on 25 September 1643. His younger brother was named after their father, suggesting that their firstborn had died very young. Some family records cause confusion when two children share the same, significant family name. If a child was ill and expected to die when the second was born, the latter might be given the same name, before the elder recovered.

Nowell married Helen Hide in 1677 and they produced at least nine children; Henry's father Thomas was baptised in August 1669, the second child and eldest son which again suggests the first son did not survive, or perhaps the name Thomas had some added significance, perhaps a wealthy patron who helped them in some important way. Their youngest child was James, baptised in May 1682. The couple named their seventh and youngest son Noel when he was baptised in 1710.

Henry the clock builder was baptised in Waltham Holy Cross on 4 February 1696 (old style, so now 1697), but his mother's name is not recorded, and his parents' marriage cannot be traced. He was the second child of six. His older brother Thomas was baptised 14 March 1694/5 and James in 1682; they provided the names for two of Henry's three sons, which causes some confusion later in this story.

Most marriages, especially in small rural parishes, were announced by the public reading of banns over successive weeks in church to allow for legal challenges. But by the eighteenth century such publicity was increasingly seen as embarrassing and sometimes made the betrothed couple the target of rowdy, and even dangerous, local rituals such as the celebratory firing of guns. Young couples often preferred

the more expensive but private marriage by licence from the Archbishop of Canterbury. A licence was also chosen when secrecy was required, such as if one or both were underage, if the parents disapproved, or if the bride was already "with child".

Henry married Sarah Trevise on 29 March 1722 by licence in her local church of Stapleford Tawney to the east of Waltham Abbey. The surname Trevise was unique in the region, and Sarah had only one brother, David. They were named after their parents. Henry and Sarah's first child, Sarah, was baptised in Waltham Abbey on 18 January the following year, so just beyond the respectable nine months. But baptisms could be delayed for various reasons, such as the frailty of the child or mother, bad weather making roads impassable, or the absence or unpopularity of a local cleric. Thus, the expected child cannot be excluded as the trigger for their marriage.

Sarah's father, David Trevise, was a yeoman farmer who gave them the grand house on High Bridge Street as a generous marriage settlement. This property was an unusual one. In 1700 it was two buildings, called 'capital messuages', so they were of good size and quality, owned by cutler Robert Oliver; he sold the premises to Robert Walker in 1707. By 1725 they had become a single property called the *ffalcon, or Falcon*.[12] The keystone over the main door bears the year 1711 so this was a major rebuild, not just knocking through a few walls. The owners did not live there, but rented it for income, probably accommodation for people travelling from London on the River Lea who disembarked at the bottom of the garden.

The terms of this dowry were unusual: on 22 March 1725 the property was placed in trust for Henry and his wife with a John Trevise, probably Sarah's uncle. After their deaths it was to be made over to the use of Henry Bridges the Younger, baptised on 13 May 1724. The property transfer was thus linked to the production of a male heir rather than the marriage. This seems an unusual practice and was probably to protect the family line should Sarah fail to produce an heir and Henry remarry. But James Boswell's parents' marriage contract was similar, with the family estate held for the eldest son, so the father could not disinherit him.[13] But Henry

managed the building till James came of age, so this large rental property was a boost for Henry the elder's income. It may have freed him from work to embark on the construction of The Microcosm. But Henry junior was buried on 10 January 1739, leaving James (baptised 30 March 1726) as Henry's eldest son and heir.

But the situation is unclear. Henry was paying poor rates for this large house, so was legally responsible for it from 1721, so was living or working there, or subletting it for profit before his marriage. Henry and Sarah's marriage certificate claimed she was of Waltham Abbey, so it seems that, like many young ladies of her age, she preferred to live in town.

In 1736 Henry advertised in the London papers that he was planning to travel, so the house was for let in whole or part.[14] He continued paying poor rates till 1747, so there seem to have been no other tenants, at least not for long. After this the records are patchy, with Henry paying rates some years, others it was empty or apparently on short lets until James, who had inherited it on Henry's death, sold it in 1767.

Did Henry take his family on the road with him? Or did they live in his smaller property in the Market Place which was left to his youngest son, Thomas? Some travelling shows involved performances by talented children, but there is nothing to suggest this happened here.

There was still a strong tradition of sons taking on the family business, James became an architect/engineer, so followed his carpenter father into the building trade. The youngest son, Thomas, may have become a carpenter. Henry's middle son David has left no trace, but it seems none of the three followed him in travelling with the clock, at least not for long.

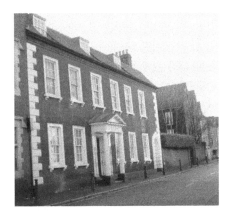

Henry Bridges' former house, High Bridge Street, Waltham Abbey

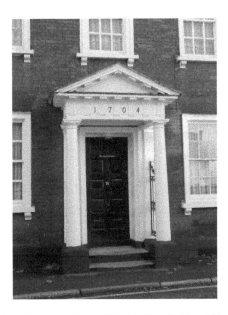

Front Door, former house of Henry Bridges, Waltham Abbey

The three-storey house on High Bridge Street is a curious building, or rather two buildings. The house that replaced the previous two was built in 1711 and was renamed *the ffalcon*. It has good sized rooms, with ornate cornices etc., but when Henry gained possession of it, he built another house onto the back, as the door locks bear the date 1734. This addition had separate staircases; connecting doorways were

added much later. This rear section had larger and more ornate rooms, one of which featured a Carrara marble fireplace and views of the extensive grounds, so the focus of the property was towards the river rather than the main road. Outbuildings reaching down to the River Lea were perhaps workshops in which The Microcosm was made. The strange design may have been for tax evasion. Poor rates were assessed on the size of the frontage, the rest of the site being garden, stables, offices and workshops etc., where tenants practised their various trades.

The name High Bridge Street reflects it being the highest navigable point on the river, so this address was historically significant as a landing stage for travellers such as King Henry VIII and Anne Boleyn when visiting the area. Access to the road is via a single arch, so no coach house was possible, showing the ongoing importance of river travel in Henry Bridges' time. It is unclear why a young family needed so much space, and what it was used for.

After Henry's death, the house was sold by Henry's son James in June 1757 to William Jessop, solicitor and Steward of the Manor for Georges II and III. It became known as the Court House, with one of the front rooms used for trials and the other as a waiting room. When the firm closed it became a private residence. The company's records were found in a skip and transcribed by the Waltham Abbey Historical Association and provided by the late Peter Huggins.

Henry's father-in-law, David Trevise was buried on 27 September 1742 and the parish records note he was buried in wool, as per law at the time. David had named his wife, Sarah, (who did not sign her name) sole executor but two years later she had not acted, so her children David and Sarah were forced to obtain the powers to deal with the estate.

Henry and Sarah lost another child, Susanna (baptised 19 June 1728, buried 17 September 1728). They produced four children who survived to adulthood, Sarah (baptised 18 January 1722/3), James (baptised 30 March 1726), David (baptised 1 November 1733) and Thomas (baptised 27 December 1735).

No family records or journals survive, so nothing is known of their

family life, but Henry served as Overseer of the Poor 1729–35 so was in charge of caring for the sick and invalid, collecting poor rates and maintaining parish accounts. This post was unpopular as it often caused conflict between parishioners in need and those who were unwilling to pay their share of the rates. In some parishes the office holder was elected in absentia, possibly for their refusal to carry their share of responsibilities and attend meetings. Henry was often described as *worthy*, so he may have held this post out of a sense of duty. Or he may have gained some benefit from it.

The dates of his overseership almost exactly correspond with The Microcosm's construction, i.e. 1725–33. The year 1725 was the year of James's birth, so probably the year Henry took possession of the grand house, which made such a scheme economically feasible. The Microcosm was a highly labour-intensive piece of work, so a strange and potentially expensive project to undertake in a small town. But putting the local poor to work would keep them occupied, reduce the poor rates and provide cheap labour for Henry. Further evidence for this is suggested by the parish taking a lease on a large house in 1734 for "destitute parishioners" which became known as the work house.[15] The house on High Bridge Street was ideal for the purpose: the river provided access to materials and machinery, outhouses could have housed forges and heavy equipment while the upper floors could have been used for work such as painting, embellishing and finishing the thousands of components as well as accommodation for the poor. Providing employment and accommodation for the poor would undoubtedly have allowed Henry to be described as *worthy*.

Given his role in the building trade, Henry should have served as either waywarden (to maintain the roads) or churchwarden (maintenance of church buildings). But there is also some confusion as to how much time he spent in Waltham Abbey. His own publicity and occasional mentions by his son James in later years claim he was from London, which may have been to add prestige to his work history, or to avoid having to describe the location, especially when dealing with foreigners. But it suggests he did some — or a lot — of his work in the capital. This is possible as the rebuilding after the Great Fire

continued into the eighteenth century, and employed most of the skilled tradesmen of the realm.

There is no record of Henry serving an apprenticeship in London or obtaining his freedom to allow him to practise in the city, but records are incomplete. London was by then spreading beyond the city limits so there was plenty of building outside the authority of the City of London Guilds. It is not even certain he ever physically practised the trade of carpentry, merely inherited the business from his father or purchased it. Widows advertised for work in building and other trades, but they managed the business, ensuring contracts were completed on time, employing journeymen or apprentices to do the design and physical work.

Henry's wife Sarah died in 1744. It is said that life was cheap in those times, but in view of how fragile it was, one could argue it was more treasured than today. Obituaries and epitaphs show the distress suffered by those left behind. Sarah was buried on 2 December in the churchyard of Waltham Abbey near her children. The large obelisk memorial is carved with: "She was an indulgent wife, a tender parent and a sincere friend." Henry's use of rhyming poetry in his publicity for The Microcosm was abandoned. This is succinct, simple and heartfelt.

Her death must have been a devastating loss to the family, with James nineteen, so probably in work or training; David was eleven and Thomas eight, so probably still in school. Their eldest child Sarah was twenty-one and single, so she probably took charge of the household. Many women never married as they far outnumbered men, with some estimates claiming a ratio of three to two, due to the huge number of male fatalities in wars, at sea and in work-related accidents.

Henry wrote his will on 19 April 1754[16] in which he claimed to be in good physical and mental health, but this was standard practice to ensure the document was legal. Ill health or the anticipation of death were the usual reasons for writing a will, hence the large number

written by those embarking on dangerous, long sea voyages; many sailors' wills survive in the National Archives.

It seems logical that a dying Henry would return home to be among his friends and family, but his tombstone states he died at Hull in Yorkshire, which is odd. Both Hull and King's Lynn were major ports, so this was not impossible. No newspapers survive for Hull at this time, and parish records are of no use as he was not buried there. Historians claim Henry could have sailed up the eastern seaboard from his last sighting at King's Lynn, but this is doubtful. Ships were not like urban buses, stopping frequently along their routes for passengers to hop on and off at will. Most coastal ships were owned by local fishermen, or supplied the huge demand for goods, but especially food, in the capital. When Henry's son James was rebuilding Bristol Bridge in the 1750s he ordered some of the finest stone from Portland in Devon. But coastal shipping was so limited it had to be sent to London, then all the way back to Bristol.

Monument to Henry & Sarah Bridges, Waltham Abbey churchyard

In William Winter's 1885 book *Our Parish Registers* he claimed the

family tombstone needed repairing.[17] But it seems this had to wait until 1913 when the parish magazine claimed the south and west faces had become indecipherable, so were recut by Mr E.J. Hatchet.[18] The local history group claims a local jeweller and watchmaker, Cecil Bond, paid for it to be recut again in 1974. This was a noble act of respect to a fellow local craftsman, but both repairs raise questions as to its reliability. Henry's obelisk is inscribed only on the south and west, so protected from the worst of the weather. The remaining faces should have recorded at least the two children who had predeceased them, as well as details of their surviving children which would have been of immense help in this research. But they have either never been inscribed or, more likely, the words have been weather-beaten to invisibility. What a shame the monument is in the churchyard rather than protected inside the abbey church.

The design of the monument is also intriguing. The above book describes it as having a pyramidal top, and an early image shows this, possibly with some extra detail on its pinnacle. But the present one is a Roman-style obelisk, which is probably the same thing. The top has been smashed, but this seems not to have been noticed or recorded by locals. An engraving by W. Woolnoth of a sketch by G. Shepherd for *The Beauties of England and Wales* was published in 1805. But the image shows the church still ruinous. The artist's name is interesting as the original copperplate engraving of the Microcosm was produced by the sculptor R. Sheppard. Allowing for variations in spelling at the time, they may have been related, and the image in the book may be based on a much earlier sketch by the engraver.

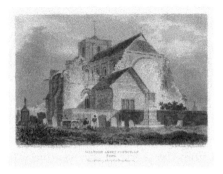

View of Waltham Abbey church engraved by Roberts published by Alex. Hogg c.1800

The monument is topped not by an obelisk but a strange assemblage of what seems to be a half globe, then a sphere and a crescent moon facing upwards, all of which fit with the builder of the Microcosm. But there is something arising from it; the closest guess would be a pineapple, or perhaps even a breadfruit, carvings of which can be found in Lambeth, London near the church where Admiral Bligh is buried. Or perhaps it was a burning torch, a popular image used in both Christian and Roman imagery. A later image shows the restored parish church, but is dated c.1800. It shows what seems to be Henry's monument in the distance, showing a simple pyramid.

Whatever version was correct, the original structure seems odd, and its apex being tall, thin and fragile seems unlikely to have survived a major storm, especially without the protection of the modern trees.

View of Waltham Abbey Church engraved by Roberts, published by Alex. Hogg c.1800

Henry and his eldest son James described themselves as gentlemen, so they had private incomes, which meant they owned property. But they were both at times described as engineers or architects. Before the Reformation, these professions had been combined under the title of surveyor, generally a cleric. After the Reformation, most engineers were in the military, and architects were generally "gentlemen by birth who supplemented their inadequate private incomes by acting as architects and artistic advisers".[19] Christopher Wren was one of them, so being an amateur did not mean poor standards of work.

Henry only named two houses in his will, but when James sold the main house he inherited, he also disposed of several acres of farmland, which raises questions as to how much they owned, especially as it seems Henry's brother-in-law died prematurely, making the Bridges family heirs to all the Trevise estates in Stapleford Tawney and elsewhere. But if so, the property was not named in Henry's will, so must have already been passed on or involved a trust or other legal arrangement. Henry's will records he wished to be "decently interred in a strong coffin... near the remains of my dearly beloved wife and children". So where were the rest, and who built the monument which he makes no mention of? It seems to confirm the family monument was not of his design or instigation.

Like most documents of the period, wills were written for local people. Street numbering began in cities from the 1760s, so addresses were still vague. A property named on a certain street, near Mr X's shop or inhabited by a certain person means nothing to us now, but was understood at the time.

Henry's will provides a valuable snapshot of his surviving family. It was proven in the court of the Archbishop of Canterbury. He thought his eldest surviving son, James, was in Antigua, which seems odd, but reminds us of the slow pace of communication at the time. He bequeathed to him the double house on High Bridge Street, forgiving him all his debts. Why would a young man from a country town in Essex be in the West Indies, usually associated with the great slaving ports of London and Bristol?

Henry named Joseph Bridges of St John Zachary in London and John Carr of Waltham Abbey as executors. The former was a vintner/wine merchant who died in 1772, but nothing is known of their connection. It again suggests a link between Henry and the capital, especially as Joseph is not described as a relative. No details can be found on John Carr, but he could have been the lawyer who wrote the document.

Henry left his house in the marketplace, which is too vague to be traceable, to his son Thomas. This suggests he, not his older brother David, was the second in line. He left The Microcosm to Thomas, David and Sarah in equal shares; if any dispute arose, it was to be sold and the money shared equally. His children were by then largely adult; the still unmarried Sarah was thirty-one, James twenty-eight, the elusive David twenty-one, with only Thomas under the legal age of adulthood at nineteen.

This author has written a book on the life of James Bridges during his difficult time as surveyor for the rebuilding of Bristol Bridge.[20] Nothing is known about his older sister Sarah before her brief will was proven at Canterbury on 13 May 1760.[21] It survives in the National Archives at Kew which suggests she had some wealth. She wished her body to be buried with her family. This should have been recorded on the family monument, so raises more doubts as to its accuracy.

Her will was dated 2 February 1760 when she stated she was in Waltham Abbey, so must have died there, but there is no record of her burial in the parish records there or in neighbouring Nazeing or Stapleford Tawney. She was probably buried about a fortnight before the will was proven. But on 16 April 1760 a "serjeant" called Ralph Bridge was buried in Waltham Abbey. Could this be another error? Some family researchers have found clerks who failed to record events at the time, or made badly scribbled notes that were later mis-transcribed. Sarah's death is the last sign of the family in the area. What happened to the rest of them?

Despite her having at least one — possibly three — adult brothers still alive, Sarah made no mention of them as legatees or executors.

The three witnesses cannot be traced, and she made no mention of anyone else, which is again unusual. Women often left clothing, jewellery and keepsakes, and allocated money for mourning rings to devoted servants, female relatives and close friends. Irrespective of wealth, women had few legal rights, forced to rely on male relatives or husbands to act on their behalf, though if single or widowed they fared better. But by this time many women were using loopholes in the law to pass wealth between themselves to ensure their financial independence. They could even limit the inheritance for their sons. Philippa Walton (1674/5–1749), widow and proprietor of the Waltham Abbey powder works claimed in her will her sons had gained enough from their father's estate, so she left most of her belongings to her three unmarried daughters who were more in need of support.[22]

Sarah did none of this; her brief will suggests she was a solitary person. She left all her unnamed property, including her third of The Microcosm, to a "dear friend", Thomas Martin, of Old Broad Street, probably in the City of London, then a wealthy area. It seems either she did not trust her brothers or had had a major falling out with them. This may have been why Henry made none of his children executors, preferring to have his estate in the safe hands of independents. Or it could be her relatives were not in need of her legacies or were not available, perhaps abroad?

Did the younger sons join the military or the navy to be later lost without trace? With the exception of James, it is not even clear where they were at the time of Henry's death, though if elsewhere, this should have been noted. There are several possibilities for Thomas; he may even have emigrated to Antigua, hence James' presence there, but this should have been mentioned in Henry's will.

The Kenwood House on Hampstead Heath which preceded the present one was built in the simple Queen Anne style between 1694 and 1704 by a William Bridges, surveyor general of the ordnance based in the Tower of London.[23] He became agent for Barbados and

Antigua, which involved him in a number of property dealings there. When he died he left his sister, the spinster Elizabeth Bridges, as his sole heir. This will was proven in Antigua,[24] so he died there. Sadly, no familial links can be traced, but the association with both Antigua and gunpowder is intriguing.

Records for the West Indies have suffered centuries of fire, hurricanes, mould, insect damage and neglect. V. L. Oliver's encyclopaedic tome *The History of Antigua* claims Britain's Caribbean colonial history was dominated by the largest island, Jamaica which was the centre of government, but Antigua was the largest of the Leeward Islands, so was their centre of finance, shipping and social life. It must have seemed a fine place for a young man with skills and ambition to make his fortune. It was also safer than Jamaica, a larger island where slaves could escape inland from where they could attack plantations and liberate other slaves, creating a more violent culture there.

But a trawl though the Council of Antigua's records shows life there was far from idyllic. In 1745 they asked Britain for a supply of small arms in case of attack by the French, but were told to pay for their own. In 1748 compensation was paid to victims of attacks. Planters placed a tax on arms and gunpowder in 1750 to subsidise their own defence. They complained that clandestine trade by British merchants with North American colonies was undermining their incomes. The same year they bemoaned the lack of able-bodied slaves, having been unable to import any for several years, and that some had escaped. Papists arrived from nearby Nevis where they had been rioting; they refused to obey British law so locals tried to ban them from settling. Rival islands stirred up trouble, encouraging slaves to desert, and lured away British craftsmen. In 1756 there were more problems with defence, requests made this time for cannons and ammunition for the forts and an increase in the regiment stationed there. They claimed to be getting little support from the navy.

A local journal recorded how in 1735 the island suffered fourteen major earthquakes in ten days. In 1738 an outbreak of smallpox took a huge toll of life. By the 1750s complaints were made of the soaring levels of debt and gambling, and of many inhabitants emigrating to

nearby islands. In 1751 they experienced the greatest storm in living memory; in May the following year they suffered a huge hurricane, an epidemic of rats and more gambling, so their tropical island was far from its modern image as a tropical paradise.[25]

Europeans originally followed explorers to the region as free settlers, but when so many died of the heat and infections, this source dried up so political prisoners and indentured servants replaced them. Some sources claim a third of Europeans died within their first year of arriving in the region. Africa's climate was closer to that of the Caribbean, so natives were seen as more likely to survive the hard manual work.

On 7 February 1753 James Bridges, with eight others including the wonderfully named "Bap. Looby" was listed as joining the local militia.[26] The conveyance of Henry's former house on 4 December 1756 in Waltham Abbey, between James Bridges "late of Antigua then of Bristol, Gent" and his wife, and William Jessop confirms this to be the same man.[27] Yet the list of inhabitants of the same year made no mention of him, but included Thomas, four men, a woman and a boy.[28] In May 1755 the first of Thomas and Sarah Bridges' children was baptised in St John's parish church, followed by others in 1757, 1759 and 1763,[29] following a common pattern for young couples. This suggests Thomas had recently either arrived or married, so Thomas and James may have gone there together.

On 8 February 1760 a carpenter named Thomas Bridges wrote his will in Antigua,[30] leaving land and negroes to his wife Sarah (nee Sanderson) and sons Thomas, John and Henry and daughter Elizabeth. Brothers-in-law Reverend Samuel Lovely and merchant Samuel Wickham Sanderson were named as executors with Francis Farley and Samuel Martin, substantial landowners and important local political figures. This was modified by the first codicil on 26 February 1762 when Thomas made allowance for the child his wife was then expecting. On 6 February 1763, Henry Bridges was baptised in St John's church Antigua, the son of Thomas and Sarah,[31] names suggesting a link with the family of Waltham Abbey.

In the second and final codicil of 9 April 1763 Thomas revoked the

appointment of Samuel Martin as co-executor. This was probably the Samuel Martin whose family was one of the wealthiest and most important in local politics, and they may have had some falling out. But there were two of the name, the father who wrote extensively on improvements to slave welfare to become known as the "father of Antigua", and his son who became an M.P. who later fought a duel with the radical John Wilkes. Thus, the falling out may have been based on politics. Or the man may simply have been too busy and far away to be able to fulfil this commitment. Martin's replacement as executor was "my kinsman James Bridges of the city of Bristol".

Henry Bridges was a carpenter, so it makes sense his sons would follow his profession; his son Thomas would have been twenty-seven at the time, so this could be him. It is impossible to know for certain what the term "kinsman" means in this context; it generally suggests some distant bond, but marriages were often with cousins; family ties could become complicated with some people being related by both marriage and by blood.

Legal documents name James's wife as being Mary, but she is impossible to trace from the large number of Jameses who married Marys in Essex at the time. In the six years James was in Bristol, there is no sign of them in any parish registers, in particular of any baptisms, which would have been expected for a young couple, but he claimed his family was with him. What did 'family' mean in this instance? Did he have his siblings with him? Did he have children but failed to have them baptised, at least in the Anglican Church, where they could be traced from parish records? Whatever his relationship with the Antiguan Thomas, they must have been close and James must have been seen as a safe pair of hands.

The timing is also interesting; when this author wrote the history of the rebuilding of Bristol's bridge on which James was surveyor, an assumption was made that his sudden departure in October 1763 was the result of his appalling treatment by the Bridge Trustees. But this was six months after the death of Thomas, time enough for him to receive a letter from the Caribbean which suggests his flight was caused by family commitment.

In 1765 John Ronan, carpenter of Antigua wrote his will,[32] in which he named James Bridges among his three executors. James was described as a planter, suggesting his link with the building trade had ceased.

On 26 November 1762 Samuel Wickham Sanderson, formerly of Antigua but by then a merchant in London, wrote his will.[33] He was brother of Thomas Bridges' wife Sarah. The will was proven by James Bridges who he describes as "a friend". James and Thomas were to receive the residue of the will after benefactions to Sarah, and several of their children. It was witnessed by the Bristol attorney Thomas Symonds who was clerk to the Trustees of Bristol Bridge on which James was surveyor, and a local 'fixer', so they must have known and trusted each other.

On 31 July 1781 a James Bridges and Mary baptised their daughter Sarah in St John's church, Antigua[34] i.e. the same parish as Thomas's family, but James was by then fifty-six, which suggests his wife was reaching the end of her fertility, so this may have been a grandchild.

The next sighting for this name combination is the baptism of Sarah, daughter of James and Mary Bridges in St John's parish, 31 January 1831 suggesting an ongoing presence in the parish. According to Dr Marion Blair of the Antiguan Archives who supplied this, their records have many gaps, so it is impossible to build up a family tree.

David Bridges is a very rare name, but there is a single possible sighting. In Vere L. Oliver's book *Caribbeana*, the will of a David Bridges was recorded in Barbados in 1786 but no details are provided.[35] Antigua was settled from neighbouring Barbados so this is a possibility. Wills written abroad were proven at the court of the Archbishop of Canterbury, hence should be in the Public Record Office at Kew; anyone who could afford an attorney to write them must have had wealth to pass on. But this did not always happen, due to problems with the post, absent officials, wars etc. Or the person may have died too suddenly to write one.

David's bypassing in Henry's will suggests he did not need an inheritance. He could have acquired a comfortable post, or perhaps married well or been adopted into a family unable to provide a male

heir. Jane Austen's brother Edward (1768–1852) was adopted by childless relatives Thomas and Elizabeth Knight of Godmersham; he became their legal heir c.1783 and they paid for him to go on a Grand Tour at the age of eighteen. He inherited their estates on condition he adopted their family name.[36] Such cases caused individuals and family lines to vanish from records.

Henry rose from humble beginnings to become one of the wealthiest men in Waltham Abbey. His monument is one of the largest in the churchyard and its design distinctively secular in appearance. He and his son James were incredibly intelligent and 'ingenious', so what happened to them? They should have thrived as Britain's economy boomed in the mid-eighteenth century. There were a number of other Bridges families in Waltham Abbey, which was a small town, so probably related. Some were involved in the foul trade of tanning, and they also disappear about this time. Their name can still be found in Antigua, so descendants may be there. As with much of this story, more research is required. The truth of Henry and his family may still be out there.

6

WALTHAM ABBEY GUNPOOWDER WORKS

Waltham Abbey Gunpoowder Works
If challenged to name inventions that transformed the world, most people would cite the printing press, the steam engine, electricity and perhaps Babbage's proto-computer. But in the age of exploration, accurate maps, compasses and time-keepers were the main engines of change, as Brenda J. Buchannan writes in her account of Waltham Abbey's early works:

> "Gunpowder and the explosives and propellants which followed it provided a form of energy which changed the world; it encouraged trade and helped to open up new lands; it provided a power beyond the previous limitations of the natural order and so allowed earthmoving, mining and engineering to take place, and it set in train military conquest, the formation of nation states, and the building and maintenance of vast empires. This was achieved through the development of many centres of gunpowder production, of which that at Waltham Abbey was crucial, for it was to become the pre-eminent powder works in this country and one of the most important in the world."[1]

It was an industry fiercely protective of its recipes, born out of the mysterious world of alchemy. As an item of trade, it destabilised traditional balances of power abroad in favour of those who traded with Europeans. It also broke the natural balance between traditional communities and wildlife, leading to mass exterminations. Gunpowder allowed coal, iron and copper mines to expand, providing raw materials for the Industrial Revolution. Copper bottomed boats were protected from the ravages of the West Indian toredo worm, protecting trade and lives. Gunpowder allowed the expansion of quarries to provide stone to rebuild English towns and cities, providing large, clean, fire-resistant buildings and paving for roads to replace the impassable quagmires which had made many routes impassable in winter, and which allowed the development of larger vehicles to carry more people and freight.

Waltham Abbey Gunpowder Works were established on the site of the former monastic corn mills, and they became the major site of research, development and production in England, hence the world. The industry involved some of the earliest factories. The process used a series of processes, from grinding ingredients, to mixing and then forming them into the final product, each of which was carried out in separate buildings along the river, so it could claim to be a precursor of Henry Ford's assembly line.

Eighteenth century newspapers are scattered with gunpowder accidents, which shows how extensive the industry was, and how much of the product was available for domestic use and abuse. It was crucial for fireworks, mining and construction and was an important and dangerous export, so its manufacture and storage presented a danger in urban areas. The accountant William Dyer in Bristol constantly bemoaned his problems finding secure storage for his gunpowder stock, as neighbours complained of the risks to their lives and properties.

Fireworks were used to celebrate major events such as military victories and anniversaries, and to entertain important visitors. Many people made their own, often in rooms heated by open fires. A small tower in the churchyard of Greyfriars in Edinburgh was used by the

town as a gunpowder store until it blew up in 1718, destroying the west end of the church.[2] In Exeter, powder spilled in the street, where children set fire to it, destroying themselves and an entire city block. In November 1772 about eighty people were killed and wounded at a puppet show in Chester when an adjoining house blew up.[3] Among many innovative methods of unblocking chimneys, such as dragging a hedgehog or goose upwards, discharging a gun was sometimes reported in the press for causing injuries and deaths. A maidservant was killed when she put a log on the fire; it had been plugged with gunpowder to stop it being stolen. There was even a wig powder that made use of the stuff, with a grisly result when a man went too close to a lighted candle.

In 1743 a German named Frasely was married in Waltham Abbey; he was described as "from the colour mills".[4] The "colour" was ground and mixed for fine artists or house painters, and was a component of the coloured fireworks used in pleasure gardens. This links industrial and recreational use of gunpowder and helped the industry survive in peacetime.

Gunpowder was first described in this country by Franciscan friar Roger Bacon in the thirteenth century, but until the advent of modern chemistry, the correct ratio of ingredients and the force generated were largely based on trial and error. When guns and cannons became widespread, access to large quantities in wartime made the industry essential for national security. Manufacture was restricted to those who paid for a royal licence, but the business was so lucrative there were many illegal works, often only discovered when they exploded.

Research into production of high quality explosives and armaments ran in parallel with that of civil engineering, as streams were dammed and channelled to drive mills which ground and mixed the raw ingredients. To limit collateral damage from explosions and fires, early powder mills had thick stone walls, often quarried from old buildings such as former monasteries, and were separated from each other by embankments, initially of earth and later of concrete. But by the eighteenth century this practice changed to constructing buildings with walls which blew outwards to disperse the force. Many of the

surviving buildings at the Waltham Abbey have solid walls with roofs that could blow upwards.

Gunpowder mills may have existed in the Lea Valley as long ago as the Battle of Crecy in 1346. Its main ingredients — saltpetre and sulphur (brimstone) — were being supplied to the area in 1561. Legends link the site with the Gunpowder Plot of 1605 and the defeat of the Spanish Armada.[5] From 1702 it was owned by several generations of the Walton family, and by 1735 was claimed to be the "largest and completest works in Britain".[6] It was purchased by the crown in 1787 to become the Royal Powder Works. An engraving of the mills featured in John Farmer's 1735 *History of Waltham Abbey* shows the site included houses for millwrights and carpenters, benevolently provided by the owner for his valued staff, which helped keep wages down, encouraged loyalty and made the site more secure. The works were surveyed by the most famous civil engineers of the age, John Rennie and John Smeaton, from the 1770s to the early nineteenth century.

Missing from accounts of the mills is the extraordinary role of Philippa Bourchier (1684–1749), the daughter of an Ipswich physician who married William Walton. This unusual surname suggests a Huguenot heritage, and her family may have been prominent Puritans as Oliver Cromwell married Elizabeth Bourchier at London's St Giles Cripplegate on 22 August 1620.

In 1702 John Walton became the proprietor of two powder works – near their home at Balham in Surrey, and at Waltham Abbey. He was a major supplier to the government, i.e. Britain's biggest consumer, especially in wartime. On his death in 1711 his widow, a thirty-six-year-old mother of ten, took over the business, and was joined by her son John in 1723. The end of the War of the Spanish Succession in 1714 saw demand plummet, but her business survived and she became England's main producer, allowing her to close the Balham factory. The site remained in her family's hands till sold to the Ordnance Board in 1789.[7] It is extraordinary that a woman could have operated such a successful industrial facility, and also that she did not rate a mention in any of the histories of the town.

Waltham Abbey was well chosen as it was between two rivers

which provided safe transport and water to extinguish fires. Sulphur was imported under Elizabeth from the Mediterranean and saltpetre from the Baltic, North Africa and later India.[8] The Lea navigation brought raw materials and sent the finished product to London's East End docks. Over the centuries, it was diverted into various streams to drive the mills before uniting downstream beyond the abbey. Nearby Epping Forest provided the third ingredient for the manufacture, charcoal, and the site was planted with more trees to maintain supplies. Transport by river was preferable to roads as it avoided jolting, so reduced the chance of accidents, and was free of highwaymen and footpads. The rural location limited the damage from accidents and reduced the risk of industrial espionage, a practice that many industries were founded upon, such as brass making, the technology of which was stolen by the English from the Swedes.

Russia's future king Peter the Great worked at Woolwich dockyard where he learned the skills to found the Russian navy. A.P. Woolrich's extraordinary book *Mechanical Arts & Merchandise: Industrial Espionage and Travellers' Accounts* contains details of other European aristocrats and industrialists who visited these islands. From the late seventeenth century they were often welcomed and provided with information on the various works. Woolrich makes the extraordinary claim that the number of Swedish visitors to Bristol tailed off by the 1730s and stopped during the wars of the 1740s. The following decade a Swedish tourist made a survey of the Bristol industries, including fine line drawings, met some of the owners, and discussed the workings of a Newcomen engine.[9]

The Longitude Prize became a magnet for other nations to try to steal the latest research, as Harrison's success was well known by 1760. The Conde de Fuentes, a Spanish envoy, visited London in search of information or to purchase one of Harrison's many timepieces. He was accompanied by the Belgian mechanical genius J.J. Merlin. They met other members of the European community who were in the capital for the same purpose, as recorded in the Frenchman Jerome Lalande's journal.[10]

Investigations into safety were carried out at Waltham Abbey, as

was work in the infant disciplines of chemistry and physics, so high levels of security were enforced and there is no record of any exotic tourists to the site. There is no evidence Henry Bridges ever worked there, but Waltham Abbey was a very small town and he must have known the Walton family, perhaps well. Henry probably knew of the engineering and mechanics of the industry, and the works probably played an important role in his own and his engineer son's education. To confuse matters, an Edward Bridges' family ran a powder works in nearby Surrey until the mid-nineteenth century, but there are no signs of familial connections between them.

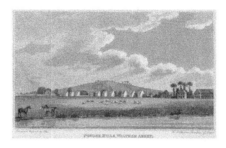

Powder Mills, Waltham Abbey. Drawn and engraved by Ellis for Dr Houghton's 'Description of London'.

The Waltham Abbey powder works provided employment for highly trained craftsmen. Henry Bridges depicted the works on his machine, showing the works played an important role in his microcosmic world just as they did in the larger, macrocosmic realm. In 1735, i.e. two years after it went on display, John Farmer's *The History of Waltham Abbey* was published and included a long poem which praises The Microcosm, and the following:

"On John Walton and his gunpowder Mills,
as portrayed on Mr Bridges Clock...
A Mill for making of Gun-powder's there,
And Water flows amazing and more rare.
Which from a Model on River's took
Of Worthy Walton's Works."[11]

The link between the clock and the works was mentioned by William Winters, another historian, who wrote in 1887:

"Henry Bridges, a local horologiographer, paid a noble compliment to Mr Walton by the insertion of a clever portrait of the Gunpowder Works on front of a beautiful timepiece made by himself... The adornment of the lower part of it consisted in rural scenery, with a picture in miniature of the Gunpowder Mills. Many were the Waltham bards who sang the praise of worthy Master Bridges."[12]

The term *worthy* is of interest here, as it suggests Walton was different to a modern businessman. It suggests both he and Bridges made significant contributions to the local community and perhaps the nation. The word was applied to great warriors and statesmen as well as Shakespeare. In landscaped gardens such as Stowe and in major libraries, busts of national worthies were displayed in niches like secular saints. As with so much from this period, the concept was imported from the classics, which listed nine worthies, including Hector and Alexander the Great. By presenting national worthies alongside these historical figures, Britons were proclaiming themselves heirs to ancient Rome. The practice echoed the pairing of Old and New Testament characters in churches. So *worthy* had much historical weight behind it, and was not used casually. By the early eighteenth century the term was applied to famous living persons such as the poet Alexander Pope.[13]

The term had deep local resonance as yet another Anglican cleric, Thomas Fuller (1607/8–1661) published his *History of the Worthies of England*, the original dictionary of biography which included details on each county.[14]

Wealthy people were seen as fortunate: that God smiled on and rewarded them. But such bounties carried a duty that they should contribute to society, setting an example by preventing injustices, serving on vestries and charities. If they witnessed a crime they were expected to intervene. Failure to do so could lead to them being shamed in public or the press.

Before the Reformation, monasteries had been major employers; workers were paid mostly with food and lodgings, allowing wages to

be kept low. When this secure employment was lost, low pay in the countryside drove young, hard-working people to seek better prospects in the towns and cities, leaving behind an ageing population, with declining production that struggled with rising demands on charity. This also meant fewer hands were available to bring in the harvest, so threatened local food supplies and that of the capital, harming large landowners. Waltham Abbey's proximity to the capital must have made this problem significant. By providing well paid work for locals, John Walton's factory was thus of benefit to the community so he was seen a noble or worthy man.

Decades later, the engineer Marc Brunel, father of Isambard Kingdom employed mostly children at his sawmills at London's Battersea in 1817, an arrangement which established his reputation as a philanthropist.[15] Today such practice is rightly outlawed for exploiting the young. But before the modern welfare state, this provided an alternative to starvation, homelessness or a life of crime. Children in the countryside were expected to contribute their labours to the family from the earliest age, such as collecting eggs, weeding, scaring birds and gleaning at the end of harvest. So before compulsory education, labour suited to the child's ability was the norm and was believed to discourage idle habits in later life.

But in towns and cities such minor employment was scarce or non-existent. Children cost money to feed and clothe, and kept women from paid work. Parents left them unsupervised for long periods while they were at work or running errands, shopping etc. This was especially the case during wartime when so many men were absent or dead, mothers could not go to work and care for their children, so many were abandoned; streets were full of young beggars likely to drift into crime.

William Winters' account of 1887 confirms Henry's clock was highly regarded locally, and his fame survived over a century after his death. It also points to the liberal mindset of the owner of the town's biggest industry, John Walton, who seems to have been a great promoter of art and education, as was Bridges.

But Winters introduced a number of errors which have been

repeated ever since. He claimed Henry was a "horologiographer" whereas he described himself as a carpenter, and that The Microcosm was his first, hence only, piece of clockwork. Winters mistakenly claimed it included a cuckoo clock.

A further link with the powder works is via the dedication of the 1734 engraving to James Brydges, the Duke of Chandos. He made a fortune — allegedly five hundred thousand pounds — as Paymaster General for his patron the Duke of Marlborough who was commander of allied forces during the War of the Spanish Succession (1701–1714), so his purchases of gunpowder contributed significantly to the wealth of Waltham Abbey.

When Henry's eldest son, James, (described as an expert architect) was working as an engineer in Bristol, he was commissioned to provide a temporary building to stage the fireworks display in Queen Square to celebrate George III's ascension in 1761. It was described as:
"a grand pile of Architecture composed of three different orders..." It was in the form of a temple, but his was Athenian while his father's was Roman, the result of the discovery of ruins at Herculaneum and Pompeii. James's structure was seventy-three feet high, extending to two pavilions of forty-six feet, including several transparencies with emblems of the royal couple. The display involved rockets and Archimedean screws and was watched by at least twenty thousand.[16]

James thus had a good working knowledge of gunpowder, probably gained from his home town. In preparing for such a spectacular display he would have worked with other tradesmen, so he understood their skills in order to design the project and possibly made parts of it himself such as the large transparency. The amount of Latin and classical images shows he had some knowledge of the ancients.

These scenes had a wooden frame for painted scenes on silk, which featured in special events at pleasure gardens such as London's Vauxhall and Ranelagh. From the early eighteenth century garden designs included 'eyecatchers', or painted scenes at the ends of avenues to suggest they continued into the distance or terminated in some feature that was cheaper to draw than to build. Some large houses had private theatres which required painted scenery, the artists of which

are largely unknown. Inigo Jones designed scenery and costumes for private masques before he became an architect.

No mention of such work was ever made by either James or Henry, but their extensive networking skills may have generated such commissions as a sideline to both their careers. Frances Terpak described popular entertainments in the late eighteenth century which often included transparencies made of paper for indoor gatherings, and large paintings on thin canvas for outdoor public spaces.[17] The latter works were expensive, so were commissioned mostly for major public celebrations, with allegorical images representing and praising eminent people, especially royalty, rather than portraits drawn from life.[18] They were produced for specific events, so none survive, though several prints of them by William Hamilton do.

Many popular books on science experiments were produced, one of which was by Dr William Hooper in 1774. It described outdoor and so-called indoor illuminations, pricked sheets of paper which moved in front of fireworks to give the illusion of moving lights. A famous attraction at Vauxhall Pleasure Gardens was a landscape which featured a moving watermill.[19]

These entertainments often made use of clockwork-driven machinery which continued to be popular well into the nineteenth century. Firework cabinets included a collection of painted paper or glass cards, at least one of which resembled a clock.[20]

The use of gunpowder in public entertainments provided an outlet for gunpowder production in peacetime, so helped maintain the skills and workforce, limiting the effects of the earlier 'boom and bust' economy. They provided welcome income for various artists and acted as a calling card for their work. The events themselves provided opportunities for tradesmen and artists to meet potential employers and patrons.

7

THE MOST PUISSANT JAMES BRYDGES, DUKE OF CHANDOS

Henry Bridges' 1734 engraving of The Microcosm was dedicated to James Brydges, the first Duke of Chandos (1673–1744), who advanced his career by building social connections at various London clubs, coffee houses and theatres. He was a member of the Royal Society, the Society for Gentlemen Performers of Music, and the Freemasons. The Churchill family became his patrons and during the War of the Spanish Succession in 1701–14, diplomat soldier John Churchill, the first Duke of Marlborough (1650–1722) trusted him to provision the army, for which he made the eye-wateringly huge sum of six hundred thousand pounds.[1] Another source claimed his wealth increased to half a million pounds from speculation.[2] Swift claimed "all he got by fraud is lost by stocks".[3] When he rebuilt the local parish church — essentially his private chapel of St Lawrence at Little Stanmore — he included boxes for his servants and bodyguards, as he had many enemies.[4] In 1711 the House of Commons discovered thirty-five million pounds missing which Brydges brushed aside by blaming accounting problems![5] Profiteering from public office became common practice under the first Prime Minister Robert Walpole, whose government has been compared with modern banana republics.

In 1713 Chandos acquired the Canons estate at Edgware, now part of London, where he spent twenty-three years remodelling the house into a palace. Its eighty-three acres were laid out in the finest taste with the most advanced technology and inhabited by exotic animals such as flamingos and macaws.[6] He was out of favour at court so spent his time building his estate, inviting artists for company and entertainment during lulls in their own careers.

He employed a series of architects including John Vanbrugh and William Kent to produce a mix of baroque and classical styles for his palace which he filled with art he purchased on his Grand Tour. It was estimated to have cost two hundred thousand pounds, importing huge blocks of Carrara marble for pillars and staircases. Many rooms were supplied with running water and flush toilets. Mark Girouard claims by 1730 all country houses could have had running water but few bothered.[7] This was probably due to such efficiency making domestic work redundant, so reducing the number of poor people who could be employed there. Grounds were laid out with grottoes, lakes, fountains and canals, largely designed by Dr J.T. Desauliers who was his chaplain and the incumbent at the parish church. The gardens were designed by Richard Bradley, a self-taught horticulturalist who struggled financially, so he was at least in part employed as an act of charity. Chandos's assistance paid off as Bradley later became the first Professor of Botany at Cambridge University.

Pope's essay *The Use of Riches* allegedly satirised Brydges, with Canons a model for Timon's villa "where all cry out 'What sums are thrown away?'" But Pope defended the work with: "Timon was famous for Extravagance, the duke for well-judged Bounties".[8] It seems Pope was treading a fine line between political satire and not biting the hand that fed him.

Some sources claim Brydges was bankrupted by the collapse of the South Sea Company, formed to trade with South America; its attempt to take over the soaring national debt sent its stocks skyrocketing before collapsing spectacularly. Chandos survived this and other unsuccessful ventures such as the Mississippi Scheme, investments in land in New York State and Nova Scotia, the Royal Africa Company,

Essex oyster fisheries and a range of pie-in-the sky mining ventures which were common before the science of geology allowed often outrageous claims to be challenged. Balanced against these, he made some highly successful investments which are seldom mentioned, such as Sun Life Assurance and York Buildings Water Works — another Desaguliers project — to provide clean water to the capital. In later years he concentrated on charitable works; serving as Lord Lieutenant for Hereford, governor of Charterhouse and the Foundling Hospital charities and Chancellor of St Andrew's University,[9] so was another man who earned the title *worthy*. With his fingers in so many pies it is hard to assess his wealth over time. The Dictionary of National Biography described his status at death as "wealthy".[10] Only later were his debts revealed and the upkeep of his palace was beyond anyone's means. The age of the great magnates was over. The estate was auctioned in parts over twelve days in 1747. Pieces can now be found as far apart as the V&A Museum in London and Stourhead Estate in Wiltshire. His equestrian statue of George II is in Golden Square, central London.[11]

Brydges was a generous patron of the arts, the only British nobleman with his own choir. When Italian opera fell from favour, Handel struggled to find work. From 1717 he stayed at Canons, composing anthems for his patron. *Acis and Galatea* was his first extended secular work in English with libretto mostly by Alexander Pope and John Gay which helped re-launch his career. But Gay's musicals helped undermine interest in European opera, so Handel was forced to change direction. Plans were made at Canons for a music academy at the Haymarket to perform his operas which he would direct, and a subscription was begun to found the future Royal Academy of Music.[12]

When Handel first arrived in London, he was supported by Dr John Arbuthnot (1667–1755), mathematician, physician and author who was also at Canons during a lull in his career and may have contributed to the libretto of *Esther*. He wrote medical treatises, ran a fashionable medical practice and had been physician extraordinary to Queen Anne in 1705. He became a fellow of the Royal Society and was

friends with prominent politicians.[13] He was the most prolific member of the *Scribblerius Club*, an extraordinary literary collaboration made up of Arbuthnot, Swift, Gay and Pope. His daughter Anne helped Gay with the songs for his *Beggar's Opera*.[14] In 1712 he published *The Art of Political Lying* which has recently been cited as a classic guide to modern politics.

Johann Christoph Pepusch (1667–1752) was, like Handel, another émigré who followed the Hanoverians to these shores. The son of a Berlin cleric, he was director of Canons music academy from 1713 to 1730 where he organised concerts by the greatest composers and musicians. He wrote a vast amount of church music, worked with Colley Cibber at Drury Lane theatre to "give the town a little good music in a language they understood". His son married Susannah, sister of Thomas Arne; she became a famous singer, one of Handel's favourites involved in early performances of his Messiah. Pepusch arranged ballads for Gay's *Beggar's Opera* in 1728 and the sequel, *Polly* which was banned. He was an antiquarian and founder of the Academy of Ancient Music to which he bequeathed most of his music collection, so Brydges' benevolence continues to benefit musicians and music lovers.[15]

The ceilings of Canons were painted by Sir James Thornhill (1675–1734), history painter to George I who worked on St Paul's Cathedral, Hampton Court, Blenheim Palace and Greenwich Hospital. His daughter later eloped with William Hogarth.

William Kent (1686–1748) was one of several architects who worked on the palace. Like Hogarth he trained as a coach painter before spending ten years in Italy where he met Lord Burlington who became a close friend and his main patron. Together they popularised the classical style of Palladian architecture, and he became a successful architect and designer. His work included Chiswick House, Kensington Palace and the Whitehall Treasury buildings. He designed the famous gardens at Stowe, and collaborated with his successors Charles Bridgeman and Lancelot 'Capability' Brown.

The Dutch-born woodcarver and sculptor Grinling Gibbons (1648–1720) made the huge monument to Chandos and his two wives in the

parish church where they are buried. He is the only woodcarver of the age whose reputation survives. He introduced the European style of delicate, complex European Rococo designs to Britain. Far more pieces are attributed to him than he could have produced in his long life, as his name came to define the genre in this country. His carvings of complex still lifes are utterly dazzling. He gave Robert Walpole a cravat which is indistinguishable from lace. He was master carver to the crown from 1693, worked on many of Wren's churches including the choir stalls at St Paul's, and at Chatsworth. His *Attributes of the Arts* was presented to Grand Duke Cosimo III de Medici by Charles II, an early version of 'sending coals to Newcastle'.[16]

In all the publicity produced by the owners of The Microcosm, the breathless praise and unverified claims of encouragement and support of the great and good, only the royal family and the Duke of Chandos were named. The dedication on the engraving has been interpreted by some authors to mean that the two men were associated or even related in some way, as when master gardener at Canons Richard Bradley dedicated his book to the duke in gratitude for his contribution to the printing costs. This was common practice at the time when work by most artists and craftsmen was too labour-intensive to be profitable. The many artists who stayed at Canons were not noted in the duke's accounts, so were treated as guests rather than employees, though they may have been given money to tide them over. Bridges' dedication to Brydges on his engraving suggests the duke paid for the artwork, not the clock itself.

Mediaeval monarchs and their courts often visited the countryside for relief from the stresses of leadership. Hunting in particular was popular as it provided fresh air and exercise in a social environment. Tudor magnates built Arcadian estates with parks for hunting which continued this tradition. They also provided a respite for the rich from crowded towns and cities in summer when outbreaks of infection and plague occurred.

But in the absence of modern policing, the rich had no means of protecting their properties, so they had a vested interest in showing benevolence towards their neighbours and tenants. Their wealth was claimed to be a sign of God's approval; their gratitude was expected to be shown by their benevolence to those less fortunate. They supported local charities, and from Norman times established local markets to provide locals with fresh food and create employment. They held open days when they entertained tenants, especially at the end of the harvest. When a new mansion was built, industries such as quarries and brickworks were established which could continue after the house was completed. Such job creation schemes were acts of benevolence, but they were also of benefit to the rich as, again, they kept people in the area to help with harvests, minimising poor rates and crime.

Brydges' encouragement of some of Britain's finest artists can thus be seen as an indulgence for a wealthy man, but also as a means of encouraging the arts and industry, both directly through funding and indirectly by providing a place for the artists to socialise and bond together. So Canons can also be seen as a sort of hotbed for creativity, a precursor to the Lunar Men's gatherings and other clubs and societies in following decades.

When Bridges dedicated his work to a wealthy patron, it may have been in recognition for such encouragement and/or support. It may have been an appeal for this to happen, or to suggest the work was worthy of such support and attract the attention of other benefactors.

Men of Brydges' stature did not just commission the works of artists, they were actively involved in the planning and design of what they paid for, to ensure it suited their needs and was completed within budget, on time, and to acceptable standards. There is nothing to suggest Bridges ever met Brydges, but his choice of such a patron fits well as it suggested high standards of art, science and technology, and the name was one everyone knew.

Simon Schaffer claims in his book *Enlightened Automata* that The Microcosm was built and installed at Canons,[17] but provides no evidence. He may have assumed the copperplate print of The Microcosm in a large, marbled hall showed Brydges' palace, misreading the

dedication. But images of this time were not always accurate; they were rather aspirational. They told stories in praise of their patrons. Portraits showed people at their best (or judiciously improved) with no blotched skin or sagging waistlines, with their estates spreading behind them to suggest a world where the sun always shone and God smiled on their endeavours.

Some authors suggest a familial link between the Bridges and Brydges, allowing for variation in spelling at the time. But literate people were consistent with their own names, as shown by surviving accounts, correspondence and journals.

So what was the connection? The simple answer is, we will probably never know. It could have been fawning in the hope of acquiring patronage. The duke's famous mansion employed the finest craftsmen in its construction and acted as a centre of excellence for training future generations. From the above, it can be seen how many connections were formed between people who visited Canons, so he seems to have brought some or many artists together. The Georgians were great travellers, with some covering forty or more miles in a day on foot, and far more on horseback or by carriage, so making visits to such mansions possible, especially when the family was away.

Henry was fifteen when construction began at Canons, possibly young enough to be apprenticed there. Canons presented the finest architecture, painting, sculpture, and landscape design during its construction, and when completed, music, experimental science including astronomy, and one of the finest libraries were added. This was not just a grand mansion, but a masterpiece, a place to learn and be inspired. The estate was a working farm with specialist trades, a grand family home, pleasure gardens, engineered canals and ponds, a place of entertainment, so was a microcosm of the country at the time.

All the above mentioned guests and employees were exactly the type of people that would have inspired Henry Bridges. His son James claimed Henry was self taught yet in his will makes no mention of a library, which suggests he had access to a substantial one. Given how many educated gentlemen lived in or near his home town, he may

have used the resources of his neighbours, or via their contacts travelled further afield, perhaps even to Canons.

The Dictionary of National Biography describes how the Irish polymath and junior member of the Lunar Men Richard Lovell Edgeworth attended several schools, then wasted six months at Trinity College, Dublin before Lord Longford invited him to use his library. His mother's interest in the work of Locke also encouraged his learning.[18]

The young Handel had access to the library of F.W. Zachow, organist of Halle's Lutheran church who recognised young Frederic's precocious talent.[19] Before the age of recorded music, music libraries were vital for the training of musicians and composers. The great promoter of science Joseph Priestley was librarian at the mansion of Stowe. Given how many wealthy gentlemen lived in Waltham Abbey in the eighteenth century, Henry potentially had access to many libraries there.

Patronage came in many forms; in a palace like Canons, provision of accommodation and food freed artists from having to earn a living, so they could concentrate on their art. The many visitors provided convivial society and the chance to develop more connections and potential patronage. But contacts were also made within local communities, via church, friends, relatives, business partners or even random encounters in the street, pub or inn.

Humphrey Gainsborough, the brother of painter Thomas, was a Nonconformist cleric; unlike Anglican ministers, he had to support himself and fund his engineering experiments. He had several patrons: Seabrook Freedman encouraged him to send details of his work to the Society for the Encouragement of the Arts, Manufacturers and Commerce. They awarded him financial prizes for a tidal mill, a drill plough and a self-ventilating fish carriage. He was employed to improve Henry Conway's estate. Thomas Hall provided him with a workshop to build machinery and conduct experiments. He also conducted experiments at the home of R.L. Edgeworth, who highly praised his work and probably expanded his social and commercial contacts.[20]

Dr J.T. Desaguliers' career seems to have begun with the support of

coal mine owner John Wilkins of Sutton Coldfield who employed him as private tutor for his son. It was there he learned hydraulics for draining mines.[21] Physician and ironmaster John Roebuck's support for James Watt involved having him as a guest in his country house, far from urban distractions and industrial spies. He also paid for James Watt's 1769 patent for a steam engine.[22] Thus industrialists supported research that improved and advanced their businesses.

Henry was born into an age when education and self-improvement were on the rise, but he was the only one who responded by building such an incredible device as The Microcosm.

The 1734 engraving shows a medallion of Isaac Newton, who Henry often claimed had approved of the clock. But if true, Newton never saw its completion as he died in 1727. Was this claim pure invention, and was it never challenged as the dead cannot speak? Or did Newton meet and encourage Henry? Perhaps they once met and discussed the design for The Microcosm, just as Henry's son later consulted the Royal Surveyor Isaac Ware on his plans for the reconstruction of Bristol Bridge.

Newton is famous for a line he wrote to Robert Hooke in 1676 which is now abridged on the edges of our two pound coins: "If I have seen further it is by standing on the shoulders of giants." This fits well with the apparent mindset of Henry Bridges.

But perhaps a more apt quote is

> "I seem to have been only like a boy, playing on the sea shore and diverting myself in now and then finding a smooth pebble or a prettier shell than ordinary, whilst the great ocean of truth lay all undiscovered before me."[23]

8

DESAGULIERS THE POLYMATH

Despite their very different origins, the Bridges family's professional history shows a surprising number of similarities with that of the French-born cleric and scientist Dr J.T. Desaguliers (1683–1744). Whilst there is no evidence to connect them, a shared link with Chandos is possible, as is the likelihood that both Henry and his eldest son, James, were also Freemasons. Given how few people in the early eighteenth century were literate, the involvement of both families in the small world of cutting-edge science and technology may be too full of similarities to be coincidences.

Desaguliers is little known today but his entry in the Oxford Dictionary of National Biography takes up a massive four pages.[1] He was probably the busiest and most productive of the early scientists, yet his story has barely registered beyond footnotes in biographies of his peers. The only detailed work on him outside Freemasonry is by Audrey T. Carpenter from 2011[2] in which she weaves together the many strands of his extraordinary life.

He was born in La Rochelle, the son of a Huguenot cleric who was forced to flee religious persecution. He obtained his B.A. from Oxford's Christ Church but moved to Hart Hall (now Hertford

College) which focused less on strict classical teaching, so was open to promoting new ideas. The college was establishing a reputation for demonstrations of natural philosophy by mathematician John Keill (1671–1721) assistant to — and early demonstrator of — Newton's complex theories.[3] Desaguliers was appointed curator of the Royal Society by Newton and became an active promoter of his work, repeating many of the great man's experiments to confirm and further develop his ideas. He wrote a poem in 1728, *The Newtonian System* which celebrated the ascension of George II. It drew parallels between Newton, English liberty and the stability provided by the royal family and is one of many ways he inspired patronage of his work. Being multilingual, he translated Newton's work into French and Dutch, and imported European interpretations of Newton's work into English, so encouraged discussion between scientific communities. This helped establish the reputation of Britain as a centre for scientific excellence and of free thinking in general.

There is no record of Henry Bridges graduating from either Oxford or Cambridge universities, where much research was carried out on the gentlemanly subject of astronomy. When his son James was in Bristol he was mocked for being the son of a jobbing carpenter. So where did Henry obtain his knowledge of astronomy, early science and the arts?

University lectures were often open to the public and Hart Hall was short of funds, so welcomed the extra income from public attendance. Nonconformist ministers often attended. Although they were unable to obtain degrees, they often became conduits for introducing the philosophy of science into the world of technicians and mechanics.

There is a more unusual source of learning which dates back much earlier, to reformer John Wycliffe (c.1330–84), described as the 'morning star of the Reformation'. He encouraged learning and education without the mediation of priests. His followers were the Lollards: impoverished itinerant preachers who promoted education and skills based on their own texts, in English rather than Latin and were supported and protected by their knights. They are claimed to have been the original reformers of the Christian church. But friars in the

mainstream church already practised austerity, so Lollards were seen as unwelcome competitors. Some sources claim they were persecuted and forced underground with their own priests, teachers and literature.[4]

Margaret Aston writes of how widespread Lollards became, travelling unshod and poorly clad in russet robes; she suggests Chaucer's Poor Parson was one.[5] J.E. Stroud extends this idea by claiming the Knights Templar were too large and powerful to have vanished, so also went underground and were absorbed into the Lollards. Though Wycliffe condemned the Peasants' Revolt of 1381, both he and the Templars were blamed for it, so there were similarities — if not close connections — between them. Stroud cites the Freemasons who claimed in 1737 to have evolved from the underground Templar movement and John Knox credited the Lollard Underground for much of the Scottish Reformation.[6] The reader is free to assess the credibility of these claims and whether men like Henry could have had any links with them.

The Black Death took a huge toll on skilled trades and tradesmen, as shown by surviving buildings. The extraordinary amount and detail of ornamentation that defines the decorated gothic was replaced by the pared-down perpendicular style. But craftsmen learned from viewing physical objects, so skills could be recovered in time if well made examples survived. Guilds enforced high standards, protected secrets and prosecuted fraudulent practices and competitors in their own trades. Apprenticeships were generally contracted outside their families, and journeymen moving to find work encouraged the circulation and improvement of skills. Until the mid-eighteenth century, the sons of merchants were sent abroad to establish foreign connections and to understand and forge trust with other cultures. These practices further encouraged the introduction of new skills, manuscripts and technology.

Urbanisation created neighbourhoods known for specific trades,

becoming centres for sharing information and/or competition which drove improvements. When people moved from the countryside to towns and cities, they were able to provide accommodation for friends and relatives to visit, and returned home themselves, so further cycling knowledge and skills. Inns were entertainment venues and foci for travellers of different trades and classes who exchanged news and information. Fairs and markets provided yet more opportunities for circulating knowledge. Underground movements were probably unnecessary when there was so much action above ground.

Desaguliers' education echoes Henry's claimed links with Newton. They both drew parallels between science and nationalism which emerged from Augustan concepts of civic pride and the benefits of a well organised state. The Restoration brought peace to Britain, but not with her continental neighbours, so patriotism was important in establishing national unity, especially between members of the established church and the many Nonconformist groups.

Desaguliers established himself in central London where he taught and lodged pupils, built scientific instruments, experimented, and demonstrated science. He was a fellow of the Royal Society from 1714. From 1716–43 he was their curator of experiments, paid to present public demonstrations, and won their Copley medal three times. He introduced the practice of science lecturers touring the provinces, published two volumes of his independent public lectures and fifty papers for the Royal Society's Philosophical Transactions. He was patronised by Georges I and II and was chaplain and tutor to the latter's son, Prince Frederick, probably the Prince of Wales that Henry claimed had offered to buy The Microcosm.

Steffen Ducheyne describes how Desaguliers' interest in science did not conflict with his faith. Religious houses such as the Cistercians promoted technology to free them for religious duties, and the Jesuits used clockwork as a proselytising tool, especially in China. Natural philosophers — many of them clerics — made use of technology, especially clocks, as a medium to contemplate God's works. The practice was akin to ancient hermits contemplating the natural world, or reading illuminated manuscripts as a focus for prayer, as a portal to

the divine. Newton claimed technology was a means to investigate natural processes and outcomes, bringing scientists closer to the mind of God, so his investigations were a form of piety.

The search to improve the human condition also echoed the sense that humanity had been forever damaged by the misuse of knowledge which led to Adam and Eve's fall. Science was seen as a means of undoing the harm caused by the first humans, offering a chance to return to Eden.[7] The search for paradise was a driving force in the European settlement of the Americas, and keeps recurring in the English-speaking world in response to wars and social upheavals. In Joni Mitchell's song *Woodstock*, written against the background of the Vietnam War, she talks of wanting to return to the garden, which is more of the same.

All of this fits in with the Bridges' publicity which claimed to promote education and offered internal views of the machine. Desaguliers used a planetarium to demonstrate the relative distances between — and the varied movements of — the heavenly bodies in his lectures. It was designed with the help of Royal Clockmaker James Graham using pearls to represent the planets, so was both an educational tool and an elite object suitable for a gentleman's library, as was Henry's Microcosm.

Desaguliers' achievements are outstanding and his contribution to early science cannot be overestimated, but though well respected and popular, he did not discover or invent anything, so he has left little trace on the historical record beyond the world of Freemasonry. Following on from Keill's work, he translated Newton's often dense and hard-to-comprehend writings into demonstrations which were a mixture of education and entertainment. Thus, he had a huge impact on the spreading and acceptance of the pioneering scientist's theories in England and Europe. Desaguliers tested experiments and the inventions of others, verifying and offering suggestions for improvements, so again is not remembered for this. Newton was not a particularly sociable man, so did little self promotion, while Desaguliers was his opposite; he loved company, and often invited people to his house in Channel Row for private demonstrations. He owned a huge collection

of instruments, many built to his own design, wrote plays and poetry, and loved music and singing.

He played a significant, but largely forgotten role in the field of mechanics. He designed a machine to demonstrate Kepler's *Second Law of Planetary Motion*, i.e. that "the planet-sun vector sweeps out equal areas in equal time".[8] In simple terms, the closer the planet comes to the sun, the faster it moves. Desaguliers initially proposed to demonstrate this with the planet mercury, whose orbit was the most eccentric. But as investigations into comets progressed, and the return of Halley's Comet approached in 1758, his invention was adapted to create a cometarium. Desaguliers' first such device was built in 1732 as an aid to his public lectures. Benjamin Martin was apparently the first lecturer to include a cometarium in his show from the early 1740s, and was closely followed by Henry's additions to The Microcosm.

Desaguliers' networking skills were formidable, a characteristic he shared with many other Augustans and the famous Erasmus Darwin. *The Oxford Dictionary of National Biography*[9] describes his role in London's complex network of engineers, philosophers and instrument makers. He was adept in using these connections to acquire patronage which helped pay for the expensive, labour-intensive equipment. By showing how these new ideas could be applied for profit and national benefit, he helped plant the seeds of the Industrial Revolution and enlightenment which the next generation harvested.

Arthur C. Clarke claimed advanced technology was often mistaken for magic. In the early eighteenth century scientists — or natural philosophers — struggled to separate themselves from the dark arts. Even Newton was claimed to have dabbled in alchemy, and used mystical symbols in his texts. But such encryption may have been to prevent his work being copied. John Dee is widely considered to have been a master of the dark arts, yet David J. Jeremiah writes of his huge library which was claimed to have held four thousand books, making it bigger than the collections of Cambridge and Oxford combined, so possibly the largest in Europe.[10] His interest in, and knowledge of, astronomy and its application to navigation at sea allowed him to

provide an important source of information for explorers, who provided Dee with details of their discoveries on their return.[11]

England was a maritime nation and many men went to sea when all were forced to work together for survival and were accustomed to sharing knowledge and skills for the greater good. Jeremiah notes a mariner who wrote an unofficial journal of his voyage in a mix of Latin and Greek to keep it secret from prying eyes at sea. Parts were also in code to prevent it being claimed by the ship's investor who owned everything from the voyage.[12] Code was also used if the information was deemed too dangerous to enter general circulation, as when Roger Bacon wrote the recipe for gunpowder in code in the thirteenth century.[13]

This shows why Dee was so important in the Elizabethan world, with his encyclopaedic knowledge of world navigation, but also suggests why he made such extensive use of encryption and mystic symbols, as did Newton. Perhaps they were less mystics, rather canny researchers protecting their hard-won knowledge. They could even have been both.

Desaguliers and Bridges bridged the worlds of ancient and modern knowledge. The former, like much of the early Royal Society's activities, still had a whiff of the occult. When scholar/poet Elizabeth Carter visited his house she wrote to a friend it seemed to be the home of a wizard, and with many visitors discussing the demonstration she claimed she feared being turned into a witch.[14] This impression was probably enhanced by the black clerical gown worn by Desaguliers which enhanced his credibility and set him apart from his audience. Like Gilbert White of Selborne and many Victorian parsons who followed, it seems his religious career was a means of financing his real passion of science.

He published and translated widely, distributing and encouraging access to the latest discoveries in Britain and on the continent, so his role was similar to that of The Microcosm in its travels. He investigated optics, mechanics, electricity, engines for draining mines or driving ornamental fountains, cranes, ventilation, measuring distances between planets and the depth of the sea. He built a ventilator for the

House of Lords and instruments used by other philosophers such as air pumps, thermometers and magnets, improved watermills, steam engines, centrifugal bellows, and carts. He adapted chimneys to burn coal instead of wood, increasing heat production and reducing smoke.[15] He experimented with optics and optical illusions; he was the first to suggest the idea of an electrical conductor, later made famous by Benjamin Franklin.[16] With clockmaker George Graham he worked on measuring muscle tension in their dynamometer, applying physics to the behaviour of the human body.[17] His translations included Vaucanson's paper explaining the automata to the French Academy in 1742, making it available in English when it toured here.[18] He may have lost some credibility when the realistic duck was later revealed as a fraud.

He claimed eight of his students made up the dozen experimental lecturers at the Royal Society, so helped produce and expand the generation of philosophers and scientists that followed him. The great experimental scientist, educator, cleric and member of the Lunar Society Joseph Priestley praised him for his inexhaustible work in experimental natural philosophy.[19] His work could have occupied several men, which caused him to neglect his clerical duties, so was dismissed from his chaplaincy by Chandos.

This wide-ranging interest was similar to that of Henry, and was very much at one with the early eighteenth century, when Britain emerged from the dark decades of war and civil disturbance to take the lead in the European Age of Enlightenment.

There is a possible link between the two families. When Henry's son James was rebuilding Bristol Bridge from the late 1750s, he made use of a technology pioneered in this country by Charles Labelye on the construction of London's Westminster Bridge. James floated caissons into place which allowed masonry to be built below the water line. This was especially important as Bristol has the second highest tidal range on the planet which limited the time available for construction.

Desaguliers was adviser for Westminster Bridge and lived so close to it his home was demolished to make way for approaches to it. Labelye was a former assistant and probably appointed on Desaguliers' recommendation. He wrote on Newsome's fire engine and Ralph Allen's railway in Bath.[20]

Desaguliers died in 1744 when James was eighteen. Was James, or perhaps his father, one of his students? Desaguliers had a large collection of equipment and models, and probably had an extensive private library, which raises the possibility of the Bridges — father and/or son — having access to them.

Desaguliers' main claim to fame is his role as the most important figure in the revival of Freemasonry at the start of the eighteenth century, earning him the title *father of modern speculative Freemasonry*.[21] He was a contemporary of John Wood the Elder (1704-54), whose development of the small West Country town of Bath Spa, based on Freemasonry principles made it England's premier resort. Desaguliers was also a zealous investigator and collector of the Freemasons' records. Whilst living in the Netherlands, he was involved in the society and he probably inspired Labelye to travel to Spain in 1727-28 where he established a lodge in Madrid.[22]

He encouraged men in a wide range of specialities, such as urging the talented oculist John Taylor to spread his knowledge, resulting in his extensive travels in Europe. They kept in contact for many years.[23] This may seem to be beyond even Desaguliers' wide range of interests, but good eyesight was essential to his work, and physicians often developed and improved eyeglasses, so were knowledgeable in optics, a field essential for telescopes and microscopes, which was yet another of Desaguliers' many interests.

There is no evidence that the Bridges — either father or son — were involved in Freemasonry, but lodges were often named after the pubs and inns where they met. They frequently moved, closed and reformed, so many records have been lost. Lodges provided training and enforced standards for the trade of masonry which had decayed when large religious centres closed at the Reformation. Their members were often prominent in the building trade.

Bristol Corporation employed John Wood the elder to build their new Exchange in the 1740s but local masons clashed with his workers; Captain Foy, the Clerk of Works complained the Freemasons were taking over the building trade. But he may have been a Methodist, and there was no love lost between the two groups.

Throughout James's time as surveyor for their bridge, he experienced similar antagonism and insults to his ability. When the grand celebrations were held for the coronation of George III in 1760, James produced the spectacular fireworks in Queen Square, so he seems to have had a wide range of skills, like his father.

The networks developed by members made travelling cheaper and easier, providing contacts for strangers on arrival, similar to the networks of masons in previous centuries who often travelled long distances for work. They promoted education and quality of workmanship as acts of public benefit, which echoes much of Henry's publicity. Membership included many wealthy men such as Chandos who provided financial support and advice for projects, so a major source of patronage for the arts and sciences which seldom appears in historic records. The list of members through history is almost a who's who of famous men, many of whom were for various reasons marginalised by the mainstream elite, for being Non-Anglican, non-English, or non-white. Many of them appear in this account, such as Pope, Burke, Sheridan, Washington, Franklin, Mozart, Voltaire and Hogarth. The list continues with Robbie Burns, Samuel Wesley, Mark Twain, Oscar Wilde, Buffalo Bill, Bud Abbot, Houdini, Richard Pryor, Nat King Cole and Duke Ellington.[24] Membership requires belief in a single god, so it now includes members of non-Christian faiths, which makes the group far more radical than its popular image suggests, though of course they still exclude women.

Henry Bridges made a hugely complicated piece of machinery, without any prior experience. James Bridges on his arrival in Bristol proclaimed himself to be an architect, taught all he knew by his father,

yet with no prior work experience he completed a wide variety of high quality works of architecture and engineering. Pevsner praised his understanding and use of the decorated gothic style when he rebuilt and restored several Bristol churches. His work was praised by the local press and defended by the city's masons, but he was treated shabbily by the Bristol Bridge Commissioners. When he fled Bristol his collaborator, the mason Thomas Paty — though clearly competent — also received little praise for his work, echoing the treatment of Wood and his Bath masons. Could this ongoing pattern be due to Paty and Bridges being members of the Freemasons, as were the father and son Woods? Where did they get their training if not via the brotherhood?

Charles Labelye's early training is likewise a mystery. He was described as a "comparatively young, untried foreigner"[25] when appointed to the surveyorship of Westminster Bridge. Like Desaguliers' family, he had fled religious persecution in France, but went to Switzerland. On his arrival in London about 1720 he spoke little English and worked as a barber. In 1725 Dr Desaguliers sponsored his entry to a French lodge of Freemasons. But he had already worked with Nicholas Hawskmoor and apparently learned his trade as an engineer at Sandwich and draining fens at Yarmouth.[26]

It is in the field of engineering that the closure of the monasteries took its greatest toll on England, putting an end to large scale projects such as churches and large bridges. The training of engineers became the preserve of the military, so little civic work was produced. There was no equivalent of France's Corps of Engineers which was founded in 1720 and developed into an academy a century later. The French and many of their neighbours migrated, traded and sometimes invaded through mountainous regions where bridges were needed, especially in winter. The Netherlands needed engineers to protect the low-lying nation from inundation from the North Sea.

Samuel Smiles in the mid-eighteenth century bemoaned the lack of British engineers. Dutch engineers had drained the eastern fens and Somerset Levels but

"at a time when Holland had completed its magnificent system of water communication, and when France, Germany and even Russia had opened up important lines of inland navigation, England had not cut a single canal, whilst our roads were about the worst in Europe."[27]

But this is to ignore the many reasons for this huge difference. In Britain, skills that had produced the great abbeys, cathedrals and bridges were lost at the Reformation and the country adapted to the loss by building in wood. Most people resided in low-lying areas where rivers could be crossed at fords. Most countries in Europe have rivers for water and transport supplied by snow melt from the Alps, while Britain had none. Europeans thus suffered from seasonal flooding whilst England was often beset by droughts in summer. Mountainous regions such as Scotland and Wales were seldom visited, except by locals, so bridges were not financially viable. In London, a formidable number of wherry or ferrymen plied the Thames, like modern black cab drivers. When a new crossing was proposed to cross the Thames at Westminster they were vocal in their opposition as it threatened their livelihood and claims were made it would bankrupt the southern parishes where many boatmen lived. In Bristol the high costs in life from road accidents should have inspired its bridge to be rebuilt and widened as a matter of urgency. But it seems the prolonged apathy to the scheme was due to the council owning a nearby ferry, so a vested interest in doing nothing.

During the centuries of chaos in Britain, her population and commerce declined. There was no need, means, or man of stature to carry out major infrastructure projects so the country learned to live without them. In isolated regions like Cornwall, roads were steep and tortuous, so sea travel was often more efficient.

The roads of England had not always been as horrific as they became from the early eighteenth century. Dirt tracks had been perfectly serviceable when most people travelled on foot and goods were transported by packhorse. The problem was the sudden rise in coaches which destroyed road surfaces. From the 1730s toll roads were built to improve them, but country people resented being

charged to repair the damage caused by urban carriages so they rioted against the unfair charges.

Comparisons with the Netherlands and their canals are also unfair. Their mills were wind-driven while many in England used water. These needed dams to build up water pressure to drive the wheels, but they obstructed boat traffic. The struggle to supply the early industrial towns on the River Stroud was a flashpoint for this battle. The woollen mills drew workers from the surrounding countryside, but the steep valley limited agriculture. Locals were at risk of starvation and of freezing every winter until the mills were at last converted to coal, which allowed the river to be canalised.

When James Bridges left Bristol in 1763, his role as bridge surveyor was given to Thomas Paty who had to provide a bond of seventy thousand pounds.[28] James was not a wealthy man, as his father's will of 1754 forgave him his debts. His disputes with the bridge commissioners often involved him pleading for payment. How could he or provincial stone carver Paty provide this eye-wateringly large sum? Who else but a large organisation such as the Freemasons could collectively underwrite them to complete the work on time and to an acceptable standard?

There are further family similarities. Eldest sons still followed their father's trade, but the Desaguliers, Bridges and Paty families adapted to the rapidly changing times. Henry Bridges and J.T. Desaguliers were entertainers and educators. They were successful at funding their expensive equipment, the former by travelling and producing pamphlets, the other by obtaining wealthy patronage, church livings, lodging pupils and giving lectures. Both their sons became civil engineers; James's bridge in Bristol still stands, as do most of his buildings, which is no mean achievement in a city infamous for demolishing its built heritage.

Desaguliers had two sons: John Theophilus junior (1718–51) followed his father into the church. Thomas (1721–80) became an army officer. But like his father, this career seems to have been a means of pursuing his real interest, that of civil engineering, or rather, how to destroy such works. He was the first Chief Fire Master at

Woolwich from 1748, aged only twenty-seven, until his death. The Oxford Dictionary of National Biography claims he was the first to apply science to the manufacture and power of gunnery in the British army, and the first since the age of Chandos to test them in a siege. "The rockets' red glare" in the USA national anthem was attributed to him, the original 'shock and awe' in warfare. He was the first artillery officer to be accepted into the Royal Society.[29] The Paty family showed a similar evolution in careers, with Thomas's sons graduating from the Royal Academy of Arts: John as a carver and William as an architect whose son became the decorated army officer General Sir William Paty.

These were all men of talent who had broken with centuries of tradition in following their family businesses. They adapted their skills as times changed, and achieved greatness in their chosen fields, so by the late eighteenth century we see them as recognisably modern, scanning the horizon for opportunities rather than following traditional career paths.

But they are largely forgotten for the same reason settlers in the New World failed to leave journals – they were too busy building a new world to contemplate their legacies. But like rockets they lit up the world about them, if only for a short time.

9

INSPIRATION AND PRECURSORS

For centuries, the English church was the social centre of communities, the beating heart on which parishioners' daily lives depended. Guilds — the precursors of later friendly societies — met in the secular spaces of their crypts. They helped with the financial costs of ill health and funerals. Masons and carvers who built and repaired the church fabric saw examples of best practice to inspire their own work. There are even sites where knives were sharpened on the stonework, though this may have been an expression of contempt during the Civil War. The spires were landmarks to guide travellers in bad weather, and on the coast were protected by the crown as they were crucial navigation aids to sailors. Their bells tolled out news, celebrations and warnings of storms, fires and invasions, so the church and its parish were a microcosm of the wider world.

Images from Bible stories and saints' lives were displayed on windows, walls and shrines, providing tales of charity and sacrifice which formed a framework for people's behaviour. Prayers were recited for the dead to reduce their souls' time being purged in purgatory en route to heaven, binding living communities with each other and with their ancestors and descendants. Guild members and other local people staged mystery plays. Some sources claim the term 'mys-

tery' refers to the audience being ignorant of the Bible. But it probably referred to the masters of the guilds who performed; the mystery is merely an accented version of 'mastery'. Involvement in such performances —whether as an actor or audience member — furthered social cohesion and deepened the understanding of their faith, of the sacrifices made for them.

Confession encouraged people to examine and atone for their behaviour, akin to modern counselling. In recent times, these plays are being revived, as a means of educating the public in Christian stories as church attendance declines. It is also a means of churches raising funds to maintain the many ancient buildings, but is also part of the growing interest in site-specific performances.

Parish boundaries were marked with numbered stones which were maintained by local masons, as were bridges and drains. From late mediaeval times parishes carried banners and their cross, or *rood*, in annual rogation processions to check the state of these markers and to remind the community of their location. The ringing of handbells drove out spirits that caused sickness in humans and animals and disputes between neighbours. Parishioners prayed for good weather and fertility in the fields. These practices were condemned by reformers as casting spells on the fields, but the processing served important civic and legal functions, so has been resurrected in some parishes. It was also, of course, a holiday to mark the passing of a year and a popular social event which concluded with a meal and drinks.[1]

Scattered through the year were many holy days involving drinking, 'bonefires' and distribution of gifts such as bread to the poor, which reaffirmed communities and encouraged charity. But the large number of such days, especially in summer, was condemned by reformers for endangering harvests and threatening famines, so many were banned by Henry VIII. David Cressy's book *Bonfires & Bells*[2] describes the many disputes. Strict Protestants held each day to be equally holy, and that the Bible makes no suggestion that Christmas or Easter were to be celebrated. But English law is based on traditional practice and custom; it has no written constitution, so the importance

of special days was accepted, provided they were used for prayer and fasting.

The English calendar incorporated elements of astronomy, paganism, classicism and local traditions. It marked the seasons, the agricultural, admiralty, school, university and legal cycles, set dates for fairs, court days and increasing numbers of secular anniversaries such as military victories, royal births and deaths and the Gunpowder Plot to replace saints' days. It is still based on Pre-Reformation dates as these were too firmly embedded to change and risked making documents unreadable to future generations.

In 1552 the parliament of Edward VI approved the celebration of Sundays and twenty-seven others as holy days, so a total of seventy-nine, plus a few evenings preceding them for fasting. Dates became disputed under the Puritans, who complained that saints' days represented Judaism, paganism and Papism. In the mid-seventeenth century there were still huge regional variations and changes over time, depending on which group was in power, with Puritans suppressing celebrations and royalists encouraging them.[3] New England attempted to replace days and months with numbers, undermining established tradition and common practice.[4] This proved to be as successful as Napoleon's attempt to convert clock time to the metric system. Celebrations added colour to people's lives, and in the absence of calendars they provided memorable dates which helped them recall significant events such as births, marriages, deaths and disasters. They were also valued as they fitted in with the use of astrology to help predict a child's future at birth. The widespread opposition to calendar reform in turn raises questions as to how much of the traditional church's popularity was based on faith, or on the many holidays it allowed.

Until modern times, most people lived in small rural communities, their little worlds limited by how far they could walk. Pre-Reformation churches were the only places they could enjoy paintings, sculpture and stained glass, where they could escape the unpleasant smells of the towns and farms for the scent of rushes and incense, and find comfort in the quiet surroundings. In modern *artspeak*, the church was

an immersive experience, so appealed to people on many levels, often very deeply.

In these same communities, relationships could become stifling. Sparks of petty disputes could easily turn into raging fires. Life was hard and people could not always share their problems with friends or family. If they needed advice they spoke to priests or they could commune with saints whose images gazed down on them, ever listening, discreet and patient, never judgemental. Masses formed a vital part of their faith, often called *their rights*, as they said prayers and tried to live according to Christian practices, of witnessing the Mass and sharing communion, so felt entitled to be included in the community and given the hope of life after death.

The host, or sacred bread, represented the miracle of transubstantiation, and in some churches was elevated by the priest in an ornate container, or monstrance. Eamon Duffy describes how some churches raised a curtain to provide a dramatic 'reveal' at the high point of the mass (the Elevation of the Host) to add extra drama. An alderman in Hull left money in 1502 for a mechanism which lowered images of angels to the altar at the time of the sacring, then rose at the end of the Paternoster, copying a device at King's Lynn.[5] Even more dramatic — but to modern readers bizarre — was the rood screen in the Cistercians at Boxley, in Kent, which had a sculpture of Christ made of paper, cloth and wood. Its arms, mouth and eyes were moved by *engines*; it was denounced as a puppet and destroyed in 1538.[6]

These examples show how elements of drama and technology were incorporated into religious practices to instil a sense of mystery and wonder in parishioners, but it also made the artefacts targets for the iconoclasts. Attacks varied from the complete destruction of a site, such as Britain's most popular pilgrimage destination, the tomb of Thomas A'Beckett at Canterbury. The site was doubly objectionable as he was seen as a traitor to the monarch as well as an object of veneration.

Complaints had long been made against ornamentation in churches by reformers such as Wycliffe on the basis that the money would be better used to feed and care for the poor. The Bible was cited

with claims that images breached the Second Commandment against the worship of graven images.

Just as the rood screen separated the sacred from the secular space in the church, the use of Latin in services formed a language barrier between the clergy and the laity. This gave clerics a monopoly on access to scripture, which was enforced in the Church of Rome on the basis that they were educated, hence able to interpret the text for worshippers. The various Nonconformist groups promoted literacy and the printing of the Bible in English, which encouraged the public to read and interpret the holy texts themselves.

The forms of iconoclasm practised by some reformers often seem bizarre. Lollards attacked images; they hanged or beheaded statues, suggesting anthropomorphism or even witchcraft. But they were demonstrating their own — mortal — power. God did not punish their vandalism, which proved the images themselves held no power.[7]

During the Reformation, church art was stolen, whitewashed or destroyed. Entertainments moved from the churches into the streets. Bible stories were replaced with secular performances by travelling players, which is why actors continued to be male in Shakespeare's time. In northern Europe, arts patronage shifted from sacred to secular, as did the subjects depicted. The Netherlands of the seventeenth century were home to the golden age of trade, but also painted landscapes, still lifes and domestic scenes, bought by rich merchants at home and in their overseas colonies.

Jesuits were called the janissaries of the Counter-Reformation, for their long, intense training and their ingenuity and promotion of child-centred education. They used clockwork devices as diplomatic gifts for the Chinese. Their ability to make and repair clocks allowed them to settle in China.

About 1560, King Philip II of Spain's son was facing death; he prayed for a miracle, promising one in return. The son lived and Philip commissioned from his engineer what is now believed to be the oldest automata: a monk that walks, prays, and thumps its chest, a trancelike performance of penitence, as an aid to prayer.[8] It is now in the Smithsonian's National Museum of History and Technology and forms an

important link in the chain connecting ancient technology via mediaeval machines to modern computers.

The monk was part of the hyper-realistic art that achieved dazzlingly high standards in the work of Caravaggio who used dramatic lighting to inspire awe and piety while Protestant nations focused instead on the reading and interpretation of the Bible. Bruised and bloodied images of the Crucifixion and of martyred saints carried in Catholic processions were offensive to Protestants. When new, Protestant churches were being built in the eighteenth century, they were based on classical architecture, inspired by gentlemen who had visited Italy on the Grand Tour. But this fashion was also a rejection of the ornate baroque styles of Catholic countries at the time. The English landscaped gardens and country houses were decorated with marble sculptures of ancient deities which Catholics rejected as being cold and lacking in passion. Each group accused the other of worshipping dead images.

When Christopher Wren was building his masterpiece of St Paul's Cathedral, he asked Thomas Tompion for a masterpiece clock. A newsletter of 1700 claims he contracted to build a clock that would run for a hundred years without winding.[9] Some authors claim England's interest in accurate timekeeping and marine chronometers was the result of her being a maritime nation, but she was not the only one. Ullyett writes of the respected mathematician/astronomer and author Christiaan Huygens in Holland who proposed a clock mounted on gimbals. He was invited to Paris by Louis XIV to demonstrate his research, so both countries were concerned with marine timekeeping. At the end of the sixteenth century, Phillip III of Spain offered a huge reward to produce an accurate chronometer, but with no result. Only England achieved success, inspired by the government offering the huge sum of ten thousand pounds for a method to determine the position of a vessel at sea within a degree of longitude on a voyage to the West Indies. The prize was increased to twenty thousand if the clock was accurate to within thirty minutes.[10]

The Longitude Prize was so large that technicians in other countries also pursued it. Jerome Lalande came to London in 1763 to

obtain information on clocks, helped by the resident French community. A special ambassador from Spain, the Conde de Fuentes, came on a similar mission. He was accompanied by the Belgian mechanic and inventor J.J. Merlin.[11]

In many rural areas of Britain, industries arose to supplement low agricultural wages and keep workers on the land to bring in the harvest. This proto-industrial period paved the way for the Industrial Revolution. The West Country had weavers, Yorkshire nail makers and Gloucestershire pinmakers. These supplemented the traditional women's industries of spinning, vegetable growing, eggs and dairy production and in the early nineteenth century, straw plaiting. This latter was encouraged by campaigning writer William Cobbett to make up the domestic shortfall when spinning and weaving were mechanised, so families no longer saved money by dressing in homespun. The shift from home weaving, often in warm, water- and fire-resistant wool, had other downsides for the quality of life of the poor. Cotton retained less heat, so the poor became more prone to catching chills. There was also an increase in people — especially the very young — coming too close to open fires and being burned, sometimes fatally.

Switzerland is known for its precision watch and clockmaking, but the small town of La Chaux-de-Fond in the Jura Mountains became an extraordinary centre for automata manufacturing in the eighteenth century where agricultural communities shifted towards proto-industrialism. Pierre Jaquet-Droz was helped by the governor for the King of Prussia, the Scot Lord Keith, who arranged for him to visit King Charles III of Spain in 1759. The monarch was so impressed he gave Jaquet-Droz twenty thousand shillings to support his work for four years.[12] The king may have hoped the automata would prove an inspiration for the industry in Spain, but this failed to thrive. Wood claimed Charles III also established a school in 1759 to train skilled mechanics in dialling and watchmaking but by 1809 had produced no graduates. In Madrid a school was also established with the same

result.[13] Spain was flooded with silver from their South American mines, which introduced inflation to Europe, but they failed to invest in industries, preferring to import their needs. It is unimaginable that anyone in England would find such generous support, which suggests the English clockmakers were forced by financial necessity to be utilitarian.

At the end of the sixteenth century, Margraf, a clockmaker in Augsburg, was building perspective boxes including mirrors and lenses, with detailed lighting which later included clockworks.[14] From 1657 Christiaan Huygens invented a box in which images painted on glass could be viewed.[15] These became popular in England, showing little worlds to those who could afford them, and were early examples of the combination of art and technology as shown in The Microcosm and other mechanical shows. In the early eighteenth century, Martin Englebrecht of Augsburg produced miniature theatres — the original peep shows — which were collected by the wealthy. One dating from c.1721 can be seen in the Victoria and Albert Museum of Childhood. These delicate boxes were made more robust and the number of scenes increased for shows at English fairs, aided by banter and storytelling, as shown in Edward Villiers Rippingale in his famous painting of the 1820s, *Bristol Fair*.[16]

Some painters turned their skills from saints in landscapes to secular portraits or landscapes, but sculptors were more limited. Some made and maintained shop signs which hung over the street, so were complained of for blocking out much of the sunlight in towns. Some inns had huge — often sculpted — signs which hung across main roads. Being exposed to the elements, they were often in need of repairs and repainting. A few carvers survived producing family memorials in churches, but diarist John Evelyn was still shocked when the French ambassador put on a display of life-size figures showing the Last Supper in 1672.[17]

The first showman in wax was Johann Heinrich Schalch from Schaffhausen who from 1685 produced images of dead royalty. In the eighteenth century, similar shows expanded to include figures from the Bible, popular literature, folklore, and the famous and infamous,

so were updated in response to current events. A storyteller stood beside the booth to explain and urge attendance at the show. By including images of freaks, they rivalled the real ones in adjoining booths at fairs, and this rivalry in turn urged the makers of waxworks and puppets to improve their skills to become more lifelike.

This same level of skill was used to produce anatomical models to train surgeons, due to the shortage of cadavers and lack of preservation which fuelled the crime of bodysnatching before the 1832 Anatomy Act. Benjamin Rackstrow's Museum was the strangest show but in many ways a continuity of the early cabinets of curiosities, i.e. collections of unusual objects used to investigate and discuss early science, was. It was a combination of the surgeon Dr John Hunter's reproductive museum and the wonderfully named Don Saltero's *Knicknackatory* at his coffee house in Chelsea. The standards of these images were high as in 1763 Rackstrow exhibited at the Society of Artists, a group which defined the arts in the classical sense, i.e. including technology as well as fine arts.[18] This exhibition produced a detailed guidebook, as did The Microcosm's proprietor from c.1760. This reflected the wide ranging interests of their audiences, but this scattergun approach also aimed to attract the biggest possible audience, especially outside the capital.

These examples suggest how widespread the hunger for knowledge and entertainment had become by the mid-eighteenth century. Performances of puppets and waxworks evolved from simple repetitive movements — ancestors of shooting galleries at modern fairs — to perform entire shows, with detailed individual movements by the 1730s. They used spring-activated, air-driven and clockwork figures and puppets, so it is often impossible to know what was involved.

Addison described whole operas performed by marionettes, thus forming a bridge between the Puritan ban on acting and the recovery of the theatres. They were also popular with managers as machines and puppets were far cheaper than actors and never got sick or drunk. The subject matter was generally restricted to the classics and the Bible, portraying mostly stories already known to the audience and unlikely to cause offence to the authorities.

A new form of mechanical show arrived in London in 1709, owned by German comedian William Pinkethman, mentioned in chapter four. It seems to have been a series of clockwork figures moving against a painted background and was known in Europe as a *Theatrum Mundi*. Richard D. Antick claims in his encyclopaedic *The Shows of London* that it displayed over a hundred figures including birds, animals, fish and ships of up to a foot high.[19] Pinkethman seems to have initiated an outburst of competition, but this was only possible because a pool of showmen with high levels of mechanical skills must have already existed.

The *Theatrum Mundi* has a much longer, literary history. The Greeks — especially the Stoics — considered the world a stage. Christians believed in the separation of soul and the earthly world. This concept continued into the twelfth century when John of Salisbury coined the term *Theatrum Mundi* and its use has often been associated with periods of instability, offering solace from worldly suffering. It was popular when the old social order was in decline, such as when the system of feudalism was seen as empty and decaying.[20] Hence the concept was revived in the early eighteenth century, the Augustan Age in the wake of so much disruption and destruction when interest turned to various improvements and education inspired by the classics. With so many classical references in his machine, this seems likely to have been Henry's inspiration.

Closer to The Microcosm, both in design and the style of his promotional material, was Pinchbeck's *Grand Theatre of the Muses* which was displayed in the capital's coffee houses and the great fairs from 1716. It included two moving scenes: Orpheus in the forest beating time as he played music to the wild beasts and a land and seascape with ships sailing, chaises and carriages with wheels turning, a swan swimming, a dog and duck. It was accompanied by music played on an organ, flute etc., and birdsongs,[21] all of which feature on The Microcosm. But these images were common, and comprised the whole of the Pinchbeck's machine, while they comprised less than half of Henry's beast. Father Christopher Pinchbeck and his two sons encompassed a world of art and engineering, education and entertainment.

Christopher became president of the Society of Engineers and like Desaguliers experimented with and produced working models which demonstrated mechanics.[22] They ran a successful, varied business while Henry's work history beyond The Microcosm is unknown.

Antick claimed the Pinchbecks began the combination of technology and clockwork with high art, presenting classical subjects,[23] but there were a number of European examples long before this. Antick rightly draws attention to the close similarities in terms of the images portrayed, accusing Bridges of lacking originality by copying Pinchbeck. The timing allows this, but this may be due to them being inspired by the same original source. Pinchbeck's work — no matter how skilful — never claimed to be more than entertainment and quality workmanship. He made no claims to any higher notions, or to inspire, or stimulate the viewer's senses as did Henry and subsequent proprietor(s) of The Microcosm. This distinction between a craftsman and a philosopher featured in debates on copyright for technology, as mentioned in chapter fifteen. Pinchbeck was an engineer, businessman and clockmaker, albeit a very good one, but Henry's inspiration arose from literary and philosophical sources.

Another fascinating but obscure clock was featured in the Museum of Dr Greene in Lichfield, a town that hit well above its weight at the time, providing the world with Dr Johnson, David Garrick, and becoming home to Erasmus Darwin. The clock is now on display in Bath's Victoria Art Gallery. The case is in the form of a gothic church tower; the front of which opens to reveal automata and panels displaying the Lord's Prayer and the Apostles' Creed in Latin. Above these is a Crucifixion scene and Pilate washing his hands.[24] This clock is unusual in its depiction of religious scenes, and the gallery guidebook claims it was made for a church. But these images are hidden, suggesting the clock was built for closet Catholics or in a room used for sacred and secular purposes. It also plays music including a Handel minuet which provides a possible date for it. It was probably custom-made for a specific client's library or curiosity cabinet.

Antick claims improvements to clockwork shows peaked in the early decades of the eighteenth century. This may have been due to the

decline of the great magnates as patrons, making way for the rise of the new middle classes. More likely, the expansion of trade with the Americas caused increased demand for navigational aids, so horologists and instrument makers focused their output on practical technology with a few pursuing the Longitude Prize.

But such mechanical shows would not have been so successful had not the first Prime Minister Robert Walpole who passed the 1737 Chamberlain's Act, part of the banana-republic-style crackdown on satirical opposition to his government. This forced theatre companies to change their output and in the short term at least, reduced their productions for fear of prosecution. The legislation followed the *Waltham Black Act* of May 1723 which was introduced to deal with hunting, wounding and poaching forest animals. It created fifty new capital offences, which should have been an emergency, short-term fix, but was renewed and the number of capital crimes extended for decades. This resulted in mass executions, overflowing jails and the transportation of prisoners to the Americas. When their colonists revolted, the colony of New South Wales was founded to dispose of the nation's soaring numbers of criminals.[25] They had been kept in redundant naval vessels (hulks) on the Thames, where they became a tourist attraction along the lines of the mentally ill at Bedlam. But the sight of Britons working in chains was deemed incompatible with the concept of British freedom, so they were sent abroad: out of sight, out of mind.

Bridges' machine was far more complicated and multifaceted than the mechanical theatres and automata shows, as it was driven by its author's philosophy. The Roman temple design of the case demonstrated Henry's knowledge of classical architecture. The other clockwork shows were displayed in boxes similar to later longcase clocks or Punch and Judy shows. They displayed a single image or idea, whereas Bridges covered a wide range of subjects and means of displaying them. This helps explain its longevity, but makes it hard for writers

and horologists to categorise, probably why it has fallen between the gaps of history. It was a show that evolved over time, shifting its focus from being a gentleman's entertainment to incorporate technical elements which were updated to include the latest astronomical discoveries. It is likely the tunes played also changed with fashions. In this it had elements of a living thing, evolving in response to its environment.

In later years, the proprietors of The Microcosm allowed the audience to view the internal workings of the machine in motion, initially for free. But this was not unique. In 1743 clockmaker Charles Clay's widow advertised an ornate musical clock, *The Four Great Monarchies*, which played tunes by Geminiani, Handel and Corelli. She also offered views of the inside workings on request,[26] to help sell the clock. The date is interesting as it was a year after Vaucanson appeared in the capital with his fraudulently defecating duck. But Bridges offered the viewing as part of the educational aspect, and the spirit of the Augustan Age.

William Winter's poem described The Microcosm as a masterpiece, produced at the end of a tradesman's apprenticeship, to demonstrate his skills. The term was not applied to other shows. It also demonstrated high standards, so encouraged other tradesmen to improve their skills. But if it was a masterpiece, what trade was Henry demonstrating?

The fourteenth century lantern which dominates Ely Cathedral by the King's Carpenter William Hurley has been described as a "masterpiece of engineering" and "wonder of the Mediaeval World".[27] It was built of wood as were many roofs of perpendicular gothic churches. So before the Tudors, masonry and engineering skills were already being lost to be replaced by the shipbuilder's craft. Or perhaps masonry skills had never fully developed in regions rich in woodland but lacking supplies of quality stone. In London's V&A Museum is a complex silver automata clock described as The Masterpiece Clock[28] which was on display in the clockmaker's shop window to encourage trade, and inspired several commissions.

To further confuse matters, the poem by "Philotechnos" included in Farmer's and Winters' histories claims:

> *"Nor need you fear the want of being known,*
> *Since Britain's Masterpiece in yours is shown."*[29]

This presents us with a mind-twisting concept of a nation as a masterpiece being represented in Henry's masterpiece of machinery, perfection displaying perfection or a world within a world. This makes it a far more complex piece of art, a palimpsest of — and for — a nation. It was a showpiece which preceded the Victorian Great Exhibition at Crystal Palace, the post-World War II Festival of Britain and more recently, Danny Boyle's opening ceremony to the 2012 London Olympics, which in turn was inspired by the book *Pandemonium: 1660– 1886...* by Humphrey Jennings.[30]

Clocks were not just beautiful pieces of art. They were the most complicated machines on our planet before the Industrial Revolution. They were included in portraits such as that of Sir Thomas More's family of c.1593–4 in the V&A Museum where they implied the owner was learned, curious about the wider world, and could be consulted to solve problems and resolve disputes. The sort of person you would want in your pub quiz team.

Paul Glennie and Nigel Thrift describe the widespread audience for clocks. People of early modern England such as diarist Samuel Pepys were fascinated with gadgetry in general, and watched watchmakers working. People owned clocks and watches for technical as well as aesthetic reasons.[31]

Henry's machine also reflects the work and the reputations of contemporary shows, especially those from England's long-time rival France. Jacques de Vaucanson's (1709–82) career shows the ongoing conflict between religion and early science. Newton hoped to become close to the mind of God by mimicking divine works, so his research can be seen as an act of piety, but this was a fine line to tread. Vaucanson had a deep knowledge of the mechanics of animal movement, but when

he created a lifelike angel automaton, this was seen as heresy so it was destroyed by his Jesuit superiors, and he left the order to pursue his research. In 1738 he exhibited a pair of androids: a faun and a shepherd who played flutes using bellows, levers and strings which mimicked human movement, and a duck that was claimed to eat and digest food.

The Swiss technician Henri Maillardet (1745–c.1800) showed a swimming swan to the Academy of Sciences in Paris in 1731, and later produced automata that could write and draw, a lady harpsichordist, and a fortune-telling machine which produced set answers to questions, the forerunners of penny arcade shows.[32] But Vaucanson's work was the closest imitation of real life, with the flute player having fingers opening and closing apertures when air moved through the instrument. He became rich and famous, his automata were on show in London in 1742 and his memoir translated into English by the great Dr J.T. Desaguliers. Vaucanson's touring shows helped inspire others to build complex automata, and he later made important advances in the weaving industry in France.

Louis Jacquet-Droz came to London in 1776 with three automata: a writer, a draftsman and a harpsichord player, showing the heights European technology had attained, but he needed access to Britain's export markets. In 1783–4 the most famous — or rather, infamous — automaton was Wolfgang von Kempelen's Turkish Chess Player, built as a demonstration of deception for Empress Maria Theresa. Dressed in a turban, it toured widely across the courts of Europe, challenging and beating the greatest human players. Whilst some suspected a small man was hidden inside the latter, suggestions were also made of witchcraft.

Though these complex automata impressed Britons with their almost magical qualities, there was also cynicism as to how they worked, especially when requests to inspect Vaucanson's duck were repeatedly refused. Von Kempelen cleverly incorporated a door that opened to reveal clockwork which was useless, so the pseudo-magical *reveal* was an added layer of deception or, for those in the know, of performance.

English philosophers from Francis Bacon onwards encouraged

investigators to repeat their own experiments and those of their peers, to test their theories and establish new truths, hence an early form of crowd sourcing. This may have inspired Henry to allow views of the machine in action, or it may have been an added level to the entertainment in response to his complaints in the press of having many rivals and imitators.

By the mid-eighteenth century, Britain had many travelling science lecturers who explained how to carry out experiments to distance themselves from magic and to establish a pool of sound experimental evidence. Vaucanson's duck was eventually exposed as having no connection between ingestion and excretion, the body holding a store of prepared liquid which was discharged. But it was still impressive in its fine workmanship and its naturalistic ability to walk, so it continued for some decades without the excretory component. As many suspected, the chess player housed a small person who could see the board via a mirror. England's attitude towards its continental neighbours had been shaped by centuries of political and religious wars and fear of invasion. These fraudulent shows further fuelled this antagonism and distrust. Many of the automata came from France, which was often seen as corrupt and degenerate, whilst at the same time many aspired to copy French fashions.

Henry Bridges was promoting knowledge, hoping for repeat visits with more guests by showing the workings of his clock. The *reveal* was thus also fuelled by a desire to show the mechanism was genuine, and — as much of the puff suggests — the product of honest English workmen, so feeding into the jingoism of the age. Though the surviving clockwork in the British Museum is of a very high standard, with only the engraving to go by it is impossible to judge the quality of the rest of the machine. Other shows were more straightforward: people got what they paid for, and went home content or not. Henry's machine was very different; it was more a gift that kept on giving, a starting point for his audience. It showed what was possible, so inspired craftsmen to improve their standards. The show promoted and encouraged learning and experimentation, which was central to the age of improvement.

As mentioned earlier, the long years of plague and failed harvests weakened European Christianity. The discovery of so many people with no knowledge of Christianity added further doubts to the concept of an omniscient being. The failure of relics to achieve miracles and save lives during the Black Death meant they were some of the earliest casualties to this collapse of faith; but some continued to hold a degree of curiosity in their own right, so instead of these artefacts being discarded, they formed some of the earliest items in cabinets of curiosities. As Christianity failed to provide answers, educated men began gathering unusual objects to help them order, arrange and understand their increasingly complex, secular world.

Interest in natural philosophy from the late seventeenth century led to the separation of magic and science; as the mechanisms of how things worked were uncovered, the mystery and magic faded. Travelling shows reflected the growing knowledge of the audience in shifting from magic and tricks to experimental science, often showing how it was done, so it could be repeated at home. But discoveries could lead to further confusion. For centuries, world maps had shown monsters and men with faces on their chests or with a giant foot to shade them from the sun. When explorers described or brought back samples of what they found, reality sometimes became stranger than myth.

One of the great achievements of the Jesuits, the janissaries of the Catholic Church, was their showmanship. They staged spectacular public performances and processions which, with the high standards of teaching and their emphasis on child-centred education, attracted support even in Protestant northern Europe.

England's Reformation was unique in being ordered by the king, rather than triggered by opposition to clerical corruption. Most of the population lived in small communities where they paid for the maintenance and decoration of the church. Many people still looked to the saints as friends who helped them in times of trouble. They resented and resisted the end of pilgrimages, and the destruction of saints' images, so either hid or painted over them for protection. When

Queen Mary returned to the old church, Masses were reinstated with impressive speed, only to be subject to the secret-police-style crackdown of Elizabeth's reign. It is possible the English have never recovered from the trauma of this destruction of their rituals, but these islands have long hit above their weight in the many arts and sciences, which have been invented and continue to be practised to fill this vacuum.

Travelling scientists and members of the Royal Society tried to pare the science from superstition, to move from the chaos of ignorance and guesswork of the past. But the popularity of magicians and showmen confirmed that crowds still craved mystery and magic; they needed colour and drama to leaven their often colourless lives. Whether in the form of tiny intricate automata or dramatic demonstrations and explosions, science shows helped fill the void left by the communal processions and the mystery and awe of the Mass in the Church of Rome. Pious exhortations from the pulpit just didn't fill this need, and the British people created their own rituals, many of which involve quantities of alcohol as any town centre on a Saturday night will demonstrate. People who work hard will always find their own means of relief, as tools to help them to survive, at least until the next weekend.

10

PUFFING AND PROMOTING THE MICROCOSM

Henry grew up and built his machine in the Augustan Age, named after and inspired by the period in Rome when culture and civilised behaviour thrived. There was a passion for order, to counter the chaos of previous centuries. Its clean, simple architecture provided a visual antidote to the restless forms of *crinkle crankle* gothic, most of which was by then ruinous. Flowery metaphors and unnecessary ornamentation in language were pruned to make space for simple, clear speech which helped provide a neutral space in which to investigate, discuss and promote philosophical and scientific ideas. Technology and clockwork represented order and reliability, serving as metaphors for God's orderly universe. Looking to an idealised Roman past also echoed the often repeated theme of using technology to help improve the world, to return to Eden which had been lost by human folly.

The first newspapers were European journals which provided information for merchants, so covered politics, wars, crop failures and bad weather that could impact on their businesses. They were supported by patrons in need of such information, and as a means of promoting their own interests. Most material was written by the proprietor/editor, but was often unattributed or signed with a pseu-

donym. Articles included much to bemuse and sometimes horrify modern readers, but owners were legally obliged to provide their name and address on the front page, so they could be forced to make corrections if any offence was caused. By the early eighteenth century such patronage in England had been replaced by advertising which dominated front pages. News of most local events spread orally, so papers published mostly births deaths and marriages, and occasional curiosities.

Literacy was actively promoted by the various Nonconformist groups which emerged after the Reformation. Members were excluded from universities and government but established many respected schools and colleges. The London Stationers' Company lost its monopoly on printing in 1694, and the world's first copyright Act was passed in 1710 which encouraged the establishment of regional newspapers and guaranteed authors' incomes.

The expansion of the press helped businesses and entertainments reach wider audiences, increased competition and developed new forms of media language. Some, such as Felix Farley's Bristol Journal, claimed to be repositories of the arts and sciences, so included essays, opinions, humorous anecdotes, curiosities and poetry. They were printed on durable rag paper, so could be collected in public and private libraries and coffee shops for future reference and discussion. This allowed travelling shows like The Microcosm to generate a wide range of publicity — or puff — from a simple notice of its arrival under the local news, to a letter from a person claiming to have seen the show, or an announcement of improvements, and sometimes poetry.

John R Milburne described how mechanical and other curious shows often toured Great Britain's urban centres, but The Microcosm's publicity — in both quantity and variety — exceeded all others. Its role in adult education, especially with its use of astronomical models is what makes it so significant.[1] James Cox ran a huge manufactory which produced exotic ornamental goods and automata. By the 1770s, i.e. towards the end of The Microcosm's career, he claimed to employ thousands of workers, and for years his museum was the most

famous show in London. Like the owners of The Microcosm, he advertised widely in the press, in handbills and a pamphlet, or rather, a book as his ran to a massive ninety-two pages. He was praised for his entrepreneurial skills, showmanship and publicity.[2]

Cox's sophisticated press campaign presented him as a successful showman and entrepreneur whilst behind the scenes he struggled to fund his expensive and highly speculative business. His clocks and automata were immensely labour-intensive, employing jewellers, gold- and silversmiths, painters, enamelers, clock- and watchmakers, so required massive upfront investment from friends and suppliers which was not recouped until the finished items were shipped to distant lands and sold. He should have become a wealthy man but he claimed whatever money he made was reinvested in the business. Like Henry, he was presented as a worthy, benevolent man.

The first, and most impressive, piece of self-promotion produced by Henry was the 1734 copperplate engraving which is a beautifully detailed image, drawn by R. West and engraved by the sculptor R. Sheppard. Copperplates were not robust, so their print run must have been small. The author has traced only three survivors. The image shown on page xi is from the British Library and is damaged around the edges. Another was sold on ebay several years ago for nine thousand pounds. The last is held by the British Museum but it lacks the dedication to the Duke of Chandos, suggesting it is of a later date. Yet these prints are still of high quality, so either this was a new engraving or very few of the original were produced. The print — in whatever form — was sold with the show but from 1764 a frontispiece was also offered. This was probably the image found on the flyleaf of the pamphlet, and in 1772 the eleventh edition included a frontispiece and additions. No trace of a separate frontispiece is known. All these items were printed on rag paper which is robust, so they should have survived.

The hallmarks of a clockmaker are patience and attention to detail,

suggesting Henry was at ease with solitude, quiet industry, sobriety and simple living; but this contrasts with his life on the road, spending time in pubs and inns where sobriety would have been difficult to maintain, especially in urban centres where there was little clean drinking water. In his early career he promoted the show at fairs, which required self-confidence, the ability to judge an audience, to cajole or encourage them to hand over their money. He may, as his publicity suggested, have enjoyed a wide range of interests and skills, so was something of a Renaissance man. More likely, as with many of his age, he was prepared to do whatever was necessary to survive. So he was in many ways a fairly typical Georgian.

The Microcosm's publicity is noteworthy for the many items which survive in U.K. and U.S.A. archives. From 1750 bills were available from various venues including London's Goldsmiths Hall, some of which bear handwritten amendments indicating changes of venue. Its first printing coincided with the addition of four planetariums and its renaming as the *Modern Microcosm*[3], so seems to have been part of a relaunch or rebranding of the show.

One of the strangest phenomena in Georgian newspapers was the number of people — from children to the elderly — who spontaneously recited poetry on seeing something noteworthy. It imparts a strange atmosphere to the time, like Gene Kelly bursting into song in the middle of a downpour, but at least he had the decency to be embarrassed and was eventually moved on by the constabulary. Boys fortunate to have a grammar school education studied classical languages which included the art of oratory. Spontaneous speeches were reported in praise of visiting worthies and benefactors of the school, or to celebrate important events, which provides some context for the versifiers. Of course these alleged outbursts were mere puff, but they were used by many travelling shows.

The best-documented eighteenth century showman was Gustavus Katterfelto from Prussia. He claimed to be from a prominent military family and to have obtained some scientific knowledge before he arrived in Britain in 1776, intent on "captivating the public".[4] He practised a wide range of science, pseudo-science and magic tricks, and his

publicity was at times so excessive that he attracted more mockery than respect, earning him the title 'The Prince of Puff'. From the outset he used extempore poetry to promote his shows, claimed it was written by other people, but it was probably self-penned.

In Dublin a gent began reciting poetry after seeing The Microcosm at College Green in 1746 when he claimed it showed mortals could create a small world as well as God, who on seeing it, was forced to leave heaven for the Stygian coast.[5]

In 1751 The Microcosm's appearance at London's Haymarket Theatre inspired an outburst of rhyming from someone called AB who seemed to suggest seeing The Microcosm was akin to taking an elixir of youth, introducing an age of peace and love between peoples. It seems Henry and others were early believers in something akin to the Age of Aquarius, and that Henry commanded globes to move in his little world just as God does in the big world.[6] He continued with a claim that The Microcosm had outdone Copernicus and by showing astronomy could be seen without a magical tube or telescope, was presenting the truth rather than fraud, so was denigrating other philosophical shows, and perhaps at the Royal Society itself.

The ability to recite poetry was largely associated with those wealthy enough to be privately educated or to attend a grammar school, but it seems acting was not restricted to professionals. David Jeremiah writes of performances of Hamlet and Richard II on early seventeenth century ships to distract sailors from idleness, games or —strangely — sleep. Given how many men went to sea, this suggests large numbers had been amateur actors. In such crowded conditions, plays probably helped reduce fights, though the material may not have been well chosen for this.[7]

Henry often recycled his publicity but after his death, the new proprietor — probably Edward Davies or Davies — raised the standards and variety of the material. When The Microcosm was put on display for sale in 1759, a cleverly designed publicity campaign appeared in the London press, when he suggested the English were skilled at imitation, but that The Microcosm showed they could also excel at invention.[8]

This article was followed by an attempt to shame those who failed to patronise the show by claiming the English had a reputation for supporting talent, which drew so many artists to these islands in search of audiences. But despite so much competition, The Microcosm surpassed them all. This was signed by "Philotechnos", echoing the author of the poem in Farmer's history, suggesting the show continued to appeal to those with some classical knowledge.[9]

Next, a lady launched into an outburst of poetry but against the reputation of her gender, she had far less to say than the men, and her claims were more modest. She writes of the show ravishing her senses, and praises the harmonious music in the wondrous little world.[10] The final contribution comes from a character who claims to have experienced an epiphany on seeing the pile of art. He claimed to be a compulsive liar, but that the sight of The Microcosm had reformed him.[11]

This shows how sophisticated the owner of The Microcosm and the press had become. Like the machine itself, this publicity acted on several levels, to engage the imagination and interest of as many different types of people as possible, to maximise its paying audience.

Henry was not alone in inspiring outbursts of poetry. His eldest son, James, showed himself to be a showman equal to his father. In April 1761 when working as surveyor on Bristol Bridge, the local paper, *Felix Farley's Bristol Journal*, described him performing tricks, passing solid brass cubes through each other, in defiance of the rules of geometry and common sense.

The following week, this inspired the following claim that James had outdone the classics, so following the footsteps of his father:

> "Blush! Grecian, Blush! To see thyself outdone
> Blush at the labours of thy British son;
> Say's thou the larger *must the* less *contain?*
> Dost ask? Why *that's to every blockhead plain.*
> Ah ha! Old Euclid's out; why, here behold,
> This the least Die with ease the Larger hold."[12]

This incident was later explained as the result of "a few friends meeting for drinks and placing a wager" which is interesting in its way, but does nothing to clarify the incident.

Alexander Pope's *Essay on Man* was published in 1733-4 and established his international reputation. It inspired *A Parody on Pope's Prologue to Cato Addressed to the ingenious constructor of The Microcosm* which capitalised on Pope's fame and attempted to contextualise the show. The poem was attributed to the late Dr Burton of Yarmouth, about whom nothing can be found beyond his subscription to a book, *The Marchioness de Lambert's Letters to her Son and Daughter, on true education &c., &c.*, which was translated by Mr. Rowell in 1749. She condemned misogyny, promoted education for girls, and was praised by Voltaire. There was a widely accepted view that women were inferior to men due to their imaginations dominating their logic. But this was countered by her by claiming that imagination helps reason by making ideas livelier and clearer, a radical, empowering idea at the time.[13] Her book became an influential text on education and women's rights; the style was later copied by Thomas Day, close friend of Richard Edgeworth, so we have hints here of links with Henry in promoting education for both sexes.

The *Parody...* was printed in the Norwich Mercury in July 1753, when Henry was on his final tour. Without the final two lines it forms an introduction to Edward Davies' *A succinct description...* printed at various sites where the show appeared in the decades after Henry's death. It opens by praising the arts in their role of improving the quality of life, an argument often made by modern artists and art therapists.

Next, it recommends technology for both recreation and education, claiming mechanical arts can teach "more than Rome knew, or Grecian sages thought."[14]

He then aligned The Microcosm with the work of Newton, echoing the presence of the great man's image on The Microcosm's print, so was an inspiration to mechanics and scientists. It praised the combination of science and technology, urging viewers to become inventors

themselves, a twist on the Good Samaritan's "Go thou and do likewise" which was so potent at inspiring charity.¹⁵

National pride is invoked; reflecting the long-standing rivalry with European nations, but there is also condemnation of their saints' images:

> "French and Italian Puppets pleas'd too long,
> And English sense was barter'd for a song;"¹⁶

The mention of France and Italy suggests this was not just nationalism; it was also condemning Roman Catholicism, which in France had turned fellow Protestants, the Huguenots, into refugees. Many of them, such as the silk weavers brought much-needed skills and knowledge of technology to these islands. The poem ends with an exhortation to the English to become inventors, to encourage local skills and ingenuity, a rallying cry for them to recover from decades of self-inflicted losses:

> "Dare to invent yourselves, to Fame aspire,
> Be justly warm'd, with own native Fire."¹⁷

This poem reflects England during the Augustan Age, flexing its military and financial muscles, claiming Britain was already outshining European rivals in technology.

It is significant where this poem was published: in the eastern counties, the former heartland of the Puritans and home of Cromwell, a region particularly adverse to puppets and luxury entertainments. But it was also a low-lying region, subject to floods and coastal erosion, where extensive drainage had been carried out by engineers from the Low Countries. Thus there were strong links with European Protestantism, especially the area that became Belgium and the Netherlands which was for so long under the control of Catholic Spain.

We have no record of how The Microcosm travelled or was promoted beyond the above printed material, but David Paton-Williams describes Katterfelto's business practices which were probably well established and followed by other shows. He would establish himself in a respectable part of town, and pay a few shillings for advertisements in local papers in which he announced his arrival as a famous educator who had astonished audiences in previous towns.[18]

Paton-Williams noted the increase of provincial newspapers, but handbills were also needed in advance at venues, distributed in the streets or posted on walls. In January 1750 The Microcosm's advertising included "bills, containing more particulars (though falls short of a full description)" given away at the place of exhibition and various other sites. They included a woodblock image of the clock.

Where Katterfelto seems to have stood out was his use of black servants dressed in livery who would announce his arrival with trumpets. In isolated towns, this must have made a huge impact, but is a practice which suggests he was more a showman than a scientist. Or like Henry and many others, doing what he could to survive.

An unknown number of octavo pamphlets, describing The Microcosm titled *A succinct description...* were produced. They served as a textbook, souvenir, and for publicity. Sold at venues, they ran to at least thirteen editions. But they appeared in 1760, after Henry's death, so were not of his instigation. The pamphlet included quotes from what were claimed to be the finest writers of the day, such as Pope, and ends with a wonderfully detailed poem in good Latin, so its unknown author was classically educated. Pope was cited in the Latin poem which was part of *A succinct description...* as Pegasus was included in the muses scene at the top of the structure. The flying horse was shown "riderless, now that the harsh Fates have seized his master, Pope". The machine was built when Pope was still alive, so this image has been misunderstood — probably on purpose — by the author of the poem. Just as the machine evolved over time, so did its publicity. The use of Latin shows that at least some of the expected audience was grammar-school-educated, but some women also managed to acquire the classics either via the encouragement of relatives or were

self-taught. Though the image included seems to be copied from the original copperplate print, the text provides details on the various additions, but not of the perpetual motion machine, so it proved to be far from perpetual.

Later editions of the pamphlet included updated details on the size, speed and distance from the sun of the various astronomical bodies as new discoveries were made, but strangely these appeared as footnotes, rather than replacing the original. For example, on page ten of the twelfth edition, the diameter of the sun is claimed to be over 800,000 miles, making it 1,000,000 times larger than the earth. But this is corrected with a footnote stating: "By some late calculations of a learned professor of mathematics, the Sun is 2,735,535 times as large as the earth."[19]

Why was this eminent professor not named? And why leave the original calculation in situ? Perhaps the intention was to show how science had progressed, so mirroring the inclusion of the Ptolemaic and Copernican systems displayed on the clock. Or were the machine and pamphlet demonstrating the progress of science, suggesting more answers will be found, so urging viewers to participate in the search for yet more accurate truths? As the story of the Good Samaritan urged, were they to emulate what they saw? The showman must have travelled with his own printing plates, to which he added new discoveries as they were made. This saved him time and money as printers did not do the typesetting.

On page thirteen of the pamphlet, an eminent astronomer is named: Mr (William) Whiston (1667–1752), an eastern counties cleric, natural philosopher, friend and promoter of Newton's ideas who advocated an astronomical explanation for Noah's Flood. He was expelled from Cambridge for expressing unorthodox religious views but was one of the promoters of the Longitude Prize for which he submitted several schemes. *A succinct description…* pamphlet quoted his estimate of the relative size of the earth, as being a minuscule part of the universe "as a drop in a bucket".[20]

The citations in the book such as Pope and Whiston were from Henry's world, the Augustan Age, rather than the better known

period that followed his death. Many items he used in his press puff were used in *A succinct description*... so his spirit lingers in its pages.

It is unclear when the promotional pamphlets for The Microcosm were first produced but the first on record seems to be from 1761, i.e. after Henry's death, so cannot be attributed to him. Whilst it provided extra income for the proprietor, it also provided a printed record of the most up to date astronomy and being much cheaper than a bound book, could be used for discussion and educational purposes long after the show had moved on. About the same time Benjamin Rackstrow's Museum opened, providing a mixture of curiosities and the reproductive section of Dr Hunter's museum. He also produced a guidebook which described sexual anatomy and pathology in scientific language, so was intended as a source of education for both sexes, so providing a radical combination of art and science.[21] These pamphlets suggest how effective Queen Anne's promotion of education and publishing had proven, as literacy was widespread by the middle of the eighteenth century.

When Henry first put the clock on show, he intended it for an upper class audience, as the admittance of two shillings sixpence was at the time more than a day's wages for the most skilled tradesman. The same price was charged by Katterfelto for two decades up to the 1780s, though this was for the best seats, with one shilling for servants and children. But in later years The Microcosm's proprietor sometimes lowered his charges, especially in Ireland where entry was a mere British sixpence, and held shows in the evenings to encourage attendance by servants and children, who were at work or school by day. This may have been purely a financial measure, but it allowed these lesser mortals to acquire education beyond their limited schooling.

Despite the many varied shows with which Henry competed, his still stood apart. Its displays, its promotion, the lectures, the information pamphlet are all important, but there is more.

Henry was born into a world when the English were emerging, blinking, into the light after two centuries of ignorance and chaos. The rigid hierarchy that held society together with God and the monarch at the top and the vast majority of people powerless at the bottom had been shattered. Bishops had been hanged, a king had been beheaded. Decades of debate on Christian belief and practice gave rise to a vocabulary of argument and demands for proof that helped lay the foundations of modern science and democracy. The English had been deprived of their beloved rituals, lost faith in religion and their leaders, and were getting on their bikes to find answers in an age before bikes were invented. The world was not their oyster; it was a vast, confusing and often dangerous territory to be explored by those with the courage and vision to take the first steps. Some authors claim these scientists were crossing or breaking boundaries. But they had to build up the information to be able to write the rules before they could be broken. It is this early work which is so poorly recorded, hence the invisibility of so many people in this story.

In August 1753 shortly after launching his perpetual motion machine, Henry announced his intention to print *The Four Books of Palladio*, translated by the Surveyor Royal Isaac Ware. This was the seminal work on classical architecture; several translations had been made, but were either incomplete or deemed not authentic enough. The champion of Palladianism, Richard Boyle, Earl of Burlington, had commissioned Ware to translate the work and engrave Palladio's sketches.[22] The engravings were printed in reverse, which seems to have been common practice, and it was immensely popular when published in 1738, which further encouraged the spread of the style. The book was in such demand that no copy was available in the American colonies until Thomas Jefferson imported one, which at least partly explains why there was such a huge difference between the architecture of the American colonies and of Britain. Though of course they did have a lot of large trees.

This style was a reaction to the many old, often gothic-style, mouldering fire hazards that made up so much of the built environment at the start of the eighteenth century. When the economy began to

recover after the War of the Spanish Succession, new builds were simple, clean, fast to build and fireproof, as echoed by developers in Britain after both World Wars. The Grand Tourists returned with a passion for Palladian mansions which made tapestries and wood panelling on walls redundant, providing space to hang paintings brought back from their travels, so established a market for fine art. In its diluted form, Palladianism is still the default style for mass-produced housing in modern Britain. Both found favour in part due to post-war manpower shortages. Palladianism's simple style was seen as displaying honesty and democracy. It is often chosen at the dawn of a nation's rise, hence it was chosen for the White House in Washington. The simplicity also allowed the transition and reskilling for carpenters to become masons, so helped expand the membership of the Freemasons. It also encouraged the practice of tradesmen, especially carpenters, to 'throw away their apron' to become master builders, and even architects.

Burlington became known as *the architect earl* and the *Apollo of the arts* who championed the style, together with his friend and protégé the architect and designer William Kent. His villa at Chiswick was the ideal, based on Palladio's 'Villa Rotunda' and his urban showpiece was his palace on Piccadilly by Colen Campbell, now rebuilt as the Royal Academy.[23] He designed and paid for the Assembly Rooms at York where he combined the roles of patron and architect.

But why did Henry in the midst of a tour with his giant clock suddenly branch out into publishing? Perhaps this wasn't a change of direction. It is possible he already produced the handbills, though not the newspaper ads as they were so varied

Henry was struggling round the eastern counties with his show, so may have been desperate for a new source of income. It was after the war, there was widespread unemployment and crime, so he may not have been making much money.

If he already owned an edition of Palladio, he could have just copied it. But printing another's work would be seen as dishonourable, so it is unlikely Henry would have stooped to this. G.A. Stevens claimed his book *A Lecture on Heads* was widely pirated, and he

often bemoaned the theft of his work.[24] Queen Anne's Statute, the copyright law, only ensured the author's original printer paid up; with so few skilled in the trade, it would have been easily monitored. But as with so much of British history, the law often failed to keep pace with practice. It did not extend to rogue publishers who became a plague to many other authors up to the time of Dickens. Francis Meynell cites a complaint from 1757 when as soon as a book became popular, a smaller, cheaper version was brought out for which the publisher did not have to pay copyright fees, so the system unwittingly encouraged piracy.[25] Even if it was relevant, enforcing the law was expensive and time-consuming. This suggests Henry knew Ware and that some sort of agreement had been made with him, or perhaps Henry merely hoped this would happen. Publishing would have raised Henry's reputation, hence that of the show, and he could have sold copies at the performances.

Within days of his advertisement, proposals were invited for people to print Palladio's books. Burlington died in December 1753, leaving no one with the wealth or interest to underwrite the venture. By the 1730s aristocratic patronage for publishing was in decline, and subscriptions were filling the void, by the many 'middling' sorts of people who contributed to build assembly rooms and other improvements. They were thus produced for a known audience rather than on speculation, forerunners of modern crowd funding.

The agricultural depression of the 1740s produced the 'lost decade of English architecture'. Ware's role as Surveyor to the King was mostly to approve major commissions, but this did not provide a livelihood so he still needed commissions. Masonry skills had improved to allow more ornate workmanship and Palladianism was breathing its last to be replaced by the 'Gothick' promoted by Horace Walpole at his masterpiece of Strawberry Hill. The discovery of Herculaneum in 1709 and Pompeii in 1748 introduced a more delicate, decorative style as promoted by Robert Adam. By the 1750s pattern books were published by carpenter/architects William Halfpenny and Batty Langley promoting the styles of Gothick and Chinoiserie, showing not just a change of style, but a shift in the promotion of

architectural fashion from gentlemen amateurs towards master builders, from grand estates to middle class villas.

There was a two-year wait, when in November 1755 an announcement was made that Ware's new book, *The Compleat Body of Architecture* was to be published,[26] this time in weekly editions, confirming the absence of a wealthy patron to take on Burlington's mantle, but also to ensure sales. The first instalment came out in January 1756,[27] with the rest following till October 1757. Another long gap was ended when in March 1768.[28] Ware's version of Palladio's *The Four Books of Architecture* was finally republished, but in six-penny instalments. But by then the interest was from antiquarians rather than gents seeking inspiration to build country houses in the style. The world of architecture had seen a revolution in the time Henry's Microcosm had been on the road. His use of a Roman temple as inspiration was old-fashioned by the time he died.

There is a further hint of a family connection with the Royal Surveyor, from when Henry's son James was rebuilding Bristol's mediaeval bridge. He took his plans to Ware, who told him he could offer no improvements, and refused to accept any payment.[29] This shows James was keen to refer to a proven expert, but does this also suggest some link via his father? Or perhaps the world of engineering was still small enough to allow him to ask the assistance of a respected stranger.

There is another — albeit tentative — link between the Bridges and Ware. The first Palladian mansion in Bristol, and the only one by a major architect, was Clifton Hill House, built by Ware in 1746–50 for the linen draper and ship owner Paul Fisher.[30] It is unclear who actually worked on the site as it is unlikely Ware was involved beyond the designs. Could James have been the clerk of works here? The Freemason on the project was Thomas Paty, a prolific carver who became an architect and developer who took on the rebuilding of Bristol Bridge and St Nicholas' church after James fled in 1763 after wasting years in a struggle for respect and acceptance. When James arrived in Bristol he claimed to know few people, but he must have had serious backers to have been appointed surveyor with no work

history. Were those backers Ware and his circle? Was it perhaps on the recommendation of Ware that James settled in Bristol in 1755 after his tour of the colonies? James also worked on Redland Chapel, again with Thomas Paty, for John Cossins, a former bookseller of St Paul's churchyard, so another London connection which may have brought James into the area.

11

TO THE CURIOUS

Many advertisements for The Microcosm from the mid-eighteenth century were addressed to "The Curious". A *succinct description...* claimed:

"A description of this inimitable piece of art must be acceptable to every person, who has any degree of curiosity."[1]

But what did curiosity mean here?

'Curious' is a curious word, with positive or negative connotations which change through time and context. Famous examples involve Eve, Lot's wife and Pandora: all negative, all female, suggesting a misogynistic bias.

Curiosity suggests risk taking, a departure from a person's comfort zone. But it has largely retreated to the worlds of *artspeak* and personal ads, a reflection of our increasingly safe and sanitised world. But for our ancestors, danger was not a lifestyle choice. When a family or tribe was under attack from wild animals or enemies, or dealing with natural disasters, united action was essential for their survival. If a fire broke out, or a storm approached during harvest, all able-bodied people rushed to help. Questioning orders in the military is still punished for the same reason. But leadership skills are often acquired by exercising curiosity, by investigating ways to make or do things

better or more efficiently. Curiosity was — and is — an essential quality for leaders as it helps them make informed decisions, but it was seen as a dangerous quality in the ignorant and unlearned.

Especially women.

When women married they became legally invisible. Under the Law of Coverture, the man provided protection for his wife who obeyed him in return, just as Christ protected his followers. But women were not always as passive or powerless as this arrangement suggests. Daniel Defoe urged women to learn their husband's trade to avoid poverty should he predecease her, so they were expected to run the business and family as efficiently as a man. In mediaeval times, men were often away from home: as traders, at war or on pilgrimage, leaving their wives to act in their stead in business and family matters, as did widows. During wars, women defended their homes and town gates. Lurking beneath the official male histories are the stories of women trained in men's skills, whilst still fulfilling their traditional roles as baby makers.

Married couples were a team, working the land or running small businesses and raising their children. They were often described as being yoked together like oxen, which seems demeaning, but it demonstrates how they had to adapt to each other, adjusting their pace to walk in time, to learn to compromise so they could live together in harmony. Some trades such as masons, carpenters, drovers and maltsters were seasonal and took men away from home for long periods, which left most of the heavy agricultural work to be done by women. Images of sturdy, sometimes barefoot, nineteenth century French peasant women by artist J.F. Millet show they were not creatures to be messed with.

Most families in Britain could not afford to keep their children, so sent them into service, often at the local manor house or as apprentices from an early age. Few families could provide dowries for their daughters, so girls had to work and save enough to set up house when they married. They learned to fend for themselves and manage their finances; the independence they acquired helped them find suitable partners when they married in their mid- to late twenties.

Christian faith and its visual expression in the various arts and architecture, flourished in the Middle Ages. Every element in a church's design was carefully chosen to represent, explain or inspire faith. But this disguises two distinct periods, divided by the disaster of the Black Death, which triggered a huge shift in belief and practice. The early period — of wealthy monastic houses, illuminated manuscripts and masterpieces of art — suggests life had a timeless, even dreamlike, quality to it. Patrick Mauriès describes how collections of relics, valued for their alleged holiness and healing properties, formed the basis of the first cabinets of curiosities in churches. Initially items chosen were those attributed to Christ, such as fragments of the True Cross, but as the cult of saints grew, objects and their associations became more varied and tenuous.[2] The relics imparted a sense of wonder and the miraculous. But after the plague, faith in the church was challenged as piety provided no protection. Belief in the miraculous power of saints faded, their relics became curiosities in their own right, acquiring an air of magic through alchemists and practitioners of the occult.

The shortage of skilled tradesmen after the Black Death caused architecture to be simplified, shifting from the ornate, decorated gothic to the simpler perpendicular style, as mentioned earlier. Pevsner goes further by claiming the concept of architectural continuity and the use of space was also transformed in Britain. The wooden roofs which replaced stone arches, though equally complex, were the work of joiners and shipbuilders.[3] This was possibly due to the loss of skilled masons, but could have been the result of poor transportation, which created a shortage of stone. Areas such as Ely were far from quarries, but England still had large areas of forest.

People became more mercenary, focusing on living in the moment, choosing to spend their money on earthly comforts rather than preparing for the afterlife. Many of the elite were killed which made room for surviving commoners to rise up through the ranks. When faith failed to halt the carnage, people turned to experimenting and investigations into treatments; they produced texts written in local languages rather than Latin to help spread and share knowledge.

But most importantly for this story, there was an explosion in interest in technology to fill the space left by labour. In every field of human endeavour, enormous advances took place. The post-plague era gave us guns, clocks, eyeglasses, crossbows, compasses and the printing press, inventions described by John H. Lienhard as the "pot of gold" at the end of the rainbow following the plague storm.[4] The small worlds of craftsmen were expanded by these new tools, which in turn encouraged further invention and discoveries.

Religious practices adapted to the manpower shortage, with musical clocks introduced to cover the lack of musicians, perhaps also to reclaim the sense of wonder in an attempt to retain worshippers. Relics were collected to form the first curiosity cabinets. But even at this early stage, such strange objects served a purpose. They became tools used in investigations, foci for rituals attempting to explain what the Christian church could not.

In Italo Calvino's collection *Italian Folk Tales* is a fascinating story, *The Canary Prince*,[5] a variant or perhaps precursor of the famous Grimm's tale *Rapunzel*. It tells of a witch who locks a beautiful princess in a forest castle where she is seen at her window by a yellow-clad prince out hunting. By turning the pages of a magic book she transforms the young man into a canary; he flies up to join her in the tower where she turns the pages back to restore him to human form. This suggests not only relics were seen as having magical properties, but books themselves, which were often included in curiosity cabinets.

Ornately decorated tomes were mysterious, powerful objects, seen by few in the secular world. Their production was hugely labour-intensive and served as a form of meditation for both artist and reader. Gerald of Wales claimed they enabled the viewer to enter into art's shrine, that such work seemed to be beyond that of humans, more of angels.[6] Many of these manuscripts were painted with several frames, allowing the viewer to see multiple worlds at the same time, so were means of interpreting and interacting with the scenes, so were almost a form of performance.

This chaotic late mediaeval period seems to have led collectors to

favour dead things, to crave stillness and continuity to balance their dangerous, depressing outer world. Mauriès talks of men being "oppressed by the cares of the world". The chaos continued for many decades, in the midst of religious disputes as city states and infant nations struggled to establish their boundaries.

Michel de Montaigne was born in 1533. He wrote *On Solitude,* in which he described how to build a cabinet of curiosities. He recommended establishing a space of solitude, of asylum, to be free of interruption where a man could be himself. This echoed the behaviour of early Christian hermits who sought solitude to commune with the divine, to test and deepen their faith and connect with God and the infinite. The antiquarian and diarist John Aubrey (1626–97) wrote of his regret at the devastating changes caused by the Reformation with: "I wished Monasterys had not been putt down... there should be receptacles and provision for contemplative men."[7]

When Grand Duke Francesco de Medici's reputation was drowning in a sea of scandal, he withdrew to his garden house at Pratolino and the laboratory built by Vasari in the Palazzo Vecchio, where he spent much of his time in the company of his goldfish and a Swedish reindeer. He planned an art gallery in the Uffizzi and an academy for purifying the Tuscan language to help maintain the region's supremacy. He studied chemistry and alchemy, became an expert in glassmaking and gemstone cutting and pioneered European porcelain manufacture. But his isolation and mysterious self-improvements led to accusations that he was consorting with a witch. So withdrawing from the wider world could have serious consequences.[8]

Cabinets of curiosities in late mediaeval churches demonstrated the range and power of God's creation; they were used to inspire contemplation of the sacred and help to connect with God. In the Abbey Church of St Denis their treasure was displayed as a miniature universe with the most prized relics at its centre, surrounded by lesser items. The wealthy had private chapels and funded altars in churches and cathedrals, some of which included relics. They established private collections which in time expanded to include non-religious curiosities. The sense of curiosity survived the Reformation to reap-

pear in new forms beyond the religious houses. At first they were hidden to avoid the attention of iconoclasts, but this imparted to them an aura of black magic, as in the collection of John Dee.

Religious institutions and secular rulers had treasuries full of exotic items. They were often depicted as being on display, like images of overflowing chests of pirates' treasure. But they were usually locked in chests for extra security, which allowed them to be removed quickly in a crisis such as the approach of enemies. In the absence of banks, these objects could be sold for funds in emergencies.

When Europe at last recovered from the waves of plague and wars, collecting shifted from being an act of survival to become a pleasurable activity for the rich, who collected fine art which they displayed in special rooms for their enjoyment and enlightenment. The first such collector seems to have been a woman, the Archduchess Margaret of Austria, daughter of Maximilian I, who appointed her regent in charge of the Netherlands in 1507. Her home in Mechelen became a centre of art and scholarship where she collected fine art and curious, often exotic, objects from the New World. Margaret gave her guests tours and became an important early patron of artists.[9]

The first purpose-built cabinet of curiosity in the form of a museum in Germany seems to have been built by Ferdinand I on his Hofburg site in c.1558. Few details of the contents survive but it included a range of antiquities and even a unicorn horn.[10]

Julia Teresa Friehs describes Emperor Rudolph II's Kunstkammer (plundered by Swedish troops in 1648) as one of the most famous. He was the greatest of all collectors, combining a boundless curiosity with near-limitless wealth. His collection was inspired by those of Charles V and Phillip III of Spain. He loved stones which demonstrated God's glory, representing and uniting the essence of the world in them.[11] St Denis wrote of the coloured light which shines through coloured glass and gems which represented the Divine Light of God and served as aids to meditation and prayer. Collectors often sought similarities between manmade and natural objects, representing the micro- and macrocosms, and how they reflected each other, so could be used to interpret and explain their world. The connections were often high-

lighted by mounting natural objects in ornate settings, linking the two realms and elevating natural objects in value. It also echoed the earlier display of religious relics.

This helps explain why early scientists such as Newton were not troubled by the modern conflict between religion and science. Many objects were collected for their value in both realms, reflecting the particular interests of the owners. Some reformers objected to them for being a waste of money that could be better spent feeding the poor, that the objects were devoid of meaning, so a waste of time. But as natural philosophers investigated the complexities of the world, they saw the hand of God in its creation. It was impossible for them to conceive that such wondrous objects, that such creatures — especially humans — could occur by mere chance. They practised curiosity but guided by wisdom and piety rather than the older belief in the miraculous. Curious objects inspired investigations into what they were made of and their purpose. Collectively, these investigations helped create an expanding base of logical, repeatable experiments, so curiosity became a tool for scientific advancement.

Another, closely related use for these objects was as a form of appeasement. The V&A's Wrangel Cabinet of c.1580 was purchased by the Duke of Braunschweig-Lünenburg at the end of the Thirty Years' War. Looting was common practice by victors, tolerated as payment for soldiers who risked their lives in battle for low pay. This cabinet was presented to the Swedish naval and military commander as a plea for him to control his troops. The ornate cabinet, with its curious contents, showed the commander was seen as a man of intelligence and culture, a diplomat as much as a warrior.[12]

The Christian objection to the use of graven images, or icons, was based on their central role in ancient pagan city states such as Athens. The city's name comes from Pallas Athene, a statue believed to be crucial in protecting the city.

A modern parallel comes from the dark days of World War II. On the night of 29/30 December 1940 London was subjected to twelve hours of bombing by the Germans. The Thames was at low tide, so there was limited water to fight the many fires. Churchill ordered that

London's icon, St Paul's Cathedral, was to be saved at all costs. It survived, though thirteen other Wren churches were lost.

When major religious houses were closed during the Reformation, their wealth was acquired by merchants and aristocrats who took over many of their responsibilities. But they also inherited the opposition to their lavish spending. Rising affluence in the late sixteenth century muted these complaints as the practice of curiosity collecting shifted from religion to corporate culture. Collections shifted from seemingly random groups of curiosities to fine art and artefacts; some became large and valuable enough to represent city states as icons.

Freed from religious restraints, some elite collectors became obsessed with collecting as a goal in itself. The Dukes of Mantua had a huge art collection which became the pride of their city but the dukes themselves were more interested in collecting dwarves, so they sold it to Charles I in 1627-8 for twenty-five thousand pounds. Unfortunately for the Huguenots besieged by the Spanish in their fortress of La Rochelle, this overstretched Charles's finances, rendering him unable to fund their relief. After it fell, Rubens became the Spanish peace negotiator in London where he was commissioned to decorate the Banqueting Hall at Whitehall.[13] Across Europe, collections which had been the pride of citizens were pillaged and redistributed during the Thirty Years' War, weakening small principalities and paving the way for modern nation states. But Charles's collection did not remain intact for long, as it was mostly sold by Oliver Cromwell to fund his wars.

Henry was referred to as the builder, the owner, but most importantly, the author of The Microcosm. In modern usage this suggests he was a writer, but it can also mean an initiator, a person who brings a thing into existence. More recognisable in this sense is the word 'authority' which carries immense weight. God is the ultimate authority, and he was the author of the world which began with the Word. So

there is something godlike about Henry building his little world, representing the macrocosm built by the supreme deity.

The Authorised Version of the Bible was translated by the finest scholars of the age and defined the words of God. It also provided the framework for English Protestant practice. The English Reformation was violent and long-lasting because it was initiated by the monarch, so was a religious dispute as well as a matter of national unity and to reflect English Protestant beliefs. The curiosity applied by the writers of the Authorised Version made curiosity unnecessary in its readers. It was a book aimed at generating peace and unity, to put an end to decades of religious disputes.

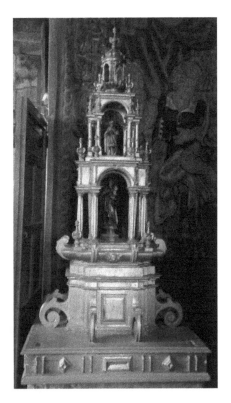

Gilt Belgian processional reliquary, Snowshill Manor, Gloucestershire. Reproduced with permission of the National Trust.

The Roman temple component of Henry's machine, with its ornate

Corinthian columns resembles the towers of Wren's St Paul's Cathedral and can be seen crowning important Victorian buildings such as the London Coliseum. At the time it was built, it was the largest, most iconic venue in the capital. But it is impossible to identify a single source for The Microcosm. The only artefact that comes close is described as a Belgian Processional Reliquary of unknown date, now at the National Trust's *Snowshill Manor* in Gloucestershire. This is a former farmhouse purchased in 1919 by the architect Charles Wade. He inherited a small fortune and devoted his life to collecting objects to create a modern cabinet of curiosities. As a child, he was sent to live with his grandmother whose austere drawing room contained a Chinese cabinet. He described their Sunday ritual which has religious and magical elements when the doors opened to reveal the contents, scented by camphor. The interior displayed "a Palace fit for the Greatest Mandarin"[14], a claim which echoes many of the Microcosm's advertisements. It included relics from his grandmother's childhood such as an angel from a Christmas tree and bone models of ladies and of a Spinning Jenny. It also included two music boxes, reflecting the inclusion in many curiosity cabinets of pieces of technology and clockwork. So this cabinet was a microcosm of several other microcosms.

It is easy to see how a solitary child could be fascinated by such an unusual object, its sense of wonder and drama when the doors opened enhanced by his limited access to it. But the cabinet also reflected his grandmother's taste, so represented her life in miniature, a microcosm of their family's history.

Wade trained as an architect but was frustrated by the lack of imagination involved, so he illustrated a book on an imaginary country house, and built a tiny village, or microcosm, for the author's daughter. He also collected small 'curios' from an early age. After serving in World War I, he travelled widely to collect and restore neglected artefacts, creating dramatic tableaux in his home. Like many ex-soldiers, he withdrew from the world, echoing the recommendations of Montaigne, but unlike the philosopher, he was not alone. Visitors joined him to perform amateur theatricals with the collection as backdrops. These included the poet and building conservationist John

Betjeman and Clough Williams-Ellis, founder of the little world for unloved buildings at Portmeirion in West Wales.[15]

Like the survivors of the Black Death, Wade's post-war generation retreated from the big outside world; unlike Montaigne, they were able to move to the countryside in search of an imagined rural idyll. The West Country was far from the bloodshed of Flanders. It became home to members of the Arts and Crafts Movement who encouraged traditional crafts in opposition to mass production and some practised unusual marital and family models. These artists and the better known hippies who flourished in the wake of World War II were the ideological descendants of the garden designing, poetry writing Augustans who were also recovering from prolonged chaos and danger.

The practice of withdrawing into a private world continues into the present day, perhaps more than ever as people become overwhelmed by the rapid pace of change.

There is also a mostly British group who collect, build and operate model train sets. They have much in common with clockmakers as they constantly tinker with their little worlds; there is always something more to add or to adjust. Famous train enthusiasts include Rod Stewart who even takes his set with him on tour, and Pete Waterman who also collects real trains. Waterman's collection of miniatures represents the microcosm to his macrocosm of real trains, and both realms together represent a past world now overtaken by the modern realm. Like wealthy magnates of the past, they have found respite from the demands of their work, their families, and the noise and clutter of modern life. The literary and cinematic genres of science fiction and fantasy — but especially the new media forms such as gaming and virtual reality — provide worlds where ideas can be investigated and tested, some of which have made their way into real world science.

The world of curiosity cabinets is largely a male realm, but there is a surprising parallel path involving women in the form of doll's houses, the only form of cabinet that is still popular. The V&A's Museum of Childhood has an impressive collection of them. They

were known as 'baby houses' or small/doll's houses, from German Docken- or Puppen-haus. The first seems to have been built for Albert V of Bavaria in 1557–8, a four-storey exact replica of aristocratic houses. It was primarily an architectural object, with masses of accurate detail. Dutch houses were mostly versions of tabletop cabinets for wives of rich merchants. They included miniature versions of domestic objects, so demonstrated status rather than curiosity. But in both cases, the furniture, decorations and even china and cutlery were finely worked miniatures of reality. The Duke of Pomerania commissioned a miniature farm a century later; it included a humbly furnished farmhouse. This contrasted with the expensive contents of the main building, which may have had some didactic or moral role, perhaps to encourage charity.

Doll's houses were often made as elite objects. Queen Mary was famous for her love of tiny, 'bijoux' objects, which may have been a response to her impoverished childhood. She became a major — and surprisingly radical — royal art collector. Her passion also brings together two strands of collecting: the doll's house and the cabinet of curiosity. After the First World War she commissioned a doll's house to represent a domestic image of the British Empire. Monarchies across Europe had suffered, especially in Russia. She built a doll's house to represent in miniature the finest of British workmanship. It included guns that could be loaded and fired. The books in the library were real, and Conan Doyle provided a special Sherlock Holmes story to be housed there. The house represents a timeless Britain in miniature, a reminder of a grandeur that would never be seen again. This is a miniature Xanadu or Camelot; a microcosm of a world that was lost with the young men who would have lived there. In the Latin poem included in the pamphlet *A succinct description...*, The Microcosm was described as "a noble house of excellent art, despite its diminutive frontage".

Protestants were freed from the costs of supporting huge monastic establishments and paying for indulgences to reduce their time in purgatory, so they had more money to spend on domestic improvements such as furniture, wall and floor coverings, china, glassware etc.

This in turn led to a demand for more complex and varied cookery and household management for the rising middle classes. Doll's houses were used to educate servants, housekeepers and wives in the decoration and maintenance of modern homes, helping them prepare for marriage.[16]

From about 1492, many books were produced on topics such as needlework and household management. Doll's houses provided instruction to the illiterate girls who entered domestic service from the 1600s. In the V&A Museum is a framed diorama called a *vanitas* from c.1659 which demonstrated the transitory nature of life. The figures were modelled in wax by nuns, a cheap, labour-intensive resource for the church which became redundant in Protestant countries. Throughout much of European history, there were far more ways for men to die, so there was always a surplus of women in need of employment or charity. This suggests some poor widows and spinsters were put to use making doll's houses after the Reformation.

The behaviour of nuns quietly producing crafts of various sorts seems to have segued into the Protestant, secular German concept of women sitting quietly but productively, referred to as 'stillsetzen' which became 'sittsamkeit', i.e. modesty or demureness. This practice was taught — or rather, forced onto — women such as Caroline Herschel from an early age, and was used to justify her exclusion from male employment and pastimes. Unable to beat the system, she made good use of her time sitting and knitting to listen and learn from the men in her house. It proved to be an invaluable skill when she became an astronomer, sitting outside at night patiently watching the heavens.[17]

For many centuries women passed their evenings on handicrafts, but especially in spinning; hence the pastime provided the term *spinster* for a single woman who had to support herself by this means. H. Grey Graham described the squalid living conditions of the rural poor in Scotland in the eighteenth century, but their lives were leavened with enjoyments such as holy days and fairs. Folk in southern Scotland gathered in the evenings to sing, dance and tell traditional stories.

"On moonlight nights they held their favourite meetings in barn or cottage, called 'Rockings' when young women brought their rocks and reels, or distaffs and spindles, — where young women assembled and to the accompaniment of the spinning of the wool and flax, the song and merriment went round. When 'rocks' were no more used, and spinning wheels had taken their place, still by the familiar name of 'rockings' were these merry social meetings called."[18]

An English poet, Susan Blamire (1747–94) makes the point more clearly with:

> "I've gotten a rock, I've gotten a reel,
> I've gotten a wee bit spinning-wheel;
> An' by the whirling rim I've found
> How the weary, weary warl [world] goes round."[19]

Thus, the productive pastimes of spinsters, and the events that helped many of them become wives, paved the way for modern popular music.

Unfortunately the earliest history of doll's houses in England has been lost, but the oldest were mostly made by carpenters or cabinet-makers for the use of adults, possibly as masterpieces for cabinet-makers or perhaps recycled from architectural models such as the one produced by James Bridges which survives in Royal Fort House at the University of Bristol. There were few before the Restoration, but they became popular in the mid-eighteenth century and their contents were obtained from the many sellers of trinkets, so they echo the role of cabinets of curiosities.

The many miniature items must have been made by people with small, nimble fingers, so mostly women and children, as were many parts of clocks and watches. This in turn suggests a huge pool of poor in need of employment, which kept costs down. Britain's many wars which produced so many widows, orphans and spinsters, also provided a large population to make tiny mechanical parts, which

played a large —though now forgotten — role in the early Industrial Revolution.

Unlike Europe, Britain did not produce great aristocratic or scholarly collections. The famous Elizabethan plant collectors the Tradescants created a museum called *The Ark* at their home in Lambeth, which later formed the basis of Oxford's Ashmolean Museum. It aimed to represent all the art, nature and culture on the planet. A catalogue of its contents was published in 1656 and it was open to the public with an entrance fee of sixpence. Don Saltero's popular *Coffee Room of Curiosities* at Chelsea was claimed to be less an early museum, more a "chaotic place of conversation, consumption and exchange"[20] where curiosities formed a background for customers to drink, smoke and enact their business. A German traveller described how visitors paid to see its mixture of exotic animals, costumes and artefacts adorning the walls and ceilings.

The Irish physician Sir Hans Sloane (1660–1735) was so obsessed with ownership of his curiosities that his will was written with so many codicils that it became a curiosity in its own right.[21] But his collection reflected his very busy and varied life. He spent two years in Jamaica as physician to the governor, the Duke of Albermarle; he returned with eight hundred plant species and curiosities associated with the slave trade. He co-founded the Royal College of Physicians, established the Chelsea Physic Garden as a centre of research for the Society of Apothecaries, and promoted and practised inoculation for smallpox.[22]

Sloane was mocked for his indiscriminate and voracious collecting. Like many collectors, his passion was almost an illness, an insatiable hunger for knowledge which reflects the huge loss of books and knowledge caused by England's painful, drawn-out, disputed Reformation. Scattered through literature from late seventeenth century England are examples of Britons displaying a childlike sense of wonder, as if let loose on the world without parental supervision.

People like Pepys were often noisy, funny, drunken and rude, but always busy, always seeking answers from a god that seemed not to be listening, so they blundered upon their own solutions to problems.

Henry VIII's uniquely top-down Reformation, the cavalier destruction of community beliefs and rituals, caused immense harm to these islands, but because the victims left no accounts, the full impact has been lost. Yet these same gambolling man-children (and a few women) set about improvements in science, education and society. They blundered into an empire with no map or adult advisers. Curiosity was their inspiration and their comfort. It drew them into personal and business relationships as they struggled to rebuild their battered country.

In the mid-eighteenth century, Sloane's plant collection became the basis of the Natural History Museum in London, moving science into the public realm, so was an act of altruism and democratisation, to inspire national pride. Collecting became an act of benevolence as it encouraged learning.[23] The great promoter of exploration Sir Joseph Banks was president of the Royal Society; he helped collect and preserve natural history samples from Captain Cook's voyages to the South Seas. But he was mocked for being a dilettante as he showed little interest in arranging or categorising his discoveries, so was not considered a scientist.

The establishment of public museums was a further stage in collecting, as curiosities shifted from the public space of a church to a private realm of the collector back to the public — but now secular — sphere. At each stage, the collection was arranged, displayed and explained in terms of the founder's, or curator's, philosophy and knowledge. Objects survived in their physical state, but their back stories and often their sense of wonder were lost.

In 2013 Bath's Holburne Museum held an exhibition, *Secret Splendour*, displaying ornate seventeenth century curiosity cabinets. The accompanying pamphlet[24] claimed collections were divided into the natural and manmade, reflecting the microcosm and macrocosm. But as collections expanded, owners discovered and/or developed particular interests. Some focused on fine art, on books, coins or weapons.

They obtained or commissioned paintings when they could not obtain the original objects. An important trade developed in curiosities as collectors obtained or disposed of items depending on their interests. This echoes the trade that developed in relics before the Reformation; both were condemned for wasting money and for having no useful purpose. Thus the few collections that survive are the final form, the moment the music stops in a game of musical chairs. The full story of the collecting and arranging is lost.

Classifications expanded along a chain of similarities, from natural objects to nature which resembled art, statuary made of natural objects, fine art, tools used to make the art, automata, navigational and astronomical equipment and finally books, but as examples of fine workmanship rather than the texts. From mediaeval times, bindings were valued and collected, often more so than the text they helped protect. These associations were based on perceived similarities, and for many years, knowledge was too limited for such groupings to be consistent. A piece of coral could be animal, mineral, a piece of fine workmanship when turned into an item of jewellery or a table decoration. It could be part of a collection of pink objects or arranged in terms of its use, e.g. as part of a child's teething ring. Or there may have been no plan; the arrangement, especially within ornate cabinets, may have been based on a whim or due to some internal logic in the display.

Cabinets became ornate, with some opening up to display little theatres, or mirrors to feature the most treasured items. Some had secret compartments for storing valuables. The exteriors were of finely worked wood or stone inlays telling edifying Bible stories such as the Prodigal Son, echoing the stained glass in churches known as the Bible of the Poor, or classical gods, so they became performance pieces. And yet for all its scholarly research, the Holburne claims the contents of their cabinets have been largely forgotten or the choices were personal, so never recorded.

Every collection was unique; it reflected the collector's life, interests, outlook, philosophy, and the age and fashions of the time. They often formed a starting point for further investigation, so were a

record of self-education. They could be bought ready furnished, as the art dealer Philip Hainhofer (1578–1647) of Augsburg obtained ornate cabinets and selected the miniature contents, so he could be seen as an early example of modern stylists. Mauriès' book includes a painting of the arrival of Hainhofer's cabinet to the Duke of Pomerania in 1612 which shows the nobles gathered to see the masterpiece delivered by the many artisans responsible for it.[25]

Augsburg's trade was mostly for such gifts, so this was a slightly different use of the cabinets. Some of the trade in curiosities was possibly due to the recipients of such gifts disposing of or swapping unwanted or inappropriate items.[26]

Dr Johnson echoed Bacon's idea that the mind was a cabinet, so should be well ordered. He complained that humans were in constant pursuit of the new and curious; he would have despised modern media. He encouraged collecting, but only of items suited to a useful purpose or which fulfilled a need in our natures. This echoed the sentiments of Fielding who emphasised the importance of an object being based on a universal truth rather than merely its novelty.[27] But it was the allegedly frivolous searching for novelty that created early collections, which in turn allowed sufficient items to be investigated to establish or rediscover these universal truths.

Ornate cabinets became a major industry in the Germanic states, especially in Augsburg where many different trades were employed; the Pre-Reformation industry which produced religious art and artefacts adapted to secular products. The term 'cabinet' is also confusing as it could refer to a room, or a piece of furniture. Some collections were so extensive they took over several rooms which contained several cabinets as space had to be found for their many gifts. Francesco de Medici's collection occupied a large part of the Palazzo Vecchio in Florence and included workshops, laboratories and displays of art, weapons, antiquities and curiosities.

The Duke of Orleans, brother of Louis XIV, lived in the Palais Royal after his marriage in 1661. He built a white room, the *cabinet blanc* which was decorated in white silk with gold and silver braid to house six cabinets made of ivory, one of which survives in the V&A

collection.[28] The most spectacular example was the *Amber Room*, built for the Charlottenburg Palace in Berlin from 1701. But in 1716 it was given to Prussia's ally Peter the Great where it was extensively expanded to contain six tons of amber before it was lost in World War II.[29] In the 1750s when William Wyndham reconstructed and redecorated his family home of Felbrigg in Norfolk, the first completed room was the cabinet or small day room which was to display the pictures he collected on his Grand Tour.[30]

Writers John Aubrey (1626–97) and Samuel Pepys (1633–1703) were heirs to the Renaissance passion for collecting which imparted a sense of power to them as investigators. By describing their travels and observations they became a new form of collector. They recorded their world in a state of flux, aware that what they described might soon be lost without trace, so were collecting and preserving word pictures of curiosities.[31] Both adapted to the new age of natural philosophy which involved close observation and experimentation as practised by the rising generation of scientists. They turned the social activity of visiting cabinets into written collections of visits, so their books became cabinets which further inspired the spread of collecting. They also helped shift the definition of a curiosity cabinet from a physical space to a written form, so the inclusion of a library within a cabinet formed a bridge between them and modern libraries.

But the philosophy behind collecting is much older. In 1587 Gabriel Kaltemarkt wrote of how a collection or theatre should serve two purposes: to acquire knowledge, and to provide a place for contemplation, moral refreshment and to inspire artists. This shows that cabinets were performing as both secular and sacred spaces. Sabine Haag and others claim the dispersion of early cabinets makes it difficult to pinpoint the philosophies they represented, but they "must have been minor".[32] But the cabinets were numerous, widespread and famous. The contents were often swapped or sold by collectors in response to

new discoveries, fashion or personal taste, so the philosophy behind them was likewise significant and well known.

The same source talks of how the microcosm of the Kunstkammer was designed to reflect the macrocosm; the objects contained in it provided evidence of the owner's claims to power in his world. There are further implications here. Leaders increasingly needed knowledge, as their role was shifting. Traditionally, leaders were soldiers who were advised by older, wise men, often priests, which allowed them to concentrate on their battle skills. The decline of the church's role meant the rulers needed to discover wisdom themselves, hence the need for curiosity cabinets. But this extra burden put more of a strain on the energies of rulers, so they needed 'down time' hence the cabinets provided both information and relaxation. Perhaps curiosity cabinets should be added to the list of inventions that shaped the modern world, along with gunpowder, the printing press etc.

In eighteenth century Britain there was also a shift from the links between land ownership and wealth as merchants grew rich from importing luxury goods from the New World. In Boswell's diary for June 1763 his friend Dr Johnson praised the close relationship between Scottish landlords and their tenants, while condemning the merchants on the Exchange, i.e. speculators, as being worth nothing, despite their great wealth. He was also in effect highlighting another change in outlook, that a man was inspired to do good deeds by the concept that God would reward him for such benevolence. But the boom and bust Restoration and Georgian economies encouraged gamblers and speculators, who were not held responsible for their actions.

Francis Bacon (1561–1626) was an Elizabethan politician, natural philosopher and writer. He encouraged the separation of religion and science and his work helped inspire the founding of the Royal Society. By removing the centrality of the Fall from natural philosophy, he introduced the concept of optimism: the radical idea that humanity was not doomed for its sins, but was capable of improvement.[33] This suggests the gloom produced by the horrors of the Middle Ages was

becoming a distant memory. Europe was at last recovering physically, spiritually and philosophically.

Bacon wrote of the need for a learned gentleman to have a good library, a garden to represent a private version of the universe, and a cabinet of curiosities. This reflects the long-established concept of the garden as an idyll, necessary for men of the world to rest and relax, to find respite from their responsibilities. It also reflects similar themes of garden/natural objects made by God versus a cabinet of manmade objects and the design of mediaeval cathedrals with their cloister gardens for walking, meditation and prayer.

Though the contents of collections have been lost, we know of several famous collectors. John Evelyn's diary records his 1671 visit to physician Sir Thomas Browne's home in Norwich. He wrote:

> "His whole house and garden being a paradise and cabinet of rareties, and that of the best collection, especially medails, books, plants, and natural things."[34]

Browne showed Evelyn round Norwich, with its impressive array of ancient buildings and rich history which provided inspiration to his antiquarian work and poetry. He has been largely forgotten outside his home town, but a recent exhibition at the Royal College of Physicians focused on his wide-ranging curiosity. Browne was also a coiner of new words, making him second to Shakespeare, showing how the English language expanded after the Reformation as discoveries required new terminology and knowledge shifted from Latin to the vernacular. In 1840 his tomb was opened accidentally and his skull removed; it was put on display in the local hospital, so this curious man became himself an object of curiosity. A team at Queen Mary University are editing his documents, to make them available to future generations of curious people.

Thomas Jefferson was wealthy, widely read and compiled a large collection on his travels in the old and new worlds. He sponsored Lewis and Clarke's expeditions, so was an active collector who could choose from the many artefacts they acquired. Of all the many

wondrous objects that could be displayed, the most curious and fascinating were, of course, humans themselves. Jefferson's collection was on display in the entrance hall to his home at Monticello where visitors could see it as an introduction to the great man; it also gave them a starting point for conversation, as an icebreaker when they met him. His collection reflected his interests, but its arrangement was also making a statement about his country. By placing pieces of Indian art alongside the greats of Europe, he was declaring his nation to be of equal merit. By displaying mastodon bones excavated from Kentucky, he declared his land to be of equal antiquity, and that its people were interested in investigating it.[35] Jefferson's cabinet was thus a means of uniting he people of the new nation, and also declaring they were capable of forging their own, independent future.

Eamon Duffy writes of how saints and their relics went in and out of fashion; some were supported as a form of protest against the unpopular — or perhaps just intrusive — government, so became politicised.[36] But the cult of saints weakened and by the late (post-plague) mediaeval period, wills provided for the upkeep of images instead of shrines and relics.[37] So what happened to such relics and their ornate reliquaries and cabinets?

In 1536 Henry VIII passed an injunction against the practice of pilgrimage and supporting the cult of saints and their relics. This was in part due to the commerce and fraud involved in their trade, but also an early example of the Protestant work ethic, in which such expeditions, along with the many religious festivals and holy days, kept people away from work and allegedly threatened famines. In 1538 the injunction was amended to encourage people to do charitable work instead.[38] Though many parishes were forced to comply, there was confusion and resistance to the changes, with some rebuilding or refurbishing their chapels and shrines in defiance.[39] Communities paid for their maintenance and upkeep; they resented the interference of outside authority. Visitations of 1535 described the presence of relics such as items of clothing and that even combs attributed to the saints were still being held responsible for miraculous cures, especially for

the relief of women in childbirth, but also for more general improvements such as reducing weeds in corn.[40]

Thomas Chatterton was born in Bristol in 1752; his late father was schoolmaster and uncle was sexton to St Mary Redcliffe Church, so the boy had free access to the ancient pile. His fame — or rather, infamy — derived from his claim to have discovered manuscripts by the fifteenth century poet Thomas Rowley. But they were forgeries by him, inspired by old manuscripts which lay neglected in the church's muniment room above the main porch. This suggests other material from the past may have survived, especially away from centres of iconoclastic activity.

The only monumental clock in Britain that resembled Henry's Microcosm was by his near contemporary Jacob Lovelace (1687–1755); it was put on display in a tavern in Fleet Street in 1739.[41] Both Waltham Abbey and Lovelace's home of Exeter were home to large, wealthy religious houses before the Reformation, with collections of relics to attract patrons, pilgrims and their money. Waltham Abbey was named after the shrine built there in the time of Cnut to house the miraculous cross found at Montacute in Somerset.[42] In the reign of Henry II it became the wealthiest of the Essex monasteries, largely due to pilgrimages, so the abbey could claim to be a giant stone reliquary.

When the Exeter Clock was advertised for sale in February 1834, it was claimed to have been modelled on the famous Strasbourg Clock. This was an enormous, complex edifice, the latest of three built in the church of Notre Dame. The first was about 18 metres high and about 7.7 metres at the base. Nothing of its size or complexity existed in Britain. It is hard to see any similarities between Exeter and Strassbourg except as examples of famous clocks, or as a mark of their high standards of construction. Or both could have been so famous to become icons representing their place of origin just as Big Ben continues to stand for London. The physical similarities — or lack

thereof — were irrelevant as nobody was likely to have seen the German example.

In the V&A's book of their 2013/4 exhibition *Art Under Attack,* they describe the many forms of iconoclasm practised in different places and times. They varied from the complete destruction of an image, to what appear to be bizarre practices by Lollards who publicly hanged or decapitated saints' statues to prove harming them did not bring down the wrath of God. Others insulted images by spitting on or injuring them. Some statues were buried, which could mean they were seen as dead, so useless, or perhaps to protect them from the iconoclasts. The Civil War's Parliamentary army carried out large-scale destruction, famously the demolition of London's *Cheapside Cross,* an important civic landmark. It was a former Eleanor Cross built to commemorate the death in 1254 of Eleanor of Castile, beloved wife of Edward I.

Under Edward VI and Elizabeth, the lower parts of rood screens which divided the clergy from the congregation were sometimes left in situ. Saints' images were painted over with text to proclaim the superiority of the new form of worship and the superiority of the written word.[43] In Suffolk's Preston St Mary, the Ten Commandments were painted inside an altarpiece, and another had the arms of Elizabeth within the wings with an exhortation against the use of images.[44] This seems more like a dog marking its territory rather than religious fanatics wreaking destruction.

Several European altars in the V&A have wings that fold out to increase the area for display to feature more saints, so allowing multiple uses of the structure. The main, upper part of the Brixen altarpiece of 1507 displays the Virgin, flanked by scenes from her life on wings that fold in to protect the sculpture but also allowing the scene to be revealed to add drama to religious services. In the British Galleries is a painting of Sir Thomas More and his family from c.1593–4 in a walnut cabinet which has folding wings: possibly to protect it from smoke which shows how the design moved from sacred to secular. The Exeter Clock had panels on its base that folded out to display the city's landscape, so iconic buildings had replaced the saints. Yet the shift in imagery was not huge, as saints were often shown in land-

scapes, preventing them from being destroyed as graven images. By surrounding saints with details of their lives and their sufferings, they told their life stories rather than being a focus for idolatry. Thus both Lovelace and Henry seem to have been inspired by religious artefacts to construct their own monumental, iconic clocks. This geographical link also appears in the life of John Harrison who grew up on the estate of Nostell Priory.

The base of the Brixen piece shows a frieze or predella showing images of our female saints. On the far right is a depiction of St Margaret, with a door cut into its lower part to house relics, an apparent act of vandalism. The constant building of altars caused congestion in many churches. Lack of space elsewhere may have made this the only place to house a reliquary associated with her. The region changed hands between Italy and the future Germany, so in this chaos, details of the altar's history have been lost.

The Reformation caused a shift from belief in the saints as interceding with God to viewing them as portraits of good and worthy Christians, whose heroic self-sacrifice should be admired and emulated. This practice was later echoed by portraits and especially public statues of national heroes which were used to promote patriotism, to encourage national unity and inspire sacrifice in Britain's wars from the late eighteenth century. Locks of Nelson's hair and other mementoes were collected but of course were never called relics. Demand for modern relics continues to be big business, especially those linked with film or pop stars who died tragically and/or young. So, yet again, the Reformation continues to be a work in progress.

For many years there was debate among Protestants across Europe focused on whether the practice of worshipping images was outlawed, or the very existence of the images, with their shrines and relics. The problem for ordinary people was that bans on popular religious practices offered nothing to replace them, so they often resisted the changes. In England many religious items were not destroyed on the king's orders, but were hidden to emerge for use in masses etc. when Queen Mary returned the country to the Church of Rome in 1553. Within a mere five years most churches in the country were again

supplied with the items for conducting Masses. To ensure Roman practices were 'extirpated' Elizabeth ordered the conversion of baptismal fonts into pig feeders and stone coffins to be used as horse troughs, a design which is still widespread. An item from the Tradescant collection seems to fit this practice: a string of seventeenth century rosary beads has been rearranged, so they can no longer be used for reciting the Paternoster. Or perhaps the string broke and the owner did not know the purpose of the beads, so restrung them randomly.

Reliquaries came in a huge variety of forms, as seen in the V&A's collection where beakers and books were used in this way, as were more famous, ornate caskets which often reflected their contents, such as a crown-shaped casket for the relic of a saint's head. Cosimo de Medici was a pious and passionate collector. An English visitor was told of a machine in his private chamber which turned to display tiny silver saints for each of their name days.[45]

Some reliquaries were made of precious metals, so were recycled Post-Reformation to become secular artefacts. Ornate monstrances to display bread for Masses became monstrance clocks. Others moved from church cabinets of curiosities into private ownership. Secular adaptations continued into the eighteenth century as Vivant Devon (1747–1825) in France owned what appeared to be a traditional glass and gold reliquary, but his held items linked to secular icons: El Cid and Ximenes, Abelard and Heloise, Ines de Castro and Henry IV.[46]

It is possible some reliquaries and collections of sacred relics and curiosities were removed but not destroyed, left mouldering in a hidden corner of the church building, or continued in use as items of furniture. They may have been rediscovered from the early eighteenth century when decaying and neglected churches were improved and rebuilt to accommodate growing congregations. The lack of provenance found by Wade when he purchased objects for his Snowshill collection shows they had lost all connection with the purposes and rituals for which they were designed. In the early years of collecting, many artefacts were obtained by sailors on speculation to supplement their meagre wages, making no attempt to categorise them. Their

context was left to travellers' tales or guesswork; they become purely visual objects, part of the thriving modern market for curiosities.

Mauriès lists early centres for collecting that had been centres of learning, such as Oxford, Milan, Verona, Bologna, Paris, Aix-en-Provence, Copenhagen, Basle and Zurich.[47] Though collections varied widely, their existence shows a common origin, i.e. the Christian church, so they form a bridge between relic use for demonstrating wonder and miracles, and curious objects for rational investigation. They may have been collected to satisfy the curiosity of clerics, but also as a means of defending the faith against secular challenges. The church needed to maintain its reputation for wisdom, providing guidance for intellectual investigations.

As curious and exotic objects were collected, patterns were sought to categorise and explain them. Modern authors claim such collections were about demonstrating the wealth and power of the owner, but they were much more than that. Each object was a mystery; by investigation, the owner acquired power via knowledge. Curiosity cabinets were tools for understanding and managing the chaos of a rapidly changing and poorly understood world.

Albrecht of Brandenburg (1490–1545) owned a reformation calendar which displayed a relic for nearly every day, a sort of mechanical Advent calendar. But as Cardinal he overspent on his collecting, so was forced to sell indulgences which became the focus of Luther's demands for reform. So this one collector can be largely blamed for triggering Luther's outrage which led to the Reformation.[48]

The Holburne Museum's exhibition catalogue describes how cabinets evolved from small, tabletop cabinets in the early sixteenth century. In Cambridge's Fitzwilliam Museum is such an example, called a *balsamario*: a box made of exotic, scented woods, echoing the gifts brought by the wise men to the infant Christ. A similar one was presented to Cromwell by the Grand Duke of Tuscany Ferdinandino II from c.1653. It seems the Protector rejected the corrupt Church of Rome, but the high cost of the Civil War meant he needed money from trade, so was forced to play the game of international diplomacy as practised by his erstwhile enemies. From the 1620s Rome had a

thriving business producing them, often by Protestant craftsmen who were forced to emigrate when demand for altars and shrines collapsed after their local regions rejected the Church and practices of Rome.

They were made with expensive stones and finely painted. Some were made on commission for Britain's Grand Tourists such as John Evelyn, whose cabinet survives in the V&A. Many had secret drawers or cabinets for valuables, but several in the Habsburg collection were described as writing cabinets, such as an example made in Nuremberg c.1560–70 of exotic wood, gilded copper etc. It originally had a front section that dropped down to form a writing table, showing yet another stage in their evolution.[49] This cabinet had become a piece of multipurpose furniture. It may also indicate a rising level of literacy in aristocrats who had traditionally left such skills to their clerks.

Many small European principalities were absorbed or dissolved in the wake of the Napoleonic upheavals, causing a fall in demand for cabinets as diplomatic gifts. Designers and builders of cabinets shifted their output to domestic furniture, and items such as desks with their multiple drawers echo their religious precursors. Evelyn's cabinet is surrounded by bureaus and wardrobes showing the next stage of evolution. Chippendale made secretaire-cabinets which have heavy religious overtones, such has one from c.1795 that includes a display case and is topped by a clock inscribed "Weeks Museum"'.[50] Thus, as objects of curiosity fell from use, their cabinets became objects of value in their own right.

The Holburne catalogue claims such cabinets became unfashionable by the early eighteenth century, to be revived in the nineteenth century.[51] This coincides with the most turbulent period of Britain's colonial and industrial expansion, when these islands were focused on practical matters and people found their sense of wonder in discoveries and inventions, while the Romantic Movement reacted against these changes. The two streams can be seen in the most famous artists of the time: Constable's rural idylls and Turner's passion for steam, fire and the destruction of the countryside.

There is no record of any of the Lunar Men or any of the great scientists or inventors owning a cabinet of curiosity. The early cabinets had been so successful that the worlds they investigated had by the mid-eighteenth century far outgrown the notion of collecting and coralling. Worlds branched off, formed their own worlds as natural philosophy and random collecting were replaced by science, and a new, more focused sense of wonder at the sheer scale of knowledge. The many, specialised worlds encompassed by the Lunar Men often interacted and overlapped with each other. They had progressed far beyond the little worlds of the cabinets.

The cabinets themselves, like the curiosities brought back by sailors, lost their context to become pieces of furniture in the houses of merchants, the power they once held had transferred to the owner whose wealth protected the cabinet and ensured its survival. This echoes the secularisation of religious artefacts whose powers were lost at the Reformation to become collectable pieces of fine art. When copies of classical temples were built in landscaped gardens, they included empty niches as they had lost all knowledge of which statues had lived there, just as the niches in Post-Reformation churches were often left empty.

Winchester's Pallant House Gallery is home to one such survivor, the mahogany Askew Cabinet obtained in c.1740, but built by Fanelli in c.1640. Whatever its original role, and whoever was the original owner, it had long since lost its original purpose. The grandest and most famous of the early curiosity cabinets in England is at the National Trust property of Stourhead, former home of banker and antiquarian Henry Hoare. Attributed to Pope Sixtus V, it was probably built c.1576, for the Palazzo Felice by its architect Domenico Fontana. Hoare acquired it c.1740 and displayed it in a special room on the south front of his country mansion to maximise lighting, with a pedestal possibly by Kent. It is displayed behind a screen to further emphasise its architectural character and sense of wonder.[52] It was a cabinet within a cabinet, a world within a world

Britain's economic recovery of the early eighteenth century also saw a shift in the role of its rulers. George II was the last monarch to

lead the nation into battle, at least as a figurehead. This filtered down into the aristocracy whose lifestyles became more indulgent. Horace — son of Robert — Walpole (1717–97) pioneered a revival of gothic architecture, with his masterpiece at Strawberry Hill, a whole building designed as a curiosity cabinet which also included a printing press. The most extreme example of an aristocrat withdrawing into his own world was that of William Beckford (1760–1844), son of a Jamaican plantation owner and Lord Mayor of London who, like Walpole, pioneered gothick fiction. But he is best known for his extraordinary fantasy house, Fonthill Abbey where he was free to indulge his private passion for high art, and which provided a private venue for allegedly scandalous behaviour that even today would be found shocking. Thus Beckford provides an example of the dangers of power without wisdom, curiosity without moral guidance.

Most commentators write of the role of curiosity cabinets being the control of the outside world, by organising and containing the various objects. But they were central to social interactions, as foci for people to meet in neutral space to discuss the objects, so paralleled the roles of Georgian spas, touring science lectures and Henry's Microcosm. Like the spas, their social role continued while the scientific role was overtaken by their own success.

The concept of a cabinet as a performance was shown years after The Microcosm's disappearance when the ageing Augustan A.G. Stevens staged his final show in October 1780. It was titled *A Cabinet of Fancy, or Evening Exhibition*,[53] a multimedia performance which included paintings, pantomime, music and explanations. This was one of the many forerunners of the early music halls, and of what later became light entertainment or variety shows.

The Microcosm was an ornate structure and its displays show a clear hierarchy, so it also forms a part of the evolution of curiosity and arts cabinets. The machine demonstrated the finest English workmanship at the time, and performed a role in educating and inspiring its viewers, as the advertisements often claimed. It also echoed earlier cabinets in being highly personal, reflecting the owner's — and in this case the designer's — interests and taste.

The talk given upon The Microcosm also reflected the practice in many large cabinets where a guide or owner was available to discuss and explain the collection. A variation on this was in *Don Saltero's Museum and Coffee House* where he made the objects speak,[54] which is utterly opaque. Was Saltero a ventriloquist, a master of ceremonies introducing the show, or putting words into the mouths of the preserved animals as a form of grotesque puppetry? Or perhaps it was an automaton like Tipu's tiger in the V&A? It could be he was performing a dumb show, whereby people performed or posed without speaking while a narrator spoke their words: a performance sometimes resorted to when plays were banned. Or was he, like Henry, merely explaining and describing his show? Journalist Isaac Bickerstaff mocked Saltero's exhibits as being locally made frauds, but in 1729 a catalogue was published to enhance claims by the owner that it was a legitimate museum.

Britain's most famous cabinet of curiosities, and the only one with its contents intact, is the nineteenth century John Soane Museum in Bloomsbury, built long after the practice had faded in these islands and a precursor of the Victorian style of gothic revival. Like the huge multi-roomed, multi-purpose cabinets of the Medici, it was both a workplace and a home, though it is unique in combining these roles so intimately. The house is crowded with items, so visitors have to leave large bags at the entrance and take care walking around for fear of damaging the displays. Objects have been placed with great care in relation to their roles, and to tell stories. Some of these are well known and can be placed in different settings, such as pieces of classical statuary. Others are specifically linked to the owner and his use of the house, serving as a workplace for him and his apprentice architects and as a memorial to his beloved wife, so this collection works on many levels. Every picture tells a story here but each image can be part of a larger story, and the viewer needs to know the story to fully understand the collection.

Modern media is creating a revival of cabinets of curiosities in new forms, as a new generation lose interest in static museums full of Victorian taxidermy and lifeless artefacts. Modern urban develop-

ments are destroying historic buildings which are sometimes temporarily handed over to artists for cutting edge exhibitions, like the glorious song of a thorn bird before it dies.

Denis Severs' house in Folgate Street, Spitalfields is an extraordinary, immersive survivor but with the surge in tower blocks of the area may likewise soon be lost. Visitors pass silently through a time capsule, an imagined version of a house inhabited by Huguenot silk weavers. The house is candlelit, with coal fires, the smells of food and flowers presented as if the inhabitants had recently left. The place even has a cat called Madge who is thoroughly at home there and has her own Twitter account.

The English Reformation, Civil War and religious and political upheavals led to the extinction and/or emigration of many great families, so by the eighteenth century, many commoners were rising in wealth and status to fill the gaps, but they did not know how to behave in 'polite society'. Elizabeth P. Archibald writes of the rise in literacy which created a demand for instructional books. Erasmus published *On Civility of Children's Manners* in 1530 which provided instruction in Latin and advice on farting. In 1622, Peachum's book *The Compleat Gentlemen* provided guidance on how to build a collection and how to behave when visiting others.[55]

Diarist John Evelyn's cabinet is on display in the Victoria and Albert Museum in London. In 1660 he recorded a visit to see the king's cabinet of rarities which included a clock by Fromanteel showing the rising and setting of the sun within the zodiac and behind a hilly landscape.[56]

This shows there was an established tradition of gentlemen visiting each other's cabinets; if the owner was a collector of curiosities, his house could itself be seen as a giant cabinet, as that of Sir Thomas Browne (1605–82) of Norwich and Wade at Snowshill Manor.

By the time Henry built his Microcosm, his potential audience probably had some knowledge of how to respond to it, and how to

behave at the show. Cabinets were not passive works of art, but demonstrative devices, requiring the participation of an audience, providing a bridge between religious practice and passive modern audiences. Viewing these same objects in modern museums enclosed in glass vitrines, unable to handle and share them, often explained by information which strips away the mystery, gives no indication of this role, so their full importance is lost to modern audiences. Stripped of their social context, they have become purely visual objects, dead images so often mocked by both sides of the religious divide.

Tate Modern's 2014 exhibition, *British Folk Art* included a fascinating item described in the catalogue as a *God in a Bottle, whimsey, patience* or *a puzzle*.[57] It was associated with the Irish diaspora in the North of England; but the tradition of constructing items in bottles seems to have arrived from Germany and Eastern Europe, so again, this suggests a Catholic — or even Orthodox — origin. They were bottles of various types containing a small shrine or a ladder and artefacts of the Passion such as a rooster, hammer, nails, ladder and cross. A Napoleonic prisoner of war camp near Peterborough 1797–1814 held mostly French, but also Dutch soldiers. A bottle was found with a tiny violin, finely made in wood. When placed in the bottle, it was filled with water to make the wooden contents expand, so fixing the contents into place. The Bowes Museum at Barnard Castle has two, more recent objects; a bottle — probably Venetian — from about 1860 showing a dressing table, and a complex Crucifixion scene made of wood, simply described as a bottle and thought to be Russian.

All these items displayed in bottles reflect the practice of housing relics in glass reliquaries. But they also reflect an aspect of the Bible that is sometimes forgotten, i.e. that Jesus was a carpenter, hence also a cross maker, which adds an extra layer to the means of his execution. In death he was mocked not just for his faith, but also for his profession, which is also echoed in other examples of *God in a Bottle* from fraternities such as the Freemasons who were often treated with hostility.

Could Henry's Microcosm have been a similar act of Christian faith, echoing his own choice of profession? This may seem to be

ironic in a Christian country, but the Civil War had shown the many ways of practising these beliefs and the hostility which this could generate. When John Wood was working on Bristol's Exchange, his workmen were in frequent conflict with locals who claimed Freemasonry was taking over the world. Was Freemasonry a factor in Henry's choice of a Roman temple for the design of his machine, an echo of the Freemason's interest in Solomon's temple?

These *God in a Bottle* pieces suggest a further stage in the decline of reliquaries, as they were still found in use by railway workers in the 1890s. These small artefacts were portable foci for worship which could be easily hidden, as the Irish Catholics faced hostility for their faith and their foreignness. The term must have been chosen by outsiders ignorant of their use, along the lines of modern evangelists being called *God botherers*. But these same bottles seem to have found another life where, stripped of their context, they seem to have evolved into curios sold to tourists in seaside towns as ships in bottles, often made by retired sailors. The author owns an example housed in an intravenous drip bottle, suggesting it was produced in occupational therapy session which may again have post-war origins.

In the Cambridge Folk Museum is yet another variation, a *witch's bottle* holding red/orange threads, claimed to be used to dazzle and distract witches from causing harm, i.e. they were protective devices similar to icons and relics. The glass container again echoes the design of reliquaries.

Napoleon is claimed to have mocked the English for being a nation of shopkeepers, but in the absence of European aristocratic patrons, it was the merchants and 'middling sorts' who encouraged and funded exploration of the world, and the accumulation of artefacts which found their way into cabinets and encouraged curiosity and discussions of science and technology. They attended the wide range of travelling science shows and some purchased the instruments and booklets which enabled them to discuss what they had seen and to continue investigations in their own time. The lack of elite patronage for intellectual and cultural activities was compensated by these same 'middling' people who helped found and fund libraries, mechanic's

institutes and campaigned for civic improvements, universal education and the abolition of the slave trade.

Henry's Microcosm fits well into this environment of curiosity and improvement, and is very much of its age, a time of rapid changes and recovery from a chaotic past. Though probably built as an entertainment for an unnamed aristocrat, it represents a surprisingly sophisticated design and hints at knowledge of horology and cabinets of curiosity from European sources. It may be one of the most important machines of the Enlightenment, drawing huge numbers of people to see and participate in its performance, which was social as much as educational and scientific. Its repeated promotion of honest English workmanship was both didactic and patriotic, demonstrating high standards of English technology and inspiring its audience to be curious, to tinker, to dream, to aspire to be better than their European rivals in both war and peace.

12

VENUES AND FAIRS

Markets and fairs are today often interchangeable terms for small, local events featuring stalls and entertainments, often as fundraisers for good causes. But for most of our history they were separate events, important dates in local and national calendars.

The Normans established markets within walking distance — usually seven miles from each other — to ensure reliable supplies of fresh food, so they were mostly held weekly. As towns and demand grew, some expanded over several days each week. Others specialised in certain goods such as hay or horses so were held on wide streets which are still named after them such as London's Haymarket. Others were held at the main crossroads, where a market, or high, cross provided steps for the display of wares. Some of these structures later provided the upright support for shelters to protect traders and their goods, such as can still be seen at places like Chichester. A few became specialised, such as the poultry cross at Salisbury and the cheese cross in Cheddar.

Fairs were much larger, often annual events, claimed by David Braithwaite to be uniquely public entertainment, attracting all classes of society to mingle freely.[1] This is a further reminder of how small

the world once was, where there were too few people to form isolated social worlds. Fairs were so important that Magna Carta protected merchants travelling to and from them, and they were allowed to buy and sell without unfair taxes.[2] Fairs were major social and commercial events for towns and where employment and marriage contracts were made. Some towns were founded to hold fairs or markets, so were early job creation schemes.

C. Henry Warren writes of how as recently as 1942, a century after a local fair vanished, it still punctuated rural life and conversation, a fixed point that marked the high point of summer and provided the traditional date when locals first enjoyed new potatoes, green peas and gooseberry tart.[3]

The Normans expanded sheep husbandry to establish huge flocks on England's uplands which supplied European weavers; this may even have been a reason for their invasion. The biggest fairs specialised in wool, such as Cambridge's Stourbridge, and the greatest of all, St Bartholomew's on the northern edge of London.

When trade with the West Indies expanded, Bristol's St James' fair was moved from July to September to coincide with the arrival of the Jamaica Fleet, so celebrating the safe return of sailors added to the festivities. Traders from London attended to supply customers in Wales and Ireland, so a market's catchment area and the amount of money exchanged was huge. Manufacturers sold a year's worth of goods, making fairs essential for national and local economies. Local shopkeepers complained of the loss of trade, but it generated work for people setting up stalls, or 'standings', and for pubs, inns and cook shops. They were also occasions for country people to come to town, renewing family and business ties.

The English introduced entertainments to attract more people, leading to claims of unfair practices from European competitors. They were held after the trading was completed, so money from sales could be spent. The fairs then extended over several days, up to a week. Lincoln's Fair was held on the feast of St Hugh and when granted by Henry IV in 1409 lasted a massive thirty days. By the mid-eighteenth century, London's Bartholomew Fair sprawled over four parishes and

had grown from three to fourteen days.⁴ This led to the formation of travelling circuits for shows. King's Lynn (until 1537 Bishop's Lynn) Mart was held on St Valentine's Day; marking the start of the eastern travelling season which ended in November at the Loughborough Charter Fair.⁵ The south east circuit began with the Easter Fair at Greenwich and ended at St Bartholomew's Fair in September.⁶ They could be lucrative for performers, such as the showman John Richardson who was claimed to have left twenty thousand pounds' worth of property when he died.⁷

In the British Library is *A Book of Country Fairs or a Guide to West Country Travellers*,⁸ a detailed catalogue of the annual circuits taking in the many fixed and moveable fairs in the thirteen counties which the author John Bridges recommended to all the chapmen and trading people who attended them. He claimed to have been a traveller for forty-nine years, so it was based on extensive research and a desire to inform others. The book lists an astounding number of fairs and markets: weekly, monthly and the big annual ones. Towns and hamlets that barely register on modern maps were once thriving agricultural and trade centres, such as the tiny village of Queen Charlton near Bath which held a major horse fair. The existence of this book shows how many people were following the circuit as traders, caterers and performers, and that they were literate. The publication is claimed to date from 1729 which seems incredibly early for there to be sufficient demand. The book provides an insight into an England that is long lost. In the eighteenth century regional press, advertisements can be found announcing the revival of several fairs, suggesting the population of the countryside had been too depleted by the Civil War etc. to support them. In 1747 the ancient fair at Weobly, Herefordshire, was revived with encouragement and support for dealers to attend, noting Kingsland Fair was only seven miles away..⁹ Some market houses were built with rooms above them to allow any unsold stock to be stored till the following market.

Bristol's St James' fair took over most of the city streets. Carpenters were busy for a month building temporary stalls, and shopkeepers extended their frontages to rent for extra income. It was described as

"the annual saturnalia"[10] which became a magnet for showmen of the South of England and the Midlands. It drew traders from as far afield as Ireland, London and by the nineteenth century even Moscow. In the late seventeenth century the navy patrolled the Bristol Channel to prevent Turkish pirates and slavers plundering ships from Ireland and Wales. A wool merchant from London claimed to have been robbed of seven thousand pounds in cash and more in credit notes on his return, so it also attracted highwaymen and footpads. Pepys recorded the launch of a ship, watched by a crowd of thousands, so it was a good promotional exercise for shipbuilders and related trades. Goldsmiths — the precursors of bankers — attended, so loans could be taken out and repaid. By the end of the seventeenth century, England's coinage was worn out and fraud was rife, so Newton was put in charge of the Royal Mint. He introduced marking the coin edges to prevent clipping, i.e. shaving the edges and melting down the precious metals. Mints were established in several towns where old coins were exchanged for new at the fairs. An estimated minimum of one hundred and fifty thousand pounds was expected to be exchanged at Bristol's St James' fair in 1697 from surrounding districts.[11] The large quantities of underweight coins were still a problem in Britain and North America well into the eighteenth century. This created a demand for accurate coin balances such as the one invented by J.J. Merlin and held by him in his portrait by Gainsborough now in Kenwood House.

From medieval times, marionette and glove puppet shows — in both religious and secular forms — featured at fairs. They flourished when other forms of theatre were banned under Cromwell's Commonwealth.[12] The first dramas appeared about 1500, and wild beast shows in the seventeenth century. Theatre booths provided training for Richardson, Saunders, Pinkethman and Timothy — not Henry — Fielding.[13] Some of the greatest actors performed there, and mystery plays were revived to include live animals which were hugely popular into the 1770s.[14]

Fairs had been a major source of income for religious houses which enforced strict codes of behaviour. But when they passed into private hands at the Reformation, new owners were more interested in profits

than law enforcement. They often outgrew their urban sites, so some — especially those specialising in animals — were moved beyond the bounds of towns and cities. Harold Scott writes of the many shows at fairs, and of streets being "honeycombed with booths"[15] where plays similar to the official venues could be enjoyed, especially in the summer when the main theatres were closed.

Standards of behaviour declined, which often added to their appeal. Plays allowed subversive ideas and satire to be aired. In 1700, even puppet shows were banned.[16] Walpole was outraged by the satire and insults aimed at him in theatres, so he tried to control them by passing the Licensing Act in June 1737, which gave direct control of venues to the Lord Chamberlain. London's two licensed venues, the Theatres Royal, were the only ones allowed to perform plays, but they still had to submit scripts for approval a fortnight in advance. The Chamberlain's powers were also retrospective; *King Lear* was banned during George III's illness, and in modern times *The Mikado* was not allowed in case it offended royal visitors from Japan.[17]

Beyond the capital, censorship was in the hands of the mayor as chief magistrate and the main punishment was under the draconian Vagrancy Act which was updated under Queen Anne and many other monarchs. This blunt tool allowed much inconsistency, bias and injustice in its application. In London it was applied to actors, but failed if they could prove they had a permanent abode. Rising affluence among the population provided a huge audience for plays. Censorship forced minor playhouses to become creative to survive. Concerts were staged which included recitations of Shakespeare. Audiences were charged to see a safe performance which was followed by a play for free. Dramatic pieces were advertised as lectures. The famous actor/manager Charles Macklin opened a dramatic academy where he charged audiences to see rehearsals of *Othello*. The 'extraordinary mimic', the actor Samuel Foote invited the public to drink chocolate with him; while the drinks were being prepared, the audience watched him instructing his pupils.[18] Non-dramatic entertainments such as pantomimes were staged, and straight drama was turned into comedies or musicals. Pedicord described a range of musicals, vaudeville, pantomime and

animal shows.[19] He should have included automata and scientific lectures and demonstrations. This explains so many surviving playbills which to modern eyes seem utterly bizarre, such as the comedy of Hamlet, and Robinson Crusoe as a musical with a cast including a harlequin. On a deserted island. Macklin wrote in 1752 how these 'minor' shows such as exotic animals, quacks, magicians, microcosms, panopticons, and other fairground shows constantly appealed for public support.[20]

Henry Fielding took on the management of the Covent Garden Theatre where he produced a series of political satires aimed at the government and the official theatres.[21] His satirical plays *Pasquin* and the *Historical Register* which ridiculed Walpole have been blamed for the Act's passage. But H. Barton-Baker claims it was

> "the immediate result of a play never acted, called *The Golden Rump*, filled with abuse of the King and his ministers. The manuscript, by a hand unknown, was sent to Giffard, who, frightened at its audacity, carried it to Walpole. It was the last straw, and, after reading it, Sir Robert at once brought in a Bill which not only strictly limited the metropolitan theatres to two, but established a censorship over the drama as well".[22]

Under the Act, every script had to be approved by the authorities to ensure it did not insult public figures or public morality. Some authors claim this Act drove Henry Fielding from the stage into law reform, which was not as great a leap as it may seem. Pedicord claimed that as a result, the minor theatres struggled to survive until the end of the eighteenth century.[23]

This period almost exactly coincides with the recorded travels of The Microcosm, so it seems shows such as puppets, clockwork, automata, and lecturers in various forms and combinations were given unexpected opportunities. Thus the unnamed author of *The Golden Rump* can claim to have provided a boost to early science and technology. This sheds light on why Bridges' machine was in 1749 called *The Modern Microcosm*, when he complained of others copying his show and

why he had to make improvements to keep ahead of his rivals. Ever the showman, he turned this alleged competition on its head when in 1751 he claimed the many imitators proved the superiority of his own show.[24]

Another unlikely beneficiary of the Licensing Act was a minor comedian and friend of Garrick, George Alexander Stephens who George A. Kahan described as having "pecked away at life".[25] Like earlier Augustans he tried his hand at writing plays, song lyrics and edited a magazine. In 1764 he premiered an extraordinary one man show, *A Lecture on Heads*. This was a two-hour monologue using props such as wigs and puppet heads to impersonate a wide range of stock characters such as a Methodist preacher (whose organisation had replaced the Quakers in condemning playhouses), an attorney, an old maid etc. He cleverly adapted it to local circumstances and events, managing to mock famous people without actually naming them, so evaded Walpole's draconian law. From about 1765 he produced a print edition which allegedly made him a fortune.

Kahan lists the many local variations in the U.K., North America and even the Caribbean when it was performed as a two-hander, some with musical accompaniment. Others featured child prodigies, young girls or matrons, so it was a godsend for the many struggling performers and even entire troupes. If they failed to attract audiences to their advertised show, or were banned for whatever reason, they could fend off bankruptcy and imprisonment by doing a version of the lecture, claiming it was educational rather than a threat to moral standards.

The other major public event was the annual assizes, when judges or recorders (barristers) went on tour; towns competed to hold them as they provided prestige and extra income. Crowds came from across the region to attend the trials. The men of law needed to relax after a hard day's sentencing, so entertainment for them evolved from providing a large dinner to formal assemblies and balls. Those unable

to fit into the courtroom or less interested in the proceedings found other distractions such as travelling shows. The diary of Thomas Turner, shopkeeper of Sussex, described how Lewes came to life for the several days of their August assizes. A race meeting was held on the Downs, the judges were welcomed to an open house at Halland estate, and there was a grand ball.[26]

Newspaper records, especially for the early part of the century, are incomplete and dates have not been cross-checked, so it is unclear whether The Microcosm followed any of these circuits, at least for long. 'Mr Bridges' Show' appeared at Stourbridge Fair near Cambridge in 1735, where Cambridge University Archives record he paid the necessary fine (i.e. toll). In August 1736 it was on show at Bartholomew Fair, initially in a Great Booth at Tottenham.[27] A fortnight later it was facing London Spa.[28] This shows how far the fair had expanded — despite government attempts to control it — to include one of the least successful springs in the capital, at Clerkenwell. This area was popular with Quakers and Huguenots and became associated with clockmaking, so it may have been a specialised part of the fair.

It was in Bath till 8 February 1748, then reappears around mid-April, so it seems to have missed Bristol's St Paul's fair, which began on 25 January. It was at [King's] Lynn, Norfolk, in 1754 at the time of the market, i.e. fair. In 1758 it was in Kingston, Surrey "until the fair was over", so fairs seem to have been a part of its travels, but not a dominant one. It appeared at the Gloucester Assizes in 1762. In 1765 it arrived in Newcastle at the Buck, Biggs Market, then it moved to Durham for the races on 19 July. It returned to Newcastle for the assizes before it was removed for the August Fair. So it seems that during the touring season, The Microcosm could often choose which events to attend; it was only limited by the availability of suitable venues for hire.

Its arrival at the Salisbury Music Festival in 1773 was part of a West Country tour though it is impossible to know whether this was its main destination. More pressing seems to have been the difficulty in obtaining a suitable room, but once found, it tended to stay until the audience was exhausted. Thus its movements seem to have been

largely dictated by the support of local audiences, making its destinations unpredictable for researchers.

Before the Reformation, official entertainments were held in the great halls of merchants' homes, in guildhalls and church crypts. By the early eighteenth century many guilds had disappeared. Aristocrats and rich merchants moved out of town centres, leaving their medieval halls to be demolished or converted to pubs, coffee houses or industrial uses. In London the Dukes of Beaufort sold their residence on The Strand with its large, well lit rooms to become the Fountain Tavern where the Society of Virtuosi met in a grand upstairs room. It was sixty-five feet by thirty and twenty-four feet high, and became the Society of the Arts' drawing academy where Hogarth trained.[29]

Nonconformists built their own chapels, but some groups were short-lived or moved elsewhere, so the venues were sold for other public uses such as auction halls or theatres. The few guilds that survived, such as carpenters and coopers (hoopers) rebuilt their halls for their grand dinners and rented them out for shows and celebrations. The most famous show of its age, Cox's Museum, was held in a former Huguenot Chapel at London's Spring Gardens, which was an auction room from 1759.

Philip H. Highfill Junior writes of the huge growth of theatre from tiny Restoration venues to huge theatres and hippodromes of the Regency period. This growth reflected the rise in population, wealth, urbanisation and leisure. The period also saw a huge variety of venues built or adapted for shows such as music rooms, taverns, pleasure gardens and amphitheatres.[30] This list can be expanded to include the many new assembly rooms, town halls and even private houses.

Pubs sometimes had rooms for events, and coaching inns provided accommodation for travellers such as Dr Johnson who praised them for their fine food and accommodation. The London to Bath Road was popular with aristocrats en route to the spa or their country estates, so its inns provided opulent accommodation with silk sheets on the beds and fine dining. Many had open galleries overlooking a courtyard, similar to the Shakespeare's Globe Theatre in London or the New Inn which survives at Gloucester. They could be used for performances

from juggling to equestrian displays. Some had large rooms for local parish meetings and travelling shows, from Italian bird impersonators to examples of curious workmanship. From the 1730s when the network of turnpike roads expanded to deal with increasing coach travel, audiences were drawn from further afield, so were larger. But this also led to more shows competing for venues and audiences.

The Microcosm generally appeared at the largest venues, often on or near the marketplace to maximise custom. Some survive, such as the Old Cock in Halifax which dates from 1668 and was visited by Pepys. Venues in London are harder to establish as addresses were so vague and names frequently changed, but they seemed to have focused on Charing Cross and the Exchange areas.

Coffee houses were often listed as venues for The Microcosm, and were a peculiarity of the time. For the price of a cup of coffee, men could meet old friends and make new ones, read newspapers, discuss current affairs and hear and participate in learned discussions, so they were called 'penny universities'. They provided a ready audience for shows involving education and/or technology. Some had rooms for such events; one of the most famous was *Don Saltero's Coffee Room of Curiosities* in Chelsea which was run by James Salter, former barber and gentleman's servant.

The grandest venue where The Microcosm appeared was the King's Theatre, Haymarket in July 1734. This event was often cited in later publicity. The admittance was an eye-wateringly high two shillings and sixpence, a day's wages for a skilled tradesman. This seems to have been its first appearance in London. Henry's initial success may have convinced him he could establish a career in show business. But when the *Lecture on Heads* appeared there, but it only performed twice per week,[31] to allow Stevens to recover from the strain of projecting his voice in a monologue for over two hours. He alternated with other shows, suggesting The Microcosm's booking may have been on similar terms. It was in the summer when the great and the good were at their country estates and the official theatre companies were closed. Thus, Henry's audience must have been mostly people who had to work for a living. From there he moved to

the Royal Exchange, another prime address, for bankers and merchants.

Henry's London advertisements often stated he was being forced to move as he could not extend his stay at a venue. In 1750 the beast was at the Royal Exchange Coffee House, but Henry advertised for a well lit room of at least ten foot six inches high, a close fit, in the area of the Haymarket or St James's, insisting it must be suitably genteel and private.[32] In 1753 it was at Mr. Pike's Great Dancing Room in Norwich. North America was more rural, so suitable accommodation was limited. When it toured there it appeared at several merchants' houses, the New Exchange in New York and the Newport Rhode Island Court House.

Throughout its career, the show was described as an upper class entertainment, appearing in the largest and most opulent venues yet in the absence of journal and diary confirmations, this is questionable. In its tours of the North of England it often appeared at town halls, which shows the wealth of the country shifting towards the new industrial areas, and the civic pride they represented. Though wealthy at this time, Bristol and Bath still have no town halls.

By providing a lecture, it draws parallels with earlier puppet shows when the story was explained by a man beside the booth. The astronomical component provides more obvious similarities with travelling science shows, so the audience could have been seated in rows of chairs. But the design of the machine included many small details, so it needed to be viewed closely.

In 1743 the widow of Charles Clay advertised "a magnificent and curious musical machine" called *The Temple of the Four Great Monarchies of the World*. It had silver reliefs and was based on work by Rysbrack and Roubilliac. The ad stated it turned around to allow the audience to see the piece in full.[33] No such claims were made for The Microcosm in its puff, but that does not mean its large base did not likewise rotate for a seated audience. It seems The Microcosm was a show where the audience were entertained with a lecture on the various elements of the machine before being invited to view it more closely and ask questions and discuss the performance.

When the *Lecture on Heads* appeared at London's Haymarket Theatre, they did not open the one shilling gallery,[34] suggesting The Microcosm may likewise not have used the entire space. In 1761 Garrick caused a scandal by banning audiences from the stage. Combined with the seriousness of his acting style, this suggests the start of attentive audiences, but it still suggests some flexibility was possible in how the show was presented and how the audience was seated.

In 1749-50 it was in the Great Assembly Room at the Exeter Exchange on The Strand, another former aristocrat's urban base, of Elizabeth's treasurer and favourite, Lord Burleigh. But it had decayed to become home to animal shows with shopkeepers on the ground floor.[35] This new address was near Charing Cross, an area formerly associated with travelling plays which became associated with displays of clockwork, automata and technology. Davies, the last known owner, lived and showed The Microcosm nearby.

In view of the constant claims of approval by the elite, it is interesting to note where the clock didn't appear. Pleasure gardens such as Vauxhall and Ranelagh often had musical and other entertainments, but visitors promenaded, flirted, socialised and dined there, especially at night, so it is unlikely that they would be interested in lectures or learning about the latest astronomy. So it is not surprising there is no record of The Microcosm there or at any of the lesser gardens such as Marylebone.

There were over a hundred spas, established at various times with varying success, but these do not seem to have been a primary destination. It made three visits to Bath, the country's premier resort, in 1747, 1757 and 1773 for the winter during Bath's 'season'. But this was also when travelling shows retreated to London, causing a shortage of accommodation, so the West Country may have been a profitable place to stay off the impassable roads.

13

ON THE ROAD

The travels of the Microcosm have been traced through local newspapers, some of which helpfully mention where the clock had been or was heading, though records are not complete. From 1760 pamphlets were printed describing the show, a souvenir and educational resource which included the latest astronomical discoveries. They often record the date and place printed, so are a sporadic source for tracing the beast's travels. Their frequency suggests they were popular, though the size of the print runs is unknown. A large part of its career was spent in London, from its first appearance in 1734 to its last in 1774, a year before it vanished. From the 1760s the rise of the industrial North and Midlands is reflected by extended tours there, as its target audience shifted from the educated elite to skilled craftsmen. This was helped by the construction of canals: ideal for heavy, breakable goods such as pottery as an alternative to jolting on Georgian roads.

In the early eighteenth century, most travelling shows were little different from those of medieval times; they still featured magic tricks, fiddling, tumbling and stunts. But as affluence and education increased, audience numbers and expectations also rose. Sailors supplemented their wages by importing curiosities from animal skins

and shells to art and crafts which were featured in travelling shows. Orders for specific items such as exotic plants or beasts could be placed with mariners before they sailed. In 1777 Bristolians could see an electric eel which the proprietor had made two voyages to Surinam to obtain, a serious investment of time and money which he must have been confident would be profitable.[1] Hans Sloane visited Jamaica in 1687–89 where he collected plant specimens which later formed the basis of London's Natural History Museum. He also collected curiosities linked to the slave trade which were later put on public show in his *Cabinet of Curiosities* in *Don Saltero's Coffee House* in Chelsea.[2]

When The Microcosm began its travels, it was often the only show in town, but when it last appeared in Bristol in 1775 at the Merchant Taylors' Hall, it was competing with Sieur Herman Boaz's magic show in which eggs were cooked to pancakes in a hat without fire, and card tricks.[3] Audiences were tempted by the first artificial flower garden, and the grandest of them all, *Cox's Mechanical Museum*,[4] so audiences were becoming spoilt for choice.

London was the centre of the court and Parliament, but also of commerce, banking, fashion, communication, media, entertainment and shipping, so its population and wealth were far greater than — and largely independent of — its provincial rivals. The capital had many newspapers, so records of The Microcosm are numerous there, but the show also faced higher costs and more competition for audiences and venues. Shows that followed the circuit of fairs, markets and assizes had less need to spend money on advertising, as — except during plagues and bad weather — crowds were guaranteed. Showmen relied on banter and performance to draw the public into their booths, so have left few traces in the press.

The following are some of the highlights of its travels.

Fog's Weekly Journal of September 1733 is the first record of Henry's clock being put on display, claiming it was the result of eight years' study. So its construction seems to have begun in 1725, the year Henry's son James was born and when he took possession of the large house on High Bridge Street, Waltham Abbey. In 1736 Henry advertised the house for rent, claiming to be travelling, so this seems to be

when The Microcosm became a professional show, possibly after its sale fell through. From November 1736 advertisements mentioned a range of additions and improvements, though the details of these were often unclear.

When James was working as an architect/surveyor in Bristol, he claimed "he had seen the works of the antients" and had been taught all he knew by his father. This raises questions as to whether James had done the Grand Tour, possibly in the company of his father and the rest of the family. If Henry could afford the time and money to make The Microcosm, he could probably also afford an extended road trip to educate his children. Roman remains survive in France, so this may have been the extent of their journey, and this could explain at least one of several extended gaps in the record.

In 1740 The Microcosm was advertised for sale in the press. Bromley[5] claims it was sold to Edward Davies but press records show it continued to be in Bridges' possession. The following year, Bridges advertised that he was busy at home, so was looking to sell or go into partnership.[6] But again, he provides no detail. Was this carpentry, some other commercial matter or family business? Or was it mere puff to get the beast off his hands? Perhaps the novelty of being a showman had already paled.

By the end of 1741 it was at the Mitre Tavern, probably the home of the Society of Antiquaries near Charing Cross. It featured shows of curiosities and automata, placing the show in a specialised circuit. *The Daily Advertiser* of 23 December claimed that two planetariums had been added, showing the solar system and the satellites (moons) of Jupiter. It was claimed to have over a thousand wheels and pinions. Bridges was still looking to sell it for seven hundred guineas or go into partnership. This was the same price Christopher Pinchbeck had asked for an astronomical clock in 1716 which showed similar elements as The Microcosm.[7] So it seems none of the additions or improvements had increased its value. These additions converted the beast from a gentleman's collectible to a public display.

For the next six years The Microcosm's travels cannot be traced.

Was it still on tour in places where newspapers have not survived? Did it or the family go to the continent?

In the middle of this gap — November 1744 — Henry's wife Sarah died. Henry became a single parent of the unmarried twenty-one year old Sarah, who probably took over the running of their home, James at eighteen was probably able to support himself; the youngest sons David and Thomas were still schoolboys of eleven and nine. Had Sarah endured a long illness which prevented Henry from leaving her for long periods? Or did he return to his trade of carpentry?

This was in the middle of what became known as the lost decade of architecture, a prolonged agricultural depression during which there was little money for major building works, especially grand country houses. This suggests there was little money to spend on entertainments like The Microcosm. Or it may have become a boom time for travelling shows, just as the Great Depression of the 1920s became the golden age of cinema, as people needed to forget their troubles and lift their spirits in such troubled times. Press records for this period are still scarce, especially in the provinces, so the show may have been more successful than it seems.

The most surprising part of its career was its prolonged career in southern Ireland. The press drought ends with The Microcosm appearing in Dublin, April 1746, so it must have toured en route via Scotland or the West Country. It was at the Raven on College Green,[8] a good central location. But the show had drifted downmarket, as entrance was a mere British sixpence, about half the price elsewhere. But they compensated by encouraging groups of at least ten rather than the usual four or more, and invited servants and children to compensate. Private showings for the rich may also have supplemented Henry's income. It returned to Dublin in 1767 then toured to Waterford, Kilkenny, Limerick and Cork before Dublin again in 1769. Undated editions of the pamphlet were printed in Newry and Dublin.

Ireland tends to be overlooked in histories of eighteenth century Britain, but cities such as Dublin and Cork were extensively rebuilt or 'improved' at the time, often by English architects. The Dublin Philosophical Society was established in 1683 at Trinity College and the

more formal Dublin Society in 1731 which aimed to improve husbandry manufacturing and other useful arts. From 1733 this expanded to include a museum, mostly of agricultural improvements: didactic displays aimed at mechanics and farmers. Models and implements were stored in the vaults of Parliament House, indicating their importance to the region, and to feed the growing population, or perhaps it was the only large, secure space available. Women, young people and amateurs were encouraged more in Ireland than on the mainland, so such displays found a larger audience there.[9] This may explain why it was such a popular destination for The Microcosm.

The machine was in Bath at the end of 1747 to early 1748, with "two planetariums never before exhibited".[10] But this is odd as they must have been the additions made and promoted seven years previously. Did he mean never shown in Bath before? Or were they improvements of the earlier additions? This was the first time he allowed views of the "within side" when the music was playing, and again Henry was trying to find a partner or to sell the machine outright. These improvements and the optional viewing may have been in response to audience demand. Or it may have been a reaction to the arrival of Jacques de Vaucanson, whose lifelike automata had been a sensation at the Opera House in London's Haymarket in 1742. The Frenchman had upped the game for mechanical shows and automata, but also raised questions as to their veracity, as requests to view their insides were refused. The widow of Charles Clay offered views of the inside of her late husband's ornate clock when it was offered for sale in 1743; the timing suggests it was also in response to de Vaucanson's visit.

In Waltham Abbey, Henry's house had been let for several periods, but the Poor Rates of February 1748 record it as being empty. This probably referred to the building facing the street, the basis of the assessment. The mansion built onto the rear was likely counted as an outhouse or office. It could have been in constant use as a resting place and accommodation for river travellers as it backed onto the River Lea, so was a landing stage for boats from the capital.

After attending Gloucester's *Three Choirs Festival* in September 1748

Henry was back in London, wintering again at the Exeter Exchange, but claiming in February 1749 the *Modern Microcosm* was "Designed for Paris in a short time".[11] A month later, Henry claimed to be "waiting for proper passage to go abroad". Given his passion and need for self-publicity, if he had ever toured Europe, he would have mentioned this and the famous people who had viewed it in his puff. The many claims that Henry and his machine were more famous on the continent thus seem to be unfounded as no evidence was ever provided.

It seems a West Country tour turned towards the Midlands, as he reappears on the newspaper record in Worcester in September 1749. He again overwintered in London in 1749/50 with his new improved astronomical display drawing crowds in anticipation of the return of Halley's Comet predicted for 1758 and the transit of Venus in 1761. Henry was selling prints, but they must have been the original copperplate engraving, as no images survive which show any of these improvements.

He seems to have moved around London for about eighteen months, during part of which his home in Waltham Abbey was empty, and then let, when he embarked on a painfully slow tour of the eastern counties. After Cambridge and Yarmouth, his stay in Norwich dragged on for at least three months when he took The Microcosm down and added a perpetual motion machine. In January 1754 it was in King's Lynn during the time of the market/fair, a lecture was being given on it (till sold). He then advertised for a reliable, literate young man to be instructed in showing the machine, promising him "an easy and genteel life".[12] These delays may have been due to him trying to find a buyer, but he again failed.

The description of an "easy, genteel life" seems unlikely to modern readers. Juddering along potholed roads, struggling through rain, flooded streams and mud or inhaling industrial quantities of dust, risking overturned or crashed coaches seems far from pleasant. Independent travellers — especially show people — have never had an easy life: at risk of arrest, accused of being thieves and vagabonds, unwelcome and distrusted by locals. If anything went wrong, if Henry became ill or was injured, or failed to attract an audience, he could

expect little help and risked prosecution under the Vagrancy Act, so he had to be strong and resourceful. His income was unpredictable, but so was everything before the invention of large companies and the modern welfare state.

Yet the Georgians were great travellers so the ends must have more than justified the means. Modern adventurers who survive near-fatal accidents seem to revel in recounting their brushes with death. Young adults — especially students — famously suffer horrific hangovers after late night parties, but relating their experiences helps bind them together the morning after.

Henry stayed in fine inns, chatted with many different people, so to many he was 'living the dream'. Canal travel provided more gentle journeys, often through scenic countryside. He was largely independent, apparently had no travelling companions with whom to fall out, and his show caused no problems for censors. Respectable travellers were often welcomed to isolated communities for bringing news of the outside world.

This slow tour of the eastern counties is curious; Henry seemed unwilling or unable to move on. His repeated additions and improvements suggest unusual desperation to draw the crowds. King's Lynn was his final appearance.

Henry's will was written on 19 April 1754 and proven by the court of the Archbishop of Canterbury on 18 July. So it seems he had been dying: able to tinker with his machine, but not the strenuous activity of moving it from place to place. He was buried with his wife and children in Waltham Abbey churchyard on 6 July. But his tombstone states he died in Hull, Yorkshire, a long way from King's Lynn, and previous researchers assume he was on tour there. It predates local press in Hull, so cannot be confirmed. As he was not buried there, his death is absent from parish records.

Henry's will states that his son James was in "Antego" or Antigua. Had James sought his fortune to become a plantation manager or

owner there or as a government official? British history is littered with periods when economic and social problems caused people to lose faith in their homeland and seek new lives abroad; such waves of emigration are a defining feature of these islands. Some were so desperate to leave they endured years as indentured servants in the American colonies as white slaves, even committing crimes to be sent to the future Australia. It was often the young and vigorous who departed, which may have prevented the eruption of revolutions here.

The fate of The Microcosm is even stranger.

In August 1755 the Virginia Gazette – Williamsburg announced The Microcosm had just arrived in Norfolk from St Christopher's, and would be shown at the Exchange Tavern. It had spent twelve months in the West Indies. This means the machine must have arrived in the Caribbean around the time of Henry's death, so he could not have been travelling with it. So why was he in Hull?

The timing may be critical. The Peace of Aix-la-Chapel of 1748 renewed Britain's Asiento contract, i.e. the licence to trade in slaves which was first granted in 1713. This triggered an increase in ships trading with Africa and the New World. Hull was a major port, so Henry probably went there to send The Microcosm to his son. This in turn suggests his delays on tour were to improve the machine for its travels in the Americas, to maximise profits.

It seems extraordinary to take such a large, complicated piece of machinery to sea. But the race for the Longitude Prize was underway, leading some authors to suggest The Microcosm had been built for this purpose and the trip to the West Indies was to test its accuracy at sea. But no such suggestion was ever made by its owners, and The Microcosm had too many elements of entertainment for this to have played any part in its design.

The slave plantations of America and the Caribbean created great wealth for many owners, but provided few entertainments. After the end of the Seven Years' War (1756–1763), theatres were established and some of England's finest actors went on tour in the northern colonies, so The Microcosm appears to have been a trailblazer for

them. The same range of advertising seen in Britain was repeated there, with detailed descriptions, poetry and woodblock images.

Parish records for the West Indies do not survive from this early date. Local papers existed, but heat, storms, insect damage and neglect means they have been lost. No record is known of any witnesses to The Microcosm there. But with no competition it was probably lucrative, though travel between the islands was dependent on variable winds, making advance planning for travel and venues difficult.

James Bridges was a member of the local militia in February 1753, suggesting his intention to settle, so the machine must have been shipped to him before his father died. The delays in Henry's touring may have been that he was at last waiting for the machine to go abroad.

In September 1755 the proprietor Mr Bridges (presumably James) held a benefit in Norfolk, Virginia, to raise funds for a forty shilling bounty to every man who signed up to Colonel Washington's expedition. This was shortly after the ill-fated Braddock's Campaign or more commonly, Disaster. Washington was increasingly disillusioned with his treatment by Britain so this was his last battle before entering politics.

Special shows were held in daylight to allow views of the internal parts. Advertisements claimed prices were not to be lowered, as had been expected in the West Indies, suggesting locals were short of cash which seems unlikely, or that the show was poor value. Or perhaps they were just not interested in fine arts and technology. By December it was in Philadelphia, and in February at the New Exchange, New York where George Washington saw it twice with royalist Mary Phillipe and her sister who he had invited to visit the city. He noted the visit in his ledger, and that it cost him eighteen shillings.[13] There was no other entertainment there at the time. But this shows a further role and the importance of shows like The Microcosm: they provided a public space to aid the young in their wooing, though in this case it was not successful. This was a feature often suggested in Joseph

Wright's depictions of dramatically lit science shows such as *The Bird in the Air Pump*.

In April it was at the Court House, Newport Rhode Island, and at Boston till June at a merchant's house where politician Benjamin Lynde Jun. recorded in his diary of 27 May that he "went to see the microcosms".[14] Using the plural is curious and may suggest the show was still comprised of two machines. An advertisement claimed the late Prince of Wales had offered Henry three thousand pounds or two hundred per annum for life. It is impossible to believe this. Even a future king would be mad to offer such a huge price, and the owner would have been even madder to turn it down. This was the last record of it in North America.

The story takes yet another twist after its return from the colonies. In March 1757 The Microcosm was in a large room at the Bell Tavern, Broad Street in Bristol, a major venue in the commercial centre of the old town.[15] Tickets could be bought at the tavern or from Mr Bridges, architect on St Michael's Hill, the main road to Wales, an area beyond the city limits popular with members of the various building trades. These advertisements claimed the clock was the result of twenty-two years' study and work, and that Henry was from London. This is a huge leap from the initial eight years but suggests the machine was repeatedly updated and improved. There is no mention of the proprietor being Henry's eldest son, so who was showing it? It probably took James some time to build up a business, so he may have practised two professions for a time. The show could have provided income and a chance to establish contacts and get a foothold in the local building trade.

In November 1756 James Bridges advertised that he had been in the American colonies, was educated by his father and could build anything. Some authors have since suggested he worked as an architect in North America, but there is no evidence for this. There was no shortage of wood and proficient carpenters, so this is unlikely. When James was employed to rebuild Bristol's St Nicholas church he claimed the tower was sound when it was not, so his career as an architect was in stone, not wood.

He apologised for the advertisement, as he knew few gentlemen in Bristol.[16] But James worked in Bristol for a further seven years whilst the clock continued its travels. He never claimed to have built anything before his arrival, but was given contracts to repair several churches, build at least two mansions, and rebuilt the city's namesake, the medieval bridge across the Avon in the centre of the city.

The following month he and his wife, "late of Antigua", finalised the sale of his late father's house on High Bridge Street, Waltham Abbey, to solicitor William Jessop who was already the tenant. It became the town's court house. But again there is confusion, as the previous June, the agreement had been signed and executed by James and his wife Mary, so they must have been in England when The Microcosm was in Boston. It was the same couple as they were both described as being "late of Antigua then of Bristol". But the acknowledgement of William Jessop to the title of the property before Essex justices mentioned a writ of January 1757 issued at Westminster which claimed James and Mary were too infirm to attend. Was James's uncle of the same name acting in his stead? Or was this a ruse to excuse their absence?

In January 1758 The Microcosm was back in London at the Exchange Coffee House, but was quitting in April as it was to be sold. This suggests Henry's younger children, who inherited equal shares in it, had fallen out, or simply had no interest in the family business. Again, its advertisements were aimed at "all sorts of people, including mechanics". In May the machine was at Greenwich, suggesting a tour of the Home Counties, when Thomas Turner of East Hoathley, Sussex, saw it with his sister and brother's wife.[17]

The Microcosm found a new London space in January 1759 at the Great Auction Room, Spring Gardens which had been improved and decorated. This was a venue for mechanical shows and automata but had also staged Mozart's first performance. By June it had relocated to Pope's Head Alley, opposite the Royal Exchange. The owner was again threatening to go abroad in response to "pressing invitations".[18] Given how many times this had been claimed, it seems unlikely.

Wherever it went, it was not for long, unless "abroad" meant

beyond London. It was in Kingston, Surrey, at the end of July for the duration of the fair and heading for Guildford, so was back on tour, following the crowds as before.

A gap of eighteen months followed, after which it reappeared in January 1761 at the Star Tavern in Plymouth en route to Tavistock, Truro and Falmouth. This gap is long enough to allow a European tour. But again, if this happened it would have featured in subsequent puffs.

This is when the first mention was made of the pamphlet, printed for Edward Davies. *A Succinct description...* describes The Microcosm and provided information on astronomy which was repeatedly reprinted and later updated as discoveries were made. It was part educational reference, part souvenir and copies of them are found in many collections in the UK and in the United States. This Davies, who was probably a witness to Henry's will, who was later a mechanical organ maker of London (whatever that means, as all organs are mechanical). He may have made the organ part of it.

A pamphlet survives in Paris's Bibliothèque nationale, a translation of A succinct description... titled *Un Description De L'Incomparable Assemblage D'Arts Appellé Le Microcosme, Avec un Abrégé du Systéme Solaire, & de ceux des Planètes.* But it omitted the original's illustrations and poetry. It also failed to name the author, listing the translator as being L. Bridoux. It was published by P.S. Lalou who produced the prestigious science journal Science Journal des Scavanas which had been printed in the Hotel de Ville in Lille from 1665 to 1792. This may be the source for claims that The Microcosm toured Europe and was more famous and respected there than in England. Lille is also significant as it is on a large, navigable river, so The Microcosm could easily travel there from the coast.

But there is no evidence the clock toured there, and this French publication may have been a pirate version which — in the absence of international copyright law — was both legal and part of the spirit of the age of sharing scientific information.

The third edition of Davies's pamphlet came out in Coventry in 1763, so the machine was touring the Midlands when Richard Edge-

worth viewed it several times, and was told of Erasmus Darwin's visit,[19] so linking the machine with the Midlands' famous Lunar Men. In May 1764 it was at Vicars' Hall, Lichfield, close to Darwin's home, so he must have seen it and known the proprietor. Such close contact probably rendered the show too mundane to deserve comment by the doctor or any of his guests. By 1767 it was in Scotland, and by the end of the year in Ireland where the eighth edition of the pamphlet was published.

After a tour of Eastern counties in 1772 which included Stourbridge Fair, it was back in London the following March when Davies published the twelfth edition of *A succinct description...* In July 1773 it arrived in Oxford for another tour of the West Country via Southampton and was at Salisbury Music Festival in October before overwintering in Bath and then Bristol where he claimed in his publicity yet again that he intended to go to a foreign court in a short time. But again, this seems to have been either wishful thinking or mere puff as it returned to London via Newbury and Oxford. Davies's address was given as being "third door east of St. John Street... with Microcosm over the door" in Pall Mall, an expensive, central location. In May he announced the machine's imminent departure for a foreign court.

It reappears on the record in December 1774 at Bristol's Merchant Taylors' Hall with claims that it was on its last tour of England. But The Microcosm was no longer alone. It was part of the *Museum Exhibition*, in company with two musical temples allegedly worth four thousand pounds, to be sent to China soon.

The last known sighting of The Microcosm was in June 1775 at Shrewsbury Town Hall. But for years, press accounts had become harder to trace. They no longer featured the distinctive woodblock image that made it so easy to spot amidst the advertisements for runaway wives, stolen or strayed animals and bankruptcy auctions. Reports of people spontaneously bursting into poetry at the sight of it had become a distant memory. For several years Davies had been supplementing his income by repairing and tuning various keyboard instruments and selling strings for them. He also advertised luxury

items such as microscopes, coin balances, glasses and even umbrellas. Several advertisements offered landscape paintings for sale, so his income from The Microcosm must have been declining.

Paton-Williams' account of Katterfelto[20] claims the showman travelled at a walking speed between towns to protect his many fragile instruments, but The Microcosm's route seems to have been via canals and tidal rivers where possible, to minimise damage, so the early industrial age provided new audiences and new ways to reach them. The machine's outer case appears detailed and fragile, with many parts at risk of breaking off, so needed careful packing and transportation.

The machine included a barrel organ, and forty years is a good age for an instrument in frequent use, possibly by members of the audience who were careless with it. Yet it survived damp, dry rot and insects. A single stumble by a man carrying it, or a rope breaking when hoisting it on or off a ship or wagon could have shattered the case, leaving only the sturdiest part intact, i.e. the clock that survives in the British Museum.

Most authors have suggested the clock finally went abroad and was largely destroyed in the French Revolution, but like much of this story, it is only one of many possibilities. It had outlived its creator, all its rival shows and its original audience. Its role in the English Enlightenment and contribution to education and culture was immense, though still not fully understood. It was found by collector Courtney A. Ilbert under a tarpaulin at the bottom of some stairs in Paris in 1938. Its presence in the British Museum, even though incomplete, is bordering on the miraculous.

14

EDUCATING THE MASSES

The surviving part of Henry Bridges' clock was not on display in the British Museum for many years because it failed to represent its full story. It was not listed in the 1981 Catalogue of Scientific Instruments because its significance lies not in its 'clockness', but in how it was used and viewed. John R Milburne claimed it demonstrated the universe, so was more important as a three-dimensional model than a clock.[1] But the movements were in a single plane, so it was more akin to the earlier tellurions than the better-known spherical versions often seen in gentlemen's libraries.

But Milburne still understates the machine. It was not just the physical world on display. It presented the wider world of land and sea travel, industry and the arts in their widest, i.e. classical, sense. It was a starting point for the consideration and discussion of Britain in a state of rapid change.

Wealthy benefactors provided patronage for artists and skilled people by subscribing to their books, providing grants for projects and granting pensions to those who had produced a substantial body of work when they became old or infirm. Some invited them to be guests in their own homes, in part for their entertaining and stimulating company, but also to allow them to concentrate on their work without

the distractions of a 'proper' job. By bringing together people with different skills and backgrounds under the same roof, ideas could be shared and new projects discussed. In modern terms, this was brainstorming. Any artist or researcher knows how work sometimes hits a fork in the road; ideas fizzle out into dead ends. Sometimes these problems can be solved by going on long walks, especially in scenic countryside. Outside input can solve such dilemmas and re-ignite the fires of creativity, without which there would have been no Industrial Revolution in these islands, so the modern world would be very different to the one in which you are reading this book.

The link between science and art in the mid- to late eighteenth century is shown in paintings by Joseph Wright of Derby (1734–97). He was not scientifically minded enough to join the Lunar Men but he was friends with Erasmus Darwin (1731–1802) and John Whitehurst (1713–88); his art was deeply influenced by their ideas.[2] Wright's *A Philosopher Giving A Lecture on the Orrery in which a Lamp is Put in Place of the Sun* of 1766 shows a wild-haired philosopher demonstrating astronomy. The scene is dramatically lit, suggesting inspiration from Caravaggio, and that the sense of religious wonder lost in England's Reformation had been recovered or re-found in modern science. Wright's pictures also challenged the rigid classifications of art history. They resembled the popular form of group portraits known as conversation pieces, yet they were more varied and dramatic. Andrew Graham-Dixon in the BBC television series *Gothic* claimed Wright's candlelit pieces were part of this mid-century genre, as they included romantic shadows and fearful expressions. But the subjects also showed wonder and delight, so are not so easily pigeonholed. In the Netherlands, such candle-lit portraits formed the basis of the popular *Caravaggist* school.

Wright's most famous work is probably *An Experiment on a Bird in an Air Pump* of 1769, now in London's Tate Britain Gallery. It shows the dramatic effect that scientific demonstrations had on the public of all ages; the surrounding faces, dramatically lamplit, show fascination, excitement, and fear. Such images encouraged people to attend lectures for education and improvements, but also for excitement and

socialising. They showed more clearly than any handbills or puff that scientific demonstrations could be entertaining as well as 'improving'. Trevor Fawcett cites a similar demonstration in 1731 by Dr Desaguliers in Bath, when Prince William's governess was so horrified by the suffocation of a fish in an air pump that she had it returned to the river.[3]

Like his scientist friends, Wright made use of recent improvements in optics, such as the camera obscura to help depict perspective. He was also radical in depicting ordinary people in a realistic manner, as opposed to society portraits by Royal Academicians such as Gainsborough and Reynolds. They were commissioned to paint the newly wealthy, often improving the appearance of the subjects and their estates. The wide-ranging interests of Wright's friends the Lunar Men included geology, and he painted eighteen views of Vesuvius erupting when he visited Italy in 1773. It was one of the most fascinating and frightening events of the time and challenged long-held Biblical notions of the age of the earth.

The staunchly Calvinist Archbishop of Fermagh, Bishop James Ussher (1581–1656) researched the Bible to claim the earth was created at about nine a.m., 26 October 4004 B.C.[4] This claim inspires incredulity and ridicule today, but at the time was accepted as Biblical truth. The Roman occupation of Britain was known from classical sources, so any investigations into the infant sciences of archaeology and geology were forced to work around these fixed points.

Henry Bridges was one of the first gentlemen — but not the only one — to produce an ornate educational model. The English envoy to Sicily, Sir William Hamilton who was more famous for his wife's affair with Nelson, built a *Vesuvius Apparatus,* an elite entertainment but also a means of representing a volcano's force, its changing nature and noise, a demonstration which excelled even the finest painting.[5]

The eruption of Vesuvius challenged artists to depict scenes of fire and molten lava, so Wright experimented with new paint and painting methods. It fuelled debate on the structure and origin of the earth, challenging Bishop Ussher's ridiculously precise calculation. It also fed into ideas of new, unlimited sources of natural energy, reflecting

the work of Desaguliers and Benjamin Franklin, and inspired engineers to experiment with perpetual motion. Vesuvius also challenged the notion and depiction of static images, of nature fixed in time as in still lifes. Volcanoes and storms provided drama, a major shift from the Augustans who favoured peaceful landscapes and classical statuary. This suggests Britain had by mid-century recovered from the traumas of previous centuries and was seeking adventure and drama, just as today's youth pursue dangerous pastimes while their baby boomer grandparents had sought inspiration in rural idylls.

Just as Henry Bridges' work seems to have inspired other scientists, Hamilton's work inspired artists such as Gainsborough, who designed and constructed picture boxes to help depict perspective.

Wright's work is also important as it records the high point of science before the French Revolution which put an end to patronage in France and saw the execution of pioneering chemist Lavoisier. Edmund Burke saw links between scientists, revolutionaries, and anyone educating the poor; even evangelists like the Wesleys and Hannah More were seen as threats to national security.

Roy Porter writes of the decline of traditional entertainments in the eighteenth century, especially in Bath. Shows of the sixteenth and seventeenth centuries involving sports, juggling, animal baiting etc. were being replaced by the more civilised exhibitions, assemblies, concerts and lectures. This paralleled a shift from public spaces such as fairs and markets to private spaces such as grand mansions and assembly rooms. It may also reflect the turbulence of the era which led to revolutions in North America and France, with concerns about the same in Britain. People must have craved more peaceful pastimes. Porter claimed the popularity of science in the provinces was due to its role in culture: the aping of fashions in the capital rather than its role in education, dissent or in promoting industry, so has been largely ignored by historians. He cites Benjamin Martin who claimed that an interest in science was a means of being respected in polite society.[6] Porter traces this concept back to John Locke (1632–1704), physician, diplomat and author who became a hero of eighteenth century Enlightenment in Britain and Europe who claimed that

knowledge of natural philosophy made a man fit for conversation, i.e. polite society.

But Locke was referring to the small number of gentlemen of independent means with time to indulge in scientific investigations. They were not motivated by the pursuit of profit, so allowed free public access to their discoveries. Like the Augustans of Rome, early scientists worked for the betterment of society. Having lived through the Civil War, Locke was aware of the chaos and bloodshed that followed the breakdown of social exchanges. An interest in science was not just about collecting the information; it provided a neutral space for social intercourse, whether between provincial neighbours or the heads of nations. Polite society of the eighteenth century understood this. Porter highlighted the shift in power and patronage by the decline of the great Whig magnates such as Chandos and Burlington. The vacuum was filled by provincials who mimicked their betters by supporting improvements, charities, publishing and the arts. Such support allowed Pope to become financially independent as early as 1715, so writing was the first of the arts in England to recover. By mid-century the great Garrick had become a patron who supported the career of sculptor Nollekens. So acting — i.e. the performance of words — was the second.

Porter's mockery of provincials for aping their betters may have been true for some people. But the population involved in and supporting science and technology was large and productive. England had fallen behind its European rivals whose universities and libraries had not been so thoroughly vandalised by the Reformation and Civil War. To catch up, such knowledge needed to be recovered and improved, which required widespread and generous financial support.

The loss of masonry yards at the Reformation meant no large-scale engineering works were carried out in stone for centuries. Most people in England lived in low-lying farmland where rivers were easily fordable, at least in summer, but London had only one bridge across

the Thames. Its piers were repeatedly damaged by floods, collisions with boats and decay; and repairs were made by repeatedly reinforcing them. This narrowed the space for water to flow, creating millraces rather than passages for boats. Travellers often disembarked upstream, crossed the bridge and joined another boat downstream.

In the eighteenth century Samuel Smiles bemoaned England's ongoing lack of interest in engineering, but part of the problem was that outside the capital, few people with wealth lived near where such works were needed. Smiles wrote:

> "At a time when Holland had completed its magnificent system of water communications, and when France, Germany and even Russia had opened up important lines of inland navigation, England had not cut a single canal, whilst our roads were about the worst in Europe".[7]

But again, this is unfair. England had been more thoroughly disrupted by the Reformation and Civil War. Being an island made movement of people and ideas from other countries harder than on the mainland. Germany in particular was a patchwork of large and small principalities, Catholic and Protestant, so tradespeople and their patrons found movement easier if their beliefs were at odds with their local rulers.

Smiles is correct that England had notoriously bad roads, but when goods travelled by packhorse and people largely on foot, local parishes maintained paths which were mostly for their own use. The real damage came with the rise in coaches and heavy farm wagons, the result of rising affluence and consolidation of farms, enclosures of common lands, and urbanisation. A network of toll roads was established to fund improvements. But these were often opposed — sometimes violently — by country people who rioted against paying for the damage caused by wealthy outsiders.

Canal transport was slow to develop because canals were major projects, and few wealthy aristocrats were prepared to fund them. Holland's mills were driven by wind, whereas many in England were driven by water, with dams that obstructed canal boats. In Cornwall

the land itself made roads difficult, with steep hills and isolated coves, so travel by sea was often cheaper and faster.

In the mid-eighteenth century when a second crossing of the Thames was proposed, it was promoted by the Earl of Pembroke whose palace was nearby. It was opposed by the many watermen who feared they would lose their employment and that southern parishes such as Southwark would struggle with the resulting surge in demand for poor relief. Eventually the project to build Westminster Bridge was funded by a lottery, and mocked by Henry Fielding as being part of the gambling culture of the time as a *Bridge of Fools*.

While Europe was forging ahead with major engineering projects, England adapted and improved existing systems. If the English had really needed major engineering works, they would have found a way to carry them out. The fact that they did not suggests they were better than the European rivals at the 'making do and mending' made so famous in World War II. Or perhaps there was a lack of leadership. It took the Great Fire of London to focus their minds on the need for fireproof buildings, but Wren's grand redevelopment, to open up the city with wide healthy streets lacked a leader powerful enough to override the demands of many small property holders.

The tragedy of the Great Fire can also be re-read. The fire followed a year after the Great Plague, which some authors claim was the result of the mass killing of cats and dogs which were blamed for spreading disease. This allowed the rat population to soar, providing fertile ground for the infection. The plague in turn led many people to leave the capital, so fewer people remained to watch for, and to fight, the fire, so its causes were complex.

According to Porter, the high prices charged for public lectures were beyond the means of mechanics and the poor. But servants were paid largely with food and lodgings, and so had little to spend their meagre allowances on, especially outside the capital. Travelling shows such as The Microcosm often advertised performances in the evenings, with special prices for children and servants, which confirms that they were part of the target audience.

E.P. Thompson describes how pre-industrial work often comprised

alternating bursts of intense physical activity with extended breaks. This was the general pattern for harvesters, sailors, and later, stokers on steam ships. But it seems to have been more widespread. He lists a wide range of trades which celebrated *Saint Monday*, a chance to recover from Sunday's hangovers, even at the height of the Napoleonic Wars, with some also claiming Tuesdays as a day of rest. Such practices were so entrenched that in some areas they continued into the twentieth century.[8] So it seems some of the lower classes had more time for recreation than most records suggest. This is reinforced by many press accounts of huge crowds attending boxing matches, boat and foot races and executions which were often held on Mondays. When public events were announced by the bellman, or fights or fires broke out, there were always people on hand to hear and if necessary, to intervene. Images of the eighteenth and nineteenth centuries often show streets were crowded on normal working days. So, even when people were at work, they were often able to down tools if a distraction presented itself.

When the economy expanded in the eighteenth century, the elite became more mobile; many spent less time at their country estates, visiting friends or relatives, going to London for 'the season' or the various spas. Thus they had less need for permanent staff at home, preferring to employ temporary staff at their destinations. These servants often shared information such as details of entertainments, so their gossip probably helped promote The Microcosm. Some fortunate servants — often supported by their masters — made use of their knowledge of polite society by setting up their own businesses, such as coffee houses, pubs and inns, some of which served as venues for travelling shows.

The promotion of science also appealed to social reformers and evangelists, as education and improvement were seen as a positive alternative to drinking, gambling and general dissipation. Bath was reputed to be a place of widespread misbehaviour, but the presence of invalids led Beau Nash to enforce a strict curfew on night-time entertainments, which restricted drinking and the resulting disorder. Bath had a special appeal to young ladies as its season was in the winter

months when they were often confined to their family estates by impassable roads. Whilst the men could escape to the countryside for riding, hunting and fishing, life for women could be dull and lonely.

Science lectures were aimed at a wide range of people, but among the Lunar Men of Birmingham, the accumulation of knowledge seems not to have been their primary goal. Erasmus Darwin's interests were wide-ranging, including a fascination with Harrison's clocks, and he often corresponded on the subject. Dr William Small wrote to Watt about his many experiments in clockmaking, yet there is no evidence that any of their members ever consulted their in-house expert, the clockmaker John Whitehurst.[9] The main purpose of their meetings was the pleasure of discussion, discovery and socialising rather than learning and improving their skills per se. Like modern entrepreneurs, they discussed and sought answers to specific problems rather than becoming expert in the whole subject. They were all busy men tinkering in a range of fields as their interests or businesses dictated. They found pleasure in the journey, not in arriving at a destination. This was highlighted by clockmaker James Graham who claimed that as soon as he completed a piece, he was already planning improvements to it, so found it impossible to replicate any of his work. Darwin had extraordinary social skills, forming four or perhaps six societies, of which the Lunar Society is the most famous, held on full moons to enable members to travel home safely.[10]

Dr John Arbuthnot of the Scribblerians seems to have been constantly writing, yet little of his work survives. This may have been due to his allowing his children to make kites from his journals,[11] so his main motive for writing was the process of creativity and composition, to get the words out of his system, rather than preserving his words for posterity. He may have seen his children as his greatest work and his finest legacy.

It is thus significant that the only detailed account we have of The Microcosm is by Richard Lovell Edgeworth (1744–1817), a younger, lesser-known member of the Lunar Men. He admired Erasmus Darwin whose extensive travelling as a country physician led him to improve methods of transportation. Like so many in this story, Edgeworth was

another man of wide-ranging interests; he promoted children's education, engineering, agricultural improvements and Irish independence. His entry in the *Oxford Dictionary of National Biography* claims he was a man of immense physical and mental energy well into his later years. But he failed to achieve fame as his interests were too diverse for him to leave his mark on any particular field.[12]

The Microcosm fits well into this world of education combined with leisure and entertainment. After Edgeworth saw The Microcosm at Chester in 1765, he claimed it inspired him to invent an improved carriage. He had already built a clock and long been interested in mechanics; the show refocused his mind on the subject. He became a prolific inventor of such items as a land-measuring instrument and won a medal from the Society of Arts for a carriage. He also experimented with a velocipede, all apparently inspired by Mr Bridges' machine.

Others may have had similar epiphanies: being inspired to take up writing after reading a good book, or music after a show or concert. Modern teachers are sometimes described as inspiring. In the age of improvement, such epiphanies could have far-reaching effects.

There are several versions of how the Reverend Edmund Cartwright (1743–1823) invented the first power loom. In 1784 Hargreaves' *spinning jenny* was being widely copied, raising concern that mechanical spinning would overwhelm the capacity of the handweavers. This was still largely a cottage industry, often carried out on the top floors of houses whose windows were enlarged to provide more light. It supplemented the meagre, largely seasonal, employment of agricultural workers.

A source claims Cartwright was on holiday at Matlock where he visited a factory and suggested to local gentlemen it should be possible to invent a weaving mill but was assured this was impossible.[13] But they were also concerned that the weaving trade would go to Germany where labour was cheaper.[14] Cartwright may have seen the *Turkish Chess Player* which could beat humans; it was believed to be an automaton. History Today claims it was Arkwright's factory that provided the inspiration for Cartwright's first power loom

which he patented in 1785.[15] He struggled to finance his invention, ran up debts and abandoned his research. But a modified form of it became popular, so he was rewarded with ten thousand pounds by parliament, placing his invention on a par with the work of Harrison. This theme of being inspired by fine workmanship recurs throughout the history of science, and echoes the practice of craftsmen visiting fine examples of their trade for professional advancement.

Like Edgeworth, Cartwright claimed to have had an epiphany which inspired his first steps into engineering. Also like Edgeworth, he had form as an original thinker. He claimed to have no knowledge of weaving, but as a classical scholar he was probably aware of ancient looms; this is suggested in the title he acquired, the *British Archimedes*.[16] He was also a famous poet, whose work was praised by Sir Walter Scott,[17] thus echoing the career of Darwin. Also like the doctor, he was concerned with public health. When visiting a boy dying of typhus, he dosed him with yeast, being aware of the local practice of keeping meat near yeast to keep it fresh. This practice was adopted by local medics, long before modern antibiotics were discovered.[18]

Closer to the modern age, Alec Cobbe grew up in his family home of Newbridge near Dublin with a museum which intrigued him as a child. In particular he was drawn to several preserved human hands. He memorised all the bones in the human body from an old first aid book, which he claims inspired him to study medicine.[19] This also echoes the training of craftsmen, who learn by seeing expert examples of handiwork. This instinctive, almost childlike practice, is driven by curiosity, as when James Graham asked to see a man's watch, was shown the interior and had the workings explained, which inspired him to make a clock, the first steps in a dazzling career as a clockmaker.[20]

The Augustans ranged over a wide vista of interests and specialities. In 1719 Sir Richard Steele — writer, theatre manager and editor — became a showman. He established a *Censorium* in his Great Rooms at York Buildings which was expensively decorated, and designed to stage the finest music, drama and science lecturing to a select group of

the rich and cultured.[21] Desaguliers performed there, and also invited visitors such as Lady Mary Cooper to his own home. She had shown an interest in nature, so was invited to view Venus in his observatory. He claimed the sight was beautiful and promised to provide some experiments in colour,[22] so he used socialising and fine art to encourage an interest in science.

Despite the many restrictions on women, some were encouraged in their learning. Elizabeth Tollet (1694–1754) was a contemporary of Henry; her genius was noticed by her father who taught her music, history, drawing, several languages, poetry and mathematics. She was encouraged by Newton, and defended women's right to education based on the life and work of Hypatia, the philosopher-mathematician from ancient times.[23]

Public lectures and The Microcosm's performances played an important role in the education and advancement of women, who were excluded from universities, the Royal Society and coffee houses. There was a women's coffee house in Bath though it is unclear if activities such as lectures were held there.

The Reformation gave rise to a wide range of religious sects, many of which encouraged women to be educated to the same level as men. Women were encouraged to teach their children at home, and knowledge of mathematics helped them with domestic management and finances. The shortage of men meant that many women would never marry, so they needed to make money to avoid being a lifelong burden on their families. Caroline Herschel was scarred by smallpox as a child so was told by her father she was not pretty or rich enough to marry.[24] She was paid to write letters for her illiterate neighbours.[25]

Women womanned barricades during the English Civil War and female aristocrats led the defence of their homes. Campaigners for the rights of women and children such as Unitarian Mary Carpenter, responsible for the *Magna Carta of Children* and Congregationalist Elizabeth Blackwell who became the first female doctor in the U.S.A., were

educated alongside their brothers. Many became the foot soldiers for campaigns such as the abolition of the slave trade. Poet Mary Robinson often compared herself to a bird in a gilded cage; like many women, deprived of legal rights, she identified with others who were oppressed. In London's *V&A Museum of Childhood* is a painting *A Girl Writing* by Henriette Brown from 1870. It shows a young girl with pen poised before an open book. She is gazing at a small bird, with its open cage behind her, a wonderful image of the liberating power of education.

Richard Edgeworth's daughter Maria (1767–1849) worked with her father on agricultural improvements and published some of the earliest novels for children. With her father she wrote *Practical Education* in 1798, a pioneering text on education still used in Britain and France into the late nineteenth century. She is best known for her depiction of life in Ireland in *Castle Rackrent* of 1800 and made more money from her writing than either Jane Austen or Walter Scott.[26] She was in Paris following the Peace of Amiens in 1802 with many young radicals such as Turner and Wordsworth, so was also highly sociable and widely, independently travelled.[27]

The Edgeworths were important in encouraging the work of other curious people. Humphrey Gainsborough, brother of and allegedly of equal genius to Thomas, carried out engineering experiments at the Edgeworths' home.[28] They praised the geometrical models of Benjamin Donne, son of a Devon mathematics teacher who shared their early interest in Rousseau's child-centred education. He was described as the finest science master in the kingdom,[29] and produced the first detailed modern maps of Bristol and ran the Merchant Venturers' navigation school which had classes of only twelve boys. Donne also became a peripatetic science lecturer, providing courses mostly in Bristol and Bath on various branches of engineering, optics and electricity.

He worked as a surveyor and sold the resulting maps, winning a Society of Arts medal for the first map of a county: of his home in Devon.[30] Donne wrote popular books on bookkeeping, navigation and surveying and frequently updated his lectures. In 1783, at the height

of balloon mania (they became popular as possible war surveillance) he lectured on how to produce *inflammable air*, i.e. hydrogen.[31] George IV appointed him Master of Mathematics and his book on geometry had an introduction by Dr Thomas Beddoes (1760–1808), physician to Sir Joseph Banks. Beddoes established his Pneumatic Institute at Hotwells, Bristol with the support of R.L. Edgeworth, whose daughter Anna he married. He employed Humphrey Davey the pioneering chemist who invented one of the first safety lamps for miners. He experimented with electricity and gases, especially nitrous oxide (laughing gas) which he used with his friends the poets Robert Southey and Samuel Taylor Coleridge. Davey's mother's holiday lodgings in Cornwall were rented by members of the Lunar Society. Thus, long before modern communications, people with money and education were exchanging ideas and socialising over large distances.

All of the above shows the existence of a busy and varied social scene connecting people working in a wide range of fields across Britain. But it is also a reminder of how small was this world of educated people with time on their hands who managed to achieve so much. The links between science and sociability worked on many levels, leading to intermarriages — Josiah Wedgwood became grandfather to Charles Darwin — and many successful commercial collaborations. Such connections helped found scientific and literary societies, mechanic's institutes etc., which further encouraged education and research. Unlike today when science and the arts are often seen as competing with each other in education, or conflicting in terms of philosophy, they were all seen as part of a whole, a liberal education which encouraged independent thought and creativity. This widespread passion for subjects formed the basis of the English Enlightenment, the Industrial Revolution and the British Empire and was much admired by European thinkers such as Voltaire.

As the eighteenth century progressed, and the economy improved, people had more time and money for leisure and self-improvement. In

1700 a local annalist claimed that most Bristolians were "as illiterate as the back of a tombstone"[32] There was a real hunger for knowledge, and for many forms of entertainment from libraries to executions. England's two universities excluded Nonconformists so they established their own schools but were still excluded from government and some professions. Catholics suffered more restrictions so the few who obtained university degrees did so in Europe. Until compulsory education was introduced in the nineteenth century, the majority of the population were fortunate if they learned the basic skills of literacy and arithmetic. To fill this vacuum, a uniquely English creature arose: the peripatetic science lecturer.

Trevor Fawcett described how Desaguliers, Fellow of the Royal Society travelled to Bath in May 1724 to lecture on the eclipse of the sun to approximately twelve hundred visitors. This event triggered the start of travelling science lecturing in Bath; his success helped establish his career and the many scientists and technologists who followed him.[33] But the concept is, as with so many others of this period, of ancient origin, as Aristotelian philosophy was described as 'peripatetic'. Such mobility meant that information had to be imparted in a limited time, so the information had to be presented in an entertaining and professional way for it to be remembered by the audiences. Yet again, Britons were not so much discovering, rather recovering and adapting the knowledge that had been lost.

This promising start established Bath as a centre of scientific enquiry. It was the first to establish a philosophical society in 1779. William and Caroline Herschel were musicians there in the 1770s before making their improved telescopes and astronomical discoveries. The resort attracted a wealthy audience for entertainment, and physicians researching cures provided a scientific audience. Lecturers ranged from cutting edge experimental scientists to dabblers in magic and fraud.

James Ferguson was a self-taught mathematical genius who made lecture tours on astronomy in the 1740s. After gaining royal patronage and becoming a Fellow of the Royal Society, he returned with a broad selection of working models including his orrery which displayed the

planets in motion. It seems his book *Astronomy Explained* was the inspiration for William and Caroline Herschel who probably saw his lectures. Another Lunar Man and member of the Royal Society, Dr Joseph Priestley was librarian at nearby Bowood House where he made major discoveries on gases. He was famous for allowing free access to his work; John Waltire and John Arden lectured on his discoveries before they were published.

At the other extreme, it was also briefly home to the quack Dr James Graham, infamous for his Temple of Health and Hymen in 1781 which involved treatment using homemade electrical apparatus in the form of a flying dragon. He delivered his lectures from his Grand Celestial State Bed with mirrors and glass pillars which he hired out for a massive fifty pounds per night, claiming it would cure infertility.[34]

Research into early science and natural philosophy was time-consuming and manufacturing or purchasing new forms of equipment was expensive and potentially dangerous. The famous example of the Herschels staying up all night holding a mirror for their telescope to set, or gazing at the stars would have been impossible had they been forced to go to work in the morning. Few aristocrats had the immense wealth and interest in improvements of Desagauliers' early patron the Duke of Chandos, but many early scientists were Anglican clerics, whose income freed them to pursue their research and share their discoveries.

The cleric John Whiston (no relation to Lunar Man William) was an early promoter of Newton. He abandoned the church to focus on his research and was granted an annuity by Queen Caroline and King George I. He campaigned for the establishment of the Longitude Prize and submitted several proposals for it himself.[35] He thus showed an admirable mixture of self-interest and altruism. For others, the Royal Society paid for some research, and coffee houses brought together men of common interest who provided patronage. M.P.s increased their popularity by supporting good causes such as local charities and research into marine safety; gentlemen's societies and lodges of

Freemasons allowed networking which could lead to patronage of various forms.

The life of James Ferguson shows the many forms patronage could take, from a simple act of praise, to providing food and lodgings, access to training and libraries and equipment or promoting and purchasing his work.[36] Unlikely collaborations and friendships arose, such as between the Swiss artist Henry Fuseli (1741–1831) and Liverpool banker William Roscoe (1753–1831).[37] They were described as having very different temperaments but both opposed slavery and had similar political outlooks. Roscoe provided emotional support and artistic advice as well as encouragement for Fuseli to continue with his work.

The astrologer George Parker (1654–1743) struggled for many years with his finances. He was accused of converting to Quakerism to marry a rich wife for her wealth. He ran a tavern or ale house off Fleet Street which attracted ingenious men, some of whom raised money to provide him with a 'salary' which enabled him to publish astronomical tables which became a profitable and useful business. He employed many people to carry out complex calculations; they were the original 'computers'. This early support was a forerunner of today's 'Kickstarter' funding. The tables were recommended by the above philosopher John Whiston.[38]

Magistrates often punished travelling show people when their performances caused offence or charged them under the draconian vagrancy laws when their careers foundered. But these men of stature also supported worthy causes and recognised enterprise. The most famous showman of the late eighteenth/early nineteenth centuries was John Richardson (1766–1836), famous for his benevolence and hard work from his start as a child in a workhouse. He lost his horses in a 1799 flood, so was unable to pay rent at Stourbridge Fair near Cambridge. He was arrested but the manager of a local theatre circuit gave him five pounds. Richardson was forced into busking until the magistrates of Waltham Abbey requested a private show, the payment for which wrote off his outstanding debts.[39]

The dearth of wealthy patronage for arts and science in Britain forced scientists to turn to the booming leisure industry in the capital and the many spas across the country for their livelihoods. But they may have chosen this independence to keep control of their research and property, rather than that of their patrons. Unlike clerics whose tenure allowed them to research in a secure environment, these lecturers were part of the freewheeling economic boom, so had to pay their own way. Competition with their peers and the many frivolous shows meant they updated their performances to include the latest research, presenting the information in an entertaining way, and pitched at the appropriate level for their audiences. They had to provide their own equipment and models, plan and promote their tours, and book suitable venues, so were multitasking almost as well as modern working mothers. Their subjects ranged over navigation, astronomy, electricity, chemistry, geography, botany, mechanics, air pumps, and even military fortifications.

During the balloon frenzy of the 1770s they explained aerodynamics and how to produce hydrogen, so audience members could poison themselves and their families, or float away, possibly crashing to their deaths in homemade balloons, or cause major explosions and fires in the comfort of their own homes. Some made extra money by writing and selling books and pamphlets, spectacles, scientific equipment and even exotic items such as umbrellas. They could also be hired for private tuition and performances.

But these travelling lecturers were still distrusted by locals, especially in isolated areas. If they failed to draw crowds and ran low on funds, they could still be imprisoned, whipped out of town or transported to their place of birth under Elizabeth's draconian vagrancy and poor laws. Hence it was vital for travellers to be well presented and make friends should they fall upon hard times. To survive, they had to become the ultimate diplomats.

One of the most famous scientist/showmen of the age was the German Katterfelto. Like the owners of The Microcosm he generated vast amounts of publicity in the press, and David Paton-Williams has described his sometimes farcical struggle to survive on the road, which included being imprisoned several times for vagrancy. He spiced

up his show with magic and kept black cats, so had to take care to avoid accusations of practising the dark arts. His magic has since become respectable, as Harry Houdini described him as an example of the mistreatment of show people.[40] But travelling shows were not necessarily treated worse than anyone else. It was more a problem with the practice of their careers. Communities were often close-knit and trusted each other, so if a crime was committed their first suspect would be a stranger. If they fell foul of the authorities for any reason, they were unlikely to find anyone to protect or defend them.

If the audience was not impressed, they could show their displeasure. In the eighteenth century the term 'bringing the house down' meant literally demolishing the venue; the performer was held responsible for the damage. If they caught him. Science lecturers had further risks, as a demonstration by Katterfelto ended badly, when his balloon landed on and set fire to a hayrick. The owner demanded compensation, but the showman was unable to pay so went to prison.[41] In 1790 magistrates refused him permission to perform but he believed his black cat would protect him, so he ignored the warning and was sent to the house of correction.[42]

Scientists — especially chemists — were also at risk of poisoning. Lead was widely used in paint and in cosmetics; mercury was used in hatmaking and blamed for sending hatters mad. Both were used in medicine with other toxic metals. What passed for laboratories were often in cellars so even by contemporary standards were poorly ventilated. They were also at risk of fires and explosions, and Katterfelto's daughter risked broken bones when she was strapped into a metal helmet and lifted to the ceiling to demonstrate magnetism.[43]

Few people could afford the services of physicians, who were of little use anyway. The precursors of family doctors were apothecaries, a profession with low life expectancy as they often worked in hospitals and jails, so were at high risk of infections such as typhus. Many poor people turned to local wise women or travelling showmen who often moved on before customers realised they had been conned. Patent medicines claiming miraculous cures were often advertised in the press. From the mid-eighteenth century electricity was used by John

Wesley's followers and some travelling shows as a cure for illnesses, but one of the side effects was patients' hair catching fire.

What is noteworthy about these travelling scientists, and about clockmakers of the age, is how many came from humble backgrounds, yet by encouragement, immense dedication and hard work managed to rise to the top of their professions and make significant contributions to public education and the advancement of science. This shows how much had changed from the inflexible social structure of earlier centuries, caused by the fall of population which made space for them to rise up through the ranks.

The famous clockmaker and writer Benjamin Martin began as an agricultural labourer. Thomas Tompion, clockmaker to the king, was a farrier who changed career when he built a mechanism for regulating a jack for roasting meat. This device was an important advance in child and animal welfare, as meat was often turned using a young boy or 'turnspit' dog on a treadmill, which was often scorched.

Perhaps the most spectacular success story was that of James Ferguson (1710–1776). Born into poverty in rural Scotland, he worked as a shepherd and drew maps of the heavens based on a length of string and some beads. This was noticed by his master who even did his work, freeing James to continue his research. He became one of the most famous mechanics and astronomers of his age. He was encouraged by George III who gave him a pension, and was accepted as a member of the Royal Society without fee. When he died he left about six thousand pounds.[44] Such dedication to — and passion for — their craft must have played a huge role in the success of lecturers and convinced at least some of their audiences that it was possible to succeed without the benefits of a wealthy family or formal education. Ferguson was cited in 1857 by the investigator of poverty in London, Henry Mayhew, as the story of the *Peasant Boy Philosopher*.

Ferguson's life is also of interest in the context of many child prodigies of the time, many of whom became travelling entertainers, reciting poems, playing instruments and singing or as members of acrobatic families such as the equestrian Astleys. There were also the poets Shelley and Pope, painters Turner, Constable and Lawrence, the

engineer Thomas Telford, and of course Mozart. Isaac Ware rose from being a chimney sweep's assistant to Royal Surveyor after being spotted drawing a building by an aristocrat, possibly Lord Burlington. Thomas Gainsborough bunked off school to draw in surrounding fields. Handel became a musician against his father's wishes, and by the age of eighteen was organist at the Halle Protestant Cathedral.[45]

Prodigies were seen as curiosities, so were part of the travelling scene, but they also challenged the fixed social hierarchy. They suggested God had blessed their families, as the best-known child prodigy was Jesus. Before compulsory education, children had more freedom to explore and discover their talents at a young age. In the case of Lawrence, with his father's lack of success in business, and being raised in an inn where patrons often welcomed entertainment, his home life played a crucial role. He began his career drawing pastel portraits for patrons. It was still expected for children to contribute to the family economy, with Locke recommending they do some form of suitable work from the age of six. So prodigies need to be seen within this context, rather than as today when they are often seen as victims of exploitative parents.

James Cox established a lucrative trade for his jewelled automata and ran the most famous museum in London in the 1770s. He seems to have trained in a number of fields, perhaps the most significant being that of a toymaker: not items for children, but expensive small pieces of clockwork and automata. He added the skills of a goldsmith and by 1767 he had become knowledgeable in gems etc. by his natural genius, so was yet another prodigy.[46] It is hard to imagine Britain's success in the eighteenth century without the contributions from these extraordinarily talented children.

Another important aspect of public lectures was their democracy; they were not restricted to full-time students or academicians, but were open to anyone who could afford the entry fee, which of course included women. Some specifically targeted the female market, such

as John Lloyd who in 1788 advertised his improved orrery or *New Eidouranion* as being educational but "neither tedious, nor grave enough to make a lady yawn".[47] The performance included poetry comprehensible to children, all of which was similar to The Microcosm's publicity.

It seems radical to encourage attendance by women and students, and that may have been the intention, but shows needed to attract the widest possible audience, and the colour of their money was all the same. Clockmaker and lecturer Benjamin Martin produced a book designed for the instruction of women in the form of a Greek-style discussion between a brother recently returned from university and his sister. By presenting it as a sibling discussion, as hearsay rather than exhortation, he avoided accusations of encouraging female education whilst managing to do so, which makes this a truly radical book.

The Microcosm should have fitted into this scene, but though the mechanism was explained, the advertisements often invited groups of at least four persons, with the lecture being only a part of the show. The public were expected not to merely view it, but to be stimulated by it, to discuss it with friends and colleagues, for the information to be a starting point of further discussions, so it was as much a social as an educational event. This is where the problem lies in finding mentions of it. The show had so many aspects it seems to have failed to register in any of them.

The lives of late eighteenth/early nineteenth century women are vividly described in Jane Austen's novels, where young women were constantly in search of husbands. This reflected a very real problem in a society where women vastly outnumbered men. The near-constant wars and establishment of colonies took a disproportionate toll on Britain's male population. Men were lost to the army and navy, to merchant shipping and moved abroad to be merchants and government employees as well as the many accidents at work and countryside pursuits. There were female equivalents as their main source of death continued to be childbirth.

By the mid-eighteenth century, Britain's trade with Europe and the Americas had expanded massively, and the lives of its people radically

changed. Farmers' incomes rose as demand for food increased. Their daughters and wives employed servants to do the heavy work, releasing them for more genteel pursuits such as reading, needlework and music. Claims were made in the press that farm carts taking food to London's markets returned to the countryside loaded with books. But many of these young ladies lived in homes that were still isolated by impassable roads in winter. Men could pass the time in hunting, shooting and fishing, or retreat to their libraries but the many childless women grew bored and lonely. So those with sufficient income flocked to live in or visit the towns and spas, expanding the market for 'improving' entertainments.

It is impossible to know how many women and children saw The Microcosm or other shows, and how much benefit they gained, but the Georgian Age produced a number of highly educated, talented females. Richard Samuel's painting The Nine Living Muses of Great Britain was shown at the Royal Academy in 1779 as a major celebration of women's achievements, with the select women dressed in classical-ish robes in a temple of Apollo. It depicted translator of classics and poet Elizabeth Carter, poet and writer Anna Letitia Barbauld, artist Angelika Kaufman, the singer Elizabeth Sheridan nee Linley, poet and novelist Charlotte Lennox, playwright and evangelist Hannah More and historian Catharine Macaulay.[48] To this list could be added the astronomer Caroline Herschel, actress Sarah Siddons, poet and royal mistress Mary Robinson, sculptor Anne Seymour Damer and novelists Fanny Burney, Sarah Fielding and Jane Austen, covering virtually every artistic field open to respectable women at the time.

Philippa Walton became a widow at the age of thirty-six with ten children but played a major role in consolidating and developing her late husband's gunpowder works at Waltham Abbey. She collaborated with other producers to build a powder magazine for its safe storage at Barking, Essex. Other women were in the trade, but she was the most successful. Yet in all the material on Waltham Abbey and its powder works, her name is never mentioned which raises questions as to how many other women are likewise invisible in historical records.[49]

Dr Johnson encouraged his friend Mrs Thrale to increase her learning, telling her that mathematics was an endless source of education and a useful skill to acquire.[50] But not all women appreciated the shows. When Mrs Thrale attended the lectures by Dr Archer in 1806, she told Johnson she had learned about attraction and repulsion of spheres, and a lady in the audience asked if the animal and vegetable kingdoms were the countries of Britain. [51] There is always one.

Employers in the fields of science and technology now struggle to find qualified women, as girls often perceive them as being too difficult. But the eighteenth century press carried warnings of the dangers of reading novels, believed to cause hysteria in young women. Fears were raised that they provided false ideas on married life, providing no details on the sometimes difficult negotiations and compromises involved. Most stories closed with what is now the stereotype of the 'happy ever after' ending. The idea that romantic love could form the basis of a happy, lifelong marriage was seen as a recipe for disappointment and failure. Learning mathematics and science were seen as suitably calming antidotes. Lord Byron's only daughter Ada Lovelace was brought up by her mother, the "queen of parallelograms"[52], and educated in mathematics and science to prevent her following her father into the dangerous world of poetry and madness. She became a talented mathematician, was friends with Babbage and wrote fluently on his difference engine, the famous early computer. She translated a paper by General Menabrea on Babbage's proposed analytical engine, and added notes which contain one of the earliest computer programs and comments on its use which are still valid.[53]

When Babbage showed her his first calculating engine, she fell in love with mathematics. As with the career of Desaguliers, she was not a pioneering scientist, but was skilled in explaining, clarifying and promoting the difficult ideas of others. She was friends with natural philosopher Mary Somerville, Charles Dickens and the engineer Sir Charles Wheatstone. She saw the potential of Babbage's work to perform music and other tasks via punched cards. A computer language of the U.S. Department of Defense is named Ada in her memory. Her writing beautifully combined female sensibility with

scientific insights which helped those who followed to understand and be inspired by her subject which could be as important as the discovery itself. Thus she practised what the Marchioness de Lambert had recommended a century before.

Some women entered the lecture circuit and pitched their shows specifically at their own gender. An unnamed lady advertised in Bristol to paint miniatures, a thoroughly ladylike profession, but she also taught geography, globes etc. to ladies.[54] She later advertised her intention to publish a book on various aspects of geography including recent discoveries in the Pacific, then known as the Southern Ocean, which showed the rising independence and education of women.

Even if women gained little from the various lectures and The Microcosm show, their money was important in keeping them on the road and in spreading the knowledge and pleasure they provided.

But the English continued to have a reputation for gullibility; their hunger for entertainment made them believe even the most outlandish claims, as an incident from 1749 shows. An Italian named Calagori made a wager that he could convince a crowd that he could climb into a simple pint bottle. The show was advertised at the Little Theatre, Haymarket, which sold out and the audience included many eminent members of the public. When he failed to appear, they tore the theatre apart in their rage. He had long fled with his takings, satisfied that he had proved the stupidity of the English mob.[55]

15

HOROLOGIES & ASTRONOMIES PART 1

Remembering to adjust our clocks twice a year is a minor inconvenience to us now, but when British Standard Time was introduced in 1916, it caused widespread distress and disruption. It loudly declared a fact that had only been murmured: that the countryside's leading role in the economy had been usurped by Britain's urban centres. Every clock in the country had to move away from the traditional standard time to a new one, so they all became liars.

The tower of Big Ben is the most iconic image of Britain, so the notion that this clock could lie was hard for many to comprehend. It was not just about timekeeping, but the dependability and honesty of Britain, the bedrock of the nation. Kenneth Ullyett writes of how, since the mid-fifteenth century, generations of Britons have relied on mechanical clocks and (water-driven) clepsydrae of churches, castles, manor houses, palaces and more recently in homes, to punctuate life and unite communities in these islands. This sense of unity was expanded to encompass the empire, with Big Ben's chimes broadcast as a clockwork "theme-song from the heart of Empire".[1] The outrage from some politicians over the two-year silencing of Big Ben's chimes for repairs from late 2017 reminds us of its ongoing importance. In a

world beset with climate change, wars, famines and incompetent leadership, the issue of public chimes fades to insignificance. Or in such chaotic times, a still point, a focus for national unity is more important than ever.

Timekeeping is at the core of this story because clocks measure something that seems not to exist. Our language is full of it: we mark time, we waste it, we lose it, we walk or march in it, and we get lost in it. We see and feel the effects of its passing, but we cannot feel, touch or understand it. The only certainty is that we can never get it back.

Yet.

It is possible the very concept of timekeeping did not exist for our ancestors, at least not as we understand it. E.P. Thompson cites research into Nuer cattle herders whose days pass in a series of cattle-based tasks. When time was discussed, it could be defined in terms of how long it took them to perform a daily task, such as cooking certain foods.[2] In religious houses, time was measured by the length and frequency of prayers A mediaeval saying was 'in a Paternoster while' referring to the time it took to say the *Lord's Prayer*, a phrase which survived the Reformation. A recent BBC programme on the history of sugar described how in Tudor times, pans were stirred for as long as it took to say an *Ave Maria*. Aristophanes claimed man measured the hour by the number of times his shadow was longer than his own feet.[3]

Work songs such as sea chanties or shanties helped co-ordinate tasks such as pulling ropes to raise sails and anchors. W.J. Turner claims these English songs were of unknown origin, but emerged during the eighteenth century when ships could be at sea for up to two years. It was universal in the merchant service, sung by a soloist, the shantyman, with the rest joining in for the chorus. Songs varied between ships and within the ships themselves, and were sung at work and at rest.[4] On land, singing helped to regulate breathing, to co-ordinate and relieved the tedium of scything, pressing grapes and breaking stones on chain gangs. The same pattern was adopted in many churches in the USA where the congregation was largely illiterate.

Such working practices may seem archaic and anti-technology, but clocks were so inaccurate that Galileo used his heartbeat to help measure gravitational acceleration.[5] By contrast, Algerian peasants were indifferent to timekeeping, condemning people who rush, and associating clocks with the devil.[6] Timekeeping is a tool; people evolved their own systems of measurement, or not. The language of time evolved, as did speech itself, to serve specific needs. Without accurate timekeeping, precious little in our modern world would be possible. The tradition of giving a clock as a retirement present represents the timekeeper as a valued, timeless object, but it also signals that time has been given back to the worker. He has been freed from time's servitude.

But the invention of mechanical clocks did not establish uniform timekeeping. In the fourteenth century, the notion of a twenty-four-hour day was established, with some areas defining day and night as comprising twelve hours each. Others followed the natural cycle, following the hours of daylight, so the length of temporal hours varied with the seasons, i.e. they were longer in the summer. Ullyett claims this system continued in Japan as late as 1870. He writes of owning a handmade Japanese clock which required daily setting at the temple to ensure its accuracy.[7]

He cites the magazine *Punch* of unspecified date which claimed the public must accept that time is the fourth dimension. Yet it is far from fixed: notions of past and present seem so obvious, but perception and use of time can still be incredibly subjective and varied. People speak of a months' old letter as being in the present, but yesterday's newspaper is in the past.[8] Time seems to speed for young children who are growing and developing, while it slows down towards the end of our lives. Its perceived speed seems linked to how much we fit into it, yet doing nothing sometimes exhausts us as much as intense activity. It is also related to the size of animals, and their heart rates.

Before the Industrial Revolution, the clock was the most sophisticated

machine on the planet. Some of the greatest minds throughout human history have dedicated themselves to the precise measurement of the phantom we call time. An interest in clocks and clockmaking is now of interest to few people; time pieces have been overtaken by so many mechanical and technological marvels. But for centuries the clock was depicted in Renaissance and Tudor portraits to signify wealth, but more particularly the scholar, the sage, the curious. The portrait of Sir Thomas More and family in the V&A Museum shows a clock on the wall, suggesting More understood its workings, that he was master of his little world, or microcosm, where he learned and practised skills and knowledge he could apply to the larger world, or macrocosm.

But clocks and watches were not the same. The professions varied not just in terms of scale but in philosophical outlooks. By the mid-eighteenth century, few watchmakers made their own pieces; they mostly assembled mass produced parts which involved more guess-work than expertise. Clockmakers understood the geometry and philosophy of their trade and often designed and made whole pieces as well as their own tools and other precision instruments. Many clock-makers branched out into other fields where they sometimes became pioneers, such as George Graham's scientific instruments and astro-nomical models known as orreries. Clockmakers, rather than watch-makers, applied their skills to the design of early spinning machines, hence they played a crucial role in the Industrial Revolution.[9]

When humans lived on the land, their work was punctuated and controlled by daylight and the seasons. Timekeeping in religious houses was a cycle of prayer regulated by clocks. Celebrations some-times featured them. The chiming of the hours announced the start of daily rituals, allowing monks to maintain their vows of silence. The closed doors of monasteries kept the secular world at bay; timekeeping enforced discipline and dedication to higher matters of faith. Many eighteenth century churches had hourglasses to time sermons. Some preachers became famous for their long sermons but parishioners sometimes slept through them. The chimes of Big Ben are still broadcast to begin and end the minute's silence to commemorate the end of World War I.

Weight-driven clocks which chimed the quarter hours, but lacked dials were built in Europe before 1300. They summoned to prayer people within hearing but not sight of the dial. In Norwich Cathedral in the mid-twelfth century was a large astronomical clock with fifty-nine automata which included a processing choir of monks,[10] possibly to ensure uniformity in the ritual, to add an aura of wonder, or to cope with a manpower shortage.

In mediaeval Britain some people moved into towns and became freemen which allowed them to trade within the walls. This freed them from paying allegiance to the lord of the manor, by working for him and following him to fight in wars. They became craftsmen, mechanics and merchants, working indoors, so to an extent they also became free of daylight-based timekeeping. But even in the countryside timekeeping was enforced. Cooks had to get food on tables at set times. On large farms, tasks — from ploughing to sheep castrating — were organised, with time allocated for their successful completion which allowed for budgets to be set. Such precision timekeeping helped establish standards for workmen, and allowed occasional bonus payments for exceptional performance.

Townspeople needed to run businesses, meet colleagues and close their town gates at night for security. So they built large public clocks which chimed the hours, like a heart beating at the centre of their communities. These timekeepers were in towers of churches, town halls or over the gates of town walls, so became important landmarks. Some were given names and discussed as if they were real people. When quarter jacks were added, public clocks became visual as well as auditory spectacles. These were automata in the form of men striking bells with clubs or hammers every quarter hour, the origins of which are widely disputed. But Fleet claims medieval clockmakers competed to make more elaborate clocks, though accuracy failed to keep pace.

In southern Germany, a single jack struck a bell which replaced the town crier who had gone round the town calling out the hours. The idea spread and variations included soldiers marching on the hour and in Hameln, the Pied Piper led a line of children. In Sweden two knights were shown striking each other instead of the bell.[11] The most

famous of these in London was at St Dunstan's on Fleet Street, an area long associated with clock and automata businesses. It became a magnet for loiterers during its chiming, which attracted pickpockets, so such public clocks became foci for petty crime. Loitering near clocks became so widespread that the dial of the parish clock in Market Harborough exhorted viewers to "Begone about your business",[12] reflecting mediaeval notions of inanimate objects having the power of speech. In 1478 an ornate outlet for the conduit near Shoe Lane displayed angels with bells which played hymns,[13] linking together clean water, music and Christian benevolence.

Jewellers made ornate watches in the form of rings and pendants. Table decorations included automata such as ornamental *nef* clocks, like the three-masted ship in the British Museum. Its dial is so small it is virtually hidden by ornament. Figures in the crow's nest strike the hours and it was originally propelled by wheels and its cannon fired. Rudolph II owned such a model which showed a tiny version of him standing on deck with various musicians. A complex entertainment began with music to announce the ship sailing; a tiny organ was incorporated which played music as it went to sea, moving across the table, to end with a volley of cannons.[14] Its design is similar to an ornate table decoration shaped as a ship on display in the V&A museum; it held table salt, known as white gold as it was so precious.

These nefs originated as ornate silver and jewelled models of ships as gifts to churches to encourage prayers for their safe journeys, or in gratitude for their successful return. With the decline of pilgrimages, these evolved into ship table decorations dating from the Middle Ages. Ships were often owned by several people, and the people who sailed them formed yet another community, or world, which was part of the world of their church. The failure of a single journey could bankrupt a community, so harm the church itself. Ships symbolised power and wealth as they were expensive and essential for large-scale trading. They were also small worlds, apart from land-based restraints so were symbols of independence. Unlike land based property they were often owned by several people, so helped forge financial communities.

Two strands of clockmaking ran in parallel in eighteenth century Britain. There was a demand for elite timepieces, often following French fashions as table furniture. In constructing the spectacular musical automaton *The Temple of the Four Great Monarchies of the World*, musical clock makers Charles Clay and his apprentice John Pyke employed the finest artists such as dial painter Jacopo Armigoni and silver dial mounts were by the sculptor John Michael Rysbrack.[15] From 1713 Clay served as clockmaker to His Majesty's Works, and examples of his pieces can be found in the Royal Palace Beijing, Utrecht's Speelklok Museum, and Birmingham Museum.

Wooden clocks were made in the Black Forest from the mid-seventeenth century, and cheap British versions were common in homes from the late eighteenth century. These coincided with the rise of factories, so this is allegedly when time ceased to be a servant of man, and became his master. E.J. Wood writes of wooden clocks being widespread for two centuries before being made redundant by cheaper, mass-produced American timekeepers in the nineteenth century. They were made in the Black Forest but were called Dutch clocks. They were often of poor quality and behaved eccentrically, as Wood quotes an owner of one, who claimed "The Dutch clock pointed to twenty minutes to three and struck eleven: the combination signifying that it was eight precisely, after the dissolute manner of Dutch clocks in general."[16] The use of the term "dissolute" suggests the concept of a clock having human characteristics survived the mediaeval period.

Clocks are not just a means of measuring time; they signal urbanisation and the rise of industry, just as surely as the destruction of the obelisk in Stanley Kubrik's classic *2001 A Space Odyssey* announced the advance of humans into the nuclear age. Clocks have been valued because they are reliable. For not varying. They provide us with a fixed point on the horizon on which we can focus while our fragile ship of life is tossed about by storms. They remind us of time passing, like the lines parents make on a wall registering their child's growth. Like *memento mori* images, they remind us our time on earth is limited,

encouraging us to assess our behaviour and repent our errors before it is too late, echoing oft-repeated concepts from the Christian — especially the unreformed — church.

Timekeeping in the workplace is often condemned as turning factory workers into extensions of the machines they operate. But some workers moved the hands back if they arrived late, and forward to allow them to leave early. Clocks can be a tool of democracy and fairness. Equal pay for equal work can include equal time spent working. They can also be worthy gifts, as Wood wrote of an account from the Dublin Workhouse whose governors gave thanks to Lady Arabella Denny whose concern for the welfare of foundlings included the donation of a clock which struck every twenty minutes, alerting staff to feed any infants that were not asleep, potentially saving their lives.[17]

Time is not biased. It does not play favourites, so provides a neutral space for human activity. It makes celebrities of athletes and inspires scientists and technicians to do things faster, with greater precision and reliability, which in emergencies can save lives.

And yet the rise of new technology has taken the concept of timekeeping into new realms. The rise of mobile phones has led to a decline in the ownership of wrist watches. With public finance cuts there are fewer working public clocks; if we forget our phones or the battery goes flat, we are forced to search for time, to ask strangers for assistance. Time has become integrated into many other machines, so is again being broken down into task-related units.

Many famous scientists tinkered with timekeepers and automata; Newton built a water-driven clock at the age of twelve. When James Ferguson was a child, he asked the time of a passing traveller. The man allowed him to see his watch's workings, explaining how the various parts worked. This allowed Ferguson to make a clock and so he took his first steps on the road to becoming one of Britain's most successful astronomers, and instrument and clockmakers.[18]

When clerics and philosophers sought metaphors for the action of God, they often saw him as a clockmaker, with the universe run by a giant system of interlocking cogs and gears representing perfect order which contrasted with the chaos of the human realm. Thus the work

of a clockmaker could be seen as attempting to demonstrate or mimic God. This could be interpreted as sacrilege or, in the hands of Newton, an attempt to become closer to His mind, so was a form of piety.

Clocks are valued for their timelessness and for outliving their owners and creators. As gifts they were symbols of eternal love, such as the little gilt bracket clock claimed to have been given to Anne Boleyn by Henry VIII on their wedding. It bears their initials between lover's knots. Ullyett claims it should have stopped when Anne died.[19] There are many anecdotal accounts of clocks stopping or never working properly after their owner dies. There was even a 1960s song about a grandfather's grandfather clock which stopped on the day he died.

Henry VIII was a pioneer among English clock owners, again taking on the former role of the churches he closed. He commissioned many pieces and received some of the finest as gifts. Charles I gave silver enamelled watches as prizes in seventeenth century tennis tournaments. He had a favourite watch which he wound himself. It woke him on the day of his execution and kept him company until he gave it to a courtier on his way to the scaffold.[20]

By the mid-eighteenth century Britain had a large pool of scientists and philosophers whose social and business interests and research overlapped and interlocked like cogs. Some of the finest timepieces changed hands between them, such as a clock in the Banff Museum, Aberdeenshire, which dates from c1595 and has been altered to include a globe showing the route of Cook's second circumnavigation. It bears a brass plate with the names of several eminent owners: J.T Desaguliers, Benjamin Franklin, James Ferguson (who probably made the additions) and Kenneth McCulloch.[21]

John Whitehurst (1713–88) was the oldest of the Lunar Men, and the only clockmaker; he supplied Benjamin Franklin with several timepieces. He went on long walks from his home in Derbyshire, an area rich in coal and minerals, which drew his attention to the layers of exposed rocks and he investigated these layers in mines. His eye for detail as a clockmaker was put to good use in producing beautiful, detailed maps of rock layers which encouraged and inspired genera-

tions of geologists.[22] Though he never stated the connection, his maps undermined the biblical concept of time; the book of Genesis claimed the earth was formed as a single act rather than a process of gradual change over incomprehensibly long periods of time.

The hourglass and the scythe are symbols of the Grim Reaper, or Father Time. They were often depicted on gravestones as symbols of the brevity of our mortal lives, so a warning to behave well or suffer the torments of hell in the afterlife.

The ownership of timepieces is associated with the elite, but their durability made them widespread across all classes. The poor could save up for cheap models. If they came into money, such as an inheritance, or if sailors received bonuses on their return from a successful voyage, they often invested in clocks or watches. In the absence of banks, they were pawned in times of hardship and redeemed when their finances improved.

Mediaeval monarchs collected treasures for similar reasons. They were often depicted as displayed overflowing from chests like pirates' treasure in fiction. But more likely they were kept in secure chests for extra security and could be moved in case of crisis, and sold to raise emergency funds.

The great architectural historian Nikolaus Pevsner claims the early English were not a sculptural nation, with most of the decoration on buildings being abstract rather than figurative. But he also notes how they excelled in tapestries and book illumination which were the finest in Europe These works were mostly small and portable, so may reflect the practice of peripatetic rulers, or perhaps the many outbreaks of violence, when the border with Scotland was a frequent source of battles, and the many Viking and pirate raids.

Clockwork was integral to the rise of scientific thinking, industrialisation, democracy, and the mass organisation and control of people which define the modern world. Quality clockmaking is generally associated with Switzerland and the German states, but by the early eighteenth century, some of the finest were English. This may have been due to a passion for order following the many decades of chaos. Some authors claim it was because England was a maritime nation, in

need of accurate navigational tools, but there were many maritime nations in Europe. In 1598 Philip III of Spain offered a huge reward for the invention of an accurate chronometer and was closely followed by the government of Holland. Several kings of France encouraged the making of luxury and precision timepieces and the Paris Academy sponsored a prize, but little was achieved.[23]

The Dutch instrument maker Christiaan Huygens invented the weight-driven pendulum and proposed a clock mounted on gimbals (self-aligning bearings) for use at sea. He was invited to Paris by the great promoter of maritime power Louis XIV to demonstrate his invention for measuring longitude. But it failed as it was affected by changes in temperature.[24] Yet French clocks were very different to those of Britain. The court focused on personal display, so watches were primarily seen as fashionable objects rather than precision instruments. Clocks were pieces of furniture as much as technology, so again, there was less interest in improved timekeeping.

Some European nations had larger navies than the Britons, but these islands have always been more dependent on 'wooden walls' i.e. ships, for defence, so this may be closer to the mark. The high turnover and lack of stability of royal families prevented them from concentrating on fashion and display. British clockmakers struggled to obtain elite patronage, but accurate navigation was of benefit to the nation. They were supported by their neighbours, business associates and citizens committed to benevolence and improvements, especially in the many ports where clockmakers diversified to make and repair telescopes and navigational equipment.

In 1714 the British government established the Longitude Prize of ten thousand pounds for a method of establishing a ship's position at sea within one degree on a voyage to the West Indies. Its huge value shows the importance of seafaring, but perhaps they never expected it to be claimed. Or like modern politicians they may not have been thinking beyond the next election. It seems this huge carrot on the end of a very long stick succeeded where European patronage had failed.

The timing is significant. The terrible maritime disaster of 1707

when Sir Cloudsley Shovel's fleet was lost with two thousand men was largely blamed on poor navigation, i.e. the inability to accurately pinpoint the longitude of the ships. The huge cost in terms of money and manpower finally forced authorities to seek a solution. In 1713 as part of the Treaty of Aix-la-Chapelle which ended the War of the Spanish Succession, Britain was granted the Asiento contract from Spain. This was the monopoly to provide Spanish colonies with four thousand eight hundred slaves per year for thirty years, which increased the financial necessity for accurate navigation. This contract was passed to the South Sea Company.

16

HOROLOGIES & ASTRONOMIES PART 2

The first definite record of a public clock dates from Milan in 1335, after which many other major centres followed, including Westminster near where Big Ben now stands, and Wimborne, Ottery St Mary and Exeter.[1] The word *clock* enters the English vocabulary in the reign of Edward III (1312–77) when the first public timepiece in Britain was erected. This was for a tower to be built in the city of Gloucester to ring bells as indicated by a "clok".[2] The West Country had a particular need or passion for such pieces as it was from these ports that so many ships sailed west to the New World.

It seems the surname *Clock* appeared in England about 1600, showing the craft was established by then. The trade soon expanded to the extent it needed control to ensure high standards so guilds of clockmakers were formed in Paris (1544), Augsburg (1564) and Nuremburg (1565), but not until 1632 in London, as E.J. Wood writes:

> "In the year 1698 an act was passed... for protecting both the trade and the public against certain fraudulent impositions then practiced by foreigners and others. The second clause of the statute recited that

'great quantities of boxes, cases and dial plates for clocks and watches have been exported without their movements, and in foreign parts made up with bad movements, and thereon some London watchmakers' names engraven, and so are sold abroad for English work; and also there hath been the like ill practice in England by divers persons, as well; as by some professing the art of clock and watch making, as others ignorant therein, in putting counterfeit names, as also the names of the best known London watchmakers on their bad clocks and watches, to the great prejudice and the disreputation of the said art at home and abroad'. For the preventing of such ill practices it was ordained that no case or dial plate should be in future exported without the movements, nor without the maker's name and place of abode engraven on every such clock and watch, under a penalty of forfeiture and a fine of £20."[3]

Women were rarely allowed to enter trades and guilds, except as widows to ensure the survival of the family business. But some became silversmiths in London via their family business. From 1715 female apprentices were permitted by the guild, the Clockmakers Company,[4] probably due to their small, nimble fingers. England struggled to fund care for the poor, especially widows and orphans, after the closure of the monasteries; many towns established factories for spinning cotton or the filthy task of picking oakum. In the early nineteenth century the parish of Christchurch in Devon employed them to manufacture tiny fusee chains for watches,[5] which kept down costs in this labour-intensive work.

Protectionism practised by guilds was often defended on the grounds of ensuring high standards of their craft, but it also defended their incomes against foreigners who undercut their businesses. As in other skilled trades, many clockmakers were Protestants, especially French Huguenots fleeing religious persecution who settled beyond London's city limits at Clerkenwell.

Nicholas Cratzer or Craczer was a Bavarian astronomer employed by Henry VIII as "deviser of the King's horloges".[6] Six French craftsmen were imported in the time of Henry VIII to make a clock for

Nonesuch Palace. Nicholas Oursiau, Frenchman and denizen, was clockmaker to Queens Mary and Elizabeth, and constructed the old turret clock at Hampton Court.

By the early seventeenth century French Catholics had entered the English trade; they took the oath of supremacy but were still distrusted. A petition was presented to the king in 1622 which complained of tricks and frauds by foreigners, asking they only be allowed to work for English masters and for a ban on imported clocks.[7]

Probably the oldest working clock dates from 1386 in Salisbury Cathedral, another reminder of the many skills practised in large religious houses, often by clerics before Henry's reforms. So yet again, the Tudors were re-introducing skills lost by their closure of the monasteries. The first British clockmaker of note was a Scot, David Ramsay, who was page to the bedchamber of James I. He was paid two hundred and thirty-two pounds fifteen shillings as King's Clockmaker.[8] He made many small, intricately detailed watches for court favourites and as diplomatic gifts. Some were hidden with family silver and documents during the Civil War.

Yet it took until 1767 for clockmaking to become recognised as a true craft, when the Clockmakers' Company and the Tin Plate Workers' Company appeared in London's Lord Mayor's procession for the first time.[9] This is out of step with the age when most guilds were in decline or had closed. Many tradesmen resented the high cost of membership and their restrictive rules. But London was — and still is — a world apart from the rest of the country.

The Victorian County History bemoans the lack of early records of the trade, necessary to protect designs in the absence of patent law. Researchers are forced to piece together the history from surviving examples of their work, aided by the law which made them record their names on their pieces.[10]

Two Englishmen were significant in establishing high standards in

these islands: Thomas Tompion (1639–1713) and his nephew and heir George Graham (c.1673–1751). They both became Royal Clockmakers and are buried together in Westminster Abbey. Tompion developed clocks that only needed winding annually, which was a huge leap forward.

Graham was a fine clockmaker, respected in Europe as well as at home, who made many expensive pieces but was more famous for his work on scientific instruments. He was a prominent amateur physicist, inventing the cylinder movement which allowed a reduction in the size of clock cases, and the mercury-compensated pendulum that countered errors caused by the effect on metal of changing temperatures, so was another huge advance. He made astronomical instruments for Edmund Halley and James Bradley and presented over twenty papers to the Royal Society, mostly on astronomy. Greenwich Observatory displays his invention the transit clock which allowed a telescope to remain focused on a star over time.[11] He provided equipment for the French Academy expedition to north Sweden in 1736, and in 1741 to Uppsala University, as directed by Andrew Celsius, so he was influential in Europe. His output ranged in size from tiny clocks to precision instruments of several metres. It was perhaps Graham's friendly attitude to continental competitors which helped spread England's fame in the field.

Given the high level of his skill, he should have been interested in the Longitude Prize. But he recognised Harrison's work was more advanced than his, so instead he provided moral and financial support, an early example of luxury goods subsidising scientific research. This shows the existence of a community of scientists who helped and supported each other for the common good.[12] A large number of his domestic clocks and watches survive, and he was as trusted and reliable as his pieces so was known as *Honest George*. His monument in Westminster Abbey claims his "curious Inventions do honour to Ye British Genius". While Tompion is known as the Father of English clockmaking, Graham began a new era, focusing on precision design which paved the way for the revolution in marine timekeeping that allowed Britain to dominate the seas.[13]

Christiaan Huygens invented the pendulum to regulate the speed of clocks in the mid-seventeenth century, a huge improvement in accuracy which allowed the inclusion of minute hands which led to a growth in clock ownership and created employment in converting existing pieces to the new system. Trade with the Americas brought new hardwoods such as mahogany and lignum vitae which became popular for ornate cases, and were used for high friction parts of wooden clocks such as bearings.

Clocks and watches varied widely in their prices and hence in their accuracy; cheaper pieces needed frequent correlation with sun time or public bells. Some watches were sold with a 'dyall', i.e. a sundial, and a table of equations to allow the calculation of temporal time from the position of the sun at midday.[14] Touring lecturers often included courses on 'dyalling' which shows how complicated was this process, but also that people were prepared to make the effort. The expansion of train networks in the nineteenth century produced a problem in timekeeping. Clocks were set to local (sun, or temporal) time, which varied across the country. But countrywide travel demanded a nationwide time system. Some towns adapted by having clocks with a pair of minute hands, displaying both local and national times, as can still be seen on Bristol's Exchange. Once national time was established, trains became so reliable they became a source for setting local timekeepers.

Glennie and Thrift describe the wider interest in, and importance of, horology. It fed into notions of time being a useful way of understanding and controlling a wide range of activities and processes.[15] It also fed into notions of the Protestant work ethic, that idle hands made the devil's work. Pepys often noted how long he took to walk to his various destinations. This could have been to pass the time as he walked, but variations in time taken could have been affected by the state of the roads, weather and a measure of his own health and fitness, so it was a way for him to engage in the wider world around him. People recorded watching watchmakers at work, so fed into the wider concepts of curiosity, but also may have helped them understand and maintain their own timepieces.

But such enthusiasm could get out of hand if unsupervised. Ullyett

described the problems of Langley Bradley when he made the clock for Wren's St Paul's Cathedral. Complaints were made that his clock often showed the wrong time, so was unfit as a standard for the city. He complained that the many visitors allowed into the tower to see the great bell were meddling with his clock.[16]

Steffen Ducheyne wrote of the existence of a skills gap: that natural philosophers learned from books, so understood the theory, but observed mechanics to understand the practical applications. Mechanics were alleged not to understand the philosophy underlying their work, so were often seen as repeating set tasks.[17] But these were extreme positions, with many practitioners combining the two, such as George Graham whose career straddled the worlds of the educated elite and technicians. An early interest in astronomy led him to construct tellurions: geared models on a single plane showing the movement of the sun, moon and earth, the first of which he made with Tompion and is now in Oxford. It is claimed John Rowley saw this and made an improved version in 1712 which was seen by Sir Richard Steele. He was ignorant of its predecessors, so coined the term *orrery* in honour of the First Earl, a great promoter of science. It subsequently became a general term for various moving models of the universe known as tellurions and planetariums.[18]

This separation between theory and mechanics led to Henry Bridges' clock being mentioned in discussions over patent law. Queen Anne's copyright law established protection for writers, but there was no equivalent for constructors of machinery, art (often complained of by Hogarth) or music. They were seen as works of the hand rather than of the mind, so were mere tools, designed to carry out a set task, requiring little intellect. Like so much British law, the original act was narrow, designed to solve a single problem, i.e. to encourage literacy. Copyright law continues to evolve as new formats and ways of creating work develop.

But this was challenged in a dispute between Charles Clay and the Clockmakers' Company in 1716 over a patent for a musical repeating watch. So it seems the concept of design protection existed for such

devices, but the matter was managed internally by the guilds rather than by patent law.[19]

This protectionism may explain why the clockmakers' guild survived so long, as it provided support for innovation. Beyond the guild system, Roger Smith describes a contract between the entrepreneur James Cox and a jeweller to produce work designed by his former chief mechanic J.J. Merlin. This document provided Cox with the right to search the tradesman's premises and for the contractor to keep the design of the work secret or risk a fine of a thousand pounds. This shows Cox was running his business along the lines of the Clockmakers' Company, but enforcing his legal powers via contract law rather than the closed world of the guild.[20] Such restrictive practices may not have been legal, but the high costs of litigation probably ensured such contracts were never tested in court.

This same concept of separation of hand and mind was applied to the constructors of orreries from the first by James Graham about 1710. He should have made a fortune from his invention, as by the mid-eighteenth century, virtually every travelling science lecturer and learned gentlemen owned a version of his model of the universe. Arguments were made that Graham's invention, and the many microcosms, clocks and watches that followed, and the earlier air pumps and chronometers were constructed just as much as the text of a book. This concept was echoed in Henry's own advertising as he often declared himself The Microcosm's author. The term *author* was also applied to architects and to Cyrus the Great for his Hanging Gardens of Babylon, so it meant instigator, creator, designer, or planner. The first and supreme author was God.

Arguments against applying copyright to such mechanisms claimed a copy could be made quickly, so would render the copyright void, but in the case of the complex, time-consuming Microcosm and other automata, this was pure nonsense. Henry's original claim of it taking eight years was unlikely to be repeated by anyone. But challenges were made as to what the act of copying involved. With text, the ownership of the material was replaced by 'style and sentiment' so allowed a

huge range of variations to be covered by law, as can be seen in the many new formats covered by modern copyright for electronic devices.

Discussions over the protection for machines such as The Microcosm thus had to include consideration of what process was involved in its production, and in the case of astronomical models, this was held to involve the understanding of astronomy, an intellectual, gentlemanly pursuit.[21] The copying of such works was seen as a means of spreading knowledge, so was a positive or worthy act. This was echoed by Henry's own apparently contradictory behaviour towards his design. Whilst complaining in print of the many imitators, he encouraged internal viewings of the machine which would enable such imitation. Or perhaps the opposite was true: elite pieces competed with his show while cheap pieces posed no such threat. Perhaps it depended on who was doing the copying and why. Henry was probably protesting against cheap copies which undermined his business, whereas quality copies were likely to be of public benefit which he claimed to be encouraging.

Patent law also noted that manufacturing was still by hand as the term suggests. Workmanship and materials were variable, so making an exact copy was impossible. But such variations were cosmetic rather than functional and so were not the purpose of such precision machines. James Ferguson claimed to have made at least eight orreries, but none were identical because each one was an improvement on its predecessor. This highlights another attraction of clockmaking: there is never an end to it. The process of completing a task leads to the discovery of another problem to be solved or potential improvement. The construction of timekeepers becomes timeless. When John Arnold offered his timekeeper for the Longitude Prize, he claimed to have made over nine hundred chronometers, with each one being an improvement on its predecessor. These included twenty Number One timepieces, i.e. equivalents of Harrison's prize-winning chronometer.[22] Harrison produced a mere four to be awarded half the Longitude prize, though Arnold received three thousand pounds for his work.

Dava Sobel's bestselling book *Longitude* presented John Harrison as

a lone genius living far from any centres of expertise, but this was far from reality. He lived near Hull, where Henry died; it was a major port where huge sums were invested in shipping, not just by captains and shipowners. A large population supported research into marine safety as so many people knew or were related to sailors or people who relied on shipping for their livelihoods. This included virtually everyone in these islands. Many towns and cities had charities for retired sailors or their widows and orphans. The government and charities often paid apprenticeship fees for poor boys to train for the sea. Maritime dangers produced high levels of mortality but this allowed the talented poor to rise up through the ranks faster than on land. Glennie and Thrift claimed Harrison's achievements were incredible, but interest in the subject was widespread. He had been working in the field for fifteen years before he moved to London.[23]

John Harrison trained as a carpenter; London's Science Museum is home to several of his marine chronometers and a fine wooden clock. His father was a joiner who was probably paid to repair their parish clock. He worked as a land surveyor, so understood and used precision instruments. John grew up seeing his father working and so followed a similar trade. Clocks made entirely of wood, rather than just the cases, were popular in North America, but are less known by British horologists as few survive here. Wood was easily available — foraged from woodland or from carpenters' offcuts — which allowed amateurs to experiment with construction and repair of clocks, especially in the long winter months.

Accurate clocks and watches were expensive, so purchasers often had a deep working knowledge of them. Potential owners discussed details with others in a similar way that we today discuss the purchase of a car. When the future Royal Clockmaker James Ferguson was a child in rural Scotland he asked a passing traveller the time and then asked to view the insides of his watch. The owner kindly explained how the different parts worked, even suggesting how they could be improved, such as by replacing the brittle iron spring with whalebone.[24] This shows how well the stranger understood his own timepiece and perhaps his pride in its ownership provided a willing-

ness to explain it to a child. He was probably surprised and perhaps delighted to find such a clever child in a poor rural environment.

Many processes were involved in the production of luxury watches, employing jewellers, enamelers, gold- and silversmiths as well as assemblers and finishers. When town or church clocks were purchased from council or parish funds, the details were debated by office holders to justify the outlay, so they needed some knowledge of what was involved. They were unpaid parishioners from a wide range of trades spending their own and their neighbours' money, so had a vested interest in it.

The skills of tradesmen were much wider than today. Many people still lived in small communities too small to include specialists. The village blacksmith had to design, build and repair anything from a nail to a ploughshare. Glennie and Thrift write of the importance of "learning from objects"[25] which is especially relevant in clockmaking, as some parts of clocks were experiments that resulted in dead ends. Harrison's timekeepers have redundant parts, representing failed experiments that were left in situ, making the machine bigger and more complicated than if properly designed.

In 2017 *This American Life's* brilliant podcast series *S-Town* featured the expert horologist John B. McLemore. He was said to be able to build a clock piece from sight, without a template or measurements.

Learning did not end when a man qualified in his trade. Some clockmakers leave *ghost* marks, empty holes for screws, or scratches to help guide future repairs. They are described as "keys to the mind of the clockmaker", but they are not always readable to others. This also shows the intimate relationship between a clockmaker and his clock, echoing the relationship between God and his universe, the links between the macro- and the microcosm.

An apprenticeship is not about learning skills by rote, but a much wider form of education. It involves solving problems, adapting to different situations and materials. The production of a set item, a masterpiece, to qualify in the trade suggests uniformity of skills, but each masterpiece is unique, reflecting the skills and interests of the apprentice. It is a calling card, aimed at making them stand out from

their peers, representing the end of their formal training, and the beginning of a wider life of learning and professional development. This also explains why apprenticeships were usually contracted outside families, and why journeymen journeyed.

Much of Henry's publicity was addressed "to the curious", a quality often associated with those involved in modern research and technology; but it seems this was a very large community. Henry emphasised the importance of honest English workmanship, which again fits with the above and was so important in laying the foundations for the Industrial Revolution. It also encouraged the notion that the pleasure of discovery could be in the national interest, so combining self-interest with public benefit, a concept associated with his fellow Augustans.

Henry's clock was often described as a masterpiece. In the V&A Museum's European gallery is an ornate table clock from 1665–70 owned by Brechtel in The Hague. It was completed by an apprentice, displayed in the master's shop; people stopped in the street to hear the music it played, providing an incentive to enter the shop. As apprentices were not paid full wages these pieces cost little beyond the price of raw materials to make, so there was no need to recoup the expenses by selling them.

The only other monumental clock in England which is similar to Henry's Microcosm was the Lovelace clock from Exeter, which was also used as a shop display, and probably also a masterpiece, though whether by the master or an apprentice is not known. But Henry paid for the construction of The Microcosm, which represented many trades and images, a whole world of them if you will, and again, this adds to the confusion for the many writers who have grappled with this subject over the centuries.

The passion for solving problems was shared in the many coffee houses, gentlemen's clubs, and even vestries. Travelling science shows conveyed information in a far more dramatic and comprehensible form

than textbooks and journals, so the information was more likely to be remembered. The practice of beating or bouncing boys on parish boundary markers to remember their locations during annual rogation processions worked likewise; it helped ensure knowledge of their parish boundaries was retained and passed on to future generations.

The ability to invent and use technology was not restricted to the elite or to tradespeople. Country folk are often condemned as being politically conservative, but working on the land, especially with animals, and being subject to the vagaries of nature and the weather means they have to be constantly inventive, making plans and adjusting them in response to changing circumstances. Such a life leads to exhaustion, a rejection of change as they have already been exposed to more than enough of it.

A similar mindset can be seen in the survivors of wars, of which there were many in the long eighteenth century. After World War I — the first mechanised war — many in England turned to the countryside, rejecting the machine age that had caused so much carnage. This gave rise to groups such as the Arts and Crafts Movement. A similar pattern has emerged in recent times in response to the rise of new technology, with new British artists such as Tracy Emin producing quilts and embroidery and Grayson Perry's pottery and tapestries, so art and technology have not marched in a straight line towards future technology, but often counterbalance and breathe new life into each other. The recent revival of Women's Institutes which were so popular and active during the last war, is more of the same.

In 2014 Tate Britain staged a major exhibition on British folk art which was impressive in the variety of its media, geography and time. In Jeff McMillan's introduction to the catalogue he suggested the closeness of Britain's cities prevented folk art flourishing as is seen in the USA and France where there are more open spaces.[26] But this claim is undermined by the huge variety of high quality work included in the show.

A better explanation is the changes of land use in the seventeenth and eighteenth centuries, as bemoaned by William Cobbett in his *Rural Rides*. The many enclosure Acts deprived the poor of access to

common land for foraging and hunting to supplement their meagre incomes. He described the appalling poverty where farming was intensive, with no wild areas between ploughed fields where foraging provided wood for fires and building, berries, fruit, nuts and mushrooms to supplement their low incomes and poor diets. He claimed the best areas for the poor were in rabbit country, as such land provided their food, but also limited the intensity of farming. Such an area was described by Gilbert White of Selborne in his pioneering journal of his parish and wildlife.

People who walk in the countryside need to be aware of weather, to take care where they step, and to search out the best paths, gaps in fences and places to cross streams. This is especially so for the few people who still forage for food or firewood; they are constantly alert for what they need. Such observational behaviour is central to folk art both in noticing the shapes of things, and devising ways to use them, like the 'Bone Wesleys' preachers carved from horse vertebrae, which were found in several farm houses and saddlers' shops.[27]

The Tate show began with a number of business signs, mostly painted but some also sculpted. Together with the later practice of coach painting, this is a field often neglected by art historians, yet some tradesmen were highly talented. When Hogarth was commissioned to produce a triptych for St Mary Redcliffe in Bristol, he made use of local painters and was both surprised and impressed at the high standards.

Richard Gough's *History of Myddle* records such a rabbiting area; land was being reclaimed by draining moors, and poor people lived in improvised housing such as old trees. Such regions gave birth to the Industrial Revolution as there was plentiful wood for construction and fire for smelting but also a culture of foraging, of inventing, adapting and applying technology to their needs. Future Royal Clockmaker George Graham trained as a farrier, but the first piece of technology he built was a firejack, a heat-driven fan to turn roast meat, a system still used in candle-driven Christmas table decorations from Germany.

When the Royal Academy was founded in 1769 it excluded crafts such as needlework, paper cutting and shell pictures,[28] so excluded

the poor and women. These items were derided as 'baubles', suggesting they were consigned to the frivolous world of females. This has led to accusations of elitism, but the work was incredibly labour-intensive, so unlikely to form the basis of careers which was at the heart of the academy's remit. The emphasis on fine art and the passion for following London fashions has played a major role in marginalising and undervaluing folk art. The Industrial Revolution and mass production accelerated the decline of traditional crafts as people fled rural poverty which had provided the time and materials for its production and demand for its products. But the inclusion of so much folk art in the exhibition in regional museums shows the effect of London-centrism in the arts, but also that locals continued to produce and to value such work.

Christopher Pinchbeck was a near contemporary of Henry who is likewise famous for practising many trades. In 1721 he constructed musical automata for Louis XIV and an organ for the Great Mogul. But he is most famous — or rather, infamous — for inventing an alloy that looked like gold and was used to make watches for the poor. The affluent bought them as decoys to carry on journeys, so they could hand them over to highwaymen while their expensive watches remained safely at home or in a hidden pocket. This led to the late eighteenth century fashion of carrying two watches. The alloy was so successful that his son took action against his rivals, charging them with making fake fake gold. In later times the reason for this alloy was forgotten and their surname became synonymous with fraud.[29] So Pinchbeck was not only an engineer, clockmaker and showman at fairs but dabbling in alchemy, an impressive range of skills.

By 1753 Henry was touring very slowly round the eastern counties. He provided no explanation for this, but he seemed to be struggling. In July he announced in the Norwich Mercury that the show was withdrawn so he could make some curious improvements, which defy the laws of nature. He described it as a ball that ran up and down a forty-

five-degree slope at the same speed, i.e. "what the unskilled in Mechanism call Perpetual Motion."[30]

This seems to have been a novelty, but the rolling ball propulsion was used by the Habsburgs' imperial clockmaker, Christoph Margraf, an example of which dates from 1596. A ball ran down a pair of wires; when reaching the bottom, it triggered the release of a second ball which was moved back up to the start. A counter registered the circuits and moved a clock with a single hand. But this was no simple timepiece. The movement of the balls was visible in front of painted scenes via a mirror, so creating a magical performance.[31] It is unlikely Henry ever saw Margraf's theatrical clocks, or any others owned by European royalty such as the Habsburgs, but he may have known of them via publications and/or seen copies. No claims were made that this machine demonstrated perpetual motion; the balls required energy to raise them up, so this was more an example of wonder to entertain an aristocrat and his guests.

Given the many astronomical additions already made, it is hard to imagine how space was found for this. As they were no longer mentioned, they had probably been removed.

The concept of perpetual motion seems to send us towards the search for the philosopher's stone that so many alchemists — but not the great Newton — had sought. They were widely discussed by medieval engineers, mostly in relation to an interest in natural, or free, energy. Winds drove mills, lightning struck trees, even destroyed churches. Jean Gimpel writes of their passion for new sources of energy, seeing the whole universe as a source of energy waiting to be harnessed. Roger Bacon was hailed as the father of modern science in Britain; he praised the work of Petrus Peregrinus or Peter of Maricourt who claimed to have invented two perpetual motion devices.[32]

Though perpetual motion was a phantom, the concept inspired improvements in technology.[33] John H. Lienhard describes perpetual motion as the "great will-o-the-wisp". But people believed in it because science had not written laws that said it was impossible. He drew parallels with waterwheels, driven by a near-perpetual source, but there are also obvious parallels with 'magical energy'.[34]

E.J. Wood wrote of Nicholas Grollier de Serviere (1596–1689) of Lyons, a soldier skilled in mathematics and engineering who retired and made clocks, some of which were propelled by balls descending inclined planes and grooves. In the late seventeenth century the French produced *gravity clocks* which rolled down inclines and were driven by their own weight. At the bottom of the incline they were lifted back up to their starting point.[35] They were not described as perpetual motion, but were designed to prevent casualties when mainsprings broke in clocks. This is yet another important aspect of clockmaking: most were driven by inflexible iron springs which could break and cause damage to nearby structures and people. Such a clock was displayed at Don Saltero's museum at Chelsea, a popular attraction at the end of the seventeenth century.[36]

When Henry was developing his perpetual motion machine, the concept had been revived in the wake of the discoveries of the ruins at Herculaneum in 1709 but especially of Pompeii in 1748, which highlighted the huge amount of free energy contained within the earth itself. The concept continued to fascinate mechanics throughout the century, as J.J. Merlin seems to have attempted several perpetual motion machines in the form of a puzzle clock and another that was wound when a door opened.[37] J.A. Lepaute, a royal clockmaker in France, made several clocks which were wound by hot air rising in a chimney.[38] *The Gentleman's Magazine* of 1785 mentioned Humphrey Gainsborough, engineer brother of the artist Thomas, whose contribution to this fringe genre involved musket balls falling from a bucket, then being raised back up via a wind-driven fan.[39]

By the early eighteenth century, this was seen as a realistic concept and was associated with Harrison's work on the Longitude Clock. Accurate timekeeping was blighted by the time lost when a clock had to stop to be wound, so the longer a clock continued between winding, the more accurate it could become. Most of the industrial power of the age came from wind and water which were close to perpetual sources, so could almost provide perpetual motion. The problem was they were not of perpetual force.

James Cox of London was famous for producing a perpetual

motion machine. Amazingly, it survives and is on display in London's Victoria & Albert Museum. Its fine mahogany and glass case houses a huge glass tube which held two hundred and fifty pounds of mercury, so the machine was driven by changes in atmospheric pressure like a barometer. Technically it is not a perpetual motion machine, though it appears so. Given the amount of effort required to produce it, the machine generated very little power so is far from cost or energy-efficient. In 1960 it was sold at Sotheby's, London, for a mere six hundred pounds.[40]

Cox's perpetual motion clock was, with a pair of diamond earrings, the top prizes in the lottery to dispose of his goods in 1775 following a spectacular bankruptcy. The machine is described in the promotional leaflet as follows:

> "The perpetual motion is a mechanical and philosophical timepiece, which after great labour, numberless trials, unwearied attention and immense expense, is at length brought to perfection; from this piece, by a union of the mechanic and philosophic principles, a motion is obtained that will continue forever; and although the metals of steel and brass, of which it is constructed, must in time decay (a fate to which even the great globe itself, yea all that it inherit, are exposed) still the primary cause of its motion being constant."[41]

Clockmaking, as with science in general, has never known national boundaries, its practitioners are bound more by a passion for their craft than the lines politicians draw on maps. Many sources claim The Microcosm toured Europe, but there is no evidence beyond the many claims by the proprietor that the clock was going abroad, and nothing to suggest when it went to France before its discovery in Paris. Claims were also made that it was more famous there than in its homeland, though, again, no sources are given. The French translation of *A succinct description...* survives in Paris's Bibliothèque nationale as mentioned previously. The pamphlet may have accompanied the clock on a tour, or it may have been used as a scientific booklet in its own right.

There is a small mention of Henry in Pierre Du Bois's book of 1849,[42] so almost within living memory of the clock's last sighting in the UK. But it is in the Appendix, just before an article on Ctesibius, the Alexandrian barber who became an early clockmaker, so Henry's clock was seen as a curiosity rather than a major part of horological history. Du Bois's image of Henry seems more lifelike than the original copperplate engraving, so it may have been drawn from another source, or perhaps even from life. The article claimed he had built clocks for the Dukes of Chandos and Buckingham. There is no evidence of either. The Chandos line later acquired the title of Buckingham, so this may explain the mistake.

Clocks have evolved over the centuries from being central to religious practices and demonstrations of technology to curiosities owned by gentlemen, as part of their collections of exotica to become the very centre of our lives, even to controlling them. Clockmakers — whether professionals or amateurs — have been some of the most talented and ingenious of men, drawn from many walks of life. Some found wealth and fame, others died in poverty. Edmund Denison Becket was a Queen's Counsel whose hobby was horology. He designed Big Ben's clock and was rewarded by becoming Baron Grimthorpe.[43]

Yet the complexities of clockmaking could defeat even the most experienced professionals. *The Gentleman's Magazine* for 1740 included an obituary for "The ingenious Mr Clay", famous for his musical clocks. It records that shortly before he died he ordered the destruction of a musical clock which he had worked on for twenty years, to prevent anyone wasting more time and expense on completing it.[44]

17
THE WORLD OF MUSIC

Music survived the loss of religious patronage to thrive in the Post-Reformation world, as the rich and powerful still needed to relax and be entertained. Erasmus wrote "The English could lay claim to be the best looking, most musical and have the best tables of any people."[1] Henry VIII was a composer; though given his fame and power, his output is seen more as a curiosity and is seldom played today. An inventory of 1547 listed many musical instruments including organs in his possession.[2] His Hampton Court Palace was claimed to house the most magnificent royal collection in Europe, though some pieces may have belonged to the unfortunate previous owner, Cardinal Wolsey. It was open to the public, so master tradesmen could view them as examples of best practice to improve their own skills. The German physician Thomas Platter visited the palace in 1599 and described in his diary wonders such as a perfumed virginal made of glass, and organs of which Elizabeth I was fond, and was a great connoisseur. He claimed she played on a virginal with strings of pure gold and silver.[3] She famously loved dancing; and patronised the great William Byrd and Thomas Tallis, despite their Catholic faith. Shakespeare and Jonson included contemporary songs in their plays, preserving them for posterity.

Most of Shakespeare's song lyrics were self-penned, with the music mostly by Thomas Morley. But all this must be offset by the huge loss of religious musical training and instruments caused by the Reformation.

Morality or Mystery plays were performed in Pre-Reformation churches by parishioners in small communities, and by clerics and members of the various religious guilds in urban centres. Their mobile stages processed round the streets, so people could see the shows from their windows. Post-Reformation, entertainment for the masses shifted from the church to secular venues where players were patronised and protected by aristocrats from bankruptcy and draconian Tudor vagrancy laws.

Henry VIII executed so many aristocrats it became almost a mark of honour for a family to have lost their eldest son. Some families refused to renounce Rome, so fled to the continent or risked their necks continuing to practise their faith. The Civil War caused further vandalism and plunder of property, leaving few dynasties able to match the wealth and luxury of their European counterparts.

In the early eighteenth century Handel established a successful career in England composing Italian operas, supported by the Royal Academy of Music. But the Earl of Burlington, champion of simple, clean Palladian architecture, also opposed ornate forms of music, which helped fuel opposition to foreign styles and languages. The Academy overstretched its finances and went bankrupt in 1728; Handel's career seemed over. But he withdrew to Canons in search of inspiration where he composed and wrote the oratorio *Esther* with a cast of children, re-launching his career in this new form.[4] The oratorio praised the rise of free English people who were represented by the nation of Israel, God's chosen people, just as Verdi did with *Nambuco* a century later. Handel's imperial marches and thanksgiving psalms reflected the rise of the English nation, providing an alternative to imported operas. But even his hugely popular *Messiah* caused problems, as some people believed the performance of any religious piece for secular society was sacrilegious. There may also have been problems with the adoption of secular tunes for a sacred work, while

some people simply didn't 'get' it.[5] Yet again, this shows how England's Reformation continued to be a work in progress.

Following the Chamberlains' Act of 1737, the performance of political satires was banned and was often replaced by what became known as light entertainment, i.e. dramatic interludes interspersed with music. Harold Scott writes of the revival of popular music from the start of the eighteenth century, attributed to the work of Tom D'Urfey who collected — and from 1675 published — a huge number of ballads. They provided a link with the past and a resource for the future. This coincided with the publication of old tunes for dancing, the combination of which led to the new form the ballad opera. Scott names Swift as the godfather of the form by demanding a Newgate pastoral from fellow Scribblerian John Gay.[6] *The Beggar's Opera* was the result and became a huge success with the public for its appealing characters such as Macheath the highwayman. But it satirised the corruption of Walpole's government, so caused considerable offence, which further increased its popularity. Its popularity continues, and it inspired Brecht's *Threepenny Opera* where the setting moved to pre-World War II Berlin, Alan Ayckbourne's play *A Chorus of Disapproval* features a group of amateurs performing the musical, so is sometimes performed back to back with the original. From Brecht came the pop song *Mack the Knife* and Tom Waits's early career. It even inspired an ad for a fast food giant, *Mac Tonight*.

Alain Corbin's extraordinary book *Village Bells* describes the huge importance of church bells in France, known since the Renaissance for its "ringing towns". Romantic poets understood their centrality to marking the passing of time, for stirring memories and in confirming a person's place in the landscape. Restoration of bells after the Reformation took precedence over education and even charity. Despite links with the distant past, they signified modernity with their ability to transmit information instantly over a wide area in a universally understood, dialect-free language. They were voices of truth and authority. Pre-Reformation, Christians claimed bells opened the path for good angels to fend off demons.[7] In Italy, people are attached to their towns or cities as represented by their bell towers, called 'cam-

panilisimo'. Modern graffiti there often proclaims the supremacy of their towns as 'caput mundi' or centre of the world.

Britain's early urbanisation, enclosures and industrialisation have prevented the survival of such traditions, though bell ringing became a popular competitive pastime in the nineteenth century. Change ringing was invented in England (possibly Cambridge) in Tudor times. The practice continues to be popular though as urbanites move to the countryside, bells often play with dampeners to avoid noise complaints. Their use in conveying information continued till they were silenced by their appropriation in World War II as alarms. Postwar construction of new suburbs and the depopulation of old town centres largely prevented the recovery of their traditional role.

Church bells could be heard by far more people than those who could see the clock dials in towns. Bells rang out patterns announcing national events such as celebrations of military victories, royal births and deaths. Passing bells announced the death of local benefactors, inspiring prayer for their souls in the hope of being remembered in their turn. A funeral knell rang for the end of the old year followed by a minute of complete silence before a celebratory peal rang for the birth of the new one. Some bells were inscribed with messages of goodwill from those who funded them, spreading an aural blanket uniting the parish. The former Bristol church of St Ewin's had a bell inscribed with "Long Life, Good Neighbours and God Save the King". Possibly the most chilling stories of the bombing of London and German cities were the outbursts of bell ringing caused by the updraught of heat from the fire storms. As the towers collapsed, their bells fell silent.

Modern armies enforced discipline by marching in time to fifes and drums, a practice introduced to North America in the eighteenth century. This worked well in open battle, as was traditional in Europe, but in the colonies, it was unsuited to battles in woodland, and musicians became prime targets for marksmen to cause chaos in the ranks. In John Wayne westerns, we can still see how cavalry orders were conveyed by bugle calls. *The Last Post* still announces the ultimate silence on Armistice Day.

The history of mechanical music is as old as clockmaking; both involve timekeeping, and require sources of power and control mechanisms, so are often combined in the same machines. Their construction provides intellectual and technical exercises and challenges and often attracted builders from unrelated backgrounds. Ctesibius (285–222 B.C.) was a Greek inventor in Alexandria, Egypt; he was famous for making a water-driven clock, and invented a playable organ with air storage, though probably played very differently to modern instruments. The Italian architect Vitruvius developed manual organs with alternating pistons, pumps, bellows and stops. The Winchester Organ of c.950 had a massive twenty-six bellows; a poem by St Wulfstan, described it:

> *"Twice six bellows are arranged in order above,*
> *Fourteen (bellows) are located below.*
> *With alternating blasts these provide great wind,*
> *Operated by seventy strong men*
> *Who in turn exhort their comrades*
> *While moving their arms and dripping with sweat*
> *To drive the wind upward with all their might,*
> *So that the well-filled windchest*
> *Roars from its full bosom."*[8]

In mid-ninth-century Baghdad, the Musa brothers designed an automatic flute player which included a rotating programmable cylinder.[9] This feat was not replicated until Vaucanson in the early eighteenth century.

A famous early author on the subject was the English physician, astronomer and mystic Robert Fludd (1574–1637). His designs were mostly theoretical and unworkable, with gems such as a carillon powered by sand and automatic bagpipes and lyre. He lived in the middle of the Reformation, when the dramatic rituals of the church were in dispute, so he may have sought refuge from the chaos by

focusing on this work. Fludd wrote of surprising elements, of pieces which had a magical effect, of musicianless music, presented as a technological marvel or entertainment at a feast when guests could be surprised by unexpected sounds.[10] This harks back to early Egypt when they described servants, *shabti*, that were completely obedient and never tired, to support the wealthy in the afterlife. Some authors claim these were the first imaginings of robots.

From the late sixteenth century a sizeable body of writing and some actual examples survive which demonstrate the difference between the theory of autonomic music and the generally poor standards achieved, as the tunes produced were simple. Some were included in early seventeenth century *Kunstshranke, Kunst Kammer, curiosity cabinets or art cabinets.*

Automata also showed figures from classical mythology, angels etc., and there are records of automatic band conductors from the Middle Ages. Surviving examples are from the sixteenth century, akin to characters in modern street organs.[11] There are accounts of organs incorporating a monk leaning out of a window, grotesque faces that opened and shut their mouths, and even appear to grimace and/or yawn,[12] so they are important objects of social history and entertainment.

Utrecht's Speelklok Museum catalogue claims Handel composed and arranged many original works to show off ornate table clocks and encourage sales.[13] Among many famous composers who produced such pieces were Haydn and Mozart, for organs and also for strings of bells, the carillon being a popular element of church music in northern Europe.

The oldest organ clock in Utrecht's Speelklok Museum was owned by and named after the collector Broomkamp, and dates from c.1730–40. Its organ has three registers which could be selected by hand with a musical cylinder programmed to play ten dances. It was built by George Pyke of London who specialised in clocks fitted with autonomic music and automata from 1739 to his death in 1763, so postdates Henry's work. But there are similarities between them, as the museum's catalogue described a landscape with animals and people

above the dial, displaying carpentry and knife grinding.[14] This shows the imagery on Henry's clock continued to be used after The Microcosm was completed, so was very much of its time.

Several sources claim Handel composed for The Microcosm, but Antick claims this is a mistake, referring to the Earl of Bute's organ which had cylinders added in "the microcosm manner".[15] While this debunks one claim, it introduces another. What was "the microcosm manner"? Was there something special — or unique — about The Microcosm organ? Unfortunately this gem is attributed to the Oxford Companion to Music, nineteenth edition, but is not included in more recent editions. Possibly as it was not strictly a musical instrument but there may also have been an element of fashion involved. It is intriguing, as Handel composed *Pieces for a Musical Clock,* single lines of music in the key of C covering a range of two or three octaves, to demonstrate and help to sell the unnamed timepiece rather than a demonstration of his own skills.[16] This matter is clarified by a source from a century ago which claims Handel composed ten tunes for Clay's musical clock which included a sonata.[17] This must have been for his *Grand Theatre of the Muses.*

Handel did not mention Henry Bridges, but he knew a Richard Bridge, the finest and most innovative English organ builder of the period. Handel recommended him when consulted to supply an organ for Gopsall church in 1749.[18] Bridge built the largest organ in England for Hawksmoor's Christ Church in London's Spitalfields in 1735. The church's online fact sheet lists its components which include flute, German flute, cornet, trumpet, hautboy, clarion and French horn.[19] Ord-Hume describes the instruments which were part of The Microcosm as "an organ, harpsichord, spinet, flute and flageolet", but these were standard stops for the period. But this is debunked by the 1750 handbill which describes the topmost layer of the clock displaying the nine muses playing on various instruments such as "the Harp, Hautboy, Bass Viol, etc.". It seems the musical component of Henry's machine was just an organ.

There is no evidence to link the two Bridges' families but Richard worked largely in Middlesex and Essex; the River Lea which passes the

end of Henry's garden formed the boundary between these two counties, so whatever links he had with London, they were probably similar to those of the organ maker. They were contemporaries, as Richard died in 1758.

Handbills describe elegant music played in single or in concert, "most of which are entirely new or composed... for this machine". But no composers are named. Some authors claimed Handel composed work specifically for The Microcosm, but this poem printed by Henry in the Norwich Mercury of 1753 makes no such grand claim:

> "BRIDGES, those sounds must ravish ev'ry Ear,
> Which HANDEL's self did not disdain to hear."[20]

This is mere puff.

In the Gentleman's Magazine of 1796, two decades after it had vanished from the records was an enquiry about The Microcosm, which toured much of Europe about forty years previously.[21] Infuriatingly, there is no source provided for this claim, so perhaps it was hearsay. A reply in the following edition claimed the then owner gave some pieces of music for The Microcosm by Handel to a gentleman in the neighbourhood. This was from "M.S." of Barnstaple who wondered if the pieces were published. Unfortunately no source is given for either of these claims, and as the reply is virtually anonymous, they cannot be traced.

Ord-Hume provides a list of the music played: "an Allegro' and a double fuge by John James, A Bagpipe air in the opera of *Porus* by Handel, an Adagio Piece' and a jig by Signior Corelli."[22]

These pieces were popular tunes and they may have changed with fashions. There is nothing to suggest they were specific to the machine, as music was not its primary purpose.

The mention of John James is interesting; he was a talented composer and organist, but unworthy of inclusion in the huge Oxford Dictionary of National Biography. Grove Music Online described him as being admired for his songs and short organ pieces called "voluntaries" played as incidental music between parts of church services.

But he seems to have been held back by his coarse manners and his fondness for the company of the lower ranks and pastimes such as bear baiting.'23

A fondness for drinking is not unknown in modern organists, and playing for church services except perhaps in the largest cathedrals was not a full-time career. He probably supplemented his church career by playing in pubs and inns. He was reported as drinking while on duty, probably why his wages were reduced in 1732 from twenty-five to twenty pounds by St Olave's at Southwark, a region of cock pits and theatres on the main road to Canterbury and Dover. Yet he wasn't dismissed, so he must have been competent, or perhaps there was a shortage of organists at the time. It is possible the only alternative was a band of local musicians who would be under the weather after Saturday night performances which were often paid in alcohol.

He resigned in 1736, apparently to play at St George in the East, another Hawskmoor church. Like many London churches of the period, it was funded in part by the 1711 Act of Parliament to set up a commission for building fifty new churches in England and Westminster. It also had a Richard Bridge organ, so they must have known each other.

Not surprisingly James's most famous pieces were *Ye Mortals that Love Drinking* and *Ye Thirsty Souls,* both of 1735, and an anthem to be sung at his own funeral. He died in London c1745. There is a record of a John James being buried at St George's c.1745 which may have been him or Hawksmoor's assistant. They were not related.

Grove claimed that five or possibly seven pieces were composed for Bridges' Microcosm, "published anonymously in a collection of Voluntaries in 1770 and were later included (with a double fuge in C) in a so-called *Microcosm Concerto* which was printed in Edward Jones' *Musical Remains* of 1796 where they were arranged for harp and attributed to Handel". If they were mistakenly attributed to the great master, James must have been a good composer. This is probably the source of the erroneous claims that Handel composed for The Microcosm, though such practice was common at the time. This is probably as close to the truth as we are likely to come regarding the music.

Edward Jones was a famous blind harpist from Wales, part of a long tradition of blind people making a living from music. This also suggests Jones's music and the association with The Microcosm continued for several decades after the machine vanished. So here is yet another stray thread which may in time lead to more information.

Research by Anthony Hicks has located a piece of music by James now in the library of Birmingham University. It was performed at a talk given by Raymond Cassidy at Waltham Abbey in 1997 when a recording of the music was played. It is made up of "a slow introduction, two short movements in triple time and a very fine and longer finale".[24]

The links between Henry Bridges and John James date from the outset, as John Farmer's History of Waltham Abbey includes a poem "To oblige Mr. John James. On Mr. Bridges' Musical clock":

> "Tunes do ravish and delight,
> Our Ears with Pleasure; and the Heart
> Is ready for to take it's Flight,
> And Soul does join to act a Part
> Trembling Strings so justly move;
> And Time's perform'd with Truth and Grace;
> That none can help but must approve,
> And the Whole Work, Applaud and Praise."[25]

James was a man of talent but of low status, so this raises questions as to Henry's status and of the social world he moved in. James's son was named Handel, suggesting high hopes by his parents. The composer was popular across many social classes, probably because, like Hogarth, he was a genuinely nice person. But Handel James became a Thames waterman, a respected profession but known for their physical stamina rather than any artistic leanings.

If The Microcosm was the finest piece of art, why wasn't the great composer Handel commissioned to compose for it? James had talent, but his lowly status seems to have been the opposite of all Henry promoted and apparently believed in. Henry's life on the road often

involved staying and working in pubs and inns, so was he, like James, a heavy drinker and less sophisticated than he claimed? Or could he have turned to the bottle after the loss of his beloved wife? Is this one of the missing pieces of the jigsaw? Does this also explain why his sons chose not to follow him into the family business?

There is also a matter of attribution here. Tradesmen often put their names on objects comprised of mass-produced parts which they assembled and marketed. The immensely detailed *Organa Britannica* describes the organ of St Helen the Great, Bishopsgate, as being by Richard Bridge (1744) via Thomas Griffin. The latter obtained the contract, promising only new parts, and to make or commission the construction of a mahogany case with Bridge providing the organ. Griffin purchased this and other organs with his own money, and the churches paid him by annual instalments, probably to maintain it as well.[26] Organs from this time were famously temperamental, and many still are, so they need frequent adjustments and tuning. Likewise, the quality of strings for spinets and harpsichords varied widely and cheap ones often broke, hence the apparent success of The Microcosm's later owner Edward Davies as a tuner and repairer who sold wire for keyboard instruments while on the road. As with early scientists, musicians needed to be able to repair and sometimes to build their own instruments.

To further confuse matters, claims were made that Bridge, Byfield and Jordan produced virtually all the organs in the country, so were effectively a partnership. But this was more a cartel to maintain prices and exclude competition. In the absence of an official guild, they seem to have formed their own in all but name.[27]

The organ sent to the Sultan of Turkey by Elizabeth I as a diplomatic gift in 1599 was attributed to Thomas Dallam organ maker, but he was accompanied by the engineer John Harvie, the wonderfully named painter Rowland Buckett and carpenter Myghall Watson who ensured the machine was reassembled on arrival,[28] suggesting they helped to build it.

It is thus often difficult to attribute work to a single craftsman even when a name is provided. The trade of organ builder had served the

monasteries, so was lost on their closure. It was thus never part of the guild system, so no apprenticeship records exist to allow the careers of craftsmen to be traced. But the barrel (or Dutch) organ was a different beast and was often made by a single craftsman.

Problems also arise in tracing the makers of clocks and automata. Claire Le Corbeiller describes a clock attributed to James Cox of 1766 which is outwardly typical of his work but is signed and dated by an obscure clockmaker, James Haggar of 1735.[29] The earliest known clock by Cox dates from 1760 which raises the question of whether he was buying pieces wholesale or recycling the works of others.

The Microcosm was highly complex, made up of elements that could be attributed to different trades: the carved and painted — possibly gilded — wooden case, barrel organ, pendulum-driven astronomical displays and moving scenery. It seems impossible that Henry could have taught himself all these trades, and reached such high standards, which raises questions as to how much of the structure he built, as opposed to designed and commissioned. His claim to be The Microcosm's "author" suggests he was in charge of the project rather than physically involved. If this is the case, and given how few good organ makers there were at the time, the possibility must be considered that someone else provided the organ component: perhaps Richard Bridge, or the clock's future owner Edward Davies who described himself as a machine organ maker.

Handel was a virtuoso on the keyboard, and his music — especially organ concertos — helped make the organ the most popular instrument of the age. Late in the eighteenth century, keyboard instruments became popular with the many young ladies who aspired to being genteel, though of course the musicians were male. This created a market for music teachers, thus adding to its popularity and creating a demand for small, ornate chamber organs. In spas such as Bath, visitors could hire instruments during their stay. Furniture maker Chippendale included several designs for church organ cases in his 1762

edition of *The Director*. Sometimes organ cases were custom-made for rooms, with the case forming part of the wainscoting, becoming integral elements of interior design.[30]

Organ expert W.J.G. Ord-Hume wrote of how the mechanical organ was popular and widespread in early church music before it improved technically to dominate secular music. Balzac claimed it was the greatest instrument invented by humans.[31] In accounts of the Industrial Revolution, organs are overlooked but, as with any other expensive goods, purchasers required a deep knowledge of them.

Some authors claim Cromwell banned organ music, but he didn't need to. Many were destroyed by the iconoclasm; his own soldiers vandalised cathedrals and melted lead from their roofs for bullets, so they probably melted down the organ pipes and used the cases for firewood. With no demand for their replacement or repair or to train future generations, the making and playing of organs must have died out. The famous organ-building families of Dallam and Harris fled to Brittany in 1642, along with many other artists and craftsmen.[32]

E.J. Wood wrote of automatic music for church and dances being used when musicians were not available. They were suited to churches in remote country areas where there were few gentry to supplement the organist's church earnings with music lessons and concerts.[33] So again, it seems automata were used to cover the absence of humans. The organ's popularity in eighteenth century Britain may have been helped by its rarity – distancing it from portable instruments used by untrained musicians in travelling shows and town waits comprised of varying numbers of drums, flutes, tambourines and fiddles. Local musicians may have been talented, but on Sundays were frequently worse the wear after entertaining locals in the pub the previous night, when they were often paid in drinks.

Any musical instrument can be adapted to play automatically, and in the eighteenth century many were, allowing street performers to become precursors of modern buskers as one-man bands. The best known were barrel organs. Like mass-produced pianolas in the twentieth century, they were also precursors of modern recorded music. Their popularity was based on them being playable by anyone with no

musical knowledge or training. Composers were drawn to automated music because — like modern computer-generated music — it removed human limitations. More notes could be produced, over a wider range and at higher speed or using unusual timing.

Or so claim many authors.

Haaspels writes of a common fable that great masters like Mozart and Handel were interested in autonomic music as it allowed instruments to be played at higher speeds and freed them of the restrictions of a keyboard played with two hands. But Utrecht's Speelklok Museum has carefully restored many such instruments; they have shown the instruments were never played at high speeds. They were more like early cinematography, when cameras were hand wound slower than modern electric film projectors.[34] It is hard to imagine there would be any interest in high speed music as the sound would not necessarily be pleasing, or even audible.

Though a method for recording live performances was described in the tenth century, it was not until 1780 in England that the Belgian genius inventor J.J. Merlin fitted a machine above a keyboard. When the notes were played, they left marks on a rotating cylinder; these marks were later translated into staples and pins that would play all the variations and irregularities. This device survives, using a continuous strip of paper moved by clockwork-driven rollers, the marks made by pencils. It accurately reproduced music from organs and harpsichords and was sent to St Petersburg where western-trained musicians were in great demand.[35] So again, automata filled the vacuum left by trained humans and served as a great educational device.

In *The Accounts of Thomas Green 1742–1790*, there is a record for 1749: "of Mr Wright at Waltham for setting two tunes on the Barrel of the Chimes at Waltham Abbey".[36] Green was an Essex organist who supplemented his income by maintaining instruments, teaching and occasionally trading in them. If barrel organs were invented in response to a shortage of organists, this suggests there was also a shortfall of bellringers. Bells were harder to reach by iconoclasts, and were often paid for by local worthies as acts of charity, so were as

much civic as religious items. This suggests automated music had become widespread in churches by this date, especially in isolated communities as noted previously. If Richard Bridge or Edward Davies did not make the organ component, could Green have contributed his work to The Microcosm?

18

RECORDS AND WITNESSES

The Microcosm was on the road for over forty years, making it the most widely travelled, so probably also the most visited show of its age, yet there are surprisingly few records of people visiting it. This silence could be due to a number of reasons, the most obvious being spelling variations. Its name is correct on Henry Bridges' tombstone and in his will, but in his daughter Sarah's final testament it was named the "Michrochosum or world in miniature", and the diary of Thomas Tye named it as the "microcosmer" clock which suggests a range of variations may have been missed due to mishearing or mis-transcription.

In researching this book, the author was amazed at how much information survives in newspapers, so perhaps the same is true of personal accounts. It may be simply that nobody has gone looking for them, though the *Complete Oxford English Dictionary* only cites George Washington, Benjamin Lynde junior and R.L. Edgeworth, and only the last has left a detailed account of his visit. Henry often complained of many imitators, yet none can be traced in the contemporary press or in the huge dictionary.

The term was widely used in philosophical circles in the seventeenth and early eighteenth centuries as a means of corralling diverse

information to allow it to be closely investigated. This imparts a sense of knowledge expanding, of patterns identified, groups established, so the image of a tree is often the most apt metaphor. By the time The Microcosm vanished the term — though less so the philosophy behind it — had penetrated the mainstream, and it seems Henry's show played a major role in this. Popular culture and education had expanded to embrace philosophy and science, preparing the soil for the Enlightenment and Industrial Revolution.

Antick claimed many words coined by the London exhibition trade are poorly represented in the *Oxford English Dictionary*, for example, Pinchbeck's *Panopticon*.[1] This could be due to the terms failing to enter mainstream language or being seen as trade names. It was an unregulated trade in which showmen were competing for audiences. The use of exotic terms was part of their puff. The *O.E.D.* compilers can be excused their omissions as many of these shows were short-lived and poorly explained in their publicity. Some were spelled differently such as the *Hombres Chinoises*, which sometimes omitted the letter H. Or perhaps the H was superfluous. The lack of copyright protection for various clockwork devices was discussed previously, suggesting such shows were common, but these terms were also poorly defined.[2] Names were not subject to copyright law, so could be applied to different shows, and as with The Microcosm, a show could evolve over time. The interest in curious machinery continued well into the nineteenth century, as Harold Scott writes of a "spate of Victorian improving entertainment"[3] at venues such as London's *Alhambra, The Egyptian Hall* and *The Home of Mystery*. He cites the many exotic, often Greek-sounding names such as the *Eidouranium* and *Holophusikon* which were often interspersed with songs and dancing, so the eighteenth century curiosity shows helped pave the way for music halls, mechanics institutes and technical colleges.

But again, the question needs to be asked, if The Microcosm was the most widely travelled and viewed show of its age, why are there so few records of it?

Visitors may have saved the handbills or descriptive pamphlet as a souvenir, so felt no need to record the visit in diaries or journals. Such

handbills and pamphlets may have later been misunderstood, misfiled and perhaps discarded as unimportant. Modern junk shops and markets often sell photos of families with no provenance; when people die, only their most treasured possessions are kept, so huge amounts of material have been lost. Visits to the show were often social outings, especially in isolated communities, so it is possible the scientific element held little attraction in itself, so didn't warrant recording. It could also be due to misunderstandings of what it was, as it was variously described in advertisements as a machine, or by some other generic term, so failing to mark it as worthy of note. Thomas Turner's diary[4] mentioned his visit in 1758 in the company of his sister and sister-in-law to the Modern Microcosm, which he praised for presenting an accurate representation of the heavens. But his editor claimed this was an orrery made by George Graham, suggesting other editors and researchers could have failed to understand the show.

In Jenny Uglow's book *The Lunar Men* she described The Microcosm as an "embellished orrery".[5] R.L. Edgeworth called it a "Mechanical Exhibition",[6] a generic term which could mean anything. More recently a blog post featured an image of The Microcosm. But the author claimed it was probably an exaggeration, so it is even possible people simply did not believe the ads or puff.

A final consideration is that some people ordered their diaries to be destroyed on their deaths, so an unknown number could have vanished. Dr John Arbuthnot was a prolific writer and diarist, but less interested in preserving his work for posterity, as his children were allowed to tear out pages of his journal to use as kites.[7]

When James Boswell wrote his London journal in 1762–3 it was an exercise in self improvement. He promised to record his thoughts and behaviour for Dr Johnson to read, so it acted as a mirror for his own behaviour. Yet it included items that were embarrassing, so he ordered them to be destroyed after his death. His descendants repeatedly refused access to the journals, but they were not destroyed, with parts of it emerging over succeeding decades. A package bought in a Boulogne market was wrapped in one of his letters which led to the discovery of more items.[8]

Despite the huge amount of historical research and archiving which has occurred in the past centuries, new records are still being discovered after being forgotten and neglected, such as the huge collection owned by the Earl of Bute. Some families are unable or unwilling to open their collections to the public. The British Newspaper Archive now provides online access to searchable records, but there are problems with their eighteenth century editions which were often printed in italics and continued to use the Roman *s* which resembles the letter *f*, so items are often mistaken or missed in searches.

This author found a mention of Thomas Tye having seen The Microcosm on 5 December 1765 in an online blog, but when this author asked for further details, the blog was taken down. Thanks for that.

In February 1756 George Washington saw The Microcosm twice in New York, when he treated some young ladies.[9] In the absence of any theatres, it was the only show in town, and perhaps this was in gratitude for the earlier fundraising event, but he only noted it as an item in his accounts. The politician Benjamin Lynde jun. saw the show and likewise recorded the price of entry. The advertisements for The Microcosm were printed in Benjamin Franklin's newspaper, but not by him, as he was already in Britain.

In October 1773 it was in Salisbury for the annual music festival. The composer John Marsh mentioned in his journal his intention to see it with Miss Thorp,[10] but it is unclear if he did so. The Journal of Organ Studies described him as an inveterate traveller with a fascination for church organs and their music. He sometimes played at church services and tuned and repaired their organs.[11] Historian Martin Renshaw suggested: "You'd have thought it right up Marsh's street, combining astronomy and an organ — and a carpenter's yard... so one might have expected an enthusiastic description from him." Brian Robbins replied "It is not that strange that he showed little interest in an account of the 'exhibition' (a word that had broader application in the eighteenth Century) — he was twenty one at this point and far more interested in Elizabeth Brown than in astronomy, a

later enthusiasm." This was near the end of its touring career, so it was less of a novelty and must have been showing its age.

Perhaps the silence is in the nature of journals themselves. Many pioneer journals exist, but few — if any — were written in real time; new settlers were too busy clearing land, planting crops, building homes and communities to find time to record events. They tend to be written in retrospect, and often through rose-tinted glasses. By contrast there are plenty of travellers' journals, as they often include long periods of inactivity which provided time to ponder and write, especially on sailing ships, and there has long been a huge readership for such tales.

The lack of personal accounts describing The Microcosm should be a point of concern, but Georgians were very different to us in what they recorded. John Wesley kept a detailed journal of his busy life, but left no record of who built his chapels, the oldest of which in Bristol is hailed by many as the city's finest and best-designed building. Pioneering scientists were probably too busy reinventing the wheel, running their businesses, juddering about on Georgian roads, dealing with family and friends, living very busy — often stressful — lives, which left them no time to record every show they saw, though they may have spent a lot of time discussing it with friends, family and colleagues.

The diary of Thomas Turner is interesting in providing a context for its existence. His wife was in poor health, and their relationship was often strained. At one point he wrote of his guilt over his lack of feelings for her, wishing he loved her more, so he seems to have written in search of solace. Eventually his wife died and he married his servant with whom he had thirteen children. His diary ended the day they were married. Had he at last found a soulmate to share his thoughts, or was he just too busy?

James Boswell claimed to have written his diary for Dr Johnson to read. He believed if he had to write honestly, this might improve his general behaviour. Another friend suggested it could provide an opportunity for him to improve his writing style. But his plan to write daily often went awry and he later had to fill in what he had over-

looked at the time. The content of his diary often suggests a man suffering from deep depression as he talks of his fear of sleeping alone, and of his inability to find happiness.

The prolific diarist Samuel Pepys also had a troublesome marriage, so could this be a factor in journal keeping in general? Had Protestants taken to pouring their hearts into books instead of appealing to Pre-Reformation saints?

There was also a heavy class bias in the press, littered with accounts of great men, of military and political events. The vast majority of people were invisible except as criminals or curiosities. When Henry died in 1754, his Microcosm was well known, yet no obituary can be found. Even better known was James Cox, whose museum was the most popular show in London in the 1770s. The Gentleman's Magazine of December 1766 published a long article on a pair of jewelled clocks attributed to "English artists"; the East India Company was presenting them to the Emperor of China. One of the pair survives and clearly shows the words "Jas. Cox London", so even contemporary records didn't think this incredible entrepreneur worthy of mention, any more than they would praise their grocer for providing them with fine tea.

At the height of Cox's fame, an anonymous letter in the press praised his "unaffected affability and modesty".[12] Another source claimed: "Though his mind is liberal, his family exhibits a picture of oeconomy, simplicity, and industry; he places his greatest glory in honest fame, is a good citizen, and, in short, ought to be ranked among Sir Richard Steele's *Heroes of Domestic Life*."[13] Yet he died in such obscurity that his date and place of death were unknown until a recent discovery placed it at Watford in 1800.[14] Cox's modest lifestyle and his links with Nonconformists, especially immigrant Huguenots, may have contributed to his invisibility.

He married Elizabeth, daughter and co-heir of the late merchant John Liron in 1745.[15] Her large dowry and family links probably helped set him up in business, a pattern similar to that of Henry.

Foreigners such as the Huguenots were excluded from guilds and settled outside city limits so they encouraged and invested in the businesses of friends and families. But like Henry, Cox was seen as a showman and/or tradesman, so unworthy of mention by the chattering classes. But more recent research has unearthed the death of Cox's wife in the Gentleman's Magazine of 1782,[16] so the silence on James Cox's fate could be explained simply by a lack of space in the press at the time.

The Royal Society was established to promote scientific knowledge, but its membership was restricted to gentlemen. Thomas Wright of Durham was proposed for membership by Dr J.T. Desaguliers and others after he presented two papers on astronomy, but was declined, probably on the basis of class. But James Graham was accepted and his fees were waived, so it seems being a genius or child prodigy overcame class barriers.

But elitism had some basis in reality, as Thomas Henry's paper on the opening of Manchester's Literary and Philosophical Society showed in 1781. He claimed gentlemen had the time to devote to studies, and that wealth nurtures genius while poverty stifles it.[17] This concept is probably more true today than it was then as society has become economically polarised.

It is also worth considering the very nature of fame, what defines 'greatness' as so many successful and philanthropic people have been forgotten. Names such as Boyle, Newton, Bacon and Harrison loom large as they invented specific things, or made advances in technology. But others from this period such as Dr Desaguliers and William Griffiss refined, promoted and collaborated with others, helping to launch and promote careers so never became stars in their own right. Cox was internationally famous at the time of his lottery which was held in 1773 to deal with his spectacular bankruptcy. The way he repeatedly delayed its drawing meant his name later became a byword for fraud and deception, so muddying his legacy.

Thomas Gainsborough is a famous painter from the period; his two ingenious brothers were claimed to be equally talented but have been forgotten. Humphrey won two awards from the Society of Arts and an

article in the *Gentleman's Magazine* of 1785 claimed he was the country's greatest genius.[18] He was a Nonconformist minister, which possibly marginalised him from mainstream culture.

But the main factor in the brothers' fame or lack of it may be their physical legacies. Fine art is now a huge industry, and Thomas Gainsborough's work continues to attract high prices at auctions, whereas the work of early engineers has been mostly lost, their canals and sluices overgrown in farmland or demolished by later development. Like early lecturers, they paved the way for later famous engineers such as the Brunels whose work still forms an important part of our built heritage. Sometimes fame endures because descendants perpetuate it, but many families died out along with their records. Humphrey Gainsborough had no heirs, no one to remember and be proud of him, and his memory. The Bridges family seems to have died out in the UK so there are no descendants to preserve and promote their memory. Or like Cox, there may have been a later dispute or scandal which caused their earlier fame to be erased. The Microcosm itself was neglected and forgotten in Paris, so its history after it vanished in England is a mystery that is unlikely to be solved.

Thomas Turner recorded his visit to the Microcosm; he also wrote of a comet shower, so had an interest in astronomy. But as with Washington, he seems to have been accompanying the ladies, so it was as much an entertainment for them as his own interest. Infuriatingly, he does not state where he saw it. In 1761 Turner went with his niece to see an electrical machine, or friction machine which produced sparks.[19] This was invented in 1759 by Francis Hauksbee, demonstrator to the Royal Society and collaborator with Dr Desaguliers. It indicates the high standards of shows touring the provinces at the time, but again, his name is unknown outside specialist publications.

The only detailed account of The Microcosm also suggests the type of person who saw it, so helps to clarify how it was perceived. It comes from the memoirs of Richard L. Edgeworth, later a junior member of the Lunar Men of Birmingham, a group of gents who gathered on full moons (to allow safe travel home from meetings) to discuss science, philosophy and their many other shared interests. It

was founded by doctor and poet Erasmus Darwin. Though this group was widely hailed as radical, this was due largely to their immense individual achievements in the arts, commerce and sciences. They were continuing a long tradition of educated men discussing science and philosophy, encouraging and inspiring each other and furthering their business and social networks, like the owners of *Kunst Kammers*, or *cabinets of curiosities*.

Edgeworth wrote in his memoirs:

"In the autumn of 1765 I returned to England, and stopped for a few days at Chester... By accident I was invited to see the Microcosm, a mechanical exhibition, which was then frequented by every body at Chester. Beside some frivolous moving pictures the machine represented various motions of the heavenly bodies with neatness and precision. The movements of the figures, both of men and animals, in the pictures were highly ingenious. I returned so frequently to examine them, that the person who shewed the exhibition was induced to let me see the internal structure of the whole machinery."[20]

His claim to have attended "by accident" suggests he had no particular interest in clocks at the time. The show was aimed at the broad, amorphous group of "the curious" rather than specifying the disparate groups of mechanics and natural philosophers. But in this way it was perhaps more radical and influential than it seems. It is a similar response to that recorded by Henry Angelo, a fencing master. He described the far more complicated automata of Swiss watchmaker Henri-Louis Jaquet-Droz in the 1770s being objects of curiosity to mechanics and inventors.[21]

Edgeworth mentioned another aspect to the show:

"In the course of conversation he [the proprietor] mentioned the names of some ingenious gentlemen, whom he had met with at different places where he had exhibited, and among the rest he spoke of Dr Darwin, whom he had met at Lichfield. He described to me a carriage, which the Doctor has invented. It was so constructed, as to

turn in a small compass, without danger of oversetting, and without the incumbrance of a crane-necked perch. I determined to try my skill in coachmaking, and to endeavour to obtain similar advantages in a carriage of my own construction. As I had no particular object to engage my attention, I had great pleasure in looking forward to this scheme, as a source of employment and amusement. Had I been present at this time of my life in the House of Commons during an animated debate, the subject of which had been level to my capacity, and to the actual state of my knowledge, it is more than probable that I should have turned my thoughts and my ambition to parliamentary instead of to scientific pursuits." [22]

This account suggests there were many people with time to visit such shows and the means to apply what they learnt. Edgeworth's epiphany is exactly the response described in much of The Microcosm's publicity; it suggests the show changed the direction of Edgeworth's life, leading him into contact with Darwin and the other Lunar Men. It acted as a *Kunst Kammer* or *cabinet of curiosities*, a focus for him to discuss ideas, as a stimulus to his imagination, to 'think outside the box' To become an inventor like Erasmus Darwin whose medical practice involved considerable travel, so he was inspired to improve methods of transport. Such improvements were driven by personal interest and need. They were involved in their communities, so such improvements were often for the benefit of others.

But Edgeworth understated his own history. His entry in the Dictionary of National Biography claims he acquired a long-lasting interest in mechanics when he saw some scientific equipment and an orrery on a visit to Dublin at the age of seven.[23] This is again the sort of response described in the puff of people viewing The Microcosm. So in terms of experiencing epiphanies, he had 'form'. He was later sent to Oxford where Paul Elers encouraged his studies in mechanics, and met Thomas Hornby who helped advance his interest in horology and astronomy to make a clock and a camera obscura.[24]

Benjamin Franklin was in England the same year and he visited Lichfield where he introduced Dr William Small to Boulton and

Darwin.²⁵ He and others probably saw The Microcosm. This possibility is mentioned in Jenny Uglow's book *The Lunar Men*.²⁶ The Microcosm appeared in May 1764 at the Vicar's Hall in Lichfield, in Vicar's Close where Darwin lived, so was a close neighbour, so the doctor probably knew the proprietor, which may suggest why he left no record. Such personal contacts were too mundane to be recorded.

If everyone from Anglo-Irish aristocratic polymaths to pioneering Midland industrialists, the future President of the U.S.A. and country shopkeepers were interested in such inventions, these islands must have been buzzing with people discussing and investigating astronomy, mechanics and the world about them, and devising ways to improve it. Whilst many of these came to naught, every attempt provided a future topic of discussion. The more people were involved, the greater was the likelihood of ideas reaching critical mass and of something important emerging. So what is often written off as frivolous entertainment had a potentially serious, long-term impact.

There seems to be a shift in historical perspectives on early science which is also relevant here. Glennie and Thrift write of the inadequacy of the *gentlemanly* model for early modern science. It fails to include the many technicians and craftspeople who were both interested and skilled in early technology and their financial backers. They suggest that weaker networks involving friendships, marriage, and membership of various clubs and societies — even random meetings — helped the development and sharing of discoveries. Such behaviour is far more likely than claims of the existence of lone geniuses. Humans are social beings for a reason. We have developed the power of speech for the same purpose: to share and pass on information. But these informal social contacts of many forms were unlikely to have been recorded,²⁷ though archive research into the many overlapping communities of letter writers is contributing to our knowledge of this.

Comparisons are often made between the Industrial Revolution and the current rise of new technology especially in Silicon Valley. But

these comparisons do not bear close scrutiny. Early science was driven and funded by need. When mine owners had problems with water seeping into the shafts, they funded work on pumps. This seems to have been Desaguliers' entry into the field as he began his career as a tutor to the son of a mine owner. Ship captains were often involved in the design and improvements of their vessels as they knew what was needed and what did or did not work. Modern tech companies tend to work in the reverse direction, playing around with ideas which they then try to find useful, profitable outlets for. In his recent BBC series *The Secrets of Silicon Valley*, Jamie Bartlett confronted several major companies about the damage to rivals and to the wider world of business, only to be rebuffed with claims that the world would have to get used to the changes. These new businesses are based on the notion of disruption of existing systems whereas the Industrial Revolution was based on making existing systems more efficient. Early technologies served people, but now they often aim to exploit people and damage civil society, or to provide the means for outsiders to do so, as evidenced by the recent election in the U.S.A. and the referendum in the U.K.

Many early scientists and technicians were Nonconformists, part of a large group excluded from mainstream society, government and some professions, so were less likely to be noticed by the 'chattering classes'. These *weaker networks* must have included the scientific lecture circuit and clockwork/automata such as The Microcosm. Edgeworth's response shows the dramatic impact of such a show, and suggests the level of information shared by visitors to it.

Gentlemanly involvement had been crucial in science's early years, especially the late seventeenth century, as wealthy men could support themselves in their research, free of the demands to hold down a proper job. This same financial independence freed them from the need to protect their discoveries. Like Dr Priestley, they failed to take out patents, making their discoveries free for anyone to share and develop. This is partly why the Royal Society was such a gentlemen's club, resistant to the admission of the lower classes who needed to earn a living and profit from their work. It also explains the welcome

often provided to foreign visitors, i.e. those free of work commitments, who were often able to gain access to British factories and workshops, a far cry from the secretive world of clockmaking and its guild. As late as 1810 F.C. Lowell travelled from New England to Britain to spy on cotton mills. He subsequently built the biggest — water-driven — textile mills in the world at Waltham, Massachusetts.[28]

But profiting from the work of others still needed to be acknowledged. Michael Faraday developed ideas on magnetism and electricity based on the work of Dr William Wollaston which he published in 1821 but omitted to cite his source. This led to charges of stealing his ideas and almost destroyed his career. He had failed to act as a gentleman, a concept which carried much more weight than today.[29]

Peter the Great of Russia worked and learnt shipbuilding at the Royal Naval Dockyard at Woolwich. A giant of a man, and obviously foreign, it seems incredible that he was allowed such open access to matters of national security. When he established his capital of St Petersburg in 1712, the merchant James Spilman (c.1680–1763) helped him recruit English staff for his industries and navy. By yet another quirk of history, Spilman was another native of Waltham Abbey and is buried there. Other Russians came to England for training, and in 1714 Russia's leading industrialist Prince Menschicov was elected to the Royal Society.[30]

The Microcosm, like many of the shows which followed, such as those of Merlin and Cox, could make no viable claims to be of any utilitarian value. Like the various European automata, they were often condemned as wasting money that would be better spent on helping the poor. But they showed what was possible, which could lead viewers to ponder what else could be achieved, just as master craftsmen were constantly seeking improvements in their work and skills. These entertainments represented what is now known as *blue sky* research. They provide a safe environment to experiment in a small world with concepts which can be later applied to the big world, like a child learning to ride a bicycle with training wheels. Dr Johnson showed incredibly modern thinking when he wrote of the amount of

ingenuity wasted on apparent trifles, but that the same principles could be applied to more important purposes.³¹ Similar arguments have long been used to justify the vast budget spent by NASA to explore outer space, and even on weapons research, which has provided new materials and benefits for the wider public.

The ultimate test of a machine is how well it can compete with humans. For several decades, chess grandmasters have pitched their skills against those of computers. More recently, Lee Sedol, long-standing world champion of the *Go* board game lost against the *AlphaGo* computer program. The machine invented moves that have never been thought of in the two and a half centuries of the game. This is leading some people to start seriously considering the possibility that computers are capable of creative thinking. But instead of smashing the machine like the Luddites or abandoning the game, players are being inspired to think more creatively, to widen the possibilities of the game.

The passion for clocks, and small elaborate machinery had a practical use, as R.D. Brewster claimed, the precision required in designing and production of *ingenious devices* improved standards of work by artisans, and encouraged them to experiment and test their works. The same principles used to entertain the vulgar were later applied to large mechanisms of the Industrial Revolution, so the little worlds of automata helped construct and improve the bigger world of industry we know today.³²

The Edgeworth example seems to have yielded fruit, as he won an award from the Society of Arts for an improved carriage.³³ This raises questions as to how many other inventions were inspired by travelling shows, such as the case of Cartwright's power loom mentioned earlier. In later years equestrian displays by Mr Johnson and the Astley family served a similar, though wider purpose. Boswell's diary noted that such performances demonstrated what man was capable of, so inspired audiences to become experts in their own chosen fields. It is not a coincidence that the fields of entertainment and the arts expanded alongside technology and science.

The above demonstrates several ideas that are surprisingly modern. It shows the value of blue sky research. It shows the value of the arts and entertainment to stimulate creativity in inventing practical solutions to problems, a claim often made by artists in a wide range of mediums, so is of direct help to industry. The Cartwright example shows it mattered little that the chess player was later exposed as a fraud. Or rather, it had been built as an entertainment for Empress Maria Theresa, but somehow this aspect was lost or ignored when it toured Britain. Knowing a small man was hidden inside the machine moving pieces on the board above him did not destroy the sense of awe in its visitors as it was still an impressive, clever performance.

Whether based on new technology, fraud or magic, the chess player drew people together to discuss and exchange ideas. The automaton also provided a link with myths of the past. Thousands of years before technology produced robots, the idea of tireless, completely obedient workers existed in Egypt, to provide servants in the afterlife.[34] Some years ago the BBC produced a programme called *Science and the Supernatural*. Its main point was that many early pioneers of radio and television were trying to contact the dead, a bizarre notion today, but which made sense when people still believed in resurrection and the afterlife. They had recently become accustomed to the apparent miracles of communicating across oceans via cables and travelling faster than horses. Again, the crucial point is that the technology was developed in response to a specific need, and once it was created, it could be adapted or applied to other purposes. If not for this belief in the afterlife, we would not have our huge world of modern communications.

Cartwright had already demonstrated his ability to solve important problems, so was clearly a talented and original thinker. He was a former Professor of Poetry at Oxford, yet another reminder of the benefits of a liberal education.

Yet another level can be added to the role of these incredible machines. As noted in the introduction to this book, life for many

people in the Georgian Age was often a Herculean struggle, probably a factor in the high suicide rate. Many people were in immense physical pain, with little beyond laudanum or prayer for relief. Advertisements for The Microcosm often claimed it would "stimulate the senses", suggesting numbing of the senses by pain, stress and hard work was widespread. Shows which actively engaged the mind, required concentration or which sent a person off on flights of fancy or imagination were even more effective, known in modern psychology as *distraction*. Anyone who has experienced this respite would likely become an evangelist for the same.

When the first clock with quarter jacks was installed in London, crowds of people stopped to watch and listen to it chiming the quarter hours; the public were so lost in the performance they forgot their own security and often became victims of pickpockets. They were encouraged to look up from their mundane lives, just as Christians were encouraged to lift their eyes up to heaven.

In northern Europe — especially the Netherlands and German states — many church towers and town halls had ornate clocks with moving figures and large assemblies of bells or carillons which could be played by hand or by automated programmes. They still attract crowds to stop, look and listen to the performance. Some even have special names, and are spoken of fondly by locals. Whether large public performances or tiny domestic works of precision art, these works continue to fascinate us. Jan Jaap Haspels describes the appeal of automata table entertainments:

> "the sheer joy of looking, for instance, at a tiny silver herald raising his trumpet; at a gilt Minerva with rolling eyes; at a stately galleon wobbling across a table while playing music and firing its guns."[35]

When we see these tiny, complicated and surprising machines, we still feel a sense of awe. The level of workmanship they represent is especially appreciated in our age of uniform, mass-produced goods, when we are told to 'be original, be like everyone else and buy this item.' There is also a strong sense of what is now termed 'childlike'

wonder which serves as an antidote to the blandness and conformity of modern life. The physicist and television presenter Professor Brian Cox was inspired to follow his career by seeing the first moon walk on television as a child.

There is a sense of delight at seeing something beyond our understanding, of fine workmanship and of great beauty, a link with generations of our ancestors. People find a special sense of connection to be gained from such works, as well as the rituals that have come to replace the religious practices abolished by the Reformation, as shown by the popular gatherings for the summer solstice at Stonehenge and Glastonbury Tor. Even astronomers who are well aware of what is happening are still struck by the magic of the experience. Knowing you are standing where people stood thousands of years ago, seeing and feeling similar sensations brings the past, and our ancestors, closer. It reminds us that no matter how difficult our lives can be, the sun will rise, life will go on, and that's better than a truckload of antidepressants. It helps us understand the mindset that caused such expensive, time-consuming precision works to be created. They remind us of a world we have lost. A world when people had time to concentrate on details, to breathe in the silence.

19

OWNERS

Henry Bridges left no record of why he built The Microcosm, but Edward Davies' publication of *A succinct description...* claimed Henry spent considerable time and money in the "expectation of public encouragement".

But what did this mean? Encouragement to make improvements to his first machine, or to build another, better one? Or perhaps some financial reward?

Or did he have some other grand design, the details of which he took with him to his grave? As mentioned in chapter four, claims that the clock demonstrates the difference between the Ptolemaic and Copernican systems don't really stand up. The main dials show the heavens in real time. It is a machine to consult for accurate astronomical detail and for timekeeping. In its original form it was not a pedagogic tool as claimed in so much of the advertising.

Thus it not was built as a touring show, but probably for sale to some wealthy person, perhaps the Duke of Chandos, or it may have been a commission that fell through. The main motivation could have been to provide employment for the local poor, as suggested by the near-synchronous dates of his role as overseer of the poor and the making of the clock. But if this was central

to the beast, why was this never mentioned in the publicity? Why miss an opportunity to appear benevolent? Or was his role as a benefactor seen as part of the privilege of being a gentleman?

Throughout its travels, there were repeated attempts to sell it, but it is unknown if there was no interest, or whether the asking price was too high. The Prince of Wales was said to have made a generous offer but that may have been mere puff. Perhaps it was just old-fashioned by the time it first went on display.

It is unknown when the Bridges family lost ownership of the machine. In London in 1741 Henry claimed he had business at home, so was seeking a partner or outright sale for eight hundred guineas.[1] In the ensuing years he repeatedly offered to sell the machine in whole or in part, so it seems the travelling show had been a short-term plan, to make money and promote it until he found a buyer. When this failed, he made a number of improvements, making it more like a travelling show before again advertising it for sale for the same price in 1750.[2]

His eldest son, James, seems to have toured with it in the Americas, but on his arrival in Bristol in 1756 it continued without him. But the dates are in doubt. As noted in chapter 5, it seems James was involved in a legal dispute in London over the sale of the house on High Bridge Street while the clock was still in North America.

Henry's will left The Microcosm to three of his children, and his daughter Sarah still owned a share when she wrote her will in 1760, but Thomas Bridges' will in Antigua of 1759 and subsequent codicils make no mention of it. Was he not Henry's son, or had he already disposed of his share? Whoever this Thomas was, his death in 1763 seems to have triggered James's flight from Britain to become Thomas's executor with responsibility for his young family, so this is the last sighting of the family in England.

When Henry was on his final tour in 1754, again making improvements, possibly to enhance the chances of a sale, he advertised for a young, literate man to be trained to exhibit the machine, promising him "an easy and genteel life".[3]

Where were Henry's other sons? Why were none of the three interested in continuing the family business?

After Henry's death it was again advertised, this time with extensive publicity. Henry's will made Sarah, David and Thomas joint and equal owners, but if any dispute arose it was to be sold. Were his children already estranged from each other? Did they fall out over the terms of his will? Could they have been in need of cash, or was the collection of their share from its showman too much effort?

In April 1758 it was on show at the Late Royal Exchange Coffee House, when the proprietor(s) claimed it would be disposed of by public sale the following September.[4]

Despite all the promotion in the press, this failed. The proprietor was still not named. The only proprietor named after Henry was Edward Davies, about whom little can be established. He probably witnessed Henry's will in 1754, but no mention was made of his profession or location. When The Microcosm was in Bath in 1773, he claimed to be a machine organ maker who had displayed the beast at his house in Pall Mall.[5] This address is confirmed in 1774 with a further advertisement, after the clock had returned from Oxford, having received the usual approval; but again, it failed to find a purchaser when it was on show "at a proper house", the meaning of which is unclear, though we can feel some relief that it was not in an 'improper house'. He probably meant well-lit and spacious. It was on the third floor rather than an expensive shop front. This may have been to maximise natural daylight. Operating theatres such as the survivor at St Thomas's in London were built on top floors of hospitals for this reason.

Davies' home was "east of John Street, opposite the Golden Ball, Pall Mall, the word Microcosm over the door".[6] Yet again, there is an enigma. The building was named after the show, but this usually referred to a shop on the ground floor. It seems Davies had a business using this name, possibly repairing keyboard instruments. The Charing Cross area had a long association with entertainments, and by the mid eighteenth century focused on automata. When Boswell lived in Downing Street he often sought ladies of the night in nearby St

James's Park which was also home to a cock pit. Davies' former home seems to be the site of a large building near Admiralty Arch, next door to where the inventor Clive Sinclair apparently lives, so continues an association with technology.

Edward Davies' name cannot be found in any trade directories. Organ making — mechanical or otherwise — had been part of the old monastic system, so lacked a guild or apprenticeship system. Thus, no records exist of his training or obtaining his freedom of the city in order to trade there. He cannot be identified from poor rates or parish records. But an insurance policy from 1772 describes him as an organ builder and toyman "near John Street Pall Mall".[7] He insured his household contents, utensils and stock which were not to exceed three hundred pounds. If this included The Microcosm, he must have placed a low value on it. More likely it was excluded as it was seldom there, and/or because it was irreplaceable, so uninsurable.

This organ maker is the only person named in the pamphlets, so he was well educated and had at least a passing knowledge of classical languages as *A succinct description...* includes a detailed description of the machine in fine Latin poetry, a translation of which is in appendix I. As his touring continued, he supplemented his income by advertising to repair and tune various keyboard instruments, occasionally taking advantage of opportunities to sell landscape pictures, umbrellas and coin balances used to check the weight of coins to detect fraud. Attendance at shows was often by ticket in advance, which allowed the weight of the coins to be checked to ensure they were legal currency.

His home was close to James Cox's Spring Gardens venue where The Microcosm appeared, near Admiralty Arch. Several sources claim Davies worked with Cox, and Antick says the venue was used by similar shows after *Cox's Grand Museum* of 1772–5. This must be the same assistant who staged *Davies' Grand Museum* in May 1782 which displayed miniature versions of Cox's work, as well as Merlin's silver swan, in a similarly opulent setting.[8]

Cox's practice of subcontracting out his work makes attribution difficult. Some of these same workers probably continued producing copies after his business collapsed.[9] The story is further confused by

his continuing to sell works by Swiss automata makers such as Jaquet-Droz for export to China.[10] So it seems Davies was a maker of toys and automata and perhaps organ components for them, or he may have contracted out some of the parts.

When Henry died, he had four surviving children. James was in Bristol from 1756–63 when he fled to Antigua and his fate is unknown. Of the other three, only Sarah, his eldest, can be traced. On 2 February 1760 she wrote her will which is now in the archives of the Public Record Office;[11] it was proven on 16 April. She left all her possessions, including her third share of The Microcosm to her "worthy good friend" Thomas Martin of Old Broad Street who she also named as sole executor. Women had very few rights at the time, especially in legal matters, so they had to act via male relatives. Given that at least one of her brothers, i.e. James, was still very much alive in Bristol, it is odd that no relatives were named.

More extraordinary is the description of Martin as "by nature a black" the meaning of which is unclear, as the term *natural* generally meant illegitimate. It seems to point to him being of African descent, but whether the description suggested he was or was not baptised, and had or had not been a slave is impossible to know. The legal status of people of colour at the time was still debated, but he probably couldn't have joined a guild or become a freeman of the city and been allowed to run a business. Like women, they generally had to act via a white man. The rise of the abolition movement led many people to try to give them their freedom. Some cited Magna Carta, claiming that any slave setting foot on British soil was automatically free. This had been the practice in Elizabethan times when many Spanish ships were captured and their slaves brought to London before attempts were made to repatriate them. In the eighteenth century many believed that freedom was acquired via Christian baptism or marriage, and such events are scattered through some parish records, especially in the capital.

This in turn has led some authors to claim the population of Britain — or at least of London — has a significant proportion of black genes. The base of Nelson's column on Trafalgar Square shows black sailors in the Royal Navy. But sailors often died young, and were highly mobile. Others were listed as servants, often a role served by young people saving to marry. If listed as mature, this suggests they remained single so left no progeny. Frank, or Francis, Barber was a former slave who was Samuel Johnson's servant and companion for thirty years. His education was paid for by Johnson on whose death he became the main heir.[12] In David Olusogu's 2017 BBC series *Black Britain*, he traced a descendant of Barber, which raises questions as to the presence and fate of other Africans of the period.

Old Broad Street was one of the most fashionable addresses in the City of London until late in the seventeenth century. But there is no entry for Thomas Martin in the trade directories of the time, so he seems not to have been running his own business. A Thomas and Mary Martin were living in the area with their children in the 1740s and a Thomas Marten married a Hannah Mason in 1737, all in the parish of All Hallows on the Wall at the northern end of the street.

The poor rates show a Martin living in 1760 in the Carpenters' Buildings but he had gone the following year, the last of that name in the parish, so this is possibly Sarah's friend, but no further details on him can be found. Carpenters' Buildings were beside the Carpenter's Hall on London Wall, near Broad Street; as shown on John Rocque's map of 1740. The six buildings produced annual rents of one hundred and ten pounds, more than the rent of the hall, so were substantial artisan dwellings.[13]

The parish register for the mid-eighteenth century is dotted with records such as Charles Clarendon and William and Catherine Shepherd all listed as black, so of African descent. If this Thomas Martin — with or without a family — was in this parish, why were he and/or his relatives not similarly noted?

To further confuse the matter, the parish of Nazeing, named as Henry's home in his will, had a Rev. Michael Martin there in 1756, and several families of the name appeared in the parish record

including the baptism of a "George Bastard of Elizabeth Cowell by George Martin" in 1767. Like the Bridges family name, Martin is too common to be traced.

Benjamin Martin (1704–82) was a schoolmaster who became an instrument maker and touring science lecturer, published on Newtonian theory and moved to London c.1742.[14] Could Thomas have been his servant, possibly an ex-slave who adopted his name? The 1734 freehold book in the Essex Record Office includes a Mr Benjamin Martin of Holbourne, London, recorded in Nazeing. Could this be the same man? Given their similar professions, did Henry and Benjamin know each other? If so there is a chance Sarah's Martin was associated with this local family, possibly as a servant.

But there is also a possible link with Antigua, where one of the wealthiest and most influential families was the Martins. Samuel Martin was alive at the time; called the *Father of Antigua*, he was one of the most enlightened slave owners of his time. He promoted humane treatment of slaves, and was the author of *An Essay upon Planters*.[15] He is most famous for the duel he fought with fellow M.P. the radical John Wilkes in 1763.[16] The Martin family originated in Ireland where The Microcosm spent considerable time, which may provide a further, albeit tenuous, link between the families.

Slaves — especially domestic ones — were often given their master's surname, so this raises the possibility that Sarah had spent some time in the colony with James where she met her future executor and legatee. Whoever this Thomas Martin was, no further record can be found of him, so what he did with his share of the clock is also lost.

The Thomas Bridges of Antigua who wrote his will in 1760 may have been Henry's son. If so, he inherited a third of The Microcosm, but no mention was made of it in his will, so he had already disposed of his share, but again, we will never know to whom.

20

THE MAD BUSINESS OF JAMES COX

Despite all its allegedly wondrous qualities, The Microcosm repeatedly failed to find a buyer, so after decades on the road, the proprietor Edward Davies was forced to seek yet another way to attract audiences and dispose of it. On 21 May 1774 he announced in the London press that the public were visiting The Microcosm: "before its final departure from this kingdom which is fixed for the 28th instant when it will be conveyed to a foreign court".[1]

This was followed two days later with: "Positively the last week... before its final departure from this kingdom which is fixed for the 30th instant".[2]

After decades of puff, this sounds like more of the same, so probably lacked the hoped-for impact. But this is the first instance a date was specified, though, infuriatingly, the foreign court was still unnamed. These notices continued in daily papers until 30 May until the end loomed into sight. Davies claimed it was so popular that people were being turned away, so the exhibition was extended "until Saturday next, positively no longer".[3]

This sounds like yet more attempts to milk the public for their shillings. If a passage had been booked to go abroad, how could this be delayed?

On 2 June, the same advertisement was repeated; on 4 June came the announcement: "the Proprietor will exhibit THIS DAY and positively no longer."[4] Then the papers finally fell silent. Where did it go? Wherever it went, it was soon back.

The Microcosm resurfaced in Bristol — probably via the Bath Road, stopping at Newbury etc. — in December 1774[5] claiming it was on its last tour of England, but for the first time, it was not alone. It was part of a *Museum Exhibition* with a pair of musical temples claimed to be worth four thousand pounds for the Emperor of China. The Microcosm was initially listed second to the temples, but it soon moved to the top of the bill, seventeen years after its previous visit. The hard-nosed merchants of Bristol were more interested in the machine than the proprietor anticipated. Six weeks later it set off up the River Severn on what appeared to be another tour of the Midlands, arriving in Gloucester at the end of January, then to Worcester where it had to leave before the assizes. It was still appearing in large venues such as Worcester's Town Hall and the Red Lion Assembly Room in Digbeth. But after 10 June when it was still at Shrewsbury town hall "as usual",[6] The Microcosm vanishes from the record.

Its fate is unknown until the astronomical part was found by Courtney A. Ilbert in Paris in 1938, so what happened to it for a hundred and forty-three years?

Assumptions have been made that the bulk of it was lost in the French Revolution which is a reasonable guess. The name plate on the dial stating "Henry Bridges/Waltham Abbey" has been replaced; this has been presumed to disguise its English origins. But this alteration may have been to make the clock a complete timekeeping device and could even have been made in England, perhaps while it was still touring, as one of the many 'improvements'.

The Microcosm vanished at an intriguing moment. The same edition of the Shrewsbury Chronicle announced the value of Museum Lottery tickets were increasing daily and drawing would finish on 17 May. The lottery was an attempt by James Cox to resolve his extraordinary bankruptcy. After endless delays, James Cox had begun

drawing his lottery on 1 May and continued daily till about 15 June at London's Guildhall. This directs the story into one of the most extraordinary businesses in an extraordinary age.

The Chinese musical temples must have been the work of Cox, a London toymaker, jeweller and, like Henry Bridges, a famous self-promoter. Though never a member of the Clockmakers' Company, he appears in their records as a toymaker from 1749, and a trade card from 1751 is in English, French and German, so he was already trading abroad.[7] From about 1759 he became an entrepreneur on a huge scale, exporting exotic automata and curious objects made of gold and silver, encrusted with gems. The high production costs meant that they were for export to Russia and China. The market for these expanded to India following Clive's victory over the Nawab of Bengal at Plassey in 1757.

The East India Company commissioned Cox to make a pair of automata with Chinese ornamentation which were sent to the Chinese Emperor to encourage the company's continued trade when their monopoly expired in 1766.[8] Antick claims the market was mostly for mandarins to obtain favours at court or as gifts amongst themselves.[9]

The Chinese passion for clocks and automata dates from 1601 when the Jesuit missionary Matteo Ricci presented the Emperor with some clocks and watches to allow the order to settle there. By the end of the century, their mission was safeguarded by the demand for their skills in repairing and designing such pieces.[10] J. Lubbock writes of how Cox's business was part of the luxury goods trade which developed in the wake of the Jesuits' missionary activities, and fed into the Chinese practice of elaborate gift rituals, so they were valued as status symbols rather than time pieces.[11]

Cox claimed to employ thousands of London's finest craftsmen, making musical automata called *sing-sings*. But his business foundered and he was threatened with bankruptcy in 1772. His problems continued as in 1775 he was still bemoaning of the lack of money in the Far East.[12]

He employed J.J. Merlin, (1735–1803) from Liege, whose name appeared on a licence issued in 1765 by London authorities to allow Cox to employ "unfree" workmen, several of whom were European watch and instrument makers.[13] Freedom was gained by having been born or apprenticed in the city, married the daughter of a freeman, or for men with skills that were in high demand, it could be purchased. Merlin had accompanied Spain's special envoy to London as a specialist to advise him on obtaining information and possibly an example of Harrison's timepieces.[14] So it seems his career in Britain began as an industrial spy. Merlin was perhaps the greatest inventor of his age and described by Terpak[15] as London's most famous harpsichord maker.

When the late Greater London Council staged their exhibition on Merlin at Kenwood House in 1985, they were privileged to include his musical masterpiece, the compound harpsichord owned by the Deutsches Museum in Munich. He worked with his friend, the music historian Charles Burney, the father of novelist Fanny. In Bath he developed chairs for invalids, and a swing that was at the heart of the Sydney Pleasure Gardens, now part of the Holburne Museum. He designed a machine to enable blind people to play cards and promoted his work with spectacular performances, one of which allegedly involved him roller skating whilst playing a fiddle before he crashed into and destroyed a large mirror. He was first or principal mechanic[16] at Cox's Museum in Spring Gardens, but in 1773 he had misgivings about his employer's business, so set up on his own. His Mechanical Museum near Hanover Square displayed tiny automata such as a lifelike tarantula; the show was extremely popular till his death.

He was at least in part responsible for the silver swan, which still delights visitors to the Bowes Museum near Durham. It was described by Mark Twain in *The Innocents Abroad* after he saw it at the Paris Exposition of 1867:

> "I watched a silver swan, which had a living grace about his movements, and a living intelligence in his eyes — watched him

swimming about as comfortably and unconcernedly as if he had been born in a morass instead of a jeweller's shop — watched him seize a silver fish from under the water and hold up his head and go through all the customary and elaborate motions of swallowing it."[17]

This is where the story becomes a truly modern one. Chinoiserie became a popular style of decoration in England from the 1750s, inspiring designs for curtains, wallpaper and furniture; it was highly stylised, and when exported to China was valued for its Europeanism. Tea was too expensive in seventeenth century Britain to be a popular drink; it was sometimes used as medicine. It was also, of course, foreign. But when Catherine of Braganza married Charles II in 1662 her dowry included the cities of Tangiers and Bombay. The latter of these gave Britain access to India, which made tea more affordable. Catherine set the fashion and helped popularise tea as a health-giving drink.[18]

Marcia Pointon describes how Britain's trade with China became a problem. Despite early opposition to the foreign practice of tea drinking, with claims that it was unhealthy, by the mid-eighteenth century, Europeans could not get enough of their tea or the fine china to drink it from. But the Chinese showed little interest in European food, cloth or other manufactured goods, so a huge trade imbalance developed. The English tried to deal with the problem by obtaining the recipe to make their own china, and potteries were established to experiment with different clays.

But had their industrial espionage been successful, it may have had little impact, as the crucial ingredients were silica in China and felspar in Britain, both unidentified materials at the time. The outflow of payments in gold became a major problem for the treasury, so Cox's business expanded to become a major player in England's overseas trade.

International trade was backed up by arts diplomacy. The Chinese

artist Tan Chitqua worked in London from 1769. He charged fifteen guineas for full-length unbaked clay statuettes, but they were fragile so few survive. The Royal College of Physicians displays the figure of prominent physician Anthony Askew from c.1770.[19] In 1771 Mr Chitqua departed England after a visit to Cox's Museum, predating official accounts. He was impressed by it, met Merlin, viewed Angelica Kaufman's paintings and attended a reception at the Royal Academy where he was honoured to be included in a group portrait of the members by Zoffany.[20] *Academicians in the Life Class of the Royal Academy* shows London's finest, so this was a huge honour. Chitqua may also have been acting as a spy and art agent for his Emperor.

Cox exported enough of his *Bijoux* automata — some up to sixteen feet high — to partially redress the balance of trade, but in 1772 something went terribly wrong, the details of which are conflicting. Some sources claimed the collapse of his business was triggered by the return of a shipment to the Far East, possibly as the Chinese Emperor had enough pieces, and a refusal by Hong merchants to accept any more, so the British market was suddenly flooded with his work. In 1770 the merchants wrote to the East India Company directors complaining they had been forced to buy many curiosities but were unable to sell them, so the company imposed a ban on private exports late in 1772.[21]

Cox, left with a huge stock, was forced to lay off staff and attempted to liquidate his assets via two sales at Christie's in the same year.[22] They were of fine Chelsea china goods destined for the East, but also included forty thousand canes from India, so were payment in kind for goods sent there.[23] Claire Le Corbeiller claims a shipment by Cox so impressed the Emperor that he bought the whole, so all the stock from his rivals was returned to Europe,[24] suggesting diplomacy had been too successful. Other sources claim the refusal of goods was due to famine and economic downturn in China.

Bankruptcies were often reported in the press, and some people were incarcerated, particularly in London's infamous Fleet Prison. Less known were the great efforts made to allow businesses to trade

out of trouble or to liquidate assets and settle the matter amicably. The world was still small enough for local communities to matter. If a business failed, the family and employees risked becoming chargeable on the poor rates which were paid by their neighbours. Local authorities thus had a vested interest in preventing bankruptcies but when this failed, in mitigating the effects. If the bankrupt was honest about his problems and behaved honourably, he was less likely to be punished. Prison cost money and prevented the man working to support his family, so was generally the last resort.

In 1773 Cox informed a parliamentary committee he had employed about eight hundred to a thousand workers over the previous seven years. But many of these were via contractors, so numbers may have varied. It is unknown if he ever laid off any staff after his initial crash, as throughout the years of the museum, he kept adding to its contents. He claimed his jewellery business was still being patronised by British gentry and aristocracy, but no evidence can be found for this.

Under normal circumstances, remaining stock would have been auctioned off and the money used to pay off debts and workers moved on to new jobs. But Cox was no ordinary bankrupt and his business practices were far from normal as he continued production.[25]

Even by modern standards, when businesses can have tentacles in many countries, the scale of Cox's bankruptcy was extraordinary, as he continued to have access to large amounts of cash. When he applied to stage a lottery to dispose of his unsold goods, he offered to buy back the two biggest prizes for five thousand pounds each, and promised to lodge this cash with the Bank of England before the drawing began. Despite the huge amounts involved, he seems to have viewed his financial problems as a bump in the road. In 1774 he claimed that when the show was removed, it would never again be exhibited, as it was intended for Asian courts.[26] This claim was reinforced by his continued output of Asian-style items, even though he claimed in his petition to hold the lottery that there was no local market for them.

In 1739 a public raffle was held for a clock made by Clay with

music by Handel, on display at Hickford's Room near Piccadilly.[27] So the lottery had a precedent in disposing of goods too costly or specialised to find a buyer. But the scale of Cox's business was unprecedented.

The finest artists spent a year decorating the auction room, the former Huguenot Chapel in Spring Gardens, before it opened in February 1772. Architects the Wyatt brothers may have been involved.[28] It included portraits of the monarchs by Johann Zoffany and a bust of Empress Catherine of Russia by Nollekens. The ceiling dome was painted with chiaroscuro paintings representing the liberal arts, possibly by Angelika Kauffmann. Admission was astonishingly high at ten shillings and sixpence. Cox claimed this paid for the high security required, and that so few could be admitted at a time.[29]

It was praised by Johnson and Boswell, though Fanny Burney's *Evelina* was less impressed by the baubles with: "it is a mere show, though a wonderful one". It was mentioned in Sheridan's play *The Rivals* which opened during the museum's existence, so apparently provided free publicity. But it was mentioned as part of a discussion between father and son as to the qualities of a potential wife. The father ordered the son to marry for money, "no matter how ugly, her eye might roll like a Bull in Cox's Museum". Using the show as a metaphor for an ugly woman is hardly likely to encourage attendance. The play was a failure, which delighted Sheridan's wife Elizabeth nee Linley as she hoped to revive her singing career which she had been forced to abandon on her marriage.[30] So Sheridan was trying to boost attendance at his play by riding on Cox's coattails.

During the three years of its existence, Spring Gardens so dominated London that it became known as *The* Museum. Cox's business had long been condemned for being a waste of money, but the museum also became a metaphor for widespread political corruption, as the now-forgotten Augustan poet/cleric/garden designer William Mason wrote in his *Epistle to Dr Shebbeare*:

> "Tax then, ye greedy ministers, your fill...

Ye know, whate're is from the public prest,
Will sevenfold sink into your private chest."

But there were also parallels with Henry's advertisements, condemning foreign fraud and links with magic, with:

"Yet when we peep behind the magic scene,
One master-wheel directs the whole machine;
The self-same pearls, in nice gradation, all
Around one common centre, rise and fall"[31]

Mason yet again highlights the English objection to luxury goods, but puts it into a wider context, and helps explain some of the objections to such extravagance. He draws parallels between Cox's show and greedy politicians claiming to act for the public good whilst motivated by private gain. He refers to magical effects used to conceal fraud, comparing it with the Europeans' love of luxury, and of course Vaucanson again. This also highlights the practice of curiosity, of how the unlearned can be easily deceived, but an educated person has the wisdom to see beyond the trickery. Mason was a friend of Pope, a garden designer and promoted lay choirs and abolition; so was yet another Augustan polymath. His objection to luxury echoes similar claims by Hogarth and Bridges, but Henry made such a luxury item and showed how it worked, so broke down the barriers between wonder and deception, between quality workmanship and fraud.

Historian Mike Rendell describes an ancestor's repeated visit:.

"It wasn't cheap: entry cost half a guinea (10/6d). Richard would lay out another 10/6 for the brochure. I still have it and it shows something of the spectacle presented to the public: the museum contained a number of salons, each with its own collection of be-jewelled automata. The foyer was dominated by giant portraits of King Gorge III and his wife Queen Charlotte, painted by Johan Zoffany. Before the portraits, upon a Throne of gold thirty two feet in

circumference of six steps, stand two rich and finely adorned altars of silver, border'd and embellish'd with gold."[32]

He described twenty-three items in the exhibition, including life-size elephants and silver tigers ranging down to tiny, ornate clockwork. It also included the famous silver swan by J.J. Merlin. Yet it was not until June 1774 that the royal family paid a visit, allowing the venue to be renamed 'The Royal Museum', with their coat of arms above the door,[33] adding even more prestige to the event.

The promotion of mechanisms as fine art, as shown by Henry's clock and Cox's output, was mentioned by Adam Smith with his theory that beauty is based on an object being fit for purpose. This may seem odd when citing such items as the beautiful, intricate peacock automata, with its many screws hidden beneath fine art. But boats were often defined as beautiful if they sailed well, so this is a thoroughly English concept. Wetmore claims such items represent a merging of liberal aesthetics with mechanical function, echoing some of Henry's claims. This shows a shift from the notion of function from what is necessary to survive, to its role to entertain or delight, in which case such luxury items could be claimed to be successful. Cox's pieces were valued as they were made of expensive materials and immensely labour-intensive to produce.[34] James Graham's early planetariums used pearls for planets, so were early — though less spectacular — examples of this.

Like Bridges and Davies, Cox was a brilliant and dedicated self-promoter. He issued a ninety two page pamphlet, *A collection of Various Extracts, in Prose and in verse, from the London Publications, Relative to the Museum in Spring Gardens; containing Many Favourable testimonials and Judicious Observations, on that Superb and Singular Display of Art*. Also like Henry he published a collection of letters to the editor, all unattributed, so likely self-penned. But Christopher Pinchbeck junior was quoted by name, and was so impressed he claimed he would name his own show "the Minor Mechanical Exhibition".[35]

Cox made no apologies for the high prices charged for his products as they provided employment for the country's finest craftsmen.

Critics complained his work was of no real use; he responded by claiming they brought five hundred thousand pounds into Britain.[36] In his petition to Parliament to hold a lottery, he compared himself favourably with the loiterers of coffee houses whose money came from abroad rather than from the honest employment of British workmen. Though not specified, he was criticising the profits made from the African slave trade. Many industrialists were Nonconformists, especially Quakers and Huguenots, who promoted humble lifestyles, and many were active in the abolition of the African slave trade movement. Like them, Cox reinvested his profits in his business rather than wasting money on palaces and luxurious living, claiming he promoted the ingenious and supported British mechanics.[37] He apparently saw no irony in running a business which relied on this same passion for luxury.

The Museum in Spring Gardens was so popular Cox sent an offshoot on tour. It arrived in Dublin in late November 1773 and opened in the Exhibition Room, William Street on 19 December, after the venue was extensively redecorated. For the first two days, all receipts were donated to the Channel Row House of Industry, i.e. the Poor House,[38] a worthy act, but it may have highlighted his claims that he employed many tradespeople, minimising the demands for poor relief.

As a stranger to Ireland, Cox was wary of making profits at the expense of local businesses, so he praised the nation's generosity, claiming that in his thirty years in business he had employed several Irish workmen, some of whose pieces were on display. Thus he cleverly reframed an ornate display from London as a form of Irish patriotism. He then launched into an extended justification of his trade, pre-empting objections raised in London.[39]

Within weeks of opening, the show included explanations of the pieces, so like The Microcosm, the static museum became a performance. Improvements were made, and visitors were urged to arrive on time to catch the surprise when the curtain was raised. This surprise

was unique to the Irish museum and was never clarified in print. But as shown in the clock in New York 1755 which enacted the *Tragedy of Bateman*, it showed the parallels between automata and live theatre, which had probably originated in the Roman Mass.

At the end of the performance two of Cox's new pianoforte pianos played, extending the socialising and performance aspects of the show, just as the Microcosm show had ended with music playing whilst all parts of the machine were in motion. These instruments were probably by Merlin, suggesting ongoing contact between the two men.

Visitors in March 1774 were urged to view the latest improvements before Spring Gardens was shut again.[40] So although the Museum Lottery was granted to allow Cox to sell off the contents of his museum, and catalogues of its contents were being given away with lottery tickets, he was still adding to it, still making goods that had caused his bankruptcy. Once again, it seems his bankruptcy was a rather extraordinary one.

In Dublin, the exhibition was to shut on 6 August before reopening in its improved state on the seventeenth when it included an ornate organ, a Chinese figure hammering out tunes on bells, and the busts of King George III and Catherine the Great of Russia, probably from Spring Gardens, placed with a gold crown over them in elegant niches.[41] The latter item suggests sales in Russia had also stalled. Claims were made that it would soon leave Dublin for England, but it seems this was doubted, so Cox's bookkeeper/agent Jasper Jay was forced to announce in the press he had been instructed to close up the museum on 1 October.[42]

Yet another Cox Museum opened in Lord Street, Liverpool, in January 1775, and it included items from London's Mansion House Easter Festival. But was this the Dublin version or a new collection entirely? The new venue took time to set up and decorate but a gap of three months seems too much for this, but too short for it to have been shown elsewhere.

The *Chester Chronicle* of 7 August 1775 announced the touring version of Cox's Liverpool Museum would close, claiming it would not appear in that part of the kingdom again. Apologies were made that it

could not visit Chester or Manchester due to the cost of transportation, but his friends in Bristol suggested a visit there might be worthwhile. Alternatively, the show could return to London and the major pieces be added to the Spring Gardens Museum. This in turn suggests items from London's Museum had been sold to allow space for the touring show.

The Liverpool show closed on 29 August, with suggestions it might move to Chester, Birmingham or Bristol.[43] It opened at Bristol's Coopers' Hall the following October[44] and included items that were not shown in London, so Cox's business was still in production. In February it raised twenty pounds for the local poor, providing a final boost for attendance before it closed in March.[45]

Lottery ticket sales were encouraged by the production of a descriptive inventory in English and French, suggesting he was selling tickets abroad, which again echoed The Microcosm's claimed links with Europe. Cox also provided a model of the "brilliant" (rock crystal) earrings and a fine print and description of the perpetual motion machine, one of the two major prizes in the proposed lottery. Tickets were later offered on flexible terms, to admit one person four times or four people once. To encourage sales by parents for their children, the tickets allowed free admission for two children. Or admission could be purchased and the difference paid to buy a lottery ticket after visitors had been tempted by seeing the prizes.

Cox initially promised to draw the lottery in May 1774 as part of the State Lottery, but he realised he could make more from a separate event, so yet again he was thinking on the hoof. He claimed the Act of Parliament to hold the lottery to dispose of his goods was passed unanimously in 1772 by both houses in recognition of the national importance of his business and of his honesty. But in May 1774 he published a long article in the Irish press. It seems the repeated delays in drawing the prizes were causing ticket holders to lose faith in him. He defended himself by claiming he did not own the museum, but that it was in the hands of the adventurers, who were apparently the ticket holders. After obtaining royal assent for the lottery, he executed a Deed of Obligation to ticket holders which assigned all items in the

schedule to them.⁴⁶ In April 1774 his agents in Bengal managed to obtain about twenty thousand pounds in old debts,⁴⁷ and other markets, which provided some welcome relief, but no mention of this was made public.

Doubts were raised about Cox's credibility, so in November 1774 he published an extended apology-cum-explanation for the delays in drawing the lottery. He said he had intended to draw it in the winter, but that the costs of advertising and running the museum had caused its postponement. He claimed he was still struggling to pay the five per cent interest and though the lottery tickets had sold well, there were still some forty thousand left. He believed he would not be blamed by his benevolent countrymen for his misfortune. He claimed his agreement to draw the lottery was "not absolute but conditional". A strange claim. And that delay would be made up for by anticipation.⁴⁸ He opened subscriptions to sell the remaining tickets.

In December 1774 a poem appeared in the *Leeds Intelligencer* which helps clarify the appeal of owning a lottery ticket. It claimed a person suffering from poverty would find serenity by the thought he might win twenty thousand pounds. But this ignored the fact that a person in poverty could not afford to buy a ticket. The article continued with claims that if such a win was soundly invested it would provide an income of eight hundred pounds per year, sufficient to live in comfort.

This piece seems to equate poverty with being a miser, who would be overjoyed, and fails to note the initial outlay or the huge odds against his winning. But when he finds his ticket has not won the prize, his rage exceeds the wildest storms; he attacks furniture and servants till he collapses in exhaustion.⁴⁹ It is hard to see how this could encourage sales as there were far more losers than winners.

The poem was followed by another extended update on the lottery drawing. Mr Cox agreed with the lottery ticket holders to begin drawing tickets within three months unless unforeseen circumstances prevented this, leaving the door wide open for more delays. How did he consult and obtain agreement with so many thousands of ticket holders? Or were the majority held by large, easily contactable groups? The article mentions a rumour that Cox was receiving all the

profits from the museum, so was delaying the lottery drawing to maximise his profits. But he assures the public that all the profits from his exhibitions were to pay off his creditors and that he was the main sufferer from the delays. But again, this makes no sense.

If his creditors were being paid off, then he was profiting from the delays. If the delays continued long enough he should have become solvent. But of course this was not the reality. Cox's ongoing production meant that he was still purchasing expensive materials — gold, silver and jewels — on credit, paying interest on them to keep his business going, paying rent on his properties, publicity and wages. It seems he was on a nightmarish treadmill: forced to keep running to stay in the same place.

Even by the standards of Georgian commerce, Cox's business was pure madness. He was producing expensive, robust goods whose novelty soon faded. How long did Cox and his supporters think these sales could continue? Or had the business grown so large and soaked up so much investment that — like modern international banks — it had become too big to fail?

There was no government bailout for Cox, no aristocratic or royal patronage to fall back on. For decades he had been juggling enough plates for several circuses. He must have known they were about to crash into pieces about him. He repeatedly deferred the drawing of his lottery, which would put an end to the madness, but his attempts to keep workers in employment ultimately ruined his reputation and that of the lottery system.

Cox's toys were famous and can still be found in collections from Russia to the U.S.A. But his handling of the lottery became equally infamous, which may explain why he is now so little known. Sir Ashton Lever established an impressive private museum, but it became too popular for him to cope with the crowds, so he offered to sell it to the government for a public museum. But this was during the American wars, with no cash for such expenditure, so he tried to

dispose of it by lottery. The Act of Parliament to allow this went to the House of Commons in July 1784 for the third time, so had faced objections, unlike Cox's clear sailing. A Mr Hussey claimed the lottery would be an insult to Sir Ashton for his benevolence in compiling his collection, citing how the Cox and Adelphi schemes had exploited the public. The bill was eventually passed as it was seen as an act of cruelty to block it at such a late stage.[50]

The attempt to save jobs caused Cox's name to become a byword for fraud. Yet his bankers discharged him the following year, so he was never charged with financial misconduct.[51] Whatever ducking and diving he had done, he still saved a lot of money on poor rates, helped control the national debt, and had largely acted in the public interest rather than for personal gain.

At last the announcement came: in early March 1775 the press announced that Cox would begin drawing his lottery on 1 May, supervised by the official state lottery. If he failed to do so he would surrender his bond of ten thousand pounds. With his track record, the matter could have dragged out indefinitely; this would have benefited Cox, his creditors and his many workmen and their families, but the drawing proceeded.

On 14 March, the press announced Cox had signed a bond to pay the ten thousand pounds, so those who had bought lottery tickets on credit were urged to pay their outstanding five shillings. Anyone who continued to have doubts was invited to view the covenants signed by Cox. Commissioners for the draw were sworn in; numbered tickets were cut up and put into boxes. The drawing was in the Privy Gardens at Whitehall, so the public could observe the event and be reassured the correct procedures were being followed. A list of the winners was to be published within forty days of the end of the drawing. The ten thousand pound bond was paid on 3 April to the Bank of England to cover the two five thousand pound prizes. It seems the same amount would be used to purchase the top prizes if the draw failed to happen, so again this was a strange arrangement.

1 May should have been the end of the ticket sales, but they continued to be advertised. The lowest ranking prizes were drawn

first, though there were a few others to maintain interest. As prizes were announced and visitors continued to view the museum, the price of tickets and the benefits were compared favourably with those of the recent state lottery, valued at ninety thousand pounds though this excluded the lower prizes, with Cox offering a hundred and ninety seven thousand, five hundred pounds, so this was yet another sly misinterpretation of the facts.

Cox's strange confidence continued, as in May he offered to pay fifteen hundred pounds for the top winning prizes, i.e. the diamond earrings and the giant elephant automaton. As late as 30 May, i.e. two thirds of the way through the draw, parents and guardians were urged to buy tickets to invest in the future security of their children or wards, so there were still plenty of tickets unsold or recycled as people lost faith in the scheme.

On 2 June Cox announced he would publish a list of the prizes and the winning tickets, and within a month would produce a full account.[52] He also claimed to pay the two main prizes within a month rather than three, as previously claimed. He also generously included two musical clocks worth two hundred pounds and four pieces of mechanism of fifteen hundred pounds for the last ticket drawn, claiming that one in every ten tickets would be a winner on the basis that twelve thousand tickets were sold. He also announced the Spring Gardens Museum would continue till 30 December.

So again, we have him playing games. The winners became owners of the prizes, but not of the museum itself. The situation was further confused by his use of terms such as "adventurers" and "proprietors". If winners wished to dispose of their prizes, Cox claimed he would sell them for them. He was involved in a complex form of legerdemain.

Cox offered to either farm out the profits or to conduct the museum for a reasonable fee. The winners of prizes were to pay Cox to run the museum which displayed the prizes they had won. Cox further suggested they occasionally sell items, and replace them with others, to ensure employment for his tradespeople. Whilst this was an admirable aim, he was offering secure employment for his workers

which was uncommon in the wider population, but this was justified by claims of encouraging ingenuity and arts.

Few people at this time had the luxury of stable, longterm employment; many still helped with the harvest and some did multiple jobs, so this demand seems extraordinary. His business was so large it held a virtual monopoly on supplying the goods, so he would continue to profit from it. The prizes were being used to advertise and support Cox's business, not to benefit the ticket holders.

To consolidate his claims of propriety and to again justify the luxury goods trade, he claimed to have imported a million pounds into the kingdom, i.e. double his previous claim, of which a quarter had gone in workmen's wages over the previous seven years.[53] Yet again, this is unclear, as there is no mention of the price of raw materials, or of all the costs of running and promoting his business. But given the size of his operations, he could justify his claim to have helped with Britain's trade imbalance. So the collapse of his business became a matter of national importance, hence Parliament's support for his lottery and apparent tolerance of his — let us say quirky — way of conducting it. He continued to keep the population of London poorhouses down, hence contributing to the maintenance of law and order in that part of the capital.

He claimed huge profits could be made from the prizes and a chronoscope similar to one in the lottery was sold in China for fifteen thousand pounds in 1769 and another item sold for treble the cost here. But this ignored the costs of exporting and marketing. Few of those purchasing tickets had the resources to send their prizes abroad to recoup such profits, even if there was a market for them, which the necessity of holding a lottery disproved. So these claims were misleading, but probably within reasonable limits for the age.

For all his praise of the various pieces being beautiful and valuable, there was never any encouragement for winners to keep them, as investments, as gifts for loved ones, or to pass on to future generations. They were promoted purely for their resale, i.e. export, value.

As the drawing of the lottery staggered towards the finish line in London, a show opened in Canterbury on a tour of the South East

called *The Museum, or, The Manners of the Eastern World displayed*. It claimed to include "Architecture, Sculpture, Music and Painting",[54] so echoed advertisements of both The Microcosm and Cox's Museum. It was a large jewelled display of an eastern monarch, and the large ad claimed it encapsulated the whole of Cox's Museum in a single view. Was this one of the major prizes from Cox's Museum or an imitation? If the former, it seems by delaying the drawing, he was allowing winners and purchasers to compete with his museum, so reducing interest in the lottery and his own show. And so his mind-boggling scheme continued.

A year after the lottery was drawn, Cox was still dragging his feet, with an announcement that proprietors of the museum were offering to sell him their shares, but he "refused to benefit from their generosity".[55] Of course he did. He claimed that when his business first hit the buffers, he was paying nine thousand pounds per annum interest to his creditors, but makes no mention of how much he had paid off in the interim. Creditors had offered to discharge his whole debt for ten shillings in the pound with no interest, which seems generous and would have resolved the problems much faster than his cunning plan to trade his way out of debt.

Cox claimed he was committed to pay off the remaining debts, so could not purchase the prizes from his lottery. He mentioned some winners had refused to collect their prizes, suggesting that some were fed up with his repeated sleights of hand. He claimed that the prize winners were damaging their own profits by selling their prizes too soon, so devaluing the remaining museum and making it harder for him to recover his finances.[56] Yet they were only following his advice and practice.

His still unnamed backers allowed him to continue, so he must have had large numbers of people agreeing with, and supporting, his decisions.

Or perhaps there was no jumping off this juggernaut.

Cox offered to hold a sale of his stock by auction, which could be paid for by tickets or parts thereof. Instead of handing over the prizes

that these people had won, he would exchange the prizes for new items produced in the interim.

Thus there were more delays, more sleight of hand from the ingenious Mr Cox.

But perhaps most astounding was his claim that profits from his jewellery business had allowed him to discharge the majority of his debts![57] So he still had a pool of rich customers. Yet again, this was a strange form of bankruptcy.

Cox then published and sold a list of all winners, making more money for him and more delays for the many so-called winners. The absence of data protection must have made life difficult for some of them, becoming a magnet for people wishing to cash in on their apparent good fortune.

Though more than one hundred and twenty thousand tickets were printed, there is no record of how many were sold or who received the prizes. The value of the lottery was set at one hundred and ninety seven thousand pounds, and tickets were sold for one guinea each over two years.[58] But tickets were sold in whole or fractions, and increased in value as the draw approached, allowing his agents — from newspaper offices to jewellers and perfumiers — to skim off income from Cox's behemoth.

When the Spring Gardens Museum opened, its catalogue listed fifty-six jewel-encrusted automata, toys and clocks which were valued at the astronomical sum of one hundred and ninety-seven thousand pounds, but when the prizes were drawn, this number of prizes had swelled to four hundred and four, the value of which is impossible to ascertain, but probably more than the wealth of many countries at the time. Perhaps even that of Britain. There is no record of how many items were sold directly from the several museums, which must have helped reduce his debts, but of course they were never mentioned in the publicity. But the repeated closures and improvements of the various museums suggests a high turnover of their contents. Cox claimed the lottery was the grand finale to the exhibition, but they fed off each other, and the museum continued long after the lottery was drawn.

Who was buying his exotic, expensive automata? Initially some can be traced in the press as they found their way into travelling shows. Some of them appear to have been a poor fit, but it seems their appeal was high, especially in the many areas where the museum had not visited. Any showman would find his popularity boosted via the fame of Cox's Museum.

In July 1775 a collection of moving pieces from London was on display in Gloucester, including a jewelled elephant and galloping Indian chariot which were clearly from The Museum. Thus, some of his items became touring shows in their own right, so Cox created jobs for itinerant showmen.

In December 1774, a Mr Astley arrived in Edinburgh with a museum which he claimed to have spent several thousand pounds on, and that it was "beyond description beautiful".[59] In the press he provided a hugely detailed description of a rock covered with flowers, animals and dragons, fountains, musicians and much more. So this seems to be another Cox piece but here incorporated into an existing show. Harold Scott writes of Astley that in 1775 "he was devoting evening performances to the *Ombres Chinoises*",[60] which fits with the above, and is a term suggestive of Cox's work.

In December 1808, it seems items from Spring Gardens were on still tour; in Manchester and the Midlands. A Mr Manuel (from Turin) was displaying an automata elephant with nabob and young lady, a spinning wheel, an Indian lady in a chariot.[61] They were accompanied by an Italian band of musicians. This show later joined up with Sieur Rea demonstrating his art of deception.

In the years that followed Cox's extravaganza, the Spring Gardens venue was rented out to a succession of entrepreneurs and artists, one of which was *Davies Grand Museum*, which included small versions of pieces in the Cox Museum, such as the bird's nest mentioned by Burney, and a jewelled moving star which he advertised in May 1782 and has caused some confusion over attribution.[62]

In the final years of the Microcosm's touring, Mr Davies made several trips back to London to obtain new stocks of toys, which must have been lesser items by Cox, which suggests other touring shows

were doing the same. Whatever remained of Cox's business was at some unknown date taken over by Mr Davies. If he was the same man who witnessed Henry's will he was well into his fifties, or older, so this may have been his son. Perhaps he had been involved on some level with Cox's Museum all along. But *Davies' Grand Museum Originally Cox's* claimed to be the grandest mechanical show in Europe, comprised of painting, architecture, clockwork and jewellery when it appeared in a large house in Newcastle's Bigg Market in December 1791.[63] It included many recognisable pieces from the Cox collection, in particular, Merlin's silver swan.

Cox's pieces survived in the exhibitions of Maillardet and Weeks, and until his death, J.J. Merlin ran his own museum on Hanover Square. Pieces by Cox can still be found in many collections, especially in the U.S.A., China, and Catherine the Great's collection in the Hermitage Museum St Petersburg. There were so many pieces they even trickled down into other travelling shows, such as that of Katterfelto.[64]

Mr Barrow's Museum included an astonishing piece of mechanism *The Museum (late Cox's)*; it toured the south coast in 1788 but no description of its contents were provided so it is unclear whether the museum was a single item or several.[65] The following year, Barrow admitted his show was chiefly constructed on the model of Cox's Museum, so may not have included any famous pieces.[66] Yet another show included the heifer with two heads and Cox's Museum, but again it is unclear what was on offer.[67] Thus it seems Cox's show, like The Microcosm, seems to have expanded to encompass a wide range of elements.

After his spectacular bankruptcy, Cox remained in trade until his death in 1800 but as a merchant rather than a manufacturer. Given his claims to have employed so many skilled tradesmen, it would be interesting to note if there was a surge in poverty and homelessness when his business finally closed. The Chinese problem became a perfect

storm, as Cox's markets in Russia and India collapsed, and war with the infant USA dried up funds in Britain. His finest workmen may well have been forced into the armed services. France's problems not only led to a collapse in demand for luxury goods there, but the UK market was flooded as refugees liquidated their assets to survive. This exacerbated the usual wartime problems of financial restraints and soaring crime in Britain and the dangers of shipping abroad.

Cox was not the only producer of fine art to become creative with his funding. The great entrepreneur and industrialist Wedgwood produced the famous Frog Service for Empress Catherine of Russia, yet another monarch with an insatiable appetite for spending money. The master potter put it on display in London to help defray the costs of shipping. This may have been to allow the public to see such fine work and be inspired by it. But he was a shrewd businessman, so this was sound publicity. Because of problems obtaining suitable clay from China, Wedgwood obtained it from the Cherokees, yet another bizarre element in this extraordinary age. The president of the Royal Academy Sir Joshua Reynolds was commissioned by Catherine the Great to paint the huge *The Infant Hercules*. He exhibited it at the Royal Academy before sending it abroad to cash in on the publicity and to help defray costs.[68]

So The Microcosm seems to have been sucked into and lost in the whirlpool of the Cox lottery. By the end of The Museum's career, even struggling magic shows included Cox's pieces, so it is hard to see any market for The Microcosm. By the 1770s many towns had their own theatres and/or assembly rooms, venues were becoming larger and the market for entertainment aimed more at the masses rather than small, intimate shows. Technology had overtaken what was once an impressive piece of clockwork. When The Microcosm began, it was still possible to imagine all aspects of British life depicted on a single machine. By the time it vanished, The Microcosm that was Britain had expanded to overwhelm the representations on a single machine, as this fractious nation steamed its way to build a new world via the Industrial Revolution and the Empire.

The astronomical clock is now in the care of the British Museum

Horology Department. They find it extraordinary that such an outstanding piece is so poorly documented, but many important pieces from this age fell out of favour. Lovelace's monumental clock was found neglected in the nineteenth century and restored. The Microcosm was found in a plain oak case beneath a tarpaulin by Courtney A. Ilbert in Paris in 1938. The moving scenery etc. was probably worn out and superseded by bigger, more sophisticated shows, so probably disposed of in some form, perhaps in Cox's fire sales or perhaps it provided firewood during the troubles in France.

No trace can be found of The Microcosm in any of the flurry of Cox's sales and lottery prizes. Sometime after June 1775 Henry's giant machine vanished from the record though it may have continued to tour in some form. Given Davies' close links with Cox and his desperate need to liquidate all his assets, it is possible The Microcosm became part of a final fire sale of Cox's goods.

Or was the timing a coincidence, its disappearance the result of a serendipitous meeting with Davies at or near Shrewsbury, a person who made an offer he chose to accept?

But if it was sold by Cox, in what form was it in? Did someone purchase the complete machine or did Cox 'improve' the case with gold, silver and jewels? Did he perhaps break it down into several pieces, each with its own ornate casing? The Microcosm seems in many ways an odd fit for the Cox business, which was mostly about display and luxury, though it was not too far from the perpetual motion machine which was a feature of the show. Desperation probably dictated that he liquidate his assets. We can only hope that Cox's children did not stand still too long for fear of becoming 'embellished' and sold.

The tragedy of so many of these mechanical masterpieces is that the wonder which is at the heart of their appeal is so quickly replaced by new novelties. By the time Henry's show vanished, steam power was becoming widespread. In the art of Wright and Turner we see the new technology, full of noise and fire. Huge mills turned England into the weaving centre of the world; British engineers and entrepreneurs were building railways and factories across Europe and the New

World. Just as the socialising at Bath had been made redundant by new churches, libraries and mechanic's institutes, the Augustan science shows had proven to be so successful that they made themselves redundant. Machines like Henry's Microcosm were cast off like abandoned toys. Merlin's amazing swan passed from Cox to Davies to Weekes' Museum, but by the time it was sold by the latter's son in 1834 it had long been neglected. Yet it appeared at the Paris Exposition in 1867 before being purchased by John Bowes to become the star attraction at the museum he and his wife, Josephine, founded at Barnard Castle in Northumberland.

The manufacture of automata — albeit simplified, and often in wood — is finding new markets as part of the fashion for 'retro'. Brian Selznick's 2007 book *The Invention of Hugo Cabret*[69] begins as a graphic novel, and though a huge tome of over five hundred pages with gold binding, is presented as being for children. Yet it is a masterpiece both of storytelling and invention. Martin Scorsese had long wanted to make a children's film, and he chose this for his film *Hugo* which again, though aimed at children, is a thoroughly satisfying entertainment for adults. Though both are fiction, they were in part inspired by the work of pioneering filmmaker Georges Méliès whose mix of science and magic created imagery that still inspires awe in modern audiences. Selznick had been inspired by Gaby Wood's Book *Edison's Eve*[70] which described how Méliès had inherited ten automata from the Jean-Eugene Robert-Houdin, the magician who had restored Vaucanson's duck and whose name had been adopted by the American escapologist. But at the outbreak of World War I, after having cared for them for over three decades, Méliès was bankrupt. He offered the automata to John Neville Maskelyne, another magician, who developed camouflage techniques for Britain's war effort. But Maskelyne wasn't interested, so Méliès donated the automata to the museum that had been established to honour Vaucanson. But they were left in an attic where they were damaged by cold and damp before the roof collapsed and destroyed their remains.

Many fine automata and clocks suffered similar fates. Unless rescued by wealthy patrons, they had little hope for survival. Show

people seldom had stable lives, and if The Microcosm had gone to France in the late eighteenth century, it had survived decades of revolutions, wars and neglect before Ilbert rescued it. Sometime, somewhere, the ornate case of The Microcosm was lost, along with the moving scenes and the many additional astronomical displays to leave the main pendulum-driven mechanism in a simple oak case now living in the British Museum, a creature full of history and secrets she continues to keep to herself.

21

MICROCOSMIC ECHOES

icrocosm is one of those words that, once discovered, seems to appear everywhere, from ancient philosophy to scientific journals. The clock's long history and wide-ranging travels seem to have had a lingering effect on our vocabulary. This is not surprising as Robert Southey claimed Bristolians were still making gingerbread versions of their high cross decades after it was removed to Stourhead, so the public can have a long memory.

Henry Bridges didn't invent the term any more than Desaguliers invented Newton's theories, but he seems to have played an important role in its migration from the vocabulary of natural philosophy into common speech. It has evolved to represent a wide range of things and ideas, suggesting the many elements of the show had become microcosms in their own rights, like scattered seeds that sprouted, but often in curious new forms. About the time of The Microcosm's disappearance the term had come to represent mechanical shows, a cluster of moving figures, museums and printed miscellanea, and a variety show. It often signified objects or displays of the highest standards. Like the older concept of a cabinet of curiosities, it provided a starting point for conversation, inspiration and further research.

R. Pearson clock and watchmaker of Oxford advertised a mechan-

ical exhibition called The Microcosm at his house in 1796 but provided no details.[1] The assemblage of exotica could take human form as in Dublin, where an "elegant Private Entertainment"[2] was attended by the Lord Lieutenant in 1783. It claimed to promote patriotism and liberty in celebration of their grand guest. It was held at the Microcosm Theatre, suggesting the venue's title was inspired by the machine's long sojourns in the capital.

The former cavalry officer Phillip Astley was a talented horseman and endlessly inventive showman both in England and France. He is credited with having invented the modern circus when he set up his amphitheatre near London's Westminster Bridge. It seems his purchase of a Cox piece helped fund this famous long-running institution, the first modern English circus.

Astley was also a forerunner of early twentieth century vaudeville shows. His wife wore a swarm of bees to encourage knowledge of beekeeping. There were tricks of magic and deception, and "other diversions" such as a young lady automaton playing the piano, claimed to be created by magic rather than human mechanics. This seems to have been the work of the Jaquet-Droz family who had arrived from Switzerland to cash in on London's export market. They made a range of exotic clocks and watches similar to those of Cox, so may have helped trigger the crisis in Cox's business by adding to the already glutted market in the capital. It also suggests Cox's success created competition for his museum as more of his works were taken on tour, probably cheaper than his expensive displays.

In 1808 Astley's display of horsemanship introduced a new show, *Microcosm of the Brazils* which enacted the arrival in Rio de Janeiro of the Prince of Portugal,[3] probably an excuse for yet more horsemanship. It seems the previous machinery was too small for such a large venue, but the concept of presenting a compact version of a grand event continued. So here we have an enclosed world of entertainment representing an exotic event, akin to people using telescopes or microscopes to view other worlds.

In 1778 Mr Manuel's Italian company was appearing in Dover with Mr Fawkes's magic tricks, the latter probably a descendant of the early

eighteenth century showmen. They were joined by a new automaton, *Hombres Chinoises*.[4] This may have been purchased from Astley after he settled in London, suggesting the pieces were already being traded within the show community.

In 1808 the acrobat Mr Gyngell included in his show *The Microcosm* which showed over four thousand five hundred figures working at various trades,[5] but four years later he performed in Canterbury with *The Microcosm, or Les Ombres Chinoises* which involved only a hundred moving figures, dialogue and comedy.[6] Was one or both of these the same Astley piece or were the terms interchangeable, or adjusting to current fashions? Like the Astleys, the Gyngells were a multitalented family; they performed balancing acts, magic tricks and music. Given that performances such as equestrian or acrobatic displays probably required some moving of scenery, and perhaps sweeping up after the horses, the automata provided distractions between major acts, similar to the role later played by clowns.

The Chinese automata of Cox thus laid the seeds of more microcosmic automata shows. Nineteenth century entertainments expanded from the single world of The Microcosm to become incorporated into bigger, more varied performances for larger crowds in grander venues.

The Microcosm's final tour was part of a *Museum Exhibition* which provides a link with Cox, but it also blurred the lines between the two terms, which is understandable as his museum had ranged between scientific instruments and fine art, from tiny jewellery to giant automata. Both shows provided extensive publicity material, so the term expanded into the world of print. This concept of providing bite size information continues today in various forms as magazines.

Edward Davies's home was named The Microcosm, so his business was represented by the giant machine, but his advertisements on tour suggest the business was wide-ranging. The building made famous for housing Cox's Museum at Spring Gardens was home to a number of successful entertainments — but especially exhibitions — before it was pulled down in the 1820s. They included *Davies' Grand Museum*; then it became jeweller Charles Wigley's auction or promenade room. In 1763 Boswell attended an exhibition of the *Society of Artists of Great*

Britain there. From the end of the century, for three months each year *The Society of Artists in Watercolours* held their annual exhibition there, the first of which attracted twelve thousand visitors, who paid one shilling admission. The painters spent the rest of the year working, with occasional meetings to paint and discuss art.[7]

One of these artists was John Claude Nattes (c.1765–1839) who had been commissioned by Sir Joseph Banks to depict the buildings of Lincolnshire. He was a friend and publisher of fellow watercolourist W.H. Pyne whose book *Microcosm, A Picturesque Delineation of the Arts, Agriculture, Manufacture &c. of Great Britain, in a series of above a Thousand Groups of Small figures for the Embellishment of Landscape* was published in 1803.[8] This book lives up to its name in portraying a whole world of people at work and rest at the start of the nineteenth century. Pyne was the first artist to show such a variety of ordinary people, often in multiple poses, so suggests not just what they looked like, but how they worked, what tools they used, and how they held them. Images included a family of brickmakers with girls whose arms resembled those of prize fighters. There was a tinker with bellows and forge on the back of his cart, travellers at rest, millwrights and masons at work, all shown with the same precision, depth and sympathy for his subject that Henry had shown with his.

It provided images to inspire and educate painters, and was Pyne's most popular book. It was published at the time of the Great Terror, when Britain feared invasion from across the Channel. By depicting diverse images of Britain's people, it hoped to unite the nation in wartime. France's problems were often blamed on giving too much power — in particular, literacy — to the poor. Pyne's images of hard-working lower class Britons showed their importance to the nation and helped dispel fears that they would copy the French peasants. It is thus very much in the spirit of Henry's masterpiece, pleasing to the eye, encouraging education, emulation and national pride.

Pyne also illustrated *Costume of Great Britain* in 1804. This was part of a widespread interest in microcosms as a genre, with the press carrying advertisements for various compilations, magazines etc. which provided bite-size information on various topics from fashion to

natural curiosities. This also echoes claims by Henry that he was facing competition. This was followed by Rowlandson and Pugin's illustrated *Microcosm of London* published by Rudolph Ackerman, which provides a valuable collection of images of early nineteenth century buildings.

Pyne's Microcosm began a flood of similar publications as European wars blocked access to overseas travel and trade. Britons turned their curiosity inward, to discover how varied were people of their own islands, so became interested in home-grown customs and clothing. His books coincided with the rise of industry and urbanisation triggered by the post-war manpower shortages which signalled the decline and sometimes death of local handcrafts and culture he depicted, so there is a sense of poignancy in these lively images. This followed the pattern of mapmakers who were often commissioned to record areas on the brink of rapid change. But Pyne's images were different to earlier microcosms, as the philosophy driving their collection was in reverse. Rather than discovering unusual objects to classify and understand them, he was confronted with a vast array of people and activities which were threatened by industrialisation with extinction, so it has echoes of earlier practices of preserving images, so was more in the Romantic tradition, or following the practice of early mapmakers.

Another watercolour source is provided by the Thewenetti family from Germany, who advertised microcosms, but it is unclear what these were.

The term seems to have reverted to its original definition when it became popular at the end of the Revolutionary and Napoleonic Wars. It was inspired by soldiers returning with tales of bravery and adventure in exotic locations which established a market for images in easily comprehensible forms.

Similar collections helped unite the nation in its darkest hours, to try and break down rigid class barriers, to urge everyone to contribute to the greater good. During the 1940s this was echoed by a collection of books which was produced by experts in a wide range of fields, such as Rose Macaulay and John Betjeman called *Britain in Pictures*. Like the

Microcosm and its competitors and successors, they were designed to unite the nation, to remind people what they were fighting for. Their very existence is extraordinary given the wartime shortages of paper and ink.

The other significant contemporary sighting of the term was Eton College's first student magazine, published 1786-7 so even closer in time to the clock, which might even have been seen by some of the authors. It included "elegant and witty articles that sniffed at literary criticism, sentimental novels and aristocratic pretensions".[9] It proved so popular the series was published in book form and went through four reprints. The future Prime Minister Charles Canning was the main author under the pseudonym of Gregory Griffin; his prose was highly regarded, especially by George III and Queen Charlotte, so was a good starting point for his career. Yet again, this suggests a link between the clock and education, which has been a continuing theme of the story.

Many of the early automata shows presented current affairs such as real crimes and especially murders, so were early forms of modern news media. In the Potteries Museum at Stoke on Trent is a cabinet displaying famous news items – acts of heroism and of the most heinous crimes which people collected, and which have since become items in antique shops, so paralleling the decline of religious relics.

In the *Gentleman's Magazine* of 1796 was an enquiry: "What became of the Microcosm, carried about through most parts of Europe, and the English America, about 40 years past, by a Mr Bridges?"[10] The reply was "The Microcosm... was exhibited in the West of England in the year 1762. It was then in the possession of a Mr Walker, who took it thence to Ireland." Is this true? Could Walker be another owner of the machine? This claim coincides with publicity which fails to name the owner.

This seems to be another error, but it introduces yet another eighteenth century family of showmen-scientists, beginning with Adam Walker (1731-1821), a Scottish school teacher. In 1766 he bought the apparatus of touring scientist William Griffiss and became a touring lecturer and writer. Griffiss is one of the forgotten greats of science

education. According to Trevor Fawcett in his Science Lecturing in Bath, he: "travelled assiduously, covered all the physical sciences except electricity, and owned a considerable quantity of apparatus". He charged a guinea each for at least thirty subscribers. His course of ten lectures in December 1755 was held at Wiltshire's Assembly Rooms.[11]

Like The Microcosm, Walker toured Scotland and Ireland and in 1777 obtained the astronomical equipment of yet another itinerant scientist, his friend James Ferguson. He was so successful he was living in George Street, Hanover Square, in London, one of the capital's premier addresses.

His main claim to fame was as the inventor of the *Eidouranion*, a magic lantern show demonstrating the latest advances in astronomy. He patented the Coelestina, a mechanical harpsichord so he was also interested in mechanical music thus both his show and his interests were similar to those of Henry. He must be the Walker mentioned, and it is possible he added The Microcosm to his collection of equipment. But he didn't need it, and it is unlikely he would have failed to advertise this acquisition. Unlike Henry, he is known to have toured the continent, in 1790, so this also fits with rumours that The Microcosm had toured there. But Walker was a public figure: a lecturer at major public schools including Eton, and his book *Epitome of Astronomy* of 1782 was still in print in 1824.[12]

If he had been the owner of The Microcosm, some record of it should have survived, so this comment from the Gentleman's Magazine suggests some confusion over time.

The sighting of The Microcosm in the diaries of Thomas Turner and Thomas Tye suggests there may still be sources of information to be found, especially if written by men called Thomas. The Microcosm's description as a machine or a piece of art do not always make it clear what the beast was, and editors may well have ignored them, so traces may have been lost from the original sources.

The philosophy at the core of The Microcosm, of education, enlightenment and entertainment, is echoed in the BBC, and in

demands for it to remain in public ownership to ensure its independence and reliability.

The pamphlet, *A succinct description...* may also have fed into contemporary language, as Boswell wrote in of how he proposed to add *A succinct account* of his expenses to the end of his journal,[13] which coincided with the earliest editions of Davies' pamphlet.

This Microcosmic story continues to have resonance for us still. The excitement and wonder that inspired Henry to build it, the inspiration he provided for others to invent, compose or create are widely described now as childlike. But it is largely this sense of wonder which gave birth to — and for decades drove — the Enlightenment and the Industrial Age. The openness of learning in the Augustan period when people shared a wide range of skills and interests has been widely replaced by narrow, tightly controlled curricula in modern education. The Augustan concept that all things were related, that scientists could be artists, or astronomers become musicians, highlights the need in all of us to have a varied intellectual diet for healthy minds, just as we need a varied diet of food and exercise for healthy bodies.

Henry must have been a man of great extremes, a patient clockmaker, an extroverted showman, which suggests he may have been subject to wide mood swings. Or he may have been a man in balance, like a pendulum in his clock. More likely he was very much a man of his age, who did what he had to in order to survive, to develop skills and confidence in order to follow his trade, to follow his dreams, but most importantly, his passion for learning.

APPENDIX I MICROCOSM POEM

Descriptio Micro-cosmi, translated by David Miller
Description of the Miniature World
To
Henry Bridges
The Glory and Stupefaction of craftsmen

O thou, Bridges, to whom at thy birth Nature, with a smile, disclosed the devices of Daedalus' skill — thou whom alone that goddess has allowed to imitate her doings so closely, with impunity — Attend! Grant that they retinue, the Muses, may be kind to my verse, and that I may depict each detail in its place as I rehearse the sights of thy renowned Microcosm.

There stands a noble house of excellent art, despite its diminutive frontage. It rises to the fourth storey, supported on various columns, picked out by their maker with many a gilt design. There, the panelled ceilings of the uppermost floor of the house are decorated with every kind of musical instrument, close-packed, making a crown for this fine work; to the beholder, it seems to be the Pigmies' palace, or the far-famed hall which was Lilliput's boast.

The front of the house displays the planets, gliding in their eternal

motions round the sun, their centre; and the moon, with no light of her own. Next follows the way in which the revolving year repeats itself, and the laws which the huge spheres must obey to avoid collision and disintegration; vast, on his own axis, turns Phoebus, and illuminates them all.

Above this (for the Peaks of Parnassus' summit surmount the regions of he air; from here the few whom God impels with pure inspiration, and enriches with the honour of the lure, look down upon the lowlands and the feeble throng) is revealed the lovely, lovely home of the Aonian[1] maidens. But what a novelty! What a sight! What sweet pleasure draws the astonished senses! What concordant harmony of voices, making the house resound, soothes the ears! Here the chaste Sisters indulge in their customary dances: one, like a goddess in the splendour of her dress and face, plays music with her hands, another with an ivory plectrum; one sings, another's foot taps the dancing-floor to the time. To the left, with outspread wings, is set the Wand-bearer[2]; to the right stands Fame, the Muses' companion; over them flies Pegasus, unbridled, round the mountain steeps, his hoof scarcely brushing their crests— riderless[3], now that the harsh Fates have seized his master, Pope.

Next opens up a second wonderful scene in this tiny theatre. We have seen, and can hear, Orpheus drawing forests and wild beasts to him; rocks of vast mass are set in motion; the forest bows its branches in silence, and the camel its lofty neck; to his strains the tigress, less fearsome now, sheds her stripes, and the hare stands fearless, ears pricked. So great is the power in the sounds, so strong the attraction of the music.

Yet, as men's fickle minds chase new delights, and earth-born creatures enjoy earthly things, here to delight their attention if flowery Spring, with the pleasures that the Microcosm forever boasts. At Spring's approach, the speedy swallow, awakening from her six-months' slumber[4], leaves her hollows and skims the pastureland. Insects come to life and give their greeting, aware of what is to come, and the cuckoo accompanies them with its single, ever-repeated call.

The cattle rejoice; the birds bethink them of nesting, as the genial warmth invites them to tender love.

Nor is there lacking, to dwell in this land, the hardy race of Men. With modelled bodies imitating live movements, they represent the manifold occupations and skills of humankind. See how cautious is the driver as his chariot teeters on the uphill track, then how he stands with slackened rein, then leans forward with the speed of his wheels as they fly downhill! Over here is a river gliding quietly along, with swans to set it off; then it rises, turning white as the rocks make it foam; and, far out to sea, ocean-going ships are to be seen, their sails bellying out as if set to a following wind. In short, we looked, rooted to the spot, at every sight earth has to show, and every delight contained in sky or sea, depicted in lifelike tableaux; and it was hard to tell whether it is Phidias' or Apelles' skill[5] that the maker has outdone.

To round off the play (for what else but a theatre can this ring of land and water be called?) there comes into view a timberyard with little workmen, each holding the tools of his trade. Each had his place, and his footrule. One is wearying a balk of wood — and his arms! — with a mallet; another is sharpening a chisel, with a mimic smile upon his modelled face; here a beam is being bitten into by a saw, there one groans under the axe. Just like this, if one may compare small things with great[6], is the din as the dockyard seethes with all kinds of industry, when the King's wrath is preparing a fearsome fleet and rapidly equipping armaments, and the men of Britain are pressing on with the joyful task, envisaging chains for the French or Spanish.

Notes

1 Aonian = Boetian; Mount Helicon, the Muses' home, is in Boeotia.

2 Mercury

3 The winged horse Pegasus is associated with the Muses; their spring Hippocrene ("Horse-fount") welled up at the touch of Pegasus' hoof. Alexander Pope died in 1744; this sentence, in referring to his death, refers also to a couplet from his *Essay on Criticism* (Part 1, lines 86-7):

The winged courser, like a gen'rous horse,
Shows most true mettle when you check his course.

Thus the compliment is paid to Pope that, now he is dead, there is no-one o exercise such control over Pegasus, the patron horse of the Muses, and so to write such disciplined verse as his.

4 This author, who writes extremely elegant Latin verse, is evidently more of a classicist than a naturalist. From Pliny, *Natural History* Book X chapter 35, he has read that the swallow migrates for its six-month absence only "to palaces near at hand, making for the sunny gulleys in the mountains" (tr. H. Rackham, Loeb edition vol. 3 p.337); and he has taken Pliny to mean that they hibernate there.

5 Famous sculptor and famous painter, respectively.

6 The Latin is a neat combination of lines from Virgil *Eclogue*1 23 'sic parvis componere magna solebam' and Ovid *Tristia* 1, 3,5 'si licet exemplis in parvis grandibus uti'.

Apart from vagaries of punctuation, there are four misprints in the Latin text, all on the second page:

Paragraph 3, first word: for Ad read At

Paragraph 4, fourth from last line: for sit qui read si quid [Deniq; here, and Quaeq; six lines from foot of previous page, are recognised abbreviations for denique and quaeque.]

Final line: for servet read fervet.

APPENDIX II NOTES

Introduction

1 Jahnke, J., i paper 15 October, 2016

2 pp. 697–8, Room, A., revised *Brewer's Dictionary of Phrase and Fable,* 15th Edition, Cassel, London, 1996

3 p. xxvii, Jennings, G.H., Ed., *Thomas Turner, Diary of a Georgian Shopkeeper,,* 2nd edition, Oxford University Press, Oxford, 1979

Ch. 1 A Succinct Description of The Microcosm

1 pp. 336–7, Symonds, R.W., *A Picture Machine of the Eighteenth Century,* Country Life, August 25, 1944

2 Handbill, Henry Bridges' Microcosm, Westminster Archives, Harvard Theatre Collection

3 p. 12, Farmer, J., *The History of Waltham Abbey,* 1735

4 p. 122, Winters, W., *The Royal Gunpowder Works,* Waltham Abbey, 1887

5 Davies, E., *A succinct description of that elaborate and matchless pile of art, called the microcosm with a short account of the solar system: interspersed with poetical sentiments on the Planets,* The twelfth edition, with addition, London, 1773

6 p. 224, Haag, S., Kirchweger, F., Ed., *Treasures of the Habsburgs,* Thames & Hudson, UK, 2013

7 p. 142, Wood, E.J., *Curiosities of Clocks and Watches; From the Earliest Times*, Richard Bentley, London, 1866

8 *The Daily Advertiser*, 23 December 1741`

9 *The General Advertiser*, 5 April 1750

10 Milburne, J.R., *The Meandering Microcosm: A Chronological Account of the Travels of this "Matchless Pile of Art" in England, Scotland, Ireland and America, 1733–1775*, Aylesbury, 1995

11 p. 142, Wood, E.J.

12 *The New York Mercury* 25 December 1755 cited in p. 946 Musical Box Society International, Silver Anniversary Edition

13 p. 23, Davies, E.

14 pp. 122–3, Farmer, J.

15 p. 123, Farmer , J.

16 ditto

17 ditto

18 *The New York Mercury, 25 December 1755*

19 p. 123, Farmer, J.

20 p. 97, Kemp, M., *Art in History 600 BC–2000 A.D.*, Profile Books, London, 2014

21 bathartandarchitecture.blogspot.co.uk/2017/09/charles-clay-clocks.html

22 Edgeworth, R.L. & M., *Memoirs of R.L. Edgeworth*, vol. 1, London, 1820

23 p. 46, Caldwell, M., *New York Night: The Mystique and its History*, Simon & Schuster, New York, 2005

24 p. 56, Mauriès, P., *Cabinets of Curiosities*, Thames & Hudson, London, 2013

Ch. 2 The World Before the Little World

1 pp. 17–18, Duffy, E, *The Stripping of the Altars: Traditional Religion in England 1400–1580*, Yale University Press, New Haven, 1992

2 p. 6, Barber, T., Boldrick, S., Ed., *Art Under Attack: Histories of British Iconoclasm*, Tate Publishing, London, 2013

3 p. 114, Pevsner, N., *The Englishness of English Art, BBC Reith Lectures*, The Architectural Press, London, 1956

4 p. 8, Baker, M., *Fame & Friendship: Pope, Roubiliac and The Portrait Bust*, The Rothschild Foundation, 2014

5 p. 18, Barber, T.

6 p. 41, Hutton, E., *Highways & Byways in Somerset*, Macmillan, London, 1923

7 p. 35, Carpenter, A.T., *John Theophilus Desaguliers, A Natural Philosopher, Engineer and Freemason in Newtonian England*, Continuum, London, 2011

8 p. 180, Duffy, D.

9 p. 13, Quennell, P., *James Boswell, in Four Portraits: Studies of the Eighteenth Century*, The Reprint Society, London, 1947

10 pp. 72-4, Baring-Gould, S., *Devonshire Folklore and Strange Events*, John Lane, London, 1908

11 p. xvii, Jennings, G.H., ed., *Thomas Turner: Diary of a Georgian Shopkeeper*, Oxford University Press, Oxford, 1979

12 p. 125, Ketton-Cremer, C.W., *Felbrigg: The Story of a House*, Futura, London, 1982

13 p. viii, Grey Graham, H., *The Social Life of Scotland in the Eighteenth Century*, A & C Black, London 1937

14 p.3, Fry, R., *Georgian Art (1760–1820)*, Burlington Magazine Monograph III', B. T. Batsford, London 1929

15 p. 37 Carpenter, A.

16 p. 72 ditto

17 Knight, D., Wright, Thomas (1711–1786) Oxford Dictionary of National Biography, www.oxforddnb.com/view/printable/30060 4/5/2017

18 p. v, Gibbs, L., Ed., *Sir Richard Steele: The Tatler*, J.M. Dent & Sons Ltd, London, 1953

Ch. 3 Other Worlds

1 Acton, E. de, *By the Author of the Microcosm*, Staffordshire Advertiser 5 December 1801

2 p. 34, Sale, K., *The Conquest of Paradise: Christopher Columbus and the Columbian Legacy*, Penguin Books, Middlesex, 1991

3 p. 174, Latimer, J., *The Annals of Bristol in the Eighteenth Century*, Georges, Bristol, 1970

4 p. 37, Carpenter, A.T. *John Theophilus Desaguliers: A Natural Philosopher, Engineer and Freemason in Newtonian England*, Continuum, London, 2011

5 V&A display notes

6 p. 129, Williams, C., Trans, *Thomas Platter's Travels in England 1599*, Jonathan Cape, London, 1937

7 Hey, D., Ed., Gough, R., *The History of Myddle*, Penguin Books London, 1981

Ch. 4 What Was Henry Thinking?

1 *The Daily Post*, London 11 November, 1736

2 p. 218, Ord-Hume, A. W. J. G., *The Musical Clock: Music and Automaton Clocks and Watches*, Hume Mayfield Books, Ashburne UK, 1995

3 pp. 393–4, Pierre Du Bois, *Histoire de l'Hologue*, Paris, 1849

4 *Courte Description de L'incomparable Assemblage D'Arts Appellé Le Microcosme, Avec un Abrégé du Systéme Solaire, & de ceix des Planètes*. Traduit de l'Aglois par L. Bridoux, A Lille, De l'Imprimeneriede de P.S. Lalau, l'Hotel de Ville

5 pp. 105–6, *The Horological Journal*, March 1804

6 *The Daily Post* London, 17 August 1736

7 *The Weekly Journal*, 8 May 1736 in *BIOS Reporter*, Jan 1997, Vol. XXI, No 2

8 p. 5, Antick, R.D., *The Shows of London*, Harvard University Press, Cambridge, USA, 1978

9 p. 46, Carpenter, A., *John Theophilus Desaguliers: A Natural Philosopher, Engineer and Freemason in Newtonian England*, Continuum, London, 2011.

10 p. 9, Fry, R., *Georgian Art (1760–1820)* in *Burlington Magazine* Monograph III B.T. Batsford London 1929

11 p. 10, Turner, W.J., *English Music*, William Collins, London, 1945

12 royal collection www.royalcollection.org.uk 10/07/2006

13 p. 671, O'Malley, E.W. ed., *The Jesuits II: Cultures, Sciences and The Arts, 1540–1773*, University of Toronto Press, Toronto, 2006

14 ditto

15 pp. 78–9, Wood, E.J., *Curiosities of Clocks and Watches; From the Earliest Times*, 1866

16 p. 54, Fleet, S., *Clocks: Pleasures and Treasures*, Weidenfeld and Nicolson, London, 1961

17 p. 41, MacLean, G., *The Rise of Oriental Travel:, English Visitors to the Ottoman Empire; 1580–1720*, Palgrave, London 2004

18 p. 282, Ord-Hume, W.J.G.

19 *The Gentleman's Magazine*, December 1766 in p. 351, Le Corbeiller, C., *James Cox: A Biographical Review*, Burlington Magazine May 112 (1970)

20 p. 191, Vincent, C., Leopold, J.H., Sullivan, E., *European Clocks & Watches in the Metropolitan Museum*, Yale University Press, Princeton, 2015

21 p. 780, Gardiner, J., Ed., *The History Today Who's Who in British History*, Collins & Brown, London, 2000

22 p. 16, Calè, L., *Fuseli's Milton Gallery: Turning Readers into Spectators*, Oxford English Monographs, Clarendon Press, Oxford, 2006

23 p. 13, Pevsner, N., *The Englishness of English Art*, The BBC Reith Lectures 1955, The Architecture Press London, 1956

24 pp. 15–16, Davies, E.

25 p. 149, Pevsner, N.

26 p. 27, Pevsner, N.

27 p. 17, Calè, L.

28 p. 401, Duffy, E., *The Stripping of the Altars: Traditional Religion in England 1400-1580*, Yale University Press, London, 1992

29 p. 413, ditto

30 p. 6, Calè, L.

31 p.35, do

32 p. 24, Pevsner, N.

33 p. 150, ditto

34 p. 145, ditto

35 p. 152, ditto.

36 p. 1, Calè, L.

37 p. 32, do

38 James Ensor, Display Notes, Royal Academy Exhibition, London 2016/7

Ch. 5 The Bridges of Waltham Abbey

1 p. 13, Pevsner, N., *The Buildings of England: Essex*, Penguin Books, London, 1954

2 Chamberlain, J.S., Keith, George (1638?–1716) Oxford Dictionary of National Biography oxforddnb.com/....15264

3 Patterson, W.B., Fuller, Thomas (1607/8 – 1661) Oxford Dictionary of National Biography oxforddnb.com/.... 10236

4 Farmer, J., *The History of Waltham Abbey*, 1735

5 p. 77, Winters, W., *Our Parish Registers*, W. Winters, Waltham Abbey, 1885

6 Larminie, V., *Saussure, Cesare-François de (1705–1783)*' oxforddnb.com... 53267 2017

7 p. 212, Markham S., *John Loveday of Caversham 1711–1789: The Life and Tours of an Eighteenth-Century Onlooker*, Michael Russell, Salisbury, 1984

8 p. 71, O'Toole, F., *Traitor's Kiss: The Life of Richard Brinsley Sheridan*, Granta Books, London, 1998

9 British History online www.british-history.ac.uk/vch/essex/vol5/pp151

10 Doggett, N., *Denny, Sir Edward (1547–1600)* oxforddnb.com/...63292 2017

11 www.coppedhalltrust.org.uk 2017

12 Title to High Bridge St, Essex Record Office

13 p. 21, Pottle, F.A., Ed., *Boswell's London Journal 1762–3* The Reprint Society, London, 1950

14 *The Daily Post*, 17 February 1737

15 p. 80, Winters, W., *Our Parish Registers*, W. Winters, Waltham Abbey, 1885

16 Last Will and Testament of Henry Bridges, Gentleman of Waltham Holy Cross, Essex, proven 18 July 1754, Probate 11/809/1371 Public Record Office Wills Online

17 pp. 79–80, Winters, W., *Our Parish Registers*

18 *Waltham Abbey Parish Magazine*, September 1913

19 pp. 54–5, Ketton-Cremer, R.W., *Felbrigg: The Story of a House*, Futura, London, 1982

20 Drummond, B., *Death and the Bridge: The Georgian Rebuilding of Bristol Bridge*, Barb Drummond, Bristol, New Edition, Bristol, 2007

21 Last Will and Testament of Sarah Bridges, Spinster of Waltham Holy Cross, Essex, proven 13 May 1760, Probate 11/855/399, Public Record Office, Wills Online

22 Fairclough, K.R., Walton [nee Bourchier] Philippa (1674–1749), Oxford Dictionary of National Biography oxforddnb.com/.... 48262 2017

23 p. 138, Wilson, V., *[london] houses: a handbook for visitors*, B.T. Batsford, London, 2002

24 p. 403, Oliver, V. L., *The History of the Island of Antigua One of the Leeward Caribees in the West Indies from the First Settlement in 1635 to the Present Time*, Mitchell & Hughes, London, 1894

25 pp. 409–10, ditto

26 p. cix, ditto

27 Title re Falcon 1756–93 written 1853 (Essex Record Office ERO D/DJg B107 Abstract of title of Joseph Jessop Esq. 4 Dec 1756

28 p. ix, Oliver, V.L.

29 p. 83, ditto

30 p. 82, ditto

31 p. 83, ditto

32 p. 50, ditto

33 p. 82, ditto

34 p. 84, ditto

35 p. 117, Oliver, V.L., ed., *Caribbeana, being miscellaneous papers relating to the history, genealogy, topography, and antiquities of the British West Indies*, Mitchell, Hughes and Clarke, London, 1910–1919

36 *Edward Austen Knight*, https://en.wikipedia.org/wiki/Edward-Austen-Knight

Ch.6 Waltham Abbey Gunpowder Works

1 p. 221, Buchanan. B.J., *Waltham Abbey Royal Gunpowder Mills: 'The Old Establishment'*, Transactions of the Newcomen Society, Vol 70:1 (1998)

2 *The Kirk of the Greyfriars Edinburgh, A Brief Guide for Visitors*

3 *The Diary of William Dyer*, manuscript, Central Bristol Library

4 p. 77, Winters, W., *Our Parish Registers: Waltham Holy Cross*, 1885

5 Royal Gunpowder Factory Waltham Abbey www.eppingforestdc.gov.uk/residents/your-conservation-area...

6 Farmer, J., *The History of Waltham Abbey*, 1735

7 Fairclough, K.R., *Walton [nee Bourchier], Philippa (1674-1749)* oxforddnb/.../ 48262 2017

8 p. 223, Buchanan, B.J.

9 p. 26, Woolrich, A.P. *Mechanical Arts & Merchandise: Industrial Espionage and Travellers' Accounts as A Source for Technical Historians*, De Archaeologische Pers, Netherlands

10 p. 48, French, A., *J.J. Merlin The Ingenious Mechanic'* Iveagh Bequest, G.L.C., London 1985

11 p. 125, Farmer, J.

12 p. 22, Winters, W., *Royal Gunpowder Works*, 1887

13 p. 7, Baker, M., *Fame & Friendship: Pope, Roubiliac and the Portrait Bust*, The Rothschild Foundation, 2014

14 Patterson, W.B. *Fuller, Thomas (1607/8–1661)* oxforddnb/.../ 10236

15 p. 68, Adams, M., *The Prometheans: John Martin and the Generation that Stole the Future*, Quercus, London, 2009

16 *Felix Farley's Bristol Journal*, 26 September 1761

17 p. 211, Terpak,F., *Free Time, Free Spirit: Popular Entertainments in Gainsborough's Era*, Huntington Library Quarterly, June 2007 Vol 70 no. 2

18 p. 213, ditto

19 p. 218, ditto

20 p. 219, ditto

Ch. 7 The Most Puissant James Brydges, Duke of Chandos

1 Johnson, J., *Brydges, James First Duke of Chandos (1674–1746)* oxforddnb.com/view/article3806.... 2017

2 p. 116, Gardiner, J., *The History Today Who's Who In British History*, Collins & Brown, London, 2000

3 p. 88, Sykes, C. S., *Private Palaces : Life in the Great London Houses*, Chatto & Windus, London, 1985

4 Norwich, J.J., *Architecture of Southern England*, Macmillan, UK, 1985

5 www.dukesofbuckingham.org/people/family/brydges/dukes_of_chandos.htm 11/07/2006

6 p. 77, Thompson, W., *Illustrated Lives of the Great Composers : Handel*, Omnibus Press, UK, 1994

7 p. 254, Girouard, M., Life in the English Country House: A Social and Architectural History, Penguin 1980

8 Lubbock, J., *Tyranny of Taste – Politics of Architecture in Design in Britain 1550–1960*, Yale University Press, New Haven, 1995

9 Johnson, J.,

10 ditto

11 p. 81, Burrows, D., *Handel – Master Musicians*, OUP, Oxford, 1994

12 p. 25, Gardiner

13 Ross, A., *Arbuthnot, John (bapt. 1667 d. 1735)* oxforddnb.com/view/article/610 2017

14 ditto

15 p. 81, Burrows, D.

16 p. 349, Gardiner, J.

17 Schaffer, S., Enlightened *Automata,* in Clark, W., Golinski, J., & Schaffer, S., Ed., *The Sciences in Enlightened Europe,* University of Chicago Press, Chicago, 1999

18 Colvin, C.E., *Edgeworth, Richard Lovell (1744–1817)* oxforddnb.com/view/article 8478

19 p. 329, Cross, M., Ewen, D., *Encyclopaedia of the Great Composers and their Music*, Doubleday & Co., New York, 1962

20 Tyler, D., *Gainsborough, Humphrey (bapt. 1718, d. 1776) Independent Minister and Engineer,* Oxford Dictionary of National Biography, www.oxforddnb.com/..../77225 4/4/2017

21 p. 18, Carpenter, A.T., *John Theophilus Desaguliers: A Natural Philosopher Engineer and Freemason in Newtonian England,* Continuum, London, 2011

22 p. 52, French, A., *J.J. Merlin: The Ingenious Mechanic*, Iveagh Bequest, G.L.C., London, 1985

23 p. 543, Knowles, E., Ed. *The Oxford Dictionary of Quotations*, Oxford University Press, 1999

Ch. 8 Desagulliers The Polymath

1 Fara, P., Desaguliers, John Theophilus, (1683–1744) oxforddnb/view/article/7539

2 Carpenter, A.T., *John Theophilus Desaguliers: A Natural Philosopher, Engineer and Freemason in Newtonian England*, Continuum, London, 2011

3 Hart Hall online (website vanished)

4 p. 863, Gardiner, J., Ed., *The History Today Who's Who in British History*, Collins & Brown, London, 2009

5 Aston, M., *Lollards and Reformers: Images and Literacy in Late Mediaeval Religion*, Hambledon Press, U.S.A., 1985

6 pp. 62–3, Stroud, J.E., *The Knights Templar And The Protestant Reformation: A Case For A Modern Day Monk*, Xulon Press, U.S.A., 2011

7 p. 353, Ducheyne, S., *The Times and Life of John Th. Desaguliers (1683–1744): Newtonian and Freemason*, Revue Belge de Philologie et d'Histoire/Belgisch Tijdscrhift voor Filologie en Geschiedenis, 87, 2009

8 Beech, M., *The Mechanics and Origin of Cometaria*, Journal of Astronomical History and Heritage 5(2) 155–163, 2002

9 Fara, P.

10 p. 50, Jeremiah, D.J., *Shakespeare's Island: St. Helena and the Tempest*, David J. Jeremiah, 2015

11 p. 57, ditto

12 p. 76, ditto

13 Buchanan, B., *Bath's Forgotten Gunpowder History: The Powder Mills at Woolley in the Eighteenth Century*, p. 73, Bath History Vol. X, Millstream Books, Bath, 2005

14 p. 37, Carpenter, A.T.

15 *Fires Improv'd: Being A New Method Of Building Chimneys, So As To Prevent Their Smocking In Which A Small Fire Shall Warm A Room*, 1715

16 Fay, B., *Learned Societies in Europe and America in The Eighteenth Century*, American History Review, 1932

17 pp. 127–34 Pearn, J., *Two Early Dynamometers: A Historical Account of the Earliest Measurements to Study Muscular Stretching*, Journal of Neurological Sciences vol. 37 June 1978

18 Desaguliers, J.T., trans., *An Account of the Mechanism of an Automata, or Image Playing on the German Flute; as was Presented in a Memoire to the Gentlemen of the Royal Academy of Sciences, Paris, by Jacques de Vaucanson*, 1742

19 p. 198, Carpenter, A.T.

20 p. 133, ditto

21 Mackay's Encyclopaedia of Freemasonry in www.masonicdictionary.com

22 p. 133, Carpenter, A.T.

23 p. 42, ditto

24 www.masonicinfo.com/famous.htm

25 p. 84, Walker, R.J.B., *Old Westminster Bridge: The Bridge of Fools*, David and Charles, London, 1979

26 p. 85, ditto

27 ditto

28 Drummond, B., *Death and the Bridge: The Georgian Rebuilding of Bristol Bridge*, New Edition, Bristol, 2007

29 Stephens, H.M., *Desaguliers, Thomas, (1721–1780)* oxforddnb.org/article/view/7540

Ch. 9 Inspiration and Precursors

1 pp. 136–7, Duffy, E., *The Stripping of the Altars: Traditional Religion in England 1400–1580*, Yale University Press, New Haven, 1992

2 p. 7, Cressy, D., *Bonfires & Bells: National Memory and the Protestant Calendar in Elizabethan and Stuart England*, Sutton, Stroud, 2004

3 p. 44, ditto

4 p. 46, ditto

5 p. 96, Duffy, E.

6 p. 17, Barber, T., Boldrick, S., Eds. *Art Under Attack: Histories of British Iconoclasm*, Tate, London, 2014

7 p. 19, do

8 pp. 264–6, King, E., *Perpetual Devotion: A Sixteenth Century Machine that Prays in Riskin, J., ed, Genesis Redux: Essays on the History and Philos-

ophy of Artificial Life, Chicago Scholarship Online chicago.universitypress.scholarship.com/view/10.7208/chicago/

9 p. 33, Ullyett, K., *British Clocks and Clockmakers*, Collins, London, 1942

10 p. 41, do

11 p. 48, French, A., *J.J. Merlin the Ingenious Mechanic*, Iveagh Bequest, G.L.C., 1985

12 pp. 313/4, King

13 p. 326, Wood, E.J., *Curiosities of Clocks and Watches from the Earliest Times*, Richard Bentley, London, 1866

14 p. 56, Antick, R.D., *The Shows of London*, Harvard University Press, Cambridge USA, 1978

15 p. 211, Terpak, F., *Free Time, Free Spirit: Popular Entertainments in Gainsborough's Era*, Huntington Library Quarterly, June 2007, Vo 70 no. 2

16 ditto

17 p. 50, Antick, R D

18 p. 63, Antick, R D

19 p. 58, Antick, R D

20 Friehs, J.T., *Theatrum Mundi: The Whole World Contained in a Single Chamber* www.habsburger.net/en/chapter/theatrum-mundi-whole-world-contained-single-chamber 8/30/2016

21 bathartandarchitecture.blogspot.co.uk/2017/09/charles-clay-clocks.html

22 p. 60, Antick, R.D.

23 Perez, L., *Of The Beauty which the Appearance of Utility Bestows upon all the Production of Art – Adam Smith* in Bensaude-Vincent, B., Blondel, C., eds., *Science and Spectacle in the European Enlightenment*, Ashgate Publishing, Aldershot UK, 2008

24 p. 12, Benington, J, *Victoria Art Gallery Highlights*, Victoria Art Gallery, Bath

25 pp. 2–3, Thompson, E.P., *Whigs & Hunters: the Origin of the Black Act*, Breviary Stuff, London, 2013

26 bathartandarchitecture.blogspot.co.uk/2017/09/charles-clay-clocks.html

27 www/visitcambridge.org/things-to-do/ely-cathedral

28 V&A masterpiece clock display notes

29 p. 124, Farmer, J., *The History of Waltham Abbey*, 1735

30 Jennings, M.L. & Madge, C., Ed, *Jennings, H., Pandaemonium 1660–1886: The Coming of the Machine Age as seen by Contemporary Observers*, Icon Books, London, 2012

31 p 273, Glennie, N., Thrift, N., *Shaping the Day: A History of Timekeeping in England and Wales 1300–1800*, Oxford University Press, Oxford, 2011

32 p. 34, Nocks, L., *The Robot: The Life Story of a Technology*, John Hopkins University Press, Baltimore, 2008

Ch. 10 Puffing and Promoting the Show

1 John R Milburne, *The Meandering Microcosm.: A Chronological Account of the Travels of this "Matchless Pile of Art" in England, Scotland, Ireland and America 1733–1775*, Aylesbury, UK, 1995

2 p. 353, Roger Smith, *James Cox (c.1723–1800): A Revised Biography*, Burlington Magazine, 141 (2000)

3 *The Whitehall Evening Post & London Intelligencer*, 4 January 1750

4 *The York Courant* in p5 David Paton –Williams, *Katterfelto, Prince of Puff*, Matador, Leicester, 2008

5 *George Faulkener & The Dublin Journal*, April 19 1746

6 *The London Advertiser & Literary Gazette*, 30 March 1751

7 p. 16, Jeremiah, D.J., *Shakespeare's Island, St Helena and the Tempest*, David J Jeremiah, UK, 2015

8 *The Public Advertiser*, 23 January 1759

9 ditto, 31 January 1759

10 ditto, 16 February 1759

11 *The Gazeteer & London Daily Advertiser*, 3 May 1759

12 *Felix Farley's Bristol Journal*, 2 May 1761

13 Marchioness de Lambert www.iep.utm/edu/lambert...

14 –17 p.15–6, Davies, E.

18 p. 5, Paton –Williams, D.

19 p. 10, footnote, Davies, E.

20 p. 13, ditto

21 p. 56, Antick, R.D., *The Shows of London*, Harvard University Press, Cambridge, USA, 1978

22 White, R., *Ware, Isaac (bapt. 1704, d. 1760)* oxforddnb.co,/view/10.1093

23 p. 100, Gardiner, J., Ed. *The History Today Who's Who in British History*, Collins & Brown, London, 2009

24 p. 1, Kahan, G., *George Alexander Stevens & The Lecture on Heads*, The University of Georgia Press, Athens, 2008

25 p. 14, Meynell, F., *English Printed Books*, Collins, London, 1946

26 *The Oxford Journal*, 1 November 1755

27 ditto 3 January 1756

28 ditto 5 March 1758

29 Drummond, B., *Death and the Bridge: The Georgian Rebuilding of Bristol Bridge*, New Edition, Bristol, 2007

30 pp. 214–5, Foyle, A., *Bristol*, Pevsner Architectural Guides, Yale University Press, New Haven, 2004

Ch. 11 To the Curious

1 p. iv, Davies, E., *A succinct description of that elaborate and matchless pile of art, called the microcosm with a short account of the solar system: interspersed with poetical sentiments on the planets*, 12th edition, London, 1773

2 p. 7, Mauriès, P., *Cabinets of Curiosities*, Thames & Hudson, London, 2013

3 p. 82, Pevsner, N., *The Englishness of English Art*, 1955 BBC Reith Lectures, The Architectural Press, London, 1956

4 Lienhard, J.H., *Engines of Ingenuity* No.123 *The Black Death*, www.uh.edu/engines/eo123.htm

5 pp. 52–6, Martin, G., trans., Calvino, I., *Italian Folk Tales*, Penguin, London, 1982

6 p. 27, Kemp, M., *Art in History*, Profile Books, London, 2014

7 Aubrey, J., in Keble Chatterton, E., *English Seamen and the Colonization of America*, Arrowsmith, London, 1930

8 p. 262, Hibbert, C., *The Rise and Fall of the House of Medici*, The Folio Society, London, 1998

9 p. 16, Haag, S., Kirchweger, F., Ed., *Treasures of the Habsburgs*, Thames & Hudson, UK, 2013

10 p. 17, ditto

11 Friehs, J.T., *The Kunst- und Wunderkammer of Emperor Rudolph '* www.habsburger.net/en/chapter/kunst-und-wonderkammer-emperor-rudolf 8/30/2016

12 V&A Exhibition Notes, Europe 1660–1815

13 p. 16, Trevor-Roper, H., *The Plunder of the Arts in the Seventeenth Century*, Thames & Hudson, London, 1970

14 p. 6, Jessup, M., Ed, *Snowshill Manor Gloucestershire*, National Trust, Swindon, 2006

15 p. 10, ditto

16 pp. 7–14, Pasierbska, H., *Dolls' Houses from the V&A Museum of Childhood*, V&A Publications, London, 2015

17 p. 147, Brock, C., *The Comet Sweeper: Caroline Herschel's Astronomical Ambition*, Icon Books, Cambridge, 2007

18 p. 186, Grey Graham, H., *The Social Life of Scotland in the Eighteenth Century*, A. & C. Black, London, 1937

19 Blamire, S., *I've Gotten a Rock, I've Gotten a Reel' (c.1790)*, in p. 121, Knowles, E., Ed., *The Oxford Book of Quotations* 5th Edition, Oxford University Press, Oxford, 199

20 p. 2, Delbourgo, J., *Slavery in the Cabinet of Curiosities: Hans Sloane's Atlantic World*, britishmuseum.org/pdf/delbourgo?20essay.pdf

21 p. 181, Benedict, B.M., *Curiosity: A Cultural History of Early Modern Inquiry*, University of Chicago Press, Chicago, 2001

22 p. 731, Gardiner, J., Ed. The *History Today Who's Who in British History*, Collins & Brown, London, 2009

23 p. 181, Benedict, B.M.

24 p. 3, Winterbottom, M., *Secret Splendour: The Hidden World of Baroque Cabinets* The Holburne Museum, Bath, 2013

25 p. 56, Mauriès, P

26 p. 252, Haag, S.

27 p. 188, Benedict, B.M.

28 V&A exhibition notes, Europe 1660–1815

29 Amber Room en.m.wikipedia.org

30 p. 151, Ketton-Cremer, R.W., *Felbrigg: the Story of a House*, Futura, London, 1982

31 pp. 41–2, Benedict, B.M.
32 p. 252, Haag, S.
33 p. 47, Gardiner, J.
34 p. 447, Bray, W., Ed., *The Diary of John Evelyn Esquire F.R.S.*, George Newnes, London
35 www.monticello.org/site/jefferson/indian-hall
36 p. 164, Duffy, E., *The Stripping of the Altars: Traditional Religion in England 1400–1580*, Yale University, New Haven, 1992
37 p. 167, do
38 p. 407, ditto.
39 p. 415, ditto
40 p. 384, ditto
41 p.1 lovelacetrust.org.uk
42 www.british-history.ac.uk/vch/essex/vol5/pp151-162
43 p.72, Barber, T., Boldrick, S., Eds., *Art Under Attack, Histories of British Iconoclasm*, Tate Publishing, London, 2013
44 pp. 50–1, ditto
45 p. 290, Hibbert, C.
46 p. 196, Mauriès, P
47 p. 7, Mauriès, P
48 https://en.wikipedia.org.wiki/Albert-of-Brandenburg
49 p. 252, Haag, S.
50 p. 133, Wills, G., *English Furniture 1760–1900*, Guinness Superlatives Limited, London, 1979
51 p. 2, Winterbottom, M.
52 Yorke, J., *Cabinet of curiosity: we do not even know for sure the maker of the Sixtus Cabinet at Stourhead* www.spectator.co.uk/2015/02/cabinet-of-curiosity-we-do-not-even-know-for-sure-the-maker-of-the-sixtus-cabinet-at-stourhead 8/29/2016
53 p. 40, Kahan, G., *George Alexander Stevens & the Lecture on Heads*, University of Georgia, Athens USA, 2008
54 p. 6, Delburgo, J.
55 p. 3, Archibald, E.A.
56 p. 32, Ullyett, K., *British Clocks and Clockmakers*, Collins, London, 1942

57 p. 72, Barber, T.

Ch. 12 Venues & Fairs

1 p. iii, Morley, H., *Memoirs of Bartholomew Fair,* Hugh Evelyn Limited, London, 1973

2 p. vi, ditto

3 p. 10, Willson Disher, M., *Fairs Circuses & Music Halls,* William Collins London, 1942

4 p. 155, Kerr Cameron, D., *The English Fair,* Sutton, 1998

5 p. viii, Morely, H.

6 Schlicke, P., *Richardson, John (1766–1836)* oxforddnb.com/view/article/23564

7 p. 326, *The Gentleman's Magazine,* May 1837

8 Bridges, J. of Chippenham, *A Book of Fairs, or a Guide to West Country travellers shewing them all the fairs in these thirteen several counties showing viz. Gloucestireshire, Wiltshire, Somerset, Dorsetshire, Cornwall, Glamorganshire, Monmouthshire, Herefordshire, Worcestershire, Oxfordshire, Berkshire & Hampshire,* London c.1729

9 *The Gloucester Journal,* 23 August 1747

10 p. 64 Latimer, J., *The Annals of Bristol, Vol. 2,* Georges, Bristol, 1970

11 pp. 173–4, Latimer, J.

12 p. 49, Kahan, G., *George Alexander Stevens & The Lecture on Heads'* The University of Georgia Press, Atlanta, 2008

13 p. vii, Morley

14 p. 159, Kerr-Cameron, D.

15 p. vii, Morley, H

16 p. 85, Scott, H., *The Early Doors :Origins of the Music Hall,* Ivor Nicholson & Watson, London 1946. Republished EP Publishing, East Ardsley, Wakefield, 1977

17 p. 83, ditto

18 pp. 85–6, ditto

19 p. 111, Pedicord H. W., *The Theatrical Public in the Time of Garrick,* King's Crown, Colombia University, New York, 1954

20 p. 21, Hawes, C., *Macklin's Panopticon* in Hawes, C., ed, *Christopher Smart and the Enlightenment,* St Martin's Press, New York, 1999

21 p. 84, Scott, H.
22 p. 77, Barton-Baker, H., *The London Stage 1576–1888*, vol. 1, W.H. Allen 1883
23 p. 111, Pedicord, H.W.
24 *London Advertiser & Literary Gazette*, 17 July 1751
25 p. 1, Kahan, G.
26 p. xxvi, Jennings, G.H., Ed., *Thomas Turner: The Diary of a Georgian Shopkeeper*, 2nd Edition, Oxford University Press, 1979
27. *The Daily Post*, London, August 1726
28 ditto London 28 August 1736
29 p. 7, Ford, J., *Ackermann 1783–1983 The Business of Art*, Ackermann, London 1983
30 p. 143, Highfill, P.H. Jr., *Performers and Performing* in Hume, R.D. Ed. *London Theatre World, 1660—1800*, Southern Illinois University Press, London, 1980
31 p. 131, Kahan
32 The General Advertiser, 2 January 1750
33 bathartandarchitecture.blogspot.co.uk/2017/09/charles-clay-clocks.html
34 p. 131, Kahan, G.
35 *The Mirror of Literature, Amusement and Instruction*, June 29 1829, Johnson Collection

Ch. 13 On the Road

1 *Felix Farley's Bristol Journal*, 30 August 1777
2 Delburgo, J., Slavery in the Cabinet of Curiosities: Hans Sloane's Atlantic World britishmuseum.org/pdf/delbourgo?20essay.pdf
3 *Felix Farley's Bristol Journal*, 26 December 1778
4 *ditto*, 1 May 1779
5 Bromley, J., *The Clockmakers' Library*, London, 1977
6 *The Daily Advertiser,* London 23 December 1741
7 www.freemansauction.com/news.docs 16/09/2004
8 *George Faulkener & The Dublin Journal*, May 10 1746
9 p. 42, Macgregor, A., Ed. *The Cobbe Cabinet of Curiosities: An Anglo Irish Country House Museum*, Yale University, New Haven
10 *The Bath Journal,* 9 November 1747

11 *The General Advertiser*, 22 February 1749

12 *The Norwich Mercury*, 12 January 1754

13 *Washington Wooed a Loyalist* www.thefreelibrary.com/Washington+wooed+a+Loyalist-a030442312 01/01/2006

14 p. 182, *The Diaries of Benjamin Lynde and Benjamin Lynde Junior*, Cambridge Riverside Press, 1880

https://archive.org/details/diariesbenjamin001lindgoog.

15 *The Bristol Intelligencier*, 12 March 1757

16 *Felix Farley's Bristol Journal*, 6–27 November 1756

17 p. 32, Jennings, G.H., ed., *Thomas Turner: Diary of a Georgian Shopkeeper'* Oxford University Press, Oxford, 1979

18 *The Daily Advertiser*, 21 June 1759

19 Edgeworth, R.L., & M., *Memoirs of R.L. Edgeworth*, vol. 1, London 1820

20 p. 14, Paton-Williams, D., *Katterfelto Prince of Puff*, Matador, Leicester, 2008

Ch. 14 Educating the Masses

1 p. 1, Millburn, J.R., *The Meandering Microcosm: A Chronological Account of the Travels of this "Matchless Pile of Art" in England, Scotland, Ireland and America 1733–1775*, Aylesbury, UK 1995

2 Egerton, J., *Wright, Joseph, of Derby (1734–1797, Painter* www.oxforddnb.com/view/... 30044 4/5/2017

3 p. 58, Fawcett, T., *Science Lecturing at Bath, 1724–1800*, in *Bath History* Vol. VII 1998, Millstream Books, Bath, 1998

4 p. 795, Gardiner, J., Ed, *The History Today Who's Who in British History*, Collins & Brown, London, 2000

5 p. 220, Frances Terpak, *Free Time, Free Spirit: Popular Entertainments in Gainsborough's Era*, Huntington Library Quarterly, June 2007 Vol. 70 no 2

6 pp. 254–5, Porter, R., *Science, Provincial Culture and Public Opinion in Enlightenment England*, in Borsay, P., ed., *The Eighteenth Century Town: A Reader in English Urban History 1688 – 1820*, Longman Group, Harlow, 1990

7 p. 85, Walker, R.J. B., *Old Westminster Bridge: The Ship of Fools*,

David & Charles, London, 1979

8 p. 74, Thompson, E.P., *Time, Work Discipline and Industrial Capitalism*, in Past and Present no. 38 (December 1967)

9 Schofield, R. E., *The Lunar Society of Birmingham – A Social History of Provincial Science & Industry in Eighteenth Century England*, Clarendon Press. Oxford, 1963

10 p. xiii, King-Hele, Desmond, *The Collected Letters of Erasmus Darwin*, Cambridge University Press, Cambridge, 2007

11 p. 391, Glennie, N., and Thrift, N., *Shaping the Day: A History of Timekeeping in England and Wales 1300–1800*, Oxford University Press, Oxford, 2011

12 Colvin, C.E., *Edgeworth, Richard Lovell (1744–1817)* www.oxforddnb.com/view/8478

13 Hunt, D., *Cartwright, Edmund (1743–1823)* www.oxforddnb.com/view/4813

14 www.nottshistory.org.uk/articles/misc/the cartwrights.htm

15 p. 138, Gardiner, J.

16 www.claytonheightslibrary.com/inventions.html

17 Hunt, D.

18 www.nottshistory.org.uk/articles/misc/the cartwrights.htm

19 p. 6, Macgregor, A., Ed., *The Cobbe Cabinet of Curiosities: An Anglo Irish Country House Museum*, Yale University Press, New Haven

20 *James Ferguson – Significant Scots* www.electricscotland.com/history/other/ferguson_james.htm 05/04/2007

21 p. 35, Carpenter, A.T., *John Theophilus Desaguliers: A Natural Philosopher, Engineer and Freemason in Newtonian England*, Continuum, London, 2011

22 p. 37, Carpenter, A.T.

23 Londry, M., *Tollet, Elizabeth (1694–1754)* www.oxforddnb.com.../27502 6 Jan 2011

24 p. 42, Brock, C., *The Comet Sweeper: Caroline Herchel's Astronomical Ambition*, Icon Books, Cambridge UK, 2007

25 p. 39, ditto

26 p. 273, Gardiner, J.,

27 p. 56, Adams, M., *The Prometheans: John Martin and the Generation that Stole the Future*, Quercus, London, 2009

28 Tyler, D., *Gainsborough, Humphrey (1718–1776)* www.oxforddnb.com.../77225 4/4/2017

29 *Felix Farley's Bristol Journal*, 4 October 1766

30 ditto, 8 June 1776

31 p. 69, Fawcett, T.

32 p. 11, Latimer, J., The *Annals of Bristol Volume 2 Eighteenth Century*, George's, Bristol, 1970

33 p. 55, Fawcett, T.

34 p. 33, Paton-Williams, D., *Katterfelto: Prince of Puff*, Matador, Leicester, 2008

35 Snobelen, S.D., *Whiston, William (1667–1752)* oxforddnb.com/view/article/29217 john whiston

36 www.electricscotland.com/history/other/ferguson_james.htm 05/04/2007

37 p. 113, Wilson, A., *William Roscoe Commerce & Culture*, Liverpool University Press 2008

38 Capp, B., *Parker, George (1654–1743)* oxforddnb.com/view/article/21298

39 Schlicke, P., *Richardson, John (1766–1836)* oxforddnb.com/view/article/23564

40 Walter Gibson & Morris Young, Editors, *Houdini on Magic*, Dover Publications, 1953, in p. 57, Paton-Williams, D.

41 pp. 17–18, Paton-Williams, D.

42 p. 16, ditto

43 pp. 122, ditto

44 www.electricscotland.com/history/other/ferguson_james.htm 05/04/2007

45 p. 329, Cross, M., and Ewen, D., *Encyclopaedia of the Great Composers and their Music*, Doubleday, New York, 1962

46 p. 354, Roger Smith, *James Cox (c,1723–1800): a Revised Biography*, Burlington Magazine, 141 (2000)

47 p. 71, Fawcett, T.

48 p. 60, Eger, E., and Peltz, L., *Brilliant Women: Eighteenth-Century Bluestockings'* National Portrait Gallery, London 2008

49 Fairclough, K.R., *Walton [nee Bourchier] Philippa (1674–1749)*, Oxford Dictionary of National Biography oxforddnb.com/.... 48262 2017

50 Dr. Johnson to Sophia Thrale, July 24th 1783, p. 252, Scott, A.F., *Every One A Witness, The Georgian Age*, Martins Publishers, London 1970

51 Balderston, K.C., ed., Thraliana: *The Diary of Mrs Hester Lynch Thrale (later Mrs Piozzi)* 2 volumes (Oxford 1942) pp 1073–4 in p.73, Bath History as above

52 p. 479, Gardiner, J., Ed.

53 Toole, B.A., *Byron (Augusta) Ada, Countess of Lovelace* oxforddnb/view/article 37235 6/1/2011

54 Felix Farley's Bristol Journal, 7 January 1775

55 pp. 135–6, Scott, A.F,

Ch. 15 Horologies & Astronomies Part 1

1 p. 9, Ullyett, K., *British Clocks and Clockmakers*, Collins, London, 1942

2 p. 58, Thompson, E.P., *Time, Work Discipline and Industrial Capitalism*, in Past and Present, no. 38 (December 1967)

3 p. 48, Ullyett, K.

4 pp. 35–6, Turner, W.J., *English Music*, Britain in Pictures, William Collins, London, 1945

5 p. 2, Glennie, P., Thrift, N., *Shaping the Day: A History of Timekeeping in England and Wales 1300–1800*, Oxford University Pres, Oxford, 2011

6 p. 59, Thompson, E.P.

7 pp. 8–9, Ullyett, K.

8 p.8, ditto

9 pp.48–9, French, A., *J.J. Merlin the Ingenious Mechanic*, Iveagh Bequest, G.L.C., 1985

10 www.oxfordartonline.com/subscriber/article/grove/art/
T018196 15/12/2008

11 p. 112, Fleet, S., *Clocks: Pleasures and Treasures*, Weidenfeld and Nicolson, London, 1961

12 p. 136, Wood, E.J., *Curiosities of Clocks and Watches From the Earliest Times*, Richard Bentley, London, 1866

13 p. 34, Ullyett

14 p. 219, Haag, S., Kirchweger, F., Eds. *Treasures of the Habsburgs*, Thames & Hudson, UK, 2013

15 www.oxfordartonline.com/subscribe/article/grove/art/T018196 15/12/2008

16 p. 211, Wood, E.J.

17 p. 139, Wood, E.J.

18 *Significant Scots – James Ferguson* www.electricscotland.com /history/other/ferguson_james.htm 05/04/2007

19 p. 12, Ullyett, K.

20 p. 28, Ullyett, K.

21 pp. 53–4, Carpenter, A.T., *John Theophilus Desaguliers: A Natural Philosopher, Engineer and Freemason in Newtonian England*, Continuum, London, 2011

22 Dick, M., *John Whitehurst and Eighteenth Century Geology*, in *Revolutionary Players*, www.search.revolutionaryplayers.org.co.uk/engine/resource/exhibition... 05/04/07

23 p. 97, Fleet, S.,

24 www.oxfordartonline.com/subscriber/articles/grove/art/T018196

Ch. 16 Horologies & Astronomies Part 2

1 p. 109, Fleet, S. *Clocks: Pleasures and Treasures*, Weidenfeld and Nicolson, London, 1961

2 p. 10, Ulyett, K., K., *British Clocks and Clockmakers*, Collins, London, 1942

3 p. 92, Wood, E.J. *Curiosities of Clocks and Watches from the Earliest Times*, Richard Bentley London, 1866

4 p. 22, Ullyett, K.

5 Newman, S., *The Christchurch Fusee Chaingang*, Amberley Publishing, Chalford, 2010

6 pp. 158–165, Page, W., Ed. *The History of the County of Middlesex: Vol. 2: Industries : Clock and Watch Making* www.british-history.ac.uk/report.aspx?compid =122169 16 Nov 2010

7 p. 18, Ullyett, K.

8 p. 21, ditto

9 *London news-letter*, November 9th 1767, in p 179 Scott, A.F., *Every One A Witness, The Georgian Age*, Martins Publishers, London 1970

10 pp. 158–165, Page, W.

11 p.37, Ullyett, K.

12 Evans, J.L., *Graham, George (c.1673–1751)* oxforddnb.com/view/artcle/11190

13 p. 38, Ullyett, K.

14 p. 40, ditto

15 p. 273, Glennie, P., and Thrift, N., *Shaping the Day: A History of Timekeeping in England and Wales 1300–1800* Oxford University Press, Oxford, 2011

16 p. 34, Ullyett

17 p. 354, Ducheyne, S., *The Times and Life of John Th. Desaguliers (1683–1744): Newtonian and Freemason*, in Reve Belge de Philologie et d'Histoire/Belgisch Tijdschrift voor Filologie en Gescheiedenis, 87, 2009, pp 349–364

18 Evans, J.L.

19 *BIOS Reporter*, 1997 vol. XXX

20 Smith, R., *James Cox (c1723–1800): A Revised Biography*, Burlington Magazine, 141, 2000

21 pp. 128–34, Jones, A., *Piracy: Intellectual Property Wars from Gutenberg to Gates*, University of Chicago Press, 2009

22 p. 43, Ullyett, K.

23 pp. 396–7, Glennie, P., and Thrift, N.

24 Electric Scotland www.electricscotland.com/history/other/ferguson_james.htm

25 pp. 398–9, Glennie, P., and Thrift, N.

26 p.12, Kenny, R.; McMillan, J., Myrone, M., *British Folk Art*, Tate Publishing, London, 2014

27 p. 84, ditto

28 p.13, ditto

29 Shenton, R., *Pinchbeck family (per c.1720-1783)* oxforddnb.com/view/article50051

30 *The Norwich Mercury* 28 July, 4–18 August 1753

31 p. 222, Haag, S., Kirchweger, F., Ed., *Treasures of the Habsburgs*, Thames & Hudson, UK, 2013

32 p. 193, Gimpel, J., *The Mediaeval Machine: The Industrial Revolution of the Middle Ages*, 2nd Edition, Pimlico, London, 1992

33 p. 127–9, ditto

34 Lienhard, J.H., *Engines of Ingenuity: Cox's Perpetual Motion Machine*, www.uh.edu/engines/ep527.htm

35 p. 48, Fleet, S.,

36 p. 112, Wood, E.J.

37 p. 62, French, A., *J.J. Merlin the Ingenious Mechanic*, Iveagh Bequest, G.L.C., 1985

38 p. 59, Fleet, S

39 p. 31, French, A.

40 p. 75, Fleet, S.

41 The Arrangement Allotment & Particular Description of the Several Prizes in the Museum Lottery, London, printed for Mr Cox, 1775, British Library

42 Du Bois, P., *Histoire de l'Horloguerie*, Paris, 1849

43 p. 28, Ullyett, K.

44 *The Gentleman's Magazine* , vol. x, May 1740

Ch. 17 The World of Music

1 Erasmus, *Morae Encomium*, or, *In Praise of Folly* https://corfublues.blogspot.co.uk/2015/03/erasmus-on-english-and-their-music.html

2 p. 2, *Curious Organs* www.westfield.org/curious.html... 16/03/2007

3 p. 204, Williams, C., translator *Thomas Platter's Travels in England 1599*, Jonathan Cape, London, 1937

4 p. 332, Cross, M., Ewen, D., *Encyclopaedia of the Great Composers and their Music*, Doubleday, New York, 1962

5 p. 336, ditto

6 p. 27, Scott, H., *The Early Doors: Origins of the Music Hall*, originally published 1946. EP Publishing, 1977

7 p. ix–xi, Thom, M., trans. Corbin, A., *Village Bells: Sound and*

Meaning in the Nineteenth Century French Countryside, Papermac, London, 1999

8 p. 56, *Musical Automata Catalogue of Musical Instruments*, National Speelklok Museum, Netherlands.

9 pp. 55–6, ditto

10 p. 245 Robert Fludd *Utriusque cosmi historia, liber septimus* in p.29 Jan Jaap Haspels, *Automatic Musical Instruments their Mechanics and their Music 1580–1820'*,

11 p. 27, Haspels, J.J.

12 p. 82, note 22 ditto

13 p. 82, note 10 ditto

14 p. 35, ditto

15 p. 62, Antick, R.D., *The Shows of London*, Harvard University Press, Cambridge USA, 1978

16 p. 137, Haspels, J.J.

17 p. 359, Squire, W.B., *Handel's Clock Music*, p. 539 *The Music Quarterly*, 1919 (41)

18 p. 130, Burrows, D., *Handel*, Master Musicians series, Oxford University Press, 1994

19 Christ Church Spitalfields fact sheet online

20 *The Norwich Mercury*, 7–14 July 1753

21 p. 106, *The Gentleman's Magazine*, vol. 66

22 p. 287, Ord-Hume, A.W.J.G., *The Musical Clock: Musical Automaton Clocks and Watches*, Mayfield Books, 1995

23 Diack Johnstone, H., *John James*, Grove Music Online, Dec 2010

24 Cassidy, R., Notes on talk to Waltham Abbey Historical Society, 1997

25 p. 125, Farmer, J., *The History of Waltham Abbey*, 1775

26 Boeringer, J., *Organa Britannica Organs in Great Britain 1660–1860*, vol. 2, Bucknell University Press, London 1986

27 Tindall, P., *Richard Bridge: Research Notes*, BIOS Reporter April 2003, Vol. XXVII, no. 2 http:://npor.emma.cam.ac.uk/Reporter/apr93/g403.htm

28 p. 10, Maclean, G., *The Rise of Oriental Travel, English Visitors to the Ottoman Empire: 1580–1720*, Palgrave, London, 2004

29 p. 351, Le Corbeiller, C., *James Cox: A Biographical Review*, Burlington Magazine 112 (1970)

30 p. 119, Wilson, M.I., *The English Country House and its Furnishings*, Book Club Associates London 1977

31 Dustjacket, Ord-Hume, A.W.J.G., *The Barrel Organ : The Story of the Mechanical Organ and Its Repair* A. S . Barnes & Co, New York 1978

32 *Curious Facts From Organ History*
https://westfield.org/programs/curiousfacts

33 p. 122, Wood, E.J., *Curiosities of Clocks and Watches from the Earliest Times*, Richard Bentley London, 1866

34 p. 65, Haspels, J.J.

35 p. 95, French, A., *J.J. Merlin The Ingenious Mechanic*, Iveagh Bequest, G.L.C., 1985

36 p. 65, Sheldrick, G., ed. *The Accounts of Thomas Green 1742–1790*, Hertfordshire Record Publications, 1992

Ch. 18 Records and Witnesses

1 p. 160, Antick, R.D., *The Shows of London*, Harvard University Press, Cambridge USA, 1978

2 p. 128, Jones, A., *Piracy: Intellectual Property Wars from Gutenberg to Gates*, University of Chicago Press, 2009

3 pp. 185–6, Scott, H., *The Early Doors: Origins of the Music Hall*, originally published 1946. EP Publishing, 1977.

4 p. 32, Jennings, G.H., ed. *Thomas Turner, The Diary of a Georgian Shopkeeper*, 2nd edition, Oxford University Press, Oxford, 1979

5 p. 80, Uglow, J., *The Lunar Men: The Friends who made the Future 1730–1810*, Faber and Faber, London, 2003

6 Edgeworth, R.L., & M., *Memoirs of R.L. Edgeworth*, vol. 1, London, 1820

7 p. 391, Glennie, P., and Thrift, N., *Shaping the Day: A History of Timekeeping in England and Wales 1300–1800* Oxford University Press, Oxford, 2011

8 p. x–xi, *Boswell's London Journal 176–-62'*, The Reprint Society, London, 1952

9 p. 15, Ford, P.L., *Washington and the Theatre*

www.thefreelibrary.com/Washington+wooed+a+Loyalist-a030332412 01/01/2006

10 p. 112, vol. 4, *John Marsh's Journals* item omitted source: Brian Robbins via email

11 John Hughes, Review *John Marsh's Journals, 180--1828*, BIOS Reporter April 2003 Vol. xxvii, No. 2 http://npor.emma.cam.ac.uk/Reporter/apr03/f403/htm

12 p. 355, Smith, R., *James Cox (c.1723-1800): a Revised Biography*, Burlington Magazine, 141 (2000)

13 ditto

14 Smith, R., Cox, James (c.1723-1800) https://doi.org/10.1093/ref:dnb/54567 3 Jan 2008

15 p. 354, Smith, R, James Cox,

16 p. 305, Le Corbeiller, C., *James Cox: A Biographical Review*, Burlington Magazine, 112 (1970)

17 p. 259, Porter, R., *Science, Provincial Culture and Public Opinion in Enlightenment* England in Borsay, P., Ed., *The Eighteenth Century Town: A Reader in English Urban History*, Longman, London, 1990

18 French, A., *J.J. Merlin: The Ingenious Mechanic,'* Iveagh Bequest, G.L.C., 1985

19 p. 49, Jennings, G.H. Ed

20 Edgeworth, R.L.

21 p. 63, Antick, R.D.

22 Edgeworth, R.L.

23 Colvin, C.E., *Edgeworth, Richard Lovell (1744–1817)* oxforddnb.com/view/article 8478

24 ditto

25 p. xiii, King-Hele, Desmond, *The Collected Letters of Erasmus Darwin*, Cambridge University Press, 2007

26 p. 80, Uglow, J,

27 p. 414, Glennie, N., Thrift, N., *Shaping the Day: A History of Timekeeping in England and Wales 1300-1800*, Oxford University Press, Oxford, 2011

28 Lienhard, J.H. *Engines of Ingenuity*, No.159 Lowell, Massachusetts www.uh.enginesofingenuity/159

29 p. 160, Adams, M., *The Prometheans: John Martin and the Generation that Stole the Future*, Quercus, London, 2009

30 Appleby, J.H., *Spilman, James (bapt. 1680, d. 1763)* oxforddnb.co,/view/article/5066

31 pp. 229-30, Baines, E., *The History of Cotton Manufacture in Great Britain*, London, 1835

32 p. 49, Brewster, *Letters on Natural Magic,* in p.76 Antick,

33 Colvin, C.E.

34 p. 21, Nocks, L., *The Robot, The Life Story of a Technology*, John Hopkins University Press, Baltimore, 2008

35 p. 11, Haaspels, J.J., *Automatic Musical Instruments: Their Mechanics and their Music 1580–1820*, National Speelklok Museum, Utrecht

Ch. 19 Owners

1 *The Daily Advertiser*, 23 December 1741

2 *The General Advertiser*, 30 March 1750

3 *The Norwich Mercury*, 19–26 January 1754

4 *The Public Advertiser*, 12 April 1758

5 *The Bath Chronicle*, 11 October 1773

6 *The Gazeteer & New Daily Advertiser*, 8 April 1774

7 p. 94, The Galpin Society: Whitehead and Net, *Sun Insurance Policies 1710–79 A to D*

8 p. 72, footnote, Antick, R.D. *The Shows of London* Harvard University Press, Cambridge USA, 1978

9 p. 355, Le Corbeiller, C. *James Cox: A Biographical Review*, Burlington Magazine, 112 (1970)

10 ditto

11 Will of Sarah Bridges, Spinster of Waltham Holy Cross, Essex, proven 13 May 1760, Probate 11/855/399, Public Record Office wills online

12 p. 45, McEnroe, N., Simon, R., *Tyranny of Treatment; Samuel Johnson, his Friends and Georgian Medicine*, The British Art Journal/Dr Johnson's House Trust, London, 2003

13 p. 3, The Carpenters' Company: General Information, March 2010

14 pp. 58–60, Fawcett, T., *Science Lecturing at Bath, 1724–1800*, Bath History Vol. VII, Millsteam Books, Bath, 1998

15 Journal of a Lady of Quality Appendices: II. The Martin Family www.electricscotland.com/history/lady/appendix2.htm

16 Martin, J., Martin, Samuel (1694/5 – 1776) father of Antigua and his son Samuel (1714–88) M.P. for Camelford and for Hastings Oxford Dictionary of National Biography

Ch. 20 The Mad Business of James Cox

1 *The Gazette and New Daily Advertiser*, 21 May 1774

2 *The Public Advertiser, 23 May 1774*

3 *The Gazeteer & New Daily Advertiser*, 30 May 1774

4 ditto 4 June 1774

5 *Felix Farley's Bristol Journal*, 3–31 December 1774

6 *The Shrewsbury Chronicle*, 10 June 1774

7 p. 35, Le Corbeiller, C., *James Cox: A Biographical Review* in Burlington Magazine 112 (1970)

8 p. 191, Vincent, C., Leopold, J.H., Sullivan, E., *European Clocks & Watches in the Metropolitan Museum*, Yale University Press, Princeton, 2015

9 p. 69, Antick, R.D., *The Shows of London*, Harvard University Press, Cambridge USA, 1978

10 Le Corbeiller, C., *James Cox and his Curious Toys* https://www.metmuseum.org/pubs/bulletins/1/pdf/3257782.pdf

11 Lubbock, J., *The Tyranny of Taste: The Politics of Architecture and Design in Britain 1550–1960*, Yale University Press, 1995

12 p. 71, Antick

13 p. 356, Smith, R., *James Cox (c.1723–1800): A Revised Biography*, Burlington Magazine, 141, 2000

14 p. 38, French, A., *J.J. Merlin The Ingenious Mechanic*, Iveagh Bequest, G.L.C., 1985

15 p. 227, Terpak, F., *Free Time, Free Spirit: Popular Entertainments in Gainsborough's Era*, Huntington quarterly, June 2007, Vol. 70, No. 2

16 Mould, C., Merlin John Joseph (1735–1893) oxforddnb.org/

17 pp. 99–100, Twain, M., *The Innocents Abroad*, New York 1984

18 Pointon, M., *Dealer in Magic: James Cox's Jewellery Museum and the*

Economics of Luxurious Spectacle in late eighteenth Century London, in *The History of Political Economy*, (1 December 1999 31, (Supplement) pp 423–51 https://doi.org/10.1215/00182702-31-Supplement-423

19 Permanent Display, Royal College of Physicians, Regents Park London

20 *The Leeds Intelligencer*, 5 May 1771

21 p. 357, Smith, R.

22 p. 69, Antick, R.D.

23 p. 354, Le Corbeiller, C.

24 p. 319, ditto

25 p. 355, Smith, R.

26 *Saunders Newsletter* 10 June 1774

27 *BIOS Reporter* January 1997, Vol. XXI, No. 2

28 p. 358, Smith, R.

29 p. 60, Antick, R.D.

30 Aspden, E., Linley [married name Sheridan], Elizabeth Ann (1754–1792) www.oxfoddnb.org/view53267

31 Mason , W., *An Epistle to Dr Shebbere: To which is added An Ode to Sir Fletcher Norton, in Imitation of Horace* pub 1777, J. Almon, London https://archive.org/details/epistletodrshebbere000masouou

32 Rendell, M., *Georgian Tourist*, London Historians website

33 *The Manchester Mercury*, 7 June 1774

34 p. 34, Perez, L., Technology, Curiosity & Technology in France and England in the 18th Century in Bensaude-Vincent, B., Blondel C., Science and Spectacle in the European Enlightenment, Ashgate Publishing, Aldershot, 2008

35 *Petition J. Cox, jeweller and citizen of London, to sell his museum.* www.bopcris.ac.uk/bop1588/ref1570.html 19/04/2007

36 Pointon, M.

37 Petition J Cox,

38 *The Hibernian Journal*, 19 January 1774

39 *Saunders Newsletter*, 29 January 1774

40 *The Manchester Mercury*, 22 March 1774

41 *Saunders Newsletter*, 15–29 August 1774

42 ditto 23 September 1774

43 *Saunders Newsletter*, 18 May 1775

44 *Felix Farley's Bristol Journal*, 14 October 1775

45 *Felix Farley's Bristol Journal*, 9 March 1776

46 *Saunders Newsletter*, 18 May 1774

47 p. 359, Smith, R.

48 *Leeds Intelligencer* 15 November 1774

49 ditto 6 December 1774

50 *The Hibernian Journal or Chronicle of Liberty*, 16 July 1784

51 p. 360, Smith, R.

52, 53, *The Derby Mercury*, 2 June 1775

54 *The Kentish Gazette*, 14 June 1775

55, 56, 57, *The Manchester Mercury*, 17 April 1776

58 *Mr Cox's Perpetual Motion, A Prize in the Museum Lottery* Romantic Circles https://www.rc.umd.edu/gallery/mr-coxs-perpetual-motion-prize-museum-lottery

59 *The Caledonian Mercury*, 21 December 1774

60 p. 97, Scott, H., *The Early Doors: Origin of the Music Hall*, Ivor Nicholson & Watson, London, 1946, republished E.P. Publishing, Wakefield, 1977

61 no. 34, Advertisement in Harvard Theatre collection, panorama box, Westminster Archives

62 *The Newcastle Chronicle*, 24 December 1791

63 ditto

64 p. 80, Paton Williams, D, *Katterfelto, Prince of Puff*, Matador, Leicester, 2008

65 *The Hampshire Chronicle*, 15 Dec 1788

66 *The Sheffield Register*, 13 November 1789

67 *The Manchester Mercury*, 30 June 1789

68 Pointon, M.

69 Selznick, B., *The Invention of Hugo Cabret*, Scholastic, London, 2007

70 p. 206, Wood, G., *Edison's Eve, A Magical History of the Quest for Mechanical Life*, Anchor, New York, 2003

Ch. 21 Microcosmic Echoes

1 *The Oxford Journal*, 23 February 1796

2 *The Dublin Journal,* 15 January 1783

3 *The Manchester Mercury,* 25 December 1775

4 *The Kentish Weekly Post,* 2 January 1818

5 *The Kentish Gazette,* 18 November 1778

6 ditto 5 February 1808

7 Roget, J. R., *A History of the Old Water Colour Society London' 1891* in pp. 401–2 footnote, Antick, R.D., *The Shows of London*, Harvard University Press, Cambridge USA, 1978

8 Flood, A., *Nattes, J.G., (c.1765–1839)* oxforddnb/view/article/19810

9 Beales, D., *Canning, George (1770–1827)* oxforddnb/view/article/4559

10 *The Gentleman's Magazine,* vol 66 p106

11 p. 62, Fawcett, T., *Science Lecturing in Bath 1724–1800*, Bath History Vol. Vii, Millsteam Books, Bath, 1998

12 E.I. Carlyle, reviewed by McConnel, A, Walker, Adam (1730/1–1821) oxforddnb/view/article/28466

13 p. 72, Pottle, F.A., Ed., *Boswell's London Journal 1762–1763*, The Reprint Society, London, 1950

APPENDIX III INDEX

A

Academy of Ancient Music 98
Ackerman, Rudolph 336
Aix-la-Chapel, Peace of 206, 248
Albermarle, Duke of 166
Albert V of Bavaria 162
Albrecht of Brandenburg III 178
Ale houses 21
Alexander Nevsky, film 60
Alpha Go 296
Amber Room 169
Andric, I. 23
Angelo, Henry 291
Anne, Queen 32, 146, 151; Statute of 32
Antigua 205, 301, 304
Apprenticeship, age of 221, 285; female 251
Arbuthnot, Anne 97; Dr John 97, 221, 285; Art of Political Lying 97
Architecture, Roman 18, 19
Arden, John 228

Armigioni, Jacopo 244
Arnold, John 257
Arts & Crafts Movement 162, 261
Arts cabinets: see under Curiosity Cabinets
Ashmolean Museum, Oxford 166
Asiento contract 206, 249
Assembly Rooms, York 148
Astley, family 296; Mr 326, 327, 333
Athens, Pallas Athene 158
Aubrey, John 156, 170
Augsburg 53, 169
Austen, Jane 61
Automata 256, 263, 273, 295, 326, 330, 331; bijoux 312; northern cathedral 242
Ayckborne, Alan 270

B
Babbage, Charles 85, 236; proto-computer 85
Babooneries 56
Bacon, Roger 87, 110; Francis 171, 172
Balsamario 178
Balzac, Honoré de 279
Banks, Sir Joseph 167, 226, 335
Baptismal fonts 178
Barbaud, Anna Letitia 235
Barber, Francis/Frank 305
Baring-Gould, Rev. Sabine 27
Barnham, P.T. 38
Barrows, Mr, museum 328
Bartlett, Jamie 294
Bath Spa 24
Bavaria, Elector of 50
Bayeux Tapestry 56
Bazalgette, Sir Joseph 21
Beddoes, Dr Thomas 226
Beaufort, Dukes of 195

Beckford, William 181
Beggar's Opera, The 97, 270
Belgian Processional reliquary 161
Betjeman, John 160, 161, 336
Bible, King James, 36; Of the Poor 37, 57, 58, 59
Bickerstaff, Isaac 182
Big Ben 238, 241, 250, 267
Bishops' book 57
Black Britain tv series 305
Black sailors 305
Black Death 38, 106, 154, 162
Blackwell, Elizabeth 214
Boleyn, Anne, clock 240
Bone Wesleys 262
Boswell, James, 68, 285, 287, 334, 338; diaries found 285
Boulton, Matthew 297
Bourdeau, French royal clockmaker 53
Bowes Museum 184, 310, 330
Boydell, John 56, 58
Richard Boyle,
Boyle, Danny 131; Richard: Earl of Burlington, third, 98, 147, 217, 269
Bradley, Richard, 96, 99; dedication to James Brydges 100
Brecht, Bertold 270
Breckel, Richard 12, 17, 260
Bridge, Byfield & Jordan 278; over the Drina 23; of Fools 219; Westminster 219
Bridges David 283, 302; Edward 90, 279; James vii, 93, 111, 113, 116, 141, 165, 200, 201, 205, 207, 208, 301; John 189; Richard 279; Sarah, spinster 150, 202, 302, 304, Thomas 301, 302, 306
Bridoux, L 210
Brinsley Sheridan, Elizabeth (nee Linley) 235, 313; Richard 34, 313
Bristol 62; Bridge vii, 150; Exchange clock 254; Swedish visitors 89
British Museum vii, 138, 213, 243; Library 138

Brixen altarpiece, V&A Museum 175
Broomkamp, collector 273
Brown, Henriette 215; Lancelot "Capability" 98
Browne, Sir Thomas 57, 172, 183
Brunel, Isambard Kingdom 92; Marc 92; 's sawmills 92
Brydges, James 1st Duke of Chandos 2, 46, 50, 64, 93, 95, 99, 104, 138, 217–218, 267, 301
Bucket Rowland 278
Buckingham, Duke of 267
Buergi, Jost 7
Burke, Edmumd 217
Burleigh, Lord 198
Burlington, Lord: see Richard Boyle
Burney, Charles 310, Fanny 235, 313
Bute, Earl of 274
Burton, Dr. of Yarmouth 142
Byrd William 268
Byron, Lord, 236; Ada – see Lovelace

C

Caligori, magician 237
Calvino, Italo 155
Camera obscura 292
Campbell, Colen 148
Canons estate 46, 100, 101
Candlemas Festival
Canning, Charles
Caravaggist school 214
Carpenter, Mary 214
Carpenter's Buildings/Hall 305
Carter, Elizabeth, bluestocking 34, 40, 109, 235
Cartwright, Rev. Edmund 222, 223, 296, 297
Castle Rackrent 225
Catherine, of Braganza 311; the Great 318, 329
Celsius, Andrew 253
Censorium, see Richard Steele

Chamberlain's Act 269
Chandos, First Duke of: see Brydges, James
Change ringing 271
Charing Cross area 195, 197
Charles I 48, 159, 246
Charles V of Spain, collection 156
Charlotte, Queen 51
Chatterton, Thomas 174
Chaucer, Geoffrey Canterbury Tales 23
Cheapside Cross 175
Chelsea Physic Garden 166
Cherokee china clay 329
Child beggars, 92, employment of 92, prodigies 232,
China ingredients of 311, chinoiserie 149
Chinese musical temples 308
Chippendale, Thomas 279
Chorus of Disapproval, A 270
Christ Church, Spitalfields 274
Christchurch Devon 251
Church attendance 29
Churchill, John 95
Clarke, Arthur C. 40, 109
Clay, Charles 49; clock of the Four Great Monarchies 18, 197. 244, 255, 267, 274; clock lottery 313; widow 197, 203 The
Clepsydrae 238
Clifton Hill House, Bristol 150
Clive, Robert 54
Clocks, Black Forest 244; Dutch 244; gravity driven 205; jacks 242, 243
Clockmakers' Guild/company 252, 255, 256; female apprentices 250
Cobbe, Dr. Alex 223
Cobbett, William 27, 261
Coelestina 338
Coffee houses 24, 196

Coleridge, S.T 226.
Columbus, Christopher 38
Comet Halley's 11; cometarium 11, 109
Conan Doyle, Sir Arthur 163
Constable, John's clouds 59
Cook, Capt. James 14, 34, 167, 246
Cooper, Lady Mary 224
Copt Hall 66
Copernicus 140; system of 79, 145
Corelli, tunes 275
Coverture, Law of 153
Cox, Brian, Prof. 299; James 54, 137, 232, 255, 265, 279, 308–331; museum 195, 200, 288, 289.303; in Dublin 317; Liverpool 318; toys survive 321
Cromwell, Oliver88, 159, 289
Crosses, Cheapside destroyed 24; Eleanor 175
Ctesibius 48, 267, 272
Curiosity cabinet 155, 156, 273; how to build a 156; of Hans Sloane 200
Cyrus the Great 47, 256

D

Dallam, Thomas 54, 278; family 280
Damer, Anne Seymour 235
Dampier, William 34, 290, 291
Darwin, Charles 226, Dr Erasmus 214, 220
Davy, Sir Humphrey 226
Davies/Davis Edward 11, 49, 210 279, 302, 302, 308–331; address 211; 's Grand Museum 327, 334, originally Cox's 327
Day, Thomas 143
Dee, John 109. 156
Defoe, Daniel 34, 153
Denison-Becket, Sir Edmund 267
Denis Severs' House Spitalfields 182
Denny, Sir Edward 65, Lady Arabella 245
Desagulliers, Dr J.T. 11, 34, 40, 41, 50, 96, 102, 104, 107, 108,

116, 117, 216, 223, 227, 228, 236, 288, 289, 290, 293; jun 116; Thomas 116, 117
 Deutsches Museum, Munich 7, 310
 Devon, Vivant, reliquary 177
 Dickens, Charles 56, 236
 Distraction 298
 Dolls' houses 102
 Donne, John 41; Benjamin 225
 Don Saltero's Coffee House Museum 166, 181, 196, 200, 265
 Dublin Society 203, Philosophical Society 202, Workhouse 245
 Drury Lane Theatre 34
 Dwarfs, collecting 159
 Dyals, dyalling 254
 Dyer, William 86

E

 East India Company 55, 309
 Eclipse of the sun 11
 Edgeworth Anna 226; Maria 225; Richard Lowell 18, 101, 102, 142, 210, 221, 223, 283, 285, 290, 291, 294, 296
 Edward VI, King 175
 Eidouranion 284, 338
 Egyptian Hall 284
 Eisenstein, Sergei 160
 Elers, Paul 292
 Elizabeth I, Queen 43, 175, 252, 268, 278
 Emin, Tracey 261
 Engelbrecht, Martin of Augsburg 125
 Ensor, James 61
 Epistle to Dr Shebbeare 314
 Erasmus/Elmo, Saint 26
 Eton College 337
 Ethiopian Savage 39
 Eve 152
 Evelyn, John 172, 179, 183, 197, 204
 Exeter Clock, see Lovelace; Exchange 38, 197, 204

Eyecatchers 94

F

Fairs Greenwich 189; King's Lynn 194; Lincoln 188' Loughborough 189; St Bartholomew's 188, 189, 194; St James 188, 189, 190; St Paul's 194; Stourbridge 188, 194, 211; Weobly, revived 189

Fake gold – see Pinchbeck

Falcon Waltham Abbey 68

Faraday, Michael 295

Farmer, John of Waltham Abbey 4, 63, 88, 131

Fawkes, Mr, magic tricks

felspar

Fens, drained

Feejee Mermaid 39

Ferdinand I 156, 178

Ferguson, James 227, 229, 232, 245, 246, 258

Fielding, Henry 35, 37, 192; Sarah 235; Timothy 190

Firejack 262

Fireworks 86

Fisher, Paul 150

Fludd, Robert 272

Folk Museum, Cambridge 185

Fonthill Abbey 181

Foy, Captain 113

Franklin, Benjamin 111, 246, 292

Frederick Prince of Wales 50

Freemasons 112; revived 25, 228

French Academy 253

Fromanteel, Ahasuerus clockmaker 183

Fuller, Thomas 62, 91

Fuentes, Conde de 90

Fuseli, Henry 58, 59, 60, 229

G

Gainsborough, Humphrey 102, 225, 265, 289, 290; Thomas 33, 59, 214, 225, 265, 289

Galileo 40, 239

Garrick, David 18, 56, 58, 193, 217
Gay, John 97, 270
Genesis, Book of 246
Geneva 31
Gerald of Wales 155
George, King III 52, IV 51
Ghost marks 259
Gibbons, Grinling 3, 98
Gilray, James 56
Gin Act 27; Lane, by Hogarth, see also Beer Street
God in a bottle 184, 185
Golden Age of Art, Netherlands 31; of cinema 202
Goldfish 156
Golden Rump, the, play 192
Goldsmiths' Hall 139
Gough, Richard 44, 262
Graham-Dixon, andrew214
Graham, George 31, 35, 108, 111, 241, 252, 255, 256, 262, 285, 288, 316; Dr James 228
 Grand Celestial State Bed 228
 Grand Museum, Cox's 303, Davies 303
 Grand Theatre of the Muses 274
 Grand Tour 17, 21, 55, 170; tourists 148, 179
 Great Fire of London 219; Mogul 263 Plague 219; Wen 219
 Greenwich Observatory 253
 Greyfriars church, Edinburgh 86
 Griffin, Gregory 337; Thomas 278

I
Ilbert, Courtney A., 308
Indoor Illuminations 94
Industrial Revolution vii, 262, 293, 294
Invention of Hugo Cabret, The 331
Italian Folk Tales 155

J
James, John 275, 277; Handel 277

Jaquet-Droz, Pierre; 291. 304, 333
Jennings, Humphrey 121
Jefferson, Thomas 147; 's cabinet 172, 173
Jessop, William 71, 81
Jesuits 53, 122, 134
Johnson, Dr Samuel 37, 169, 170, 195, 236, 285, 295, 304
John Soane's Museum 182
Jones, Inigo 94

K

Kaltenmacht, Gabriel 170
Katterfelto, Gustavus 139, 144, 245, 146, 212, 230, 231, 311, 313, 327; daughter 231
Kaufman, Angelika 61, 235
Kent, William 96, 98, 148
Kepler, Johannes 7; 's second law 109
Keill, John 41, 104, 108
Keith, George 62
Kelly, Gene 139
Kempelen, Wolfgang Von 132
King's College, Cambridge organ 54
King Lear banned 111
King's Theatre, Haymarket
Kite making 221
Knights Templar 105, 106
Knox, John 106
Kristofferson, Kris 30
Kubrik, Stanley 244
Kundst Kabinets/Kunstkammers 19, 156, 273, 290; see also curiosity cabinets

L

Labelye, Charles 111, 112
Lambert, Marchionesse de 142, 236
Landskip painting 31
Langley, Batty 149
Lawrence, Sir Thomas 59

Lecture on Heads 148, 196,197
Lee/Lea River 27, 28; navigation 89
Lennox, Charlotte 235
Les Hombres Chinoises 334
Lepaute, J.A. 265
Lever, Sir Ashton 321; museum lottery 321
Lichfield 293
Licensing Act (theatres) 191
Lignum vitae, wood 254
Lille 210
Lloyd, John 234
Locke, John 216, 217
Lollards 105; underground 106, 175
Longitude Prize 33, 39, 90, 228, 248, 253, 257
Lot's Wife 152
Louis XIV 53, 248, 263
Lovelace, Ada 235; Jacob 174; Exeter clock 260, 329
Loveday, John of Caversham 63
Lowell, F.C. 295
Lunar Men/Society 111, 179, 214, 220, 226, 246, 285, 290
Luther, Martin 38
Lynde, Benjamin jr. 208, 283, 286

M

Macaulay, Catherine 235; Rose 336
Mack The Knife; Mack Tonight 270
Macklin, Charles 191
Magna Carta 20, 304; for children 214; for Market traders 187
Mahogany 254
Maillardet, Henri Exhibition 327
Manners of the Eastern World Explained 324
Manuel, Mr. from Turin 327, company 333
Mantua, Dukes of, collection 159
Maria Theresa, Empress 297
Margraf, Christoph 264
Margaret Archduchess of Austria 156

Market crosses 187; origins 187; Harborough, clock 243
Marlborough, Duke of – See John Churchill
Marsh, John 286
Martin, Benjamin 109, 216, 234, 306; Samuel, father of Antigua 306; Thomas 304
Mary, queen 51
Marylebone Gardens 163, 252
Maskelyne, John Neville 297
Mason, Rev. William 314, 315
Masterpiece, Brechtel clock 43, 47
Mayhew, Henry 232
McCulloch, Kenneth 246
McLemore, John 259
Medici, Grand Duke Francesco de 156, 169, 177
Méliès, Georges 331
Mememto mori 245
Menschicov, Prince 295
Merlin, J.J. 190. 256. 181, 'silver swan 303
Merchant Taylors' Hall, Bristol 200
Methodists 193
Michaelangelo 56
Microcosm, of the Brazils 333; concerto 276; modern 139, 285
Microscope, solar 40
Millet, Jean François 153
Milton, John 56; Gallery 58
Mikado, the, not allowed 191
Mission, The, film 52
Mississippi Scheme 52, 196
Mr Pike's Dancing Room, Norwich 196
Mitchel, Joni
Mitre Tavern, The 201
Moliere 37
Monasteries, closure of 41, 43
Monkey fish, Japanese 39
Montacute 174

Montaigne, Michel de 156, 162
Monticello 173
More, Hannah 235
Morley, Sir Thomas painting 175, 241
Mozart, Wolfgang 233
Musa brothers of Baghdad 272

N

Nash, Richard ('Beau') 25, 61, 220
Nattes, John Claude 335
Natural History Museum 167, 200
Nef clocks 243
Nelson's column 305
New Inn, Gloucester 195
Newsome, fire engine 112
Newton, Sir Isaac 41, 103, 109, 224, 245, 264
Nine Living Muses of Great Britain 235
Noah's Flood 38, 145
Nollekens, Joseph 217, 313
Nonconformists 23, 33
Nonesuch Palace
Norwich 62; Cathedral 242
Nuer cattle herders 239
Nuremberg 53

O

Olusogu, David 305
On Solitude 156
Orleans, Duke of 169
Orpheus 42
Ottery St Mary 250
Ottoman Empire 54
Overseer of the Poor

P

Palazzio vecchio 156, 169
Palladio, Four Books of Architecture 150 palladian mansion 5
Pallant House Gallery 180

Pallas Athene 158
Pandora 152
Paradise Lost 60
Parker, George 229
Patent Law 255, 257
Paty, family 116; John 117; Thomas 116, 150; General Sir William 117
Peasants' Revolt 106
Pegasus 144
Peasant Boy Philosopher 232
Pepusch Johann 55
Pepys, Samuel 170, 190 196, 254.288
Penny universities 24
Perpetual motion machine 264
Perry, Grayson 261
Peter the Great 89, 295
Pevsner, Nikolas 20, 55, 56, 59
Phillip II of Spain 122, 156, 247; III 123
Phillipe, Mary 20
Physician priests, loss of 28
Pied Piper of Hameln
Pioneers' Journals 287
Pinkethman, William 49, 50
Pirates, Turkish 190
Pinchbeck, Christopher 201, 263
Plassey, victory 54, 309
Platter, Thomas 43, 268
Plays mystery/morality 269
Poets' Corner, Westminster Abbey 23
Pomerania, Duke of 169
Poor Rates, Elizabethan 22
Pope, Alexander 23, 91, 96, 97, 142, 144, 315
Portmeiron 162
Potosi, Silver mines of 52
Pre-Raphaelites 56

Priestley, Dr Joseph 102, 111, 228, 294
Primum nobile 5
Prince of Wales 208, 301
Prodigies 232, 233
Protestant Work Ethic 254
Ptolemaic universe 6, 145
Pyke, John 273
Pyne, W.H. 335

Q
Quacks, travelling 28
Quakers 30, 193
Quatermass and the Pit 39
Queen Charlton 189
Queen Anne's statute 148

R
Raleigh, Sir Walter 65
Ramsay, David, clockmaker 252
Ranelagh Gardens 93
Raphael 56
Redand Chapel, Bristol 151
Reindeer, Swedish 156 – see also goldfish
Reliquaries, V&A Museum 154, 155 modern 177; variety of 177;
Rennie, John 88
Revolution, French 216; American 216
Reynolds, Sir Joshua 56, 214, 329
Ricci, Matteo 309
Richard III, play 141
Richardson, John 189, 229; Samuel 190
Ringing towns 270
Rivals, The, play 313
Robert-Houdin, Jean-Eugene 331
Robinson, Mary 214
Rochester, Earl of 48
Rocks, rockings 270
Roebuck, Dr John 103

Rogation processions 261
Romantic movement 179
Rood screens 175
Roscoe, William, banker 229
Roslyn Chapel, 49; apprentice pillar 49
Rousseau, J.J. 225
Rowlandson & Pugin 336
Rowley, John, clockmaker; 335; Thomas fictitious poet 174
Royal Academy of the Arts, 39, 60, 262; of Music 97, 269; Africa Company 96; Fort House Bristol 165; Society 24, 40, 105, 107, 171, 227, 228, 253, 288, 289, 294; of Music 97, 269; Society, College of Physicians 46, 172; Exchange 196; Literary and Philosophical Society of Bath 61; Royal Exchange Coffee House 196; Museum 315;

Rubens, Peter Paul 159
Rudolph II, Emperor 7, 156
Rysbrack, Michael 243

S

Saints, female 26; St Andrew's University 96; St. Denis Abbey Church 156; St Christopher (St Kitts) 206; St Dunstan's, Fleet St 243; St Ewin's Bristol 271; St Erasmus (Elmo) 26; St George in the East 276; St Helen the Great 278; St Mary Redcliffe church, Bristol 174, 262; St.Nicholas' church, Bristol 208; St. Monday 220; St Olave's Southwark 276; St. Paul's Cathedral saved 159, 161; clock 255; St Wulfstan 272

Salisbury Cathedral 251; Music Festival 211
Samuel, Richard 23
Saussire. C-F de 63
Savage Landor, Walter 39; Ethiopian 39
Science Lecturers 220, 227; Museum, 257
Scribblerius Club 97, 221, 270
Scorsese, Martin 331
Scott, Sir Walter 223, 225
Sea chanties/shanties 239
Selznick, Brian 331
Shabti 273

Shakespeare, William 49, 56; songs 268
Sheep castrating 242
Shelley, P.B. 233
Shepperd, G., artist 138
Shoe Lane Conduit 243
Shovell, Sir Cloudsley 33, 248
Siddons, Sarah 235
Silicon Valley 293; Secrets of 294
Sing-sings 309
Slaves, Spanish 304
Sloane, Sir Hans 166, 200; collection 167, 200
Smallpox inoculation 28
Small, Dr William 220, 292
Smeaton, John, engineer 88
Smiles, Samuel 114, 218
Smithsonian Museum of History and Technology 122
Snowshill Manor 161, 183
Society of Antiquaries 201; of Apothecaries 177; Artists in Watercolours 335; of Virtuosi 195
Sommerville, Mary 236
South Sea Company 96, 219; Bubble 50, 52;
Southey, Robert 38, 226
Spa, St Georges' 24; Sadlers' Wells 24, see also Bath
Spalding Gentleman's Society 25
Spectator, The 25
Speelklok Museum, Utrecht 248, 273, 281
Spilman, James 245
Spinning Jenny 222
Spring Gardens, great auction room 209; Museum, Dublin 317
S-Town, podcast 259
Stapleford Tawney parish 68
Stationers' Company 137; monopoly 32, lost 137
Steele, Sir Richard 34; 's Censorium 25, 223
Stevens, G.A. 141, 181, 193; cabinet of fancy 181
Stewart, Rod (yes, him) 162

Stourhead 180, 331
Strasburg clock 174
Strawberry Hill 149, 181
Suicide, widespread 52
Sultan of Turkey
Swan, silver, see J.J. Merlin
Swift, Jonathan 41, 95
Symonds, Thomas 83

T

Tan Chitqua 311
Tallis, Thomas 268
Tatler, The 25, 34
Tea drinking, objections to 27, 311
Tellurions 213, 255
Temple of Health and Hymen 228; of the Four Grand Monarchies 18, 197, 244
Theatrum Mundi 49
Theweneti family 336
This American Life 259
Thornhill, Sir James 55, 60, 98
Thrale, Mrs 236
Threepenny Opera 270
Tinplate Workers Company 253
Tipu's Tiger 182
Tollett, Elizabeth 22, 46
Tompion, Thomas, royal clockmaker, 31, 232, 252, 253, 255
Toredo worm 86
Tradescants Museum/the Ark 38, 166
Tragedy of Bateman, The, clock 12
Trevise, David 68
Turkey, sultan of 278
Turkish chess player 222
Turner, Thomas 194, 208, 285, 287, 290
Turpin, Dick's wife 62
Tye, Thomas 283, 286

U
Uffizzi gallery 156
Universities Cambridge 33; Oxford 227
Ussher, Bishop James 215
D'urfey, Tom 270

V
V&A (Victoria & Albert) Museum 43, 37, 243, 260, 266; Museum of Childhood 162
Vagrancy Act 191
Vanbrugh, John 96
Vaucanson, Jaques de 111, 203, 272; fraudulently defecating duck 315, 331
Vauxhall Gardens 94, 198
Venus, transit of 11, 14
Vitruvius 271
Voltaire 142, 226

W
Wade, Charles 171, 177
Waites, Tom 270
Walker, Adam 337
Waltham Holy Cross/Abbey vii, 20, 52, 62, 174; magistrates of 229; powder works 64, 86;
Waltham, Massachusetts 295
Walpole, Horace 149, 181; Robert 95, 98, 191, 192, 270
Waltire, John 228
Walton, family 88; John 88–91; Phillippa nee Bouchier 88, 235; William 88
War, American Civil 38; English Civil 21, 214, 268; of the Roses 37; Seven Years' 14, 206; Spanish Succession 89, 93, 148; Thirty years 158, 159; World War I 162; World war II 162
Ware, Sir Isaac 35, 147
Washington, Col, George 207, 283, 286
Water, unclean drinking 29; ways 218
Waterman, Pete 162
Watson, Myghall 278

Watt, James 103
Wedgwood, Josiah 226, 328
Weekes Museum 179
West, R., artist 138
Wesley family 61, John 231, 287,
Westminster Abbey 252, 253 see also Poets' Corner, Bridge 114
Wheatstone, Charles 236
Whimsey 184
Whiston, John 218, 229 William 145
Whitehurst, John 214, 220, 246
White House, Washington D.C 148.
William, III King 53; -Ellis, Clough 162
Wilkes, John MP 306
Wilkins, John of Sutton Colifield 103
Wilson Peale, Charles Museum of Curiosities 50
Winchester, organ 272
Witch's bottle 185
Wood, E.J. 7; John the elder 112, 113; Gaby 331
Wooden Walls of England 248
Woolaston, Dr. William 295
Womens' Institutes 261
Wrangel Cabinet 158
Wren, Christopher 123
Wright, Joseph 56 of Derby 56, 208, 214; Thomas, Wizard of Durham 34, 288
Wyatt Brothers 313, 314
Wycliffe, John 105
Wyndham, William 169

Y

York Buildings Water Works 96, 223

Z

Zoffany, Johan 311, 313

ACKNOWLEDGMENTS

I wish to thank Mike Handford for encouraging this project for many years, and for the many librarians and archivists who helped me track the story.

I also wish to thank the late Peter Huggins. What a shame we never made it to Antigua.

But ultimately this book is dedicated to the Augustans, the endlessly curious, sometimes confused child-adults whose contribution to our history deserves far more respect and attention.

ABOUT THE AUTHOR

Barb Drummond climbs mountains to see past times. She burrows for hidden stories and lures them into the open to reveal their secrets. She asks why things happened, who was involved, how could they think it was a good idea. Sometimes she finds diamonds, or dust of things that mattered. She finds a single name, or a sentence, that lights up the sky like fireworks. Or she finds silence, which can also bear great meaning. She seeks patterns, themes, traces. Or shapes left by them. Sometimes she uses guesses to patch what is missing, but she makes it from the best possible material.

barbdrummond.com
Twitter: @Barb Drummond
Facebook: Barb Drummond

UNTITLED

Lightning Source UK Ltd.
Milton Keynes UK
UKHW01f2237110918
328728UK00007B/511/P